¡PRINTING THE REVOLUTION!

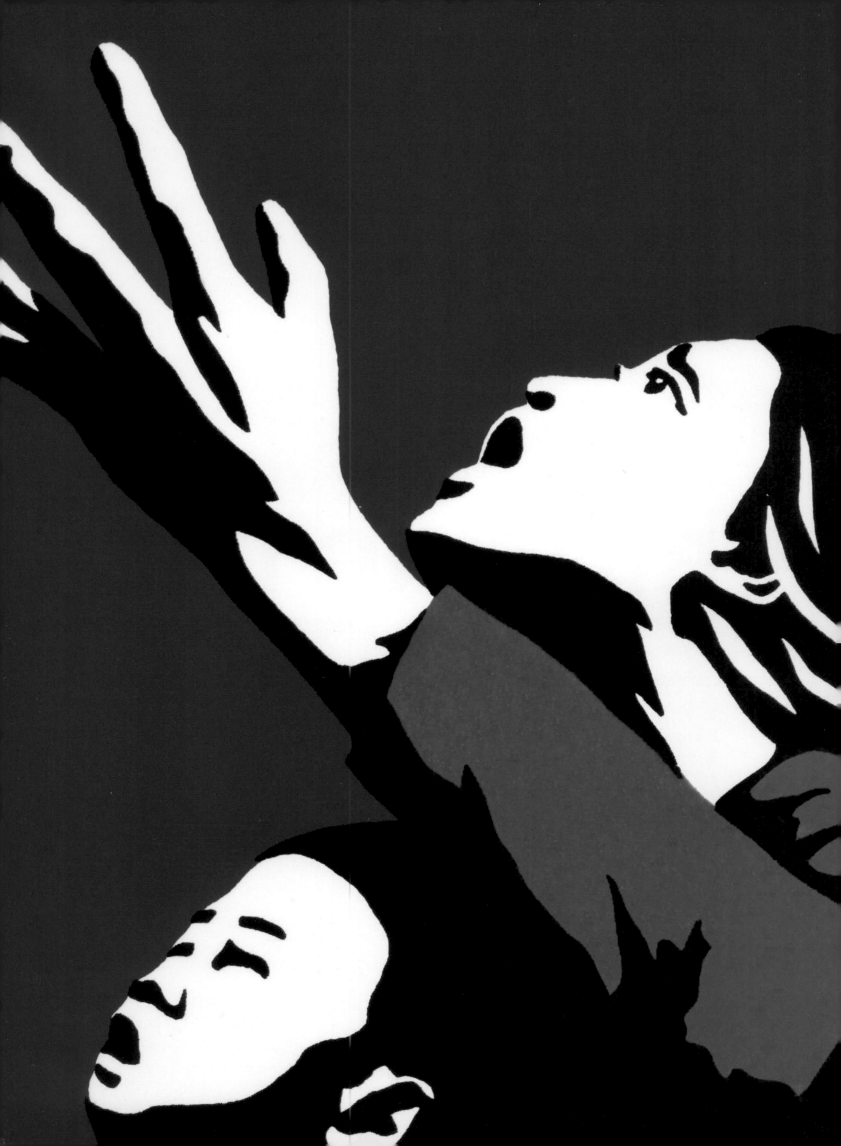

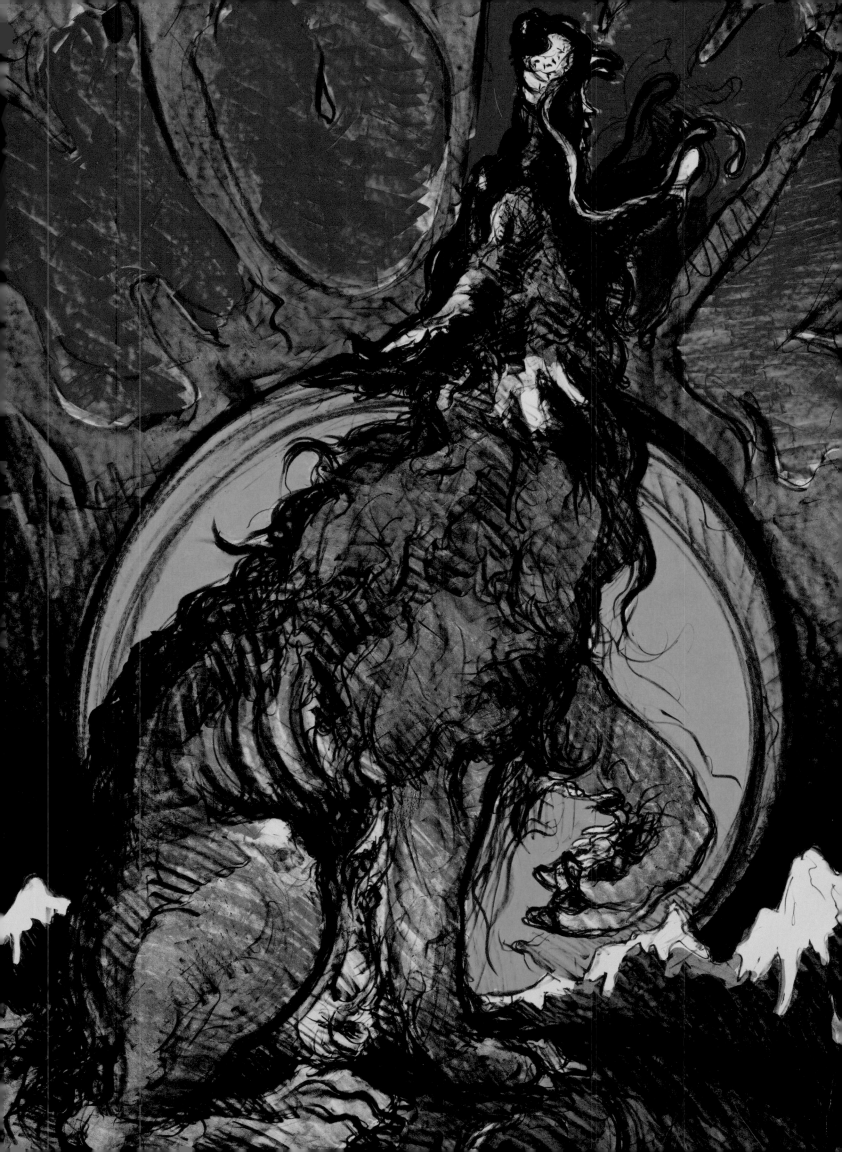

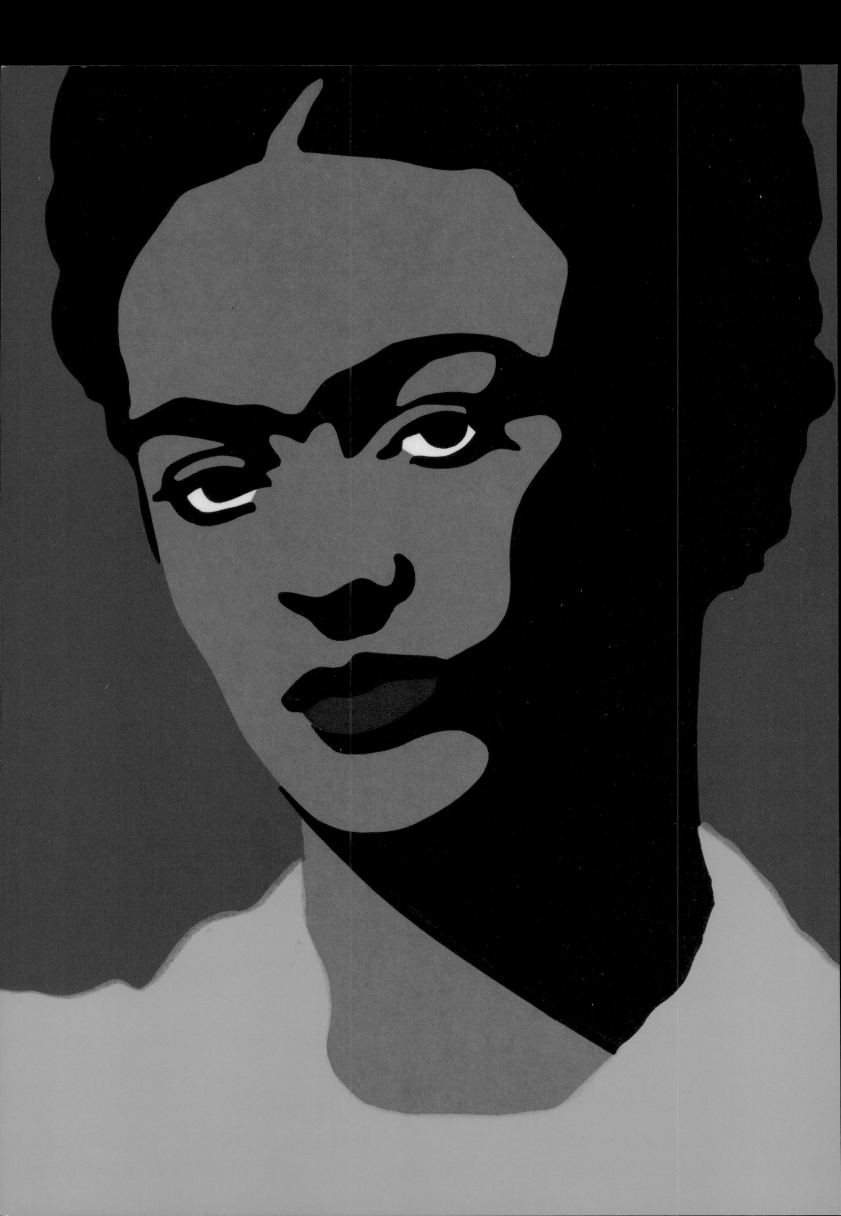

Edited by

E. Carmen Ramos

Contributions by

E. Carmen Ramos, Tatiana Reinoza,

Terezita Romo, and Claudia E. Zapata

¡PRINTING THE

The Rise and Impact of Chicano Graphics, 1965 to Now

REVOLUTION!

Smithsonian American Art Museum,

Washington, DC, in association with

Princeton University Press,

Princeton and Oxford

¡PRINTING THE REVOLUTION!

The Rise and Impact of Chicano Graphics, 1965 to Now

Published in conjunction with the exhibition of the same name, on view at the Smithsonian American Art Museum, Washington, DC, November 20, 2020, through August 8, 2021.

Produced by the Publications Office, Smithsonian American Art Museum, Washington, DC, americanart.si.edu

Theresa J. Slowik
CHIEF OF PUBLICATIONS

Mary J. Cleary
SENIOR EDITOR

Denise Arnot
DESIGNER

Richard Sorensen, Aubrey Vinson
PERMISSIONS & IMAGES COORDINATORS

Magda Nakassis
PROOFREADER

Kate Mertes
INDEXER

Published by the Smithsonian American Art Museum in association with Princeton University Press, Princeton and Oxford, press.princeton.edu.

Smithsonian American Art Museum

PRINCETON
press.princeton.edu

The Smithsonian American Art Museum is home to one of the largest collections of American art in the world. Its holdings—more than 43,000 works—tell the story of America through the visual arts and represent the most inclusive collection of American art of any museum today. It is the nation's first federal art collection, predating the 1846 founding of the Smithsonian Institution. The Museum celebrates the exceptional creativity of the nation's artists, whose insights into history, society, and the individual reveal the essence of the American experience.

Typeset in Knockout, Alright Sans, Rockwell, and printed on Périgord.

IMAGE DETAILS

COVER | FRONTISPIECE Leonard Castellanos, *RIFA*, 1976 [pl. 27]

BACK COVER Melanie Cervantes, Dignidad Rebelde, *Between the Leopard and the Jaguar*, 2019 [pl. 117]

P. 2 Nancy Hom, *No More Hiroshima/Nagasakis*, 1982 [pl. 43]

P. 3 Luis Jiménez, *Howl*, 1977 [pl. 28]

P. 4 Rupert García, *Frida Kahlo (September)*, 1975 [pl. 19]

P. 5 Rupert García, *¡LIBERTAD PARA LOS PRISONEROS POLITICAS!*, 1971 [pl. 8]

P. 9 Gilbert "Magu" Luján, *Cruising Turtle Island*, 1986 [pl. 50]

PP. 10–11 Xavier Viramontes, *Boycott Grapes*, 1973 [pl. 11]

ENDPAPERS Sandra C. Fernández, *Mourning and Dreaming High: con mucha fé*, 2014–18 [pl. 102]

LIBRARY OF CONGRESS CATALOGING-IN-PUBLICATION DATA

NAMES Ramos, E. Carmen, editor. | Reinoza, Tatiana. War at home. | Romo, Terezita. Aesthetics of the message. | Zapata, Claudia E. (Claudia Elisa). Chicanx graphics in the digital age. | Smithsonian American Art Museum, organizer, host institution.

TITLE ¡Printing the revolution! : the rise and impact of Chicano graphics, 1965 to now | edited by E. Carmen Ramos ; with contributions by E. Carmen Ramos, Tatiana Reinoza, Terezita Romo, and Claudia E. Zapata.

DESCRIPTION Washington, DC : Smithsonian American Art Museum ; Princeton : in association with Princeton University Press, [2020] | "Published in conjunction with the exhibition of the same name, presented at the Smithsonian American Art Museum, Washington, DC, November 20, 2020 to August 8, 2021." | Includes bibliographical references and index.

IDENTIFIERS LCCN 2020027314 | ISBN 9780937311066 (SAAM hardcover edition) | ISBN 9780691210803 (SAAM and Princeton University Press flexi-cover edition)

SUBJECTS LCSH: Mexican American prints—Exhibitions. | Art and society—United States—History—20th century—Exhibitions. | Art and society—United States—History—21st century—Exhibitions.

CLASSIFICATION LCC NE539.3.M4 P75 2020 | DDC 769.973089/6872—dc23

LC record available at HTTPS://LCCN.LOC.GOV/2020027314

10 9 8 7 6 5 4 3 2

PRINTED IN ITALY BY CONTI TIPOCOLOR

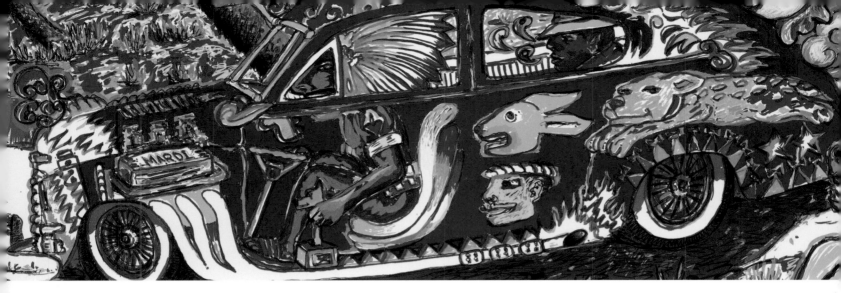

CONTENTS

¡PRINTING THE REVOLUTION! THE RISE AND IMPACT OF CHICANO GRAPHICS, 1965 TO NOW is organized by the Smithsonian American Art Museum with generous support from:

The Latino Initiatives Pool, administered by the Smithsonian Latino Center

Michael Abrams and Sandra Stewart

The Honorable Aida Alvarez

Joanne and Richard Brodie Exhibitions Endowment

James F. Dicke Family Endowment

Sheila Duignan and Mike Wilkins

Ford Foundation

Dorothy Tapper Goldman

William R. Kenan Jr. Endowment Fund

Lannan Foundation

Henry R. Muñoz, III and Kyle Ferari-Muñoz

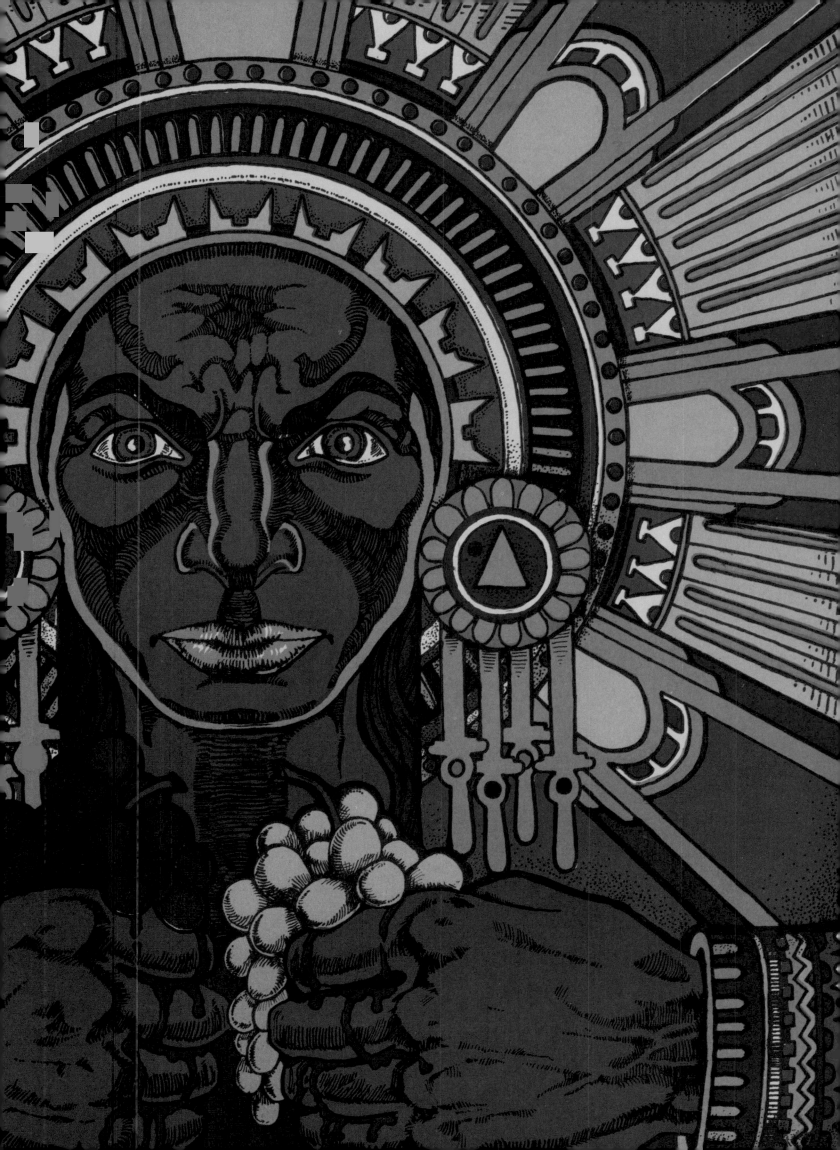

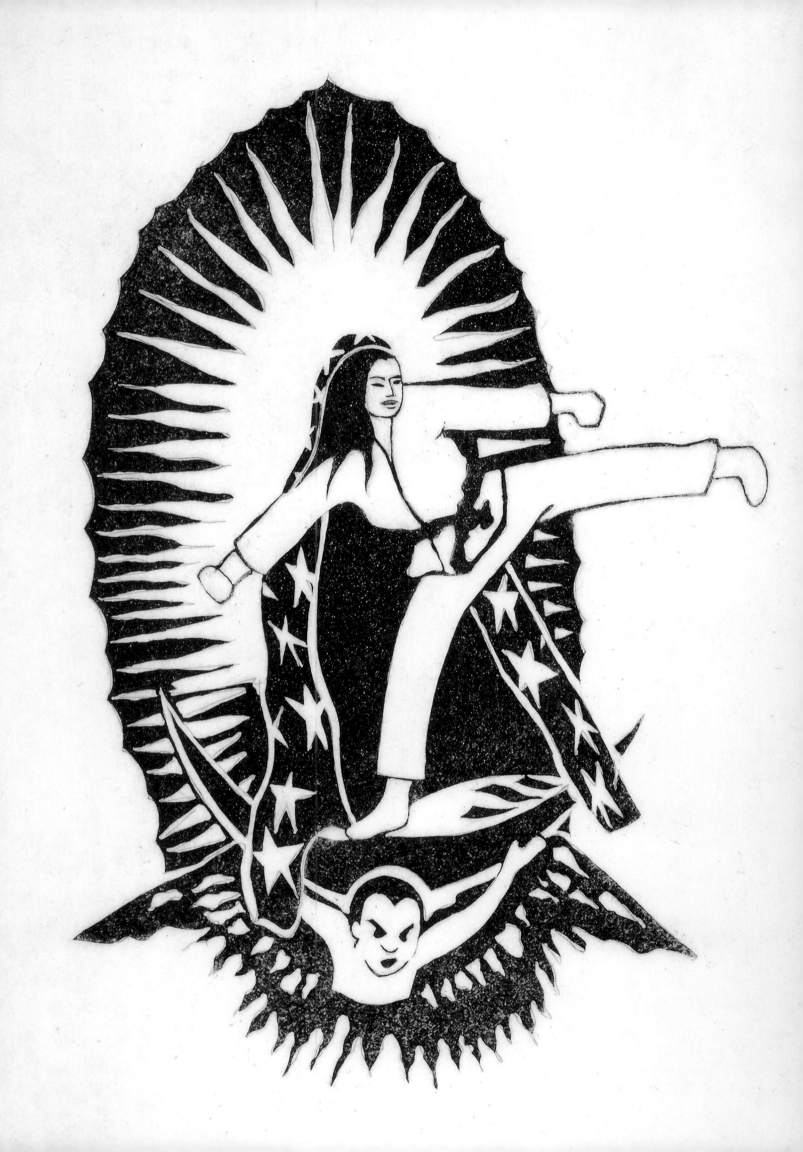

Stephanie Stebich
The Margaret and Terry Stent Director

DIRECTOR'S FOREWORD

¡Printing the Revolution! represents a notable milestone in a remarkably fraught and transformative global moment. This timely project, which showcases visual representations of resistance and revolution, rests alongside a similarly uneasy present. As I write this introduction in July 2020, people around the world are flooding the streets to protest racism and continued acts of police brutality. The coronavirus pandemic, which has disproportionately impacted communities of color, has once again exposed the deep structural inequities in American society. Climate change activists are seen brandishing handmade and printed signs that telegraph the urgent need for action. In recent years, acrimonious debates have emerged about economic and social equality, along with heightened tensions over trade and immigration. These are the insistent voices of our shared global moment, and in every instance protest art has been present.

Visual defiance against authority has a long history. From the French, Mexican, and American revolutions through twenty-first-century movements—suffrage, India's independence, American civil rights, women's rights, Argentina's Mothers of the Plaza de Mayo, anti-apartheid solidarity efforts, LGBTQ+, Black Lives Matter, #MeToo—artists and activists have used broadsheets, banners, political cartoons, posters, murals, and graffiti to voice discontent and demand change. Urban streets and NBA game courts are activism's newest "canvas," printed with bold graphics for Black Lives Matter. With social media, activists can now amplify their images and messages with the tap of a finger. Whether on paper or online, protest art continues to give voice to excluded communities, spur societal change, and by extension alter the

Ester Hernandez,
*La Virgen
de Guadalupe
Defendiendo los
Derechos de
los Xicanos*,
1975, pl. 21.

course of history. For museums, collecting, exhibiting, and interpreting works allows us to capture the artist's role in society, and to document our changing social values.

For over forty years, the Smithsonian American Art Museum (SAAM) has staged more inclusive narratives of the American experience. Since the 1970s, SAAM has committed itself to deepening its collection and scholarship in the field of Latinx art. In Chicanx art in particular, the Museum has a proud history. In the 1990s, we hosted the groundbreaking survey *Chicano Art: Resistance and Affirmation* and the solo exhibition *Man on Fire: Luis Jiménez.* The major gift in 1995 of sixty Chicano posters from scholar Tomás Ybarra-Frausto motivated the current project. We acquired works by civil rights–era artists Amalia Mesa-Bains, Carlos Almaraz, Frank Romero, Carmen Lomas Garza, and Mel Casas, among others. Chicanx art features prominently in our galleries and national traveling exhibitions like *Arte Latino* (2002). Since 2010, E. Carmen Ramos, acting chief curator and curator of Latinx art, has been instrumental in shaping this effort. In the last ten years she has doubled the Museum's holdings and marshalled them into innovative, award-winning exhibitions. She produced *Our America: The Latino Presence in American Art* (2013), which questioned the omission of Latinx artists from the history of U.S. art, and *Down These Mean Streets: Community and Place in Urban Photography* (2017), an examination of how Latinx photographers and artists responded to the history of urban neglect and decline in U.S. cities since the 1960s. Ramos's projects routinely push for both a recognition and critical assessment of how Latinx artists actively participate in the history of U.S. art. I applaud Carmen and Claudia Zapata for advancing the field with this important publication.

¡Printing the Revolution! is built on the recent acquisitions of over five hundred graphic works by Chicanx artists and their collaborators. It highlights more than one hundred works, the majority of which were acquired in the last two years through purchase and the generosity of visionary collectors and donors, including Gilberto Cárdenas and Dolores Carrillo García, Harriett and Ricardo Romo, and the estate of Margaret Terrazas Santos. This selection represents one-fifth of SAAM's holdings of Chicanx graphic arts, which is now the largest museum collection of its kind on the East Coast. We look forward to producing many more exhibitions from this material and sharing these national collections with other museums in the years ahead.

The featured works were created from 1965 during the Chicano civil rights movement in the United States, and since then. The movement, or El Movimiento, championed reform on a range of issues affecting Chicano life, including labor unions, farmworkers' rights, police brutality, and educational equity. Chicanx artists and their collaborators used their art to critically reflect on pivotal moments in American history and express solidarity with other aggrieved groups, both locally and globally. In more recent works, artists continue to probe such issues, while bringing renewed focus to immigration, environmental justice, and the desire for increased visibility of LGBTQ+ communities. Authors E. Carmen Ramos, Tatiana Reinoza, Terezita Romo, and Claudia E. Zapata

consider the diverse graphic forms created by artists who seek to highlight injustice and challenge the status quo. In their remarkable range of colors and inventive designs, these works are honored as both functional objects and artworks in their own right.

¡Printing the Revolution! marks a shift in the scholarship of Chicanx graphic arts. As an East Coast institution, we know that the history of Chicanx graphic arts is less well known in our region and regrettably is still routinely omitted from U.S. exhibitions and histories of graphic arts. The present survey marks a new path forward, one that affirms Chicanx art integral to the history of American art. By uniting civil rights–era artists with those active today, our exhibition presents Chicanx graphic arts as a living, vibrant movement, revealing the strong intergenerational links among such foundational figures as Malaquias Montoya, Rupert García, Ester Hernandez, and Juan Fuentes, and younger artists. Unlike earlier exhibitions, *¡Printing the Revolution!* draws attention to how artists from other communities worked alongside Chicanx artists as peers and mentees. Our growing collection of time-based media coupled with our desire to tell this story in the digital age also led us to trace how early innovators and current trailblazers embrace technology to reach audiences in novel ways. No other exhibition of Chicanx graphic arts has captured such an expansive and nuanced picture of the field.

We are grateful for the generosity of organizations and individuals who recognized the importance of this project. We thank the Ford Foundation and the Lannan Foundation for their major support. Additional funding was provided by the Honorable Aida Alvarez, Michael Abrams and Sandra Stewart, the Joanne and Richard Brodie Exhibitions Endowment, the James F. Dicke Family Endowment, Sheila Duignan and Mike Wilkins, Henry R. Muñoz, III and Kyle Ferari-Muñoz, Dorothy Tapper Goldman, and the William R. Kenan Jr. Endowment Fund. The Latino Initiatives Pool of the Smithsonian Latino Center offered crucial support, part of its dedication to presenting the rich history of the Latino experience in the United States. Each donor shares the Museum's commitment to fostering a deeper understanding of our country's diverse stories and experiences. We thank them all.

The events of 2020 ushered in a profound period of reckoning across U.S. society, including cultural institutions. SAAM leadership and staff remain committed to addressing racism and systemic inequities in transparent and accountable ways, particularly in the collections and exhibitions we share with the nation. This exhibition allows us to see the roots of today's activism in the very public struggles unleashed during the American civil rights era, and to recognize that much work remains to be done. Artists change the way we see the world, and through their art they inspire urgent and important conversations about who we are, as a society and country, and who we want to be. *¡Printing the Revolution!* offers us all an opportunity to begin that conversation anew by revisiting the powerful work of Chicanx graphic artists and their collaborating peers.

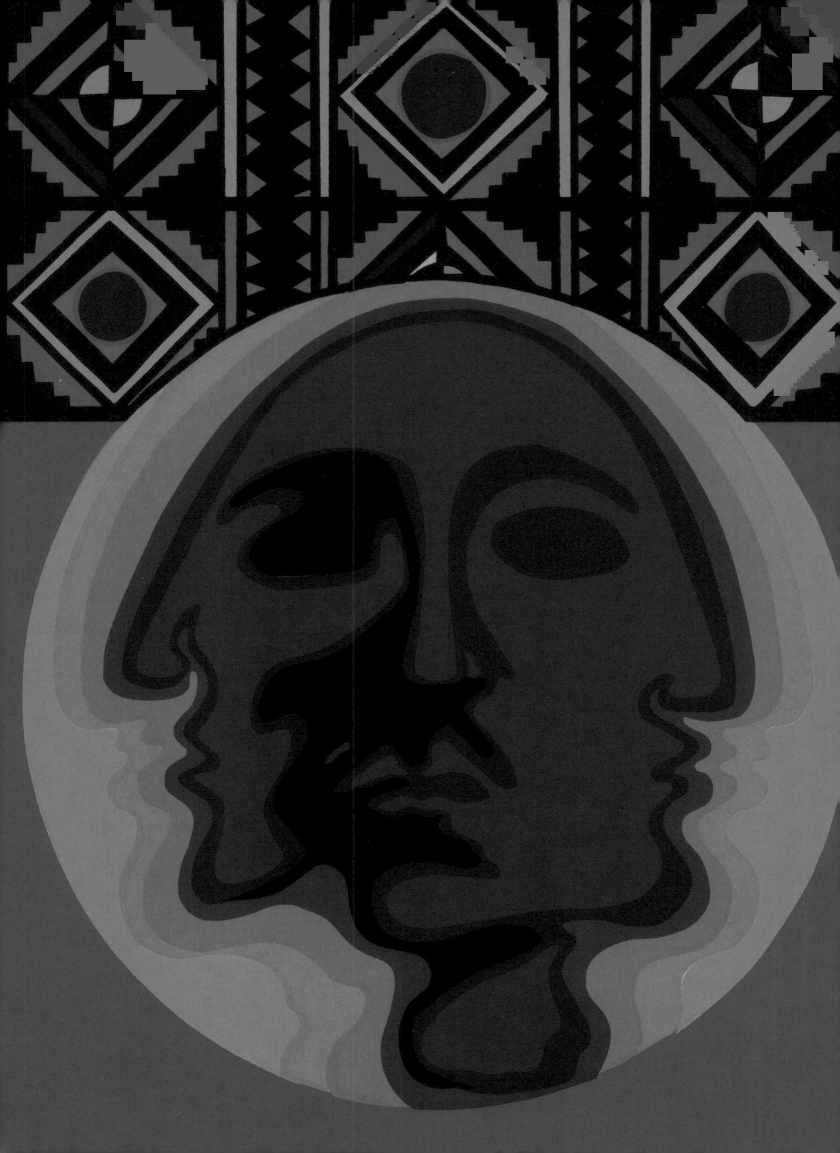

E. Carmen Ramos
Acting Chief Curator and Curator for Latinx Art

ACKNOWLEDGMENTS

¡Printing the Revolution! has been a discovery from the very start. It began with the idea that we should mount an exhibition of our Chicanx graphics collection, most of which was gifted to the Smithsonian American Art Museum (SAAM) by the foundational Chicano scholar Tomás Ybarra-Frausto in 1995. As with every permanent collection exhibition I've organized for the Museum, I knew our holdings needed expanding. Key artists and key works are always missing. I also knew I wanted to broaden our collection's historical frame. The phrases "Chicano graphics" or "Chicano posters" are often inextricably linked to the words *civil rights era*, as if nothing happened before or after. Thus began my quest to identify works that date not only from the Chicano civil rights movement of the 1960s and 1970s, but also from the years that follow those decades. Early on, I was afforded a special gift: Claudia E. Zapata. This bright young scholar joined our staff and brought a wealth of knowledge and dedication to the study of Chicanx art. She has made the project enjoyable, rewarding, and deeply enriching, and I am thankful for our collaborative partnership. Scholars Tatiana Reinoza and Terezita Romo contributed catalogue essays, as did Claudia; together, their participation has greatly enhanced the exhibition and this publication. It's been a special honor to work with such intelligent and knowledgeable women.

This project would not be possible without the gifts and generous contributions of our major donors, starting with Tomás Ybarra-Frausto. Our collecting efforts led us to old friends Dr. Gilberto Cárdenas and Dolores Carrillo García, and Drs. Harriett and Ricardo Romo, who expanded their donations in remarkable ways. Good fortune

Amado M. Peña Jr.,
Mestizo, detail,
1974, pl. 13.

brought us to the estate of Margaret Terrazas Santos, which generously donated works that enrich both the exhibition and our collection as a whole. I am deeply grateful to Jody and Rosa Terrazas for entrusting me and SAAM with Margaret's memory. Over the years, numerous other donors gave works that are featured in the exhibition and this publication. We are grateful to the generosity of Lalo Alcaraz, Barbara Carrasco, Rodolfo O. Cuellar, Lincoln Cushing, Ester Hernandez, the late Luis Jiménez, Susanne Joyner, Emanuel Martinez, Alfred S. Pagano and Susan A. Tyler, Amado M. and Maria Peña, Zeke Peña, Mario Torero, and the Trustees of the Corcoran Gallery of Art. We also thank Jesus Barraza, Luis C. González, Ernesto Yerena Montejano, and the Rasul Family Chicano Art Collection for gifting works during this latest period of collection growth.

Generous funding for this ambitious exhibition and catalogue came from other quarters. We greatly appreciate the major support of the Latino Initiatives Pool, administered by the Smithsonian Latino Center, which supported the installation and public and teacher programs. We are deeply grateful to the Ford Foundation, especially its program officer Dr. Rocío Aranda-Alvarado, and the Lannan Foundation for funding this project, which resonates so deeply with their commitment to social justice and culture. We are honored to have earned their support. I am personally touched by the donations of our current and former SAAM commissioners and dear friends of our Museum, including the Honorable Aida Alvarez, Michael Abrams and Sandra Stewart, Henry R. Muñoz, III and Kyle Ferari-Muñoz, Dorothy Tapper Goldman, and Sheila Duignan and Mike Wilkins. I feel fortunate that we were also able to rely on the Joanne and Richard Brodie Exhibitions Endowment, the James F. Dicke Family Endowment, and the William R. Kenan Jr. Endowment Fund for support.

To research this project, Claudia and I spoke to and corresponded with numerous scholars, curators, and cultural workers who shared their advice and vast knowledge of Chicanx graphics. We especially thank Rocío Aranda-Alvarado, Betty Avila, Angélica Becerra, C. Ondine Chavoya, Cary Cordova, Ruben Charles Cordova, Deborah Cullen, Lincoln Cushing, Karen Mary Davalos, John Vincent Decemvirale, Ella Maria Diaz, V. Gina Diaz, Lisa Duardo, Julia Fernandez, Josh Franco, Helen Frederick, Ramón García, Rita Gonzalez, Colin Gunckel, Robb Hernández, Olga Herrera, Carlos Francisco Jackson, Guisela Latorre, Gabriela Lujan, Amelia Malagamba, Amalia Mesa-Bains, Dylan Miner, Harvey Mireles, Harper Montgomery, Tey Marianna Nunn, Laura Pérez, Tatiana Reinoza, Pilar Tompkins Rivas, Kaelyn Rodríguez, Terezita Romo, Rose Salseda, Marsha Shaw, Francesco Siqueiros, Gina Tarver, Mary Thomas, George Vargas, Kathy Vargas, Carol Wells, and Tomás Ybarra-Frausto. I am thankful to Ana María Reyes and the anonymous peer reviewers for reading and commenting on early versions of this catalogue. Their questioning and recommendations strengthened the content of this book.

I am also grateful for the hospitality and professionalism of the presses in the United States that we visited, who pulled countless prints and shared their institutional histories with us. We appreciate the assistance of Burning Bones Press, Coronado

Print Studio, Design Action Collective (previously Inkworks Press Collective), Dignidad Rebelde, Mission Cultural Center for Latino Arts, Modern Multiples, El Nopal Press, La Printeria, Self Help Graphics, Segura, Serie Project at Coronado Studio, and the Taller Arte del Nuevo Amanecer (TANA).

I am very grateful to our director, Stephanie Stebich, for entrusting me to build our collection, and for providing the time and resources needed to tell this story. This project is proof that ever since she arrived in 2017, she has made Latinx art a priority. I am always indebted to Virginia M. Mecklenburg, senior curator and former chief curator, for always championing my projects and helping find solutions to bumps in the road. She has been a mentor and a cheerleader since I joined SAAM in 2010. Eduardo Díaz, director of the Smithsonian Latino Center, continues to offer his unwavering support for the work I do and for my vision.

The organization of the exhibition and catalogue required an army of colleagues to mount. Deputy Director David Voyles, who arrived at our museum in the midst of this project, provided sound financial oversight. I thank Donna Rim, chief development officer, and her colleagues Kate Earnest and Christie Davis, who fundraised with great fervor. I am indebted to our Registrars office, which worked above and beyond the call of duty to bring hundreds of prints to the Museum from across the country, only a fraction of which are presented here. Chief Registrar Melissa Kroning and her able staff—especially Emily Conforto, David DeAnna, Craig Pittman, Lynn Putney, Lily Sehn, Denise Wamaling, and Marjorie Zapruder—worked tirelessly to transport and process so many new acquisitions. Former management support assistant Jean Lavery and curatorial assistants Laura Augustin and Anne Hyland handled voluminous acquisitions paperwork with poise and an eye for detail. Paper conservator Kate Maynor and time-based media conservator Dan Finn were instrumental from the very start. They cared for new acquisitions and offered keen advice on addressing the needs and protocols of digital works that are transforming the field.

I thank Erin Bryan for providing great exhibition coordination throughout all phases of this large and multifaceted exhibition. Exhibit designers Eunice Park Kim and Grace Lopez approached the installation layout with creativity, excitement, and sensitivity. Harvey Sandler helped us envision our interactive and digital kiosks for the exhibition, and stepped up with creative solutions when we had to change our plans in response to COVID-19. Martin Kotler and Tom Irion carried out the seemingly endless task of matting and framing with humor and professionalism. As always, I am grateful to Theresa Slowik, director of the Publications office, who connected us with our copublishing colleagues at Princeton University Press, and who deftly managed details in the production of this catalogue. Senior Editor Mary Cleary used her skill and judgment to bring language and content into a cohesive manuscript. I especially appreciate Mary's ability to navigate the Spanish language when needed, and work through our changing language conventions as we adopt more inclusive terminology. This beautiful catalogue

would not be possible without the creativity of graphic designer Denise Arnot, one of our newest colleagues, and the tireless work of Riche Sorensen and Aubrey Vinson, who secured rights and image permissions. I am grateful to Mildred Baldwin and Mindy Barrett, who took countless photographs that appear in this book and on our website. I appreciate the talents of Joanna Marsh, deputy education chair and head of interpretation and audience research, and Anne Showalter, digital interpretation specialist, who worked collaboratively with Claudia Zapata and me to devise compelling interpretation strategies for our visitors. The exhibition experience is much richer for their contributions. I am grateful for our External Affairs and Digital Strategies department, led by Sara Snyder and powered by colleagues Laura Baptiste, Kayleigh Bryant-Greenwell, Amy Fox, Howard Kaplan, and Rebekah Mejorado, for embracing this project with enthusiasm. I deeply appreciate the research assistance of intern Melissa San Miguel and Latino Museum Studies Program Fellow Natalie Solis. It was wonderful to involve the next generation in this project.

The final planning stages of this exhibition and catalogue coincided with the outbreak of the COVID-19 pandemic and the civic protests and unrest following the police killings of George Floyd and Breonna Taylor, and the many others who preceded them. These two national crises brought into palpable relief the entrenched racial and economic disparities that permeate American society. This reality has made the social justice lens of this exhibition even more important to bring to fruition.

I owe my deepest gratitude to my husband, Steven Alfred, and our sons, Esteban Miguel and Miles Santiago. This exhibition required many trips and late nights away from them. I appreciate their unwavering support and love. I dedicate this project to my beloved parents, Rosa and Miguel Ramos, whose sense of moral justice continues to shape my vision of the world.

NOTE TO THE READER This catalogue uses the term Chicano to refer to the historical Chicano movement in the United States (starting roughly in 1965) and its participants. Chicana references women who fought for and prefer this designation. We use the term Chicanx as a current, inclusive designation that is gender-neutral and nonbinary.

Spanish-language names and words are spelled according to individual preferences and precedent. Spellings may not correspond to the rules of Spanish orthography.

E. Carmen Ramos

PRINTING AND COLLECTING THE REVOLUTION

The Rise and Impact of Chicano Graphics, 1965 to Now

The **REVOLUTION** will not be televised...The **REVOLUTION** will be live. —Gil Scott-Heron, 1970 The nature of Chicanismo calls for a **REVOLUTIONARY** turn in the arts as well as society. [It] must be **REVOLUTIONARY** in technique as well as content. It must be popular, subject to no other critics except the pueblo itself, but it must also educate the pueblo toward an appreciation of social change. —Luis Valdez, "Notes on Chicano Theater," 1970 It is in [the United States] that art could function as a **REVOLUTIONARY** weapon. If **REVOLUTION** is simply no more than society rapidly changing (which I doubt), then, art could be the catalyst that brings about that change, or to put it more modestly, some of that change. —Carlos Almaraz, "The Artist as a Revolutionary," 1976

The revolutionary rhetoric of the 1960s and early 1970s was so common-place that the meaning of the word *revolution* could almost be lost in retrospect. While revolution can mean a dramatic change in government, often through armed conflict, in the United States during these same decades it signified an individual and societal paradigm shift, as citizens, residents, and entire communities demanded equality and justice embedded in a reconceived social contract between people, governments, and the institutions that affect their daily lives. For these reasons, the civil rights, labor, anti-war, Black Power, and women's and gay liberation movements modeled activist notions of citizenship and worked to change policies and heighten public awareness about persistent inequities in American society. For Mexican Americans, this period was nothing short of

Yolanda López,
Free Los Siete,
detail, 1969, pl. 6.

a turning point. Mexican American activism existed before the 1960s, but the tenor of what came to be known as the Chicano civil rights movement, or El Movimiento, marked a completely new way of being a person of Mexican descent in the United States. To call yourself Chicano—a formerly derogatory term for Mexican Americans—became a cultural and political badge of honor that expressly rejected the goal of melting-pot assimilation. Malaquias Montoya, an early activist artist and acclaimed printmaker, visualized this shift in consciousness with

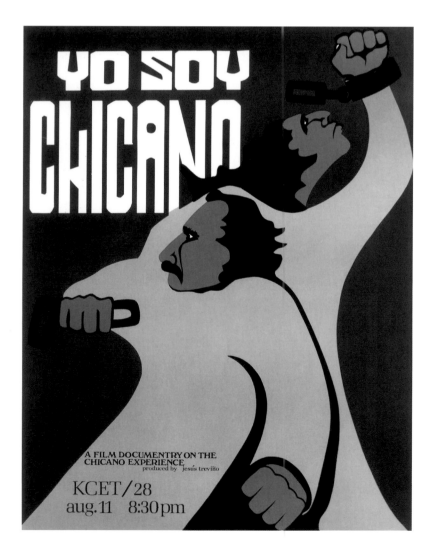

his depiction of two figures holding or wearing broken shackles to evoke a conceptual break with the past (**PL. 10**). The late journalist Rubén Salazar also used iconoclastic references when he classically defined Chicano as "a Mexican-American with a non-Anglo image of himself."[1] Yet, pronouncing oneself Chicano was not solely an individual act; it was also a shared effort to build community, enact political change, and reimagine U.S. identity, history, and culture. Indeed, Montoya's *Yo Soy Chicano*, which he initially created to promote a nationally broadcast public-television documentary of the same name (**FIG. 1**), functions as both personal affirmation and a collective call to action.

Chicano graphic artists were among the first to immerse themselves in civil rights activism. Working independently and with labor unions, community and student groups, and in collectives and institutions they founded themselves, Chicano graphic artists created visually arresting works that catalyzed a Chicano public coming into awareness of itself. One striking example is Yolanda López's *Free Los Siete,* which advocated for the release of a group of young Latinos accused of killing a police officer in San Francisco in 1969 (**PL. 6**). Her poster circulated at rallies and in newspapers, and galvanized the Mission District's Chicano and Latino community into a powerful social force with a noticeable presence in subsequent city politics (**FIG. 2**).[2] Chicano posters and prints announced labor strikes and cultural

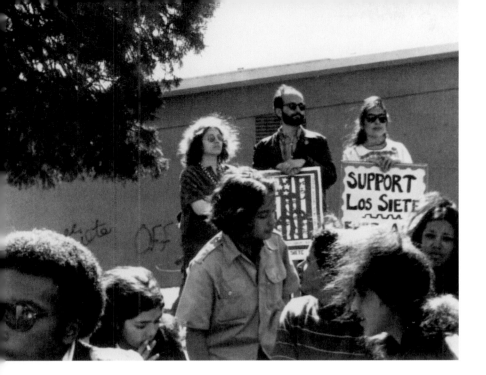

events, raised awareness of the plight of political prisoners, schooled viewers in Third World liberation movements, and, most significantly, challenged the rampant invisibility of Mexican Americans in American society. Artists created works that defined Chicanos as a racialized group in the United States with a distinct yet overlooked culture and political history. Graphic artists had a real impact on people's lives, and through their creativity, active participation, and engagement forged a Chicano graphic arts legacy that remains vital today.

¡*Printing the Revolution¡ The Rise and Impact of Chicano Graphics, 1965 to Now* presents selections from the Smithsonian American Art Museum's (SAAM) extensive graphic holdings as a way to recognize the remarkable history of Chicano graphic arts and to acknowledge the medium's special role in staging critical debates about U.S. history and identity. Though the practice of political graphics has a long global history and deep roots among many U.S. groups—whether defined by race, class, ethnicity, gender, disability, or sexuality—Chicanx artists, institutions, and networks have demonstrated a sustained

commitment to the medium that is noteworthy, innovative, and largely overlooked in broad art museum surveys of U.S. graphic arts.[3] In fact, there is a discernible color line that pervades exhibitions that encompass the rise of "fine art" printmaking during the so-called American print renaissance of the mid-twentieth century, demonstrating how racial segregation shaped the art world and subsequently art history.[4] Alternatively, Chicanx and other non-white artists appear regularly in studies and exhibitions of political graphics—most of which focus on silkscreen or offset printmaking, two techniques historically viewed outside the realm of fine art—including several shows mounted by history museums, archives, and independent scholars.[5] Yet even within these more inclusive histories, Chicanx graphics, alongside printmaking in other communities of color, demand to be understood for its profound interpenetration of politics, aesthetics, and cultural affirmation that is unrivaled in more general leftist graphic practices.[6] By starting with the surge of Chicano graphics during the civil rights era, this exhibition captures the pivotal ways the graphic arts—alongside muralism—imagined and sustained emergent identities and political viewpoints. By focusing on practitioners working since then, the exhibition also explores how artists today continue to use graphic arts to directly engage audiences, address ongoing social justice concerns, and grapple with the shifting meanings of Chicano—most recently demonstrated

by the rising use of Chicanx over Chicano. Importantly, *¡Printing the Revolution¡* features many works donated to SAAM by collectors who were themselves participants in the Chicano civil rights movement. Their gifts demonstrate how Chicano and Chicana activism has reached the art museum in ways that are only now being recognized.

At the center of this intertwined political and graphic movement is the very definition of Chicano, something that many early movement–era cultural productions wrestled with. The present exhibition and catalogue employ the terms Chicano, Chicana, and Chicanx in various ways. Most of the featured artists are of Mexican descent and came of age during and after the Chicano civil rights movement. Many identify with the political and cultural denotations of these terms that stress a non-assimilationist view of identity and convey the specific cultural, political, and historical experiences of people of Mexican descent in North America since before the Conquest of the Aztec Empire (1519–21) and to the present. Variations on the term Chicano—which over the years has encompassed several fluctuations, including Xicanx, Xicano, Chicana, Chicano/a, Chicana/o, Chican@, and most recently Chicanx and Chicano/a/x—developed since the 1960s as community members challenged the colonial, patriarchal, and heteronormative structures of language and knowledge. Chicano and Chicana are used in order to represent history as it transpired and to acknowledge that some

artists prefer these self-chosen designations. Our use of Chicanx supports artists who adopt this gender-neutral and nonbinary language and allows us to uphold inclusive language that is welcoming to all. We use the phrases "Chicanx graphics" and "graphic arts" to describe the broad artistic field that spans the civil rights era to today.

Because of how prints and graphic images circulate in the world, this rich and prolific field allows us to examine the changing dimensions of Chicano identity and politics. In the 1960s and 1970s, posters were carried in rallies, taped to glass doors and windows of local stores, high schools, and college campuses, displayed at alternative art centers, discussed and created in community and school workshops, and sold in bookstores, even through mail order.[7] Artists working today have other dissemination vehicles at their disposal, including circulating images through digital space, which users can download, customize, and activate in real time.

Yet the political content and context of these works should not obscure their status as art. Since the 1960s, when Chicanx and other socially engaged artists responded to turbulent times of war and domestic crisis with works that deftly integrated form, process, and content and challenged the prevailing social detachment of formalist modernism, critics often dismissed their work as merely illustrative, even literary.[8] Early on, these artists consciously set out to interact with non-white and other marginalized audiences, a goal

FIG. 3

Eric J. García, *Social Practice? Been There, Doing That!*, 2015, Photoshop, photograph *LA Times*, Fitzgerald Whitney, 14 × 11 in. Courtesy of the artist.

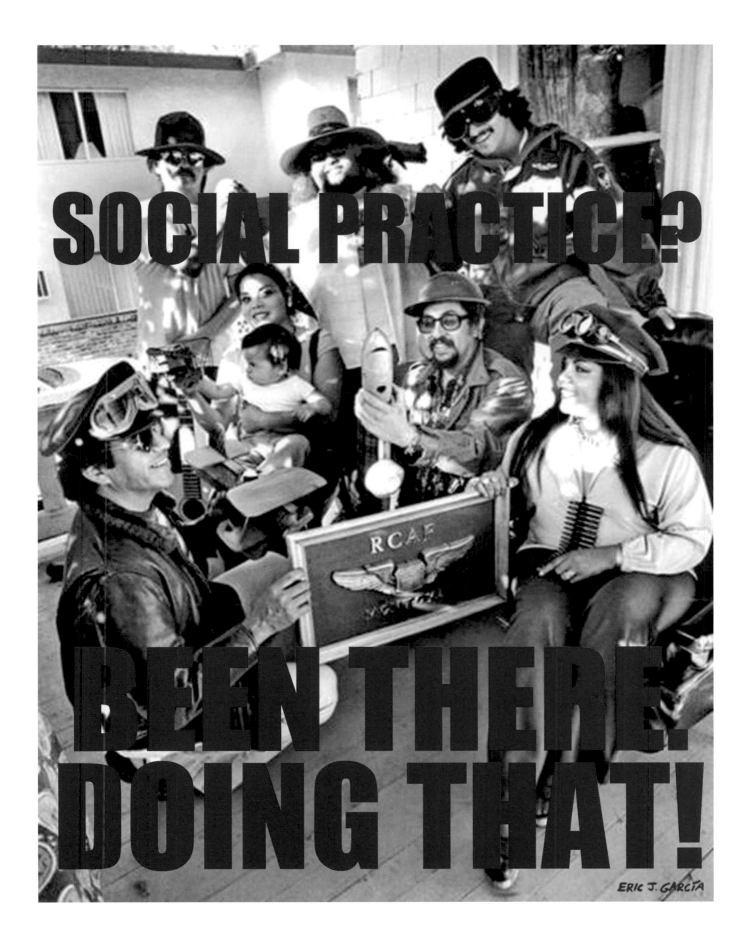

SOCIAL PRACTICE?

BEEN THERE. DOING THAT!

ERIC J. GARCIA

rarely valued at the time by critics or cultural institutions. Chicanx artists' innovative strategies, in graphics and dissemination, stem from their intent to directly engage audiences without relying on traditional art-world structures, which largely ignored them anyway. Chicano artists and their multiracial and cross-cultural collaborators and peers are pioneers of what we now call social practice art. Suzanne Lacy succinctly defines this field as artistic practice "that resembles political and social activity but is distinguished by its aesthetic sensibility."[9] In a wry prod, Eric J. García's altered photograph *Social Practice? Been There, Doing That!* (FIG. 3) comments on how the ever-expanding history of social practice art—which tends to privilege performative artworks that emphasize dematerialization—sidelines or diminishes the work of Chicano artists, including Sacramento-based collectives like the Royal Chicano

Air Force, or RCAF, for whom print-making was a central activity.[10] U.S. art history has yet to fully grasp Chicanx artists' fluid negotiation of aesthetics and politics, and still largely places these artists in segregated tracks that rarely acknowledge their interconnectedness to the broad history of art. This exhibition and catalogue challenge this historiographic sleight of hand. To do so, it is important to focus on artists' strategies, some of which connect and/or disrupt established movements like pop art and conceptualism, as well as highlight artists' and institutional links to various art worlds. For example, one major impetus for founding Self Help Graphics, the flagship East Los Angeles print shop established by Sister Karen Boccalero and Mexican immigrant artists Carlos Bueno and Antonio Ibáñez in 1970, was the teaching and example of artist Sister Corita Kent, the religious reformer who redefined pop art through the prism of civil and human rights (FIG. 4).[11]

This exhibition's 1965 start date is not a statement about the definitive beginning of Chicanx printmaking. Recent scholarship shows that graphic artists of Mexican descent were active in the United States before 1965.[12] *¡Printing the Revolution!* takes 1965 as its point of departure for two important reasons. First, most people cite 1965 as the start of the Chicano civil rights movement because it marks the year César Chávez and Dolores Huerta's National Farm Workers Association joined the Filipino farmworkers' grape strike in Delano,

California, unleashing the farmworkers movement that galvanized people of Mexican descent in unprecedented ways.[13] Other milestones soon followed, from Reies López Tijerina's land rights activism in New Mexico, to Rodolfo "Corky" Gonzales's Crusade for Social Justice organizing in Colorado, and to the explosive activism of high school and college students that dovetailed with Vietnam War protests and the push for ethnic studies departments.

Secondly, these historic events fueled a simultaneous and multidisciplinary cultural boom among artists, which, despite ebbs, flows, tense debates, and disengagements over the past five decades, remains strong and prolific.[14] Burgeoning Chicano artists drew on local, national, and global tendencies— from pop art to revolutionary-era posters from Cuba, Russia, and China, and very consciously, the history and example of muralism and printmaking that flourished in pre- and post-revolutionary Mexico. To use these two public mediums, which Rupert García called "wall art," was in part a culturally specific reference within an ethno-racial social movement and a political strategy to engage a community with little access to or control of mainstream news or cultural outlets.[15] If, as Gil Scott-Heron affirmed, "the revolution will not be televised" through conventional modes of communication, printmaking became an immediate, affordable, and accessible platform to forge and project an emergent new consciousness. Chicano artists, and others engaged in the social

movements of the era, grasped the historical relationship between graphics and social and political commentary that goes back hundreds of years and stems from the medium's inherent reproducibility and potential for mass distribution.[16] Artists working since the rise of digital technology and social media have similarly realized the potential of these platforms to circulate knowledge and build community and political networks.

¡Printing the Revolution¡ also seeks to take the discussion of Chicanx graphic arts in new directions. In using the terms *graphics* and *graphic arts* as opposed to *posters*, the exhibition and catalogue acknowledge that Chicanx artists embrace a wide range of printmaking techniques and formats, from lithography to linocut and installation art, public interventions, and the broad field of expanded graphics, which includes works that exist beyond the paper substrate and circulate in the digital realm. Like earlier important exhibitions in the field, we use *graphic arts* as a synonym for *printmaking*.[17] Nonetheless, *graphics* can also denote a broader array of visual culture that is not usually the focus of art museum exhibitions or museum collections. The overlap between art and visual culture remains a tendency within the history of Chicanx graphic arts and emerges from the immediate need to reach audiences in varied contexts around pressing causes.[18] It should be noted, however, that the contexts of specific works can also shift over time. Thus a work that was produced in an activist

context can later become a valued commodity in the art market.[19] Our transhistorical focus allows us to delve deeper into how new technologies have questioned the very nature of traditional graphic arts—especially its reliance on paper and the aura of originality and preciousness that comes with it—and explore how Chicanx artists and their collaborators have capitalized on these tools and ways of working to reach audiences in innovative ways.

This project also moves beyond traditional ways of conceiving of Chicano art history. While previous major exhibitions on Chicano graphic arts focused on artists based mostly in California or Texas, the current project takes a wider national view that includes artists from these major centers of graphic production, as well as those working in the Midwest and on the East Coast. ¡Printing the Revolution! further questions tendencies in scholarship that strictly periodize Chicanx graphics into political or assimilationist/commercial phases, or that focus on artists working either during or after the civil rights era.[20] Our wide historical span not only brings together multiple generations, allowing for a clearer view of mentor-mentee relationships, artistic and political continuities, and the varied ways to be political; it also foregrounds the innovative practices of Chicanx printmakers over time and the ways in which Chicanx artists and institutions welcomed, nurtured, and supported artists from other communities. The presence of non-Chicanx artists within Chicanx networks as partners in art and activism has always been there, but not always explored in depth in the literature.[21]

For these reasons, this exhibition and catalogue use the terms Chicano or Chicanx graphic arts to also denote the institutional and artist networks created during and since El Movimiento that established a context for artists that followed, whether they are Latinx artists with links to other Latin American nations, white allies, card-carrying Chicano activists, or recent Mexican immigrants who may or may not identify as Chicanx. This includes artists like Mario Torero, who emigrated from Peru to San Diego as a young man and became a member of the artistic team that created Chicano Park, the major mural environment and now National Historic Landmark in San Diego.[22] Torero adopts the moniker Chicano to signify his indigeneity as a person from the Americas.[23] Favianna Rodriguez, a younger artist born to Peruvian immigrants in California who was later mentored by Chicana artist Yreina D. Cervántez, followed in his footsteps. Our exhibition presents works by Herbert Sigüenza (Salvadoran American), René Castro (Chilean-born), and Jos Sances (Italian American), the latter two who played leadership roles in San Francisco's Mission Gráfica.[24] We include a print by Nancy Hom, an artist active with the Kearny Street Workshop in San Francisco, an Asian American art center modeled after Galería de la Raza; she printed many of her works at Mission Gráfica.[25] Also featured is the work of Mexican

immigrants like Enrique Chagoya, who arrived in the United States as an adult in 1979 and later participated in the Bay Area's vibrant Chicano-Latino scene, which included a stint as director of the Galería de la Raza. Works by more recent Mexican immigrants are also represented, from Juan de Dios Mora, whose prints delve into the contemporary nuances of the transnational border space that is South Texas, to the digital works of Julio Salgado, a Dreamer who received legal status through the federal immigration policy called Deferred Action for Childhood Arrivals (DACA).[26] We profile the activities of Dominican American artist Pepe Coronado and his collective the Dominican York Proyecto GRAFICA as well as the Ecuadorian American artist Sandra C. Fernández, both of whom had transformative experiences at the Serie Project, a print residency established by the late Chicano artist Sam Coronado in Austin, Texas. This inclusive approach allows us to recognize how interracial and cross-cultural solidarity was and remains an important element of Chicanx print networks.

The chapters that follow take up specific perspectives in the history of Chicanx graphics, its legacy and art-historical context. Terezita Romo elaborates on patterns of artistic activism during the early Chicano movement, showing how some artists chose to work with institutions, collectives, or as individuals. Tatiana Reinoza identifies an iconoclastic and conceptual thread running through the works of several artists, relating their work to the histories of U.S. and Latin American conceptualism. Claudia E. Zapata maps, for the very first time, a history of digitally informed Chicanx graphics, from early innovators to current practitioners.

SCOPE AND ORGANIZATION OF THE EXHIBITION

SAAM's collection of Chicano graphics—which now includes over five hundred works, making it the largest museum collection of its kind on the East Coast—demonstrates what can be achieved when an institution prioritizes the field of Latinx art and develops an infrastructure to support historically underrepresented artists.[27] While not comprehensive, the selected works presented in ¡Printing the Revolution¡ tell a story of the rise of Chicano graphics during the height of the civil rights movement, and the ways in which this period set a foundation—institutional, artistic, and discursive—for the artists that followed. The categories outlined below map out artistic strategies, conceptual frameworks, and recurring concerns within the expansive field of Chicanx graphic arts.

Urgent Images

The Chicano civil rights movement was a momentous time, and artists lent their skills to make powerful images that helped organize people and advocate for change. The urgent tenor of those years comes across in numerous ways, from artists' iconographic choices that show active, emotional, and emboldened figures to the use of bold lettering,

declarative text, and eye-popping color that aims to catch viewers' attention. The need to put one's work out there by any means necessary is discernible in one surprising way: many artists in the 1960s and 1970s used affordable paper whose fibers have now yellowed. Artists used whatever they had at hand. Emanuel Martinez printed his *Tierra o Muerte* (Land or Death) poster, which re-purposed Emiliano Zapata's likeness to demand Chicano land rights in Colorado and New Mexico, on half of a manila folder (**PL. 3**).[28] An unidentified artist emblazoned their pro-labor, boycott Gallo Wines message on recycled com-puter tractor paper likely obtained from their college campus, an acknowledged practice at the University of California at Berkeley in the late 1960s (**PL. 7**).[29]

Some of the earliest works in SAAM's collection reveal the important role of the United Farm Workers (UFW) as a catalyst for artistic activism. César Chávez is a critical figure in the history of Chicano art—as patron, instigator, supporter, and inspiration—who was aware of the central place of symbols and art in social movements.[30] He be-lieved that art could activate reluctant farmworkers unaccustomed to protest and garner wide public support. Labor unions have long used graphic media to advance their cause.[31] Chávez undoubt-edly learned from this history and his knowledge of Mexican revolutionary art, and incorporated multidisciplinary art-ists into the union's activities from the very start.[32] He encouraged Luis Valdez to found El Teatro Campesino, the

innovative theater group incubated within the UFW itself that staged per-formances on truck beds, dirt roads, and picket lines, which were themselves captured in a print (**FIG. 5**).[33] When Chávez asked artist Carlos Almaraz to create "decorations" to set the stage for major meetings and rallies, the result was a huge portable mural, "a la Diego Rivera."[34] The UFW established their own print shop, El Taller Grafico, which created and sold calendars, posters, Christmas cards, bumper stickers, and jewelry to promote the union's message and earn income. While these forms of visual culture were seen as "effective organizing tools in boycott cities," they also helped circulate imagery that visu-ally linked the Chicano experience to the history and spirit of Mexican reform movements.[35] El Taller Grafico sold posters of Pancho Villa and Emiliano Zapata, reprinted and recontextualized prints by Taller de Gráfica Popular (TGP) artists (often on the cover of the news-paper itself), and nurtured the talents of Andrew Zermeño, whose iconic pos-ter *Huelga!* imbibed the satirical style associated with TGP (**PL. 2**).[36] Zermeño's political cartoons regularly appeared in *El Malcriado*, the UFW's mouthpiece, and true to the newspaper's moniker that can suggest the antics of an out-spoken child, they critiqued the hierar-chical dynamic between growers and farmworkers (**FIG. 6**).

In the years that followed, many artists directly and indirectly supported the UFW. Xavier Viramontes created *Boycott Grapes, Support the United*

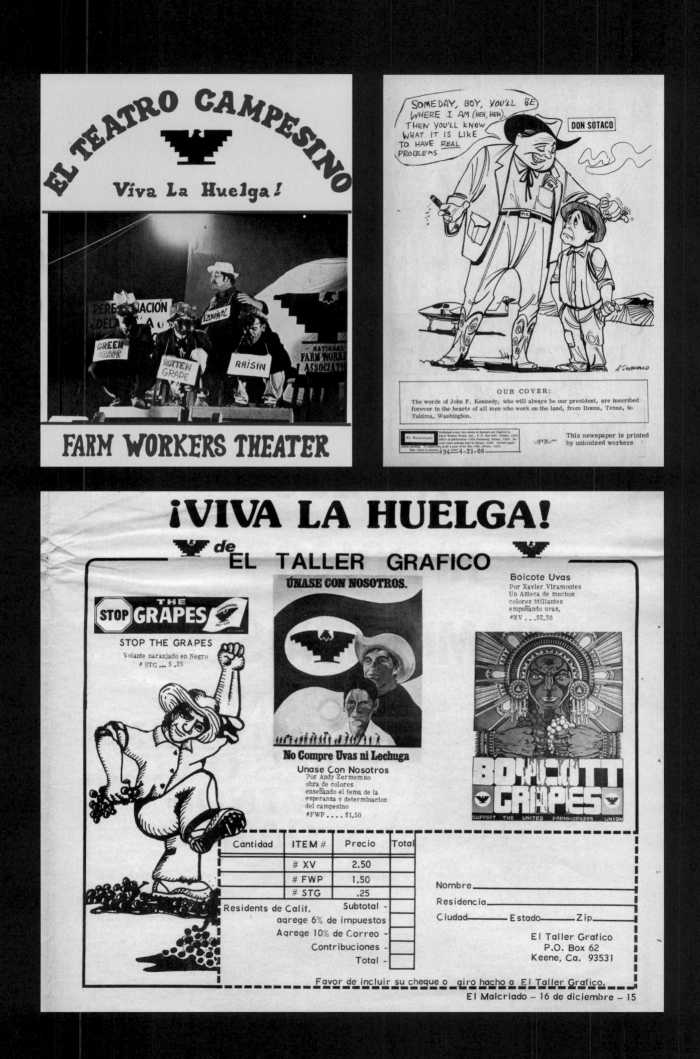

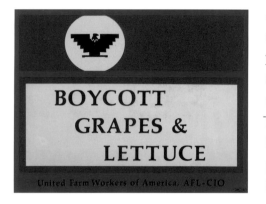

FIG. 8

Ricardo Favela,
*Boycott Grapes &
Lettuce*, 1976,
screenprint
on paperboard,
22 ⅛ × 28 ¼ in.
Smithsonian
American Art
Museum, Gift of
Tomás Ybarra-
Frausto, 1995.50.47.

Farm Workers Union (**PL. 11**) in 1973, the year Chávez initiated a new boycott in response to the Teamsters' violent intervention in disputes between the UFW and California growers.[37] Viramontes was aware of the Teamsters' tactics, which likely informed his imagery of an Aztec warrior squeezing grapes that spew blood instead of juice.[38] While the union believed the print's blood symbolism might lead the "squeamish to have a few problems," they agreed to the artist's terms and sold the print via mail order (**FIG. 7**).[39] The RCAF, the major Chicano art collective founded and active in and around Sacramento, became the unofficial visual "mouthpiece" for the UFW, preparing posters whenever Chávez and Dolores Huerta came to the region. They produced banner-like works in support of the UFW (**FIG. 8**) and works that combine bold graphic design, which could be seen from a distance, and concrete poetry, which could be read close-up (**PL. 20**). Rupert García turned to bright colors and three simple letters to create *DDT*, to support Chávez's call to address the dangerous use of pesticides in agriculture (**PL. 5**).[40] García placed a running and screaming girl with unnatural purple hair in a disorienting field of blue. Without visible arms, her silhouette suggests the physical injury caused by exposure to the widely used pesticide known as DDT. The letters hover above the figure like crop dusters spraying the now banned pesticide. The child's screaming face eerily anticipates by a few years the iconic photograph, taken in 1972, of Phan Thị Kim Phúc, the young girl whose image showing her running naked down a road after a napalm attack became synonymous with the bodily harm caused by chemical weapons during the Vietnam War.

Farmworker rights were among the many causes that Chicanx artists responded to swiftly. Immigrant rights, in particular the push to stop deportations, started in the 1970s. Rupert García's emphatic, bold, and memorable *¡Cesen Deportación!*, which translates into "Stop Deportation!," issued a call to public action (**PL. 12**). The print, first created in 1973, draws on barbed wire imagery, which has long been associated with Western expansion, the genocide of people during the Holocaust, the incarceration of Japanese Americans during World War II, and the bracero program in the United States.[41] Malaquias Montoya turned instead to an image of corporeal abjection. His iconic *Undocumented* deploys Christian and art-historical references to emphasize the humanity of undocumented people (**PL. 36**). The faceless bleeding figure is caught within the spikes of the wire and assumes the posture of the crucified Christ, while also evoking the central victim in Francisco de Goya's *Third of May 1808 in Madrid* (1814). Montoya created this print during his years of activism that preceded the passing

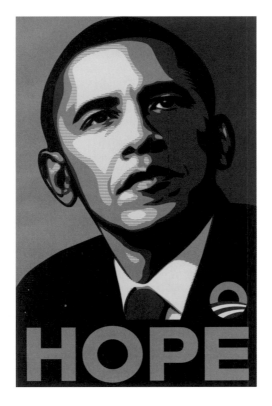

FIG. 9

Shepard Fairey,
Hope, 2008, color
screenprint poster,
36 × 24 in.
National Portrait
Gallery, Smithsonian
Institution; gift of
Chisholm-Larsson
Gallery, New York City.

of the U.S. Immigration Reform and Control Act of 1986, which secured various forms of temporary legal status for undocumented people.[42]

It is important to emphasize, however, that SAAM's *¡Cesen Deportación!* is not from 1973, but from 2011, when the Oakland-based collective Dignidad Rebelde worked with García to issue a new print.[43] Created during the presidency of Barack Obama, the image took on renewed significance in light of his administration's high record of deportations.[44] Three years earlier, during the administration of George W. Bush, Ester Hernandez also reimagined her classic *Sun Mad* poster (**PL. 40**), which originally addressed the harmful health consequences of pesticides, and turned it into a condemnation of U.S. Immigration and Customs Enforcement

(ICE) (**PL. 41**). In addition to changing the main text of the print from Sun Mad to Sun Raid, she clothed her original *calavera* (skeleton) with an ICE wrist monitor and a huipil (traditional garment) to reference the ranks of Zapotecs, Mixtecs, and other indigenous groups who represented a visible segment of undocumented immigrants.

Favianna Rodriguez and César Maxit's *1 Million Deportations ain't Enough for Pres. Obama! Sign the Petition & Spread Art* (**PL. 93**) also harks back to an earlier poster, just not one of their making. The collaborative team's choice of color and composition directly invokes Shepard Fairey's *Hope* (**FIG. 9**), one of the most iconic posters of the new millennium. Fairey created it to support the presidential campaign of then senator Barack Obama. Both an earlier rendition, which couples the portrait with the word *progress*, and the later iconic version render a youthful Obama gazing upward as if envisioning a better national future. The artist chose a red, white, and blue palette to emphasize the candidate's patriotism.[45] In 2011, during Obama's third year in office, Rodriguez and Maxit created a circulating digital image meant to garner support against his administration's extensive deportations, which had earned him the moniker "Deporter in Chief."[46] Their image presents a near-three-quarter view of Obama, off-center and staring directly at the viewer. His posture is neither presidential nor hopeful, and instead reads as unsteady and insecure. Rodriguez and Maxit also pointedly changed Obama's circular

horizon-line logo, seen near the lower right of Fairey's print, into a sheriff's badge that visually invokes his deportation record. The overall design of the digital image, with all-caps letters and use of exclamation points, suggests urgency, and the instructions at bottom direct social media followers on how they can protest government policies.

Working in another context entirely, Alejandro Diaz created *I ♥ Cuba* (**PL. 62**) for the 2003 Havana Biennial, which unfolded in the midst of a national crisis in Cuba. He offered event participants souvenirs branded with a warm graphic message, adapted from the well-known "I ♥ New York" logo designed by Milton Glaser. His gesture took on a life of its own when Cubans, who were experiencing major deprivations as a result of the evaporation of Soviet subsidies during the Special Period, began to sell his goods to tourists in the streets of Havana. His project demonstrates how print culture and conceptual strategies can infiltrate everyday life and powerfully impact the lives of people.

A New Chicano World

Chicano graphics played a generative and instrumental role in projecting the consciousness of Mexican Americans turned Chicanos. As noted, printmakers visualized acts of protest against abysmal labor practices and anti-immigration policies and legislation, among other causes, while simultaneously imagining and documenting a world that centered on Chicanx experience and history. The proliferation of visual works beginning in the 1960s inundated Chicano communities with imagery and references that contested their social invisibility and assigned value to their culture. Or, as George Lipsitz has argued, "[within] the Chicano movement, poster production emerged as one of the important sites where insurgent consciousness could be created, nurtured, and sustained."[47] By addressing the public, Chicanx printmakers constituted a public, and the graphic field became a charged space for generating meanings of Chicano and its subsequent reformulations.

Several masterworks capture the sheer bravado of artists imagining a world where Chicano culture is dominant. Gilbert "Magu" Luján created fantastical scenes centered on indigenous visions of Chicano culture. In works like *Cruising Turtle Island*—which adopts a Native American name for North America—jaguars, anthropomorphic animals, and people in feather headdresses riding lowriders coexist with pyramid-like buildings, flying objects (or dogs), and a heart-shaped sun-star that looks like a volcanic explosion (**PL. 50**).[48] Subtly futuristic, the print shares much with the work of Latin American, Latinx, and Black artists who adopt science fiction to critique the present and imagine an alternative reality. The print imagines a world unencumbered by the histories of colonialism—or perhaps specifically the Conquest, as Karen Mary Davalos has argued about other works—and its ills.[49]

Richard Duardo's *Aztlan* (**PL. 42**) offers an assertive sign that similarly conjures different temporalities. Toggling between the foreground and background, Duardo references the ancient mythical homeland of the Aztecs, adopted by Chicanxs as a native, territorial claim to the American Southwest, as well as modernist abstraction and Chicanx urbanism. Here the word *Aztlan* appears in front of a series of nonobjective squares, linear formations, and abstract shapes that add color, depth, and dynamism to the print. These visual strategies recall Hans Hofmann's notion of "push and pull," in which overlapping shapes appear to emerge from and recede into the pictorial surface. Duardo's stylistic lettering, rendered with art deco machine-age curves, suggests the streamlined design of classic American cars that Chicanxs transformed into lowriders, as well as the artistry of cholo graffiti.[50] The latter is further conveyed by the artist's deft application of color. In some areas, the ink appears diffuse, as if applied with an aerosol canister. Together, Duardo's varied references emphasize a Chicano presence in North America since before the Conquest. He directly conjures Aztlán, while invoking lowriders that assertively claim the land by riding through it, and graffiti artists that tag surfaces to claim turf.

Chicanx printmakers were instrumental in forging new traditions centered on reimagined Mexican cultural traditions. The RCAF collective, which consisted of visual artists and other cultural workers who together staged elaborate community events, organized Cinco de Mayo celebrations and initiated new events grounded in indigenous traditions. Their Fiesta del Maiz events presented reenactments of Mesoamerican rituals, which at once promoted cultural indigenism and claimed public space in Sacramento during periods of gentrification (**PL. 33**).[51]

As part of a cultural reclamation effort, artists mined the everyday and reconceived the routine, often through work grounded in close observation. In delicate etchings like *La Curandera*, which memorializes Mexican American folk healing practices, Carmen Lomas Garza chronicles intimate Chicano daily life scenes based on remembrances of her own childhood in Kingsville, Texas, in the 1950s and 1960s (**PL. 14**).[52] Her consciously folk art–styled works make visible communal and spiritual traditions that both record gendered and intergenerational roles and relations and bring to light a universe of borderland culture rarely acknowledged as part of the American experience. Working in a style that recalls the signature linocut medium of the TGP, Juan de Dios Mora achieves a similar feat through his focus on contemporary life in Laredo, a border town in South Texas. Mora's *El Animo es Primero (Encouragement Is First)* (**PL. 111**), which depicts a resident of Laredo who customized his wheelchair to mow lawns and earn money, celebrates the texture of transnational immigrant life and the ways in which *rasquachismo*—a Chicano making-do sensibility—extends to new generations

of Mexican-descent people in the United States.

Artists also conceived new print formats inspired by material culture. As Terezita Romo has affirmed, early Chicanx artists grew up surrounded by illustrated Mexican-themed calendars hanging in their homes.[53] Given as gifts by local stores, these signs commonly portrayed classicizing scenes of indigenous myths by Mexican artist Jesús Helguera (1910–1971). Chicano artists challenged Helguera's Europeanizing style, but they absorbed his indigenous themes and drew inspiration from the calendar format. Chicanx organizations and collectives like Galería de la Raza,

the RCAF, Méchicano Art Center, and La Raza Silkscreen Center adopted the calendar format. They sold affordable calendar sets to raise money and tackled a range of cultural and political subjects. Unlike political posters, which were often meant for public display, these productions were more likely destined for home or office use.[54] Artists ambitiously conceived what could be relayed through this culturally specific format. In 1976 the RCAF and artists affiliated with Galería de la Raza created the *Calendario de Comida* entirely devoted to food. The series hailed Mexican foodways, commemorated historic establishments like La Victoria

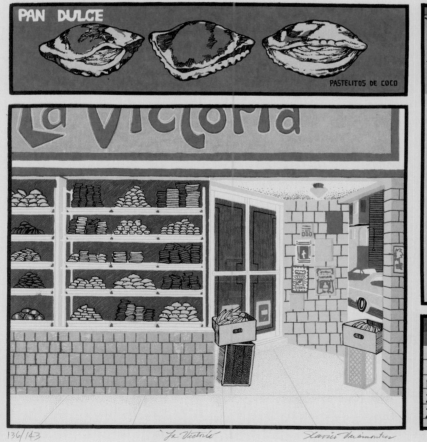

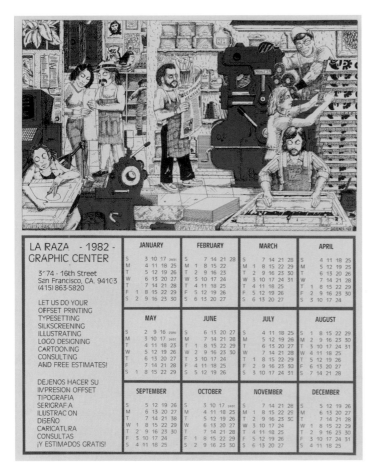

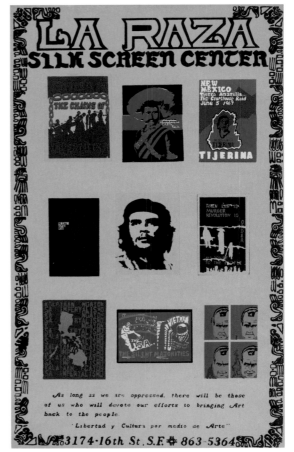

FIG. 11

Herbert Sigüenza,
*La Raza Silkscreen
1982 Calendar*, 1982,
screenprint on paper,
image: 21 7/8 × 16 5/8 in.;
sheet: 22 1/2 × 17 1/2 in.
Smithsonian American
Art Museum, Museum
purchase through the
Luisita L. and Franz H.
Denghausen Endowment,
2020.45.12.

FIG. 12

La Raza Silkscreen Center,
*As long as we are
oppressed there are
those of us who will
devote our efforts...*, n.d.,
screenprint on paper,
sheet and image:
28 1/4 × 17 1/4 in.
Smithsonian American
Art Museum, Museum
purchase through the
Luisita L. and Franz H.
Denghausen Endowment,
2020.45.7.

Bakery in San Francisco (**FIG. 10**), and humorously acknowledged how the poor relied on food stamps during hard times (**PL. 25**), effectively interweaving tradition, place-making, and class consciousness in a single series. Both La Raza Silkscreen Center and Galería de la Raza shared political history with their buyers, from promoting solidarity with Palestine (**PL. 44**) to raising awareness of the history of CIA activities in Latin America (**PL. 17**). Francisco X Camplis, who had worked for IBM in the late 1960s and was aware of the firm's involvement in U.S. government affairs abroad, created a print for February 1975 that linked large multinationals to U.S. interventions in Latin America (**PL. 18**). His image of violent repression relates to a personal encounter. In the mid-1970s, the artist met a man in California who had been a member of the Halcones, a repressive paramilitary

group active in Mexico during the presidency of Luis Echeverría.[55]

In their desire to reach the widest audience, Chicanx artists worked to make graphics a ubiquitous part of daily life. Through the practice of social serigraphy, institutions like La Raza Silkscreen Center in San Francisco offered their printmaking services to local organizations and sold affordable works of art to local residents.[56] Their ads portrayed their art establishment as a bustling center of community life (**FIG. 11**). They advertised their work through creative "posters of posters," prints that laid out virtual exhibitions on paper (**FIG. 12**).

As the artworks in this exhibition demonstrate, envisioning and defining Chicano culture remains a fluid process. Imagery like Malaquias Montoya's *Yo Soy Chicano* (see **PL. 10**), and key writings like

Corky Gonzales's *Yo Soy Joaquin*, often privileged male representations as the face of the community, yet by the early 1970s, self-defined Chicanas pushed back against patriarchal ways of conceiving community, aesthetics, and politics. Often in the face of hostility, Chicanas pioneered new understandings of Chicano and Chicana experience, paving the way for future questioning.[57] In the context of printmaking, Ester Hernandez, Yolanda López, Judithe Hernández, and Yreina D. Cervántez ushered in new imagery and conceptual frameworks that centered on women's lives. Ester Hernandez's prints of the mid-1970s were among the first to challenge the passive role assigned to women in early-movement organizations, art, and statements. *La Virgen de Guadalupe Defendiendo los Derechos de los Xicanos* reimagines the Virgin as a modern, karate-fighting woman breaking out of her sunburst (**PL. 21**). Hernandez's Bicentennial-era print *Libertad* portrays a woman sculptor transforming the Statue of Liberty into a female, Maya-like sculpture entitled *Aztlán* (**FIG. 13**). She places a woman in the role of icon maker while simultaneously undermining U.S. nationalist celebrations of liberty on formerly indigenous lands. These two key works recast revered Chicanx and U.S. icons and render Chicanas as social and political forces. Chicanas across disciplines foregrounded the nexus between sexuality and cultural politics.[58] In the late 1980s, Hernandez's *La Ofrenda*, in which a woman offers a rose to another whose back is emblazoned with a Virgin of Guadalupe tattoo, subtly visualizes

intimacy between two women (**PL. 54**). In 1991, when the image became the cover of Carla Trujillo's book *Chicana Lesbians: The Girls Our Mothers Warned Us About*, the print became more clearly associated with sexual desire between women.[59] Chicanx artists working since then have continued to make space for queer representation. Following in Ester Hernandez's footsteps, Alma Lopez personalized her image of the Virgin, using photography, digital strategies, and real models, including a queer-identified one, to depict the icon and the angel beneath her as modern and assertive women (**PL. 59**).[60] In *Quiero Mis Queerce*, Julio Salgado upturns a different tradition (**PL. 103**). His double self-portrait, which features a figure wearing a tuxedo and another donning eye shadow, dangling earrings, and a *quinceañera*-style dress that does not hide their bodily hair, was inspired by Frida Kahlo's well-known painting *Las Dos Fridas* (1939). Salgado employs a similar duality to reflect on his challenges as a gay teen hiding his femininity. As a young man, Salgado wanted a fifteenth-birthday celebration or *quinceañera*, a traditional coming-out ceremony reserved for young women. When the artist turned thirty, he created this image to honor his unfulfilled dream for a *quinceañera*.

Subverting History

From the inception of the civil rights movement, Chicano activists, thinkers, and artists challenged traditional structures of knowledge—definitions, categories, geographies, and historical frameworks—that obscured, marginalized, and distorted Chicanx experience.[61] One of the most revolutionary ideas to come out of the late 1960s was the movement's embrace of the concept of Aztlán, the mythical homeland of the Aztecs discussed and illustrated in Spanish colonial-era codices, from which Chicanxs claimed descent (**FIG. 14**). Legend holds that Aztlán was located northwest of the Aztec capital of Tenochtitlan, somewhere in what is now the southwestern United States, the territory that was taken from Mexico after the Mexican-American War (1846–48). Such a claim positioned Chicanxs not as immigrants in the United States, but as rightful heirs to western lands, and thus conquered "territorial minorities."[62] Knowledge of Aztlán spread through foundational

FIG. 13

Ester Hernandez, *Libertad*, 1975, aquatint/etching on rag paper, 15 × 12 in. Courtesy of the artist.

FIG. 14

Page from the Codex Aubin, referencing Aztlán, 1576, bound volume of European paper with hand-painted illustrations, 6 1/10 × 5 1/4 in. The British Museum.

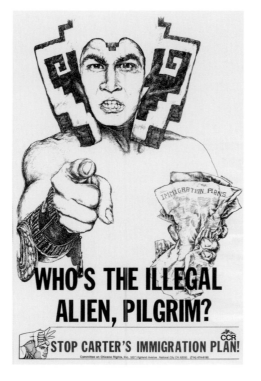

FIG. 15

Yolanda López,
*Who's the Illegal Alien,
Pilgrim?*, 1978, offset
lithograph on paper,
sheet and image:
17 × 11 in. Smithsonian
American Art Museum,
Museum purchase
through the Samuel
and Blanche Koffler
Acquisition Fund,
2020.43.2.

documents like *El Plan Espiritual de Aztlán*, which instilled a strong indigenist pulse within the Chicano movement.[63] Even though Aztlán has critical fault lines—especially in how early articulations overlooked other Native claims to the Southwest—it foregrounds how subverting received and accepted histories and geographies has been central to the Chicano movement from the start. Artists especially turned to charged moments of U.S. and international current events and history that implicate or ignore Chicanx lives and other aggrieved groups with whom they stand in solidarity. In order to challenge established historical narratives, many Chicanx artists revisit key moments in U.S. history by carefully mining the archive of art and visual culture, and strategically using photographs and specific genres as a creative resource.[64]

Several Chicanx artists turn to ground zero of Western hemispheric history: the Conquest and colonization of the Americas since 1492. While prints tend to address temporally specific issues or causes, they often lodge broader trans-historical critiques. Yolanda López recreated *Who's the Illegal Alien, Pilgrim?* (**PL. 39**) in 1981 as part of an ongoing campaign initiated when President Jimmy Carter unveiled his controversial four-point immigration program, which included efforts to limit amnesty for undocumented immigrants already in the country.[65] The first iteration of the poster, created in 1978, points directly to this connection with the text "Stop Carter's Immigration Plan!" (**FIG. 15**), which is placed beside an image of the Statue of Liberty, a widely acknowledged symbol of immigration. Both versions resemble the Uncle Sam "I Want You" poster (see **FIG. 3**, p. 76), turning the male figure into a Native American who points angrily at the viewer while clutching a crumpled document inscribed "Immigration Plans." The title of López's poster draws us back to the colonial period, when Europeans settled in North America without the consent of the regions' original inhabitants. López challenges accepted history and positions Europeans as illegitimate border crossers. In this way, the print's critique is evergreen, and responds in perpetuity to ongoing nativist arguments against immigration generally and undocumented immigrants in particular. Jesus Barraza and Nancypili Hernandez's *Indian Land*

(PL. 110) echoes López's critique and turns to a long history of cartographic images produced by Latin American and leftist modernist artists, like Joaquín Torres García and the surrealists.[66] Barraza and Hernandez offer a silhouette of the Americas that erases national borders and emphasizes a major common denominator of the region: indigeneity.

Chicago-based artist Eric J. García satirically revisits the events and aftermath of the Mexican-American War.[67] His *Chicano Codices #1: Simplified Histories: The U.S. Invasion of Mexico 1846–1848* (PL. 107) deploys Uncle Sam as the personification of the U.S. and adopts the codex format, a pre-Conquest accordion-style book associated with ancient Mesoamerica and which was famously resurrected as a contemporary art form by Santa Barraza and Enrique Chagoya. Over seven narrative frames, García depicts Uncle Sam's desirous dreams and aggressive acts to take Mexican land. The artist's imagery and style ingeniously combine visual references to cartoons, contemporary self-help books for "dummies," and most importantly turn-of-the-twentieth-century U.S. political cartoons that routinely featured Uncle Sam as a protagonist. García's version of Uncle Sam as an old yet energetic man descends from types popularized in journals like *Puck* and *Judge* that proliferated during the United States' imperialist expansion in the Caribbean and Pacific from the late nineteenth to early twentieth century (FIG. 16).

FIG. 16

Louis Dalrymple, *School Begins*, from *Puck* magazine, January 25, 1899, chromolithograph. Library of Congress, Prints and Photographs Division.

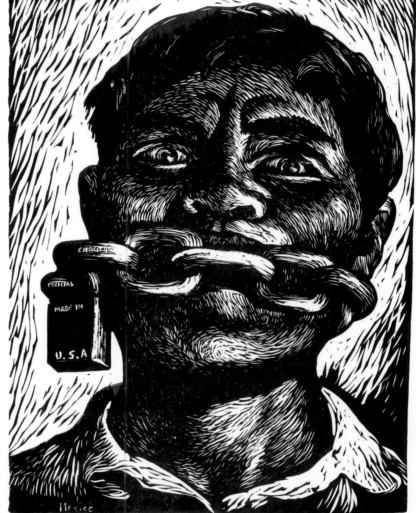

In these works, cartoonists resorted to racial tropes and culled familiar images from daily life to help visualize a hierarchical relationship between the United States and its recently acquired territories and political charges. In this representative work from 1899 entitled *School Begins*, Uncle Sam heads a classroom with reluctant students from Hawai'i, Cuba, Puerto Rico, and the Philippines, all of whom are represented as dark-skinned children, on the tools of self-governance. Racial and gendered cues peppered throughout the image signal the relative position of these newly acquired lands and peoples with the social and racial standing of existing U.S. populations—African Americans, Asian Americans, Native Americans, and women. García replicates this personification of Uncle Sam, and renders Mexico not as a child, but as a welcoming and gullible short-stature man unaware of Uncle Sam's ambitions. The final scene includes a portrait of the artist standing alongside a screaming baby, suggesting how current Chicanx generations critically recall the past.

In the mid-1970s, as President Gerald Ford and his administration commemorated the nation's Bicentennial (1976), Chicanx and other communities of color turned a critical eye to events that celebrated freedom and liberty in the United States.[68] For example, during a Bicentennial address held on July 4, 1976, Rodolfo "Corky" Gonzales reflected: "They are celebrating that 'All Men are Created Equal,' but when they signed that Declaration of Independence,

FIG. 17

Adolfo Mexiac,
*Libertad de
Expresión Mexico 68*,
1968, offset,
16 13/16 × 11 7/16 in.
Courtesy Center
for the Study of
Political Graphics.

remember that they were not considering Black people, who were their slaves, they were not considering Indians, whom they considered savages and whom they were murdering; they were not considering Mexicanos, who would be the people they would conquer in 1848, a hundred years later."[69] Chicanx artists followed suit and recalled how many official Bicentennial events and paraphernalia sidelined difficult chapters in U.S. history and instead emphasized patriotism and projected the optimism of a nation seeking to put a long, and recent, period of national turmoil to rest. These omissions resonated with Chicanx artists, especially those who had lived through the civil rights and anti-war eras.[70]

RCAF artists Ricardo Favela and Rodolfo O. Cuellar addressed the Bicentennial head-on. Favela's print honors Russell Redner and Kenneth Loudhawk, American Indian Movement activists arrested in 1973 after their participation in a staged protest at Wounded Knee, South Dakota (PL. 23). Cuellar's *Humor in Xhicano Arte* (PL. 22) appropriates a Mexican image, Adolfo Mexiac's *Libertad de Expresión Mexico 68* (FIG. 17). Created in 1954, the print portraying a young man gagged with a padlock, with the text "Made in USA," references the U.S.-backed military coup of Guatemalan president Jacobo Árbenz.[71] When Mexiac reprinted it fourteen years later, he incorporated the official logo for the 1968 Summer Olympics in Mexico City to cal out the Mexican government's repressive acts against student protesters during the international event. Cuellar encountered

FIG. 18

Roy Lichtenstein,
Masterpiece, 1962,
oil on canvas,
54 × 54 in.
Private collection.

Mexiac's reprint image in the Chicano journal *La Raza*, and immediately saw a parallel between official Bicentennial celebrations and the treatment of young Chicanx activists and political organizations, many of whom were surveilled through operations like the FBI's Counterintelligence Program (COINTELPRO).[72]

Starting in the 1970s and 1980s, several artists addressed U.S. interventions in Latin America during the final decades of the Cold War. Especially in the San Francisco Bay Area, home to a multifaceted Latinx community that has included immigrants and exiles from Central and South America, artists produced works that provided a counternarrative to accounts that permeated U.S. newspapers and popular culture, from the Iran-Contra hearings to presidential State of the Union addresses. Jos Sances visualized a leftist adage and turned the United States into a shark that swallows a destructive and powerful scorpion in the shape of Mexico and Central America (**PL. 45**). Herbert Sigüenza colored and amplified the reach of *It's Simple Steve* (**PL. 37**), a print first designed by an unidentified artist that deftly interweaves appropriation and satire.[73] The artists emulated Roy Lichtenstein's visual style and female textual banter—which Lichtenstein developed in classic works like *Masterpiece* (**FIG. 18**)—to surprise viewers with an unexpected connection between pop art and U.S. political interventions. The

print redeploys characters from local Bay Area comic strips to offer up a couple that look more like Mr. and Mrs. Frankenstein than Lichtenstein's Ken and Barbie types.[74] The figures have squared heads and chins, and the female figure—usually the focus of Lichtenstein's gaze—stares and frowns to convey frustration or annoyance. For the viewer, the image may be visually unappealing, but ultimately the text packs an expletive-rich final punch. The artists' art-historical quote has a deeper resonance if we consider that Lichtenstein's playful and privileged art-world references gained a following as the United States was building its presence in Southeast Asia during the early decades of the Cold War. The parallel presented here underscores a continuation of the United States' interventionist policy in another part of the world.

Twenty years later, Sam Coronado created *Guerillera II* (**PL. 61**) after a friend showed him a picture of a young female guerrilla fighter from El Salvador.[75] Upon realizing that the girl was only in her

teens, Coronado was struck by how historical circumstances demanded that she occupy herself with war and not the characteristic beauty rituals of teenagers. The artist overlays images of bullets, lipstick, and the girl's upside-down likeness on a background that resembles scratchy burlap, a material often used to package ammunition. Coronado's dystopian print advances what Kency Cornejo has called "solidarity aesthetics."[76] For Cornejo, activist artists in support of Central American nations during the years of U.S. intervention and armed conflicts imagined Central Americans as valiant revolutionary fighters or vulnerable victims of wars. Coronado's *Guerillera II* unites these two paradigms into one.

To subvert established accounts of the past or combat historical amnesia, Coronado and other artists in this exhibition often manipulate archival sources to question what we value and how we see our national past.[77] Carlos Francisco Jackson's *Breaking the Fast, 1968* (**PL. 105**) appropriates a documentary photograph of César Chávez the day he ended his twenty-five-day hunger strike in 1968. At twenty-five by forty inches, the print gestures toward history painting. Jackson was expressly invoking the example of René Mederos, the late Cuban graphic artist who in the 1970s commemorated the major events of the Cuban Revolution in a series of billboards and highly graphic, pop-style posters (**FIG. 19**).[78] Jackson monumentalizes a recorded event in U.S. history, rendering it in vivid colors that capture

FIG. 19

René Mederos, *Dirección del Ataque*, 1973, silkscreen, 23 1/16 × 29 1/8 in. Courtesy Center for the Study of Political Graphics.

Chávez's gray, lifeless skin and weakened physical state. At its enlarged scale, we can easily recognize several important attendees, including Helen Chávez (César's wife), Filipino American labor organizer Larry Itliong, and U.S. Senator and then presidential candidate Robert F. Kennedy, sitting next to Chávez. Kennedy had supported the UFW quite vocally since the mid-1960s and was highly esteemed, even idolized, by a large segment of the Mexican American community.[79] For those unaware of the labor leader's deeds or importance, Kennedy's presence reinforces Chávez's national significance. Jackson manipulated the original image to proclaim that day a momentous event in U.S. history that should be remembered and valued by all.

Enrique Chagoya's *Ghost of Liberty* (PL. 63) takes a satirical stance toward history as told through an ancient form: Mesoamerican codices. Chagoya is quite aware of his ancient Mexican and U.S. antecedents; he prints his work on amate paper—the same substrate used in pre- and post-Conquest times— and in this case, his drawn likeness of President George W. Bush toward the center of the print resembles Philip Guston's *Poor Richard* series created before Watergate. Chagoya undertook his project in the years following 9/11, when people across the United States questioned Bush's foreign policy decisions and motivations, especially concerning the invasion of Iraq. Chagoya's codex, which reads from right to left like historical codices, mixes incongruous visual references from the Lone Ranger and

Tonto to plumed serpents, dinosaurs, Arabic and Chinese text, flying saucers, and much more—to create an illogical narrative that requires the viewer's focused participation to decipher. Chagoya, however, is not a disinterested creator. His title suggesting the eclipse of liberty and his appropriation of Hollywood stereotypes that rehearse racial hierarchies offers enough fodder to spark debate and dissent.

Ideological Portraiture

Chicanx artists also approached history through one particular genre: portraiture.[80] While the likenesses of iconic revolutionary figures abound in Chicanx graphics—Che Guevara and Emiliano Zapata, to name two—artists turned to known and obscure national and global figures that resonated with civil rights struggles and the international solidarity networks central to Chicanx activism. In the hands of Chicanx artists, portraiture, a category commonly associated with wealth and privilege, becomes a pedagogical medium that shifts attention from personal aggrandizement and vanity to activism, sacrifice, and social memorialization. Presented in art centers, protest signs, and on the street, such images provide viewers with portraits of change-makers and an entry into the historical events they helped shape.

Based on their own lived experience, artists and patrons knew that the deeds of many important history figures— especially people of color and the working class—rarely appeared in school curricula

or history books. The goal was to educate audiences about historical figures that were directly or indirectly fighting to change the local, national, and global power dynamics in ways that resonated with the objectives of civil and human rights activists. Oscar Melara and Luis C. González portrayed, respectively, José Martí and Hidalgo y Costilla, leaders of nineteenth-century independence movements in Cuba and Mexico (**PLS. 24, 48**). Melara used a split-fountain technique to render Martí's skin color in shifting shades of beige to brown, as if to call out the leader's belief in the equality of all races.[81] Chicano organizations frequently sought out Rupert García to design posters for their events. One such poster depicts Emma Tenayuca, the young labor activist who organized pecan workers in Texas in the 1930s (**PL. 29**).[82] García based his print on a photograph of a defiant Tenayuca smiling in front of a jail cell (**FIG. 20**).

In the 1980s, in the midst of the Divestment from South Africa campaign, Juan Fuentes portrayed then political prisoner Nelson Mandela, repeating his likeness five times over a large red ribbon, which was then a symbol of anti-apartheid activism (**PL. 51**). Barbara Carrasco depicted Dolores Huerta at a time when she was sadly under-recognized despite her pivotal role as cofounder of the UFW (**PL. 60**).[83] The perfectly balanced and bright-hued print, which references Huerta's first name only, urges viewers to recognize female leadership. The artist's close-up focus on Huerta's face recalls Andy Warhol's celebrity portraits, yet like Rupert García's approach to pop art, Carrasco shifts her focus away from popular culture to activist history. Her Dolores Huerta is not a hollow Hollywood image, but a vivid portrait of a beautiful, weathered, and tireless labor leader.

Using text to intensify their portrait's pedagogical address, artists portrayed fallen heroes, quoting their own words to keep their wisdom and perspectives alive. Carlos A. Cortéz depicted Joe Hill, the labor activist and folk singer, relaying both the details of his life and the lyrics to his songs that urged workers to strike to demand their rights (**PL. 34**).[84] René Castro, who had been a political prisoner in Chile before finding his way to San Francisco, depicted Víctor Jara, the slain Chilean folk singer killed during the early days of the Augusto Pinochet regime (**PL. 49**). Castro presents a youthful Jara, bathed in vivid colors, with bright eyes that pop off the surface

of the print and reinforce his lyrics: "The star[t] of hope will continue to be ours." Similarly, Jesus Barraza pairs Steve Biko's likeness with a quote by the South African anti-apartheid activist killed in 1977 (**PL. 101**).[85] The artist conveys Biko's passion for freedom by surrounding him with red, green, and black, the colors of the Pan-African flag. Castro's portrait of Martin Luther King Jr. connects the past and the present, interpreting a quote from King's anti–Vietnam War speech in 1967: "the greatest purveyor of violence on earth is my own country" (**PL. 56**).[86] Castro added more text near the bottom edge of the print to highlight the start of the Persian Gulf War, which began in January 1991 and closely coincided with the observation of Martin Luther King Jr.'s national holiday. Given the large number of Central American

and South American activists in the Bay Area, where Castro lived and worked, the quote resonated with their experience of U.S. intervention in Latin America.

Artists have used portraiture to swiftly respond to history as it unfolded in real time, allowing viewers to recognize their own lived realities and support burgeoning activism. Rodolfo O. Cuellar's large-scale print *Selena, A Fallen Angel* depicts singer Selena Quintanilla in 1995, the same year of her tragic murder (**PL. 57**). The intense public outpouring of grief upon her death revealed the extent to which the bicultural artist had become a role model to young people across the United States and Latin America. To signify her importance, Cuellar's print monumentalizes the cover image of her best-selling album *Amor Prohibido* (1994). And the United Teachers of Los Angeles union, which went on strike in early 2019 for better pay and work conditions, commissioned Ernesto Yerena Montejano to create a print to support their cause. The artist immediately went into action and collaborated with Roxana Dueñas, a teacher whom he felt represented the ethnic and racial demographics of both teachers and students in Los Angeles. Her portrait appeared on billboards, on screenprints distributed for free, and in the pages of the *Los Angeles Times* (**FIG. 21** and **PL. 118**).[87]

The portraits featured in this exhibition go beyond major historical figures to capture the likenesses of everyday people who have left their mark on the world, often through tragedy. In

FIG. 21

United Teachers of Los Angeles teachers' strike billboard featuring Ernesto Yerena Montejano's portrait of educator Roxana Dueñas, 2019. Photograph by Joe Brusky.

1975, Amado M. Peña Jr. created the mournful *Aquellos que han muerto* (**PL. 15**) in honor of Santos Rodriguez, the twelve-year-old boy who was senselessly killed by a police officer in Dallas, Texas, in 1973. The case garnered national attention and spurred protests in Dallas. The print depicts the child's innocent likeness marred by a gunshot wound to the head. In 2014, Oree Originol began his series *Justice for Our Lives* (**PL. 119**) during the rise of the Black Lives Matter movement as a way to memorialize Black people killed by the police. When he started the project, Originol reached out to the victims' families to request a photograph of their loved one. Using these pictures as inspiration, he created simple but striking black-and-white digital portraits that he made available for download online. Over the next few years, Originol expanded his focus and created more than seventy portraits of victims of all backgrounds and abilities—Black, Asian, Latinx, male, female, and transgender—which he frequently wheat pastes in different grouped configurations on urban walls

(**FIG. 22**). Originol's project lets him, and his followers, respond in real time to recent events. His latest work depicts children like Jakelin Caal Maqu n who died while in custody of U.S. Customs and Border Protection, as well as George Floyd and Breonna Taylor, whose recent killings unleashed mass national protests in May and June 2020. *Justice for Our Lives* continues a long history of interracial solidarity within Chicanx graphic arts and demonstrates the power of portraits to make space for mourning, protest, and remembrance.

Expanding Networks

Chicanx graphics rose as a force during the social movements of the 1960s. These movements were local, global, and linked. As a graduate student at San Francisco State during the strike of 1968, Rupert García recalled what led him and his fellow activists to turn to silkscreen posters: "The impetus was Alf Young from England, the instructor who was teaching part-time at San Francisco State[.] He talked about his experiences in Paris and what the

students were doing there in terms of the rebellion going on and how they were using posters and silk screen posters as a way to articulate visually their points of view. So when we heard that, we thought seemingly in unison, *that's what we need to do*."[88] Artists involved in the struggle for equal rights were not only acutely aware of worldwide student and anti-colonial movements—especially as they were constructing their own discourses of Third World solidarity at home—they were attuned to how art played a vital role in those settings. These pulsating social, artistic, and political networks shaped Chicanx graphics and created a context for its impact in the broader world.

Initially, the galvanizing impact of the Cuban Revolution and later post-revolutionary Cuban posters was incredibly powerful for activists and artists, especially for those who saw themselves as both. Artists of the era often paid homage to the Cuban Revolution itself, while emulating the style and political ethos of Cuban posters. The example of Cuban posters—especially the use of bold colors, flat, graphic forms, revolutionary imagery, and multilingual text—reached far and wide and became a kind of visual shorthand for protest.[89] African American artist Emory Douglas, the Black Panther Party's minister of culture and art director of the organization's eponymous newspaper, was well aware of the anti-colonial thrust, style, and iconography of Cuban posters, which informed his images of revolutionary women and men wielding

rifles and placed against radiating, graphic designs (see **FIG. 6**, p. 141).[90] Malaquias Montoya's *Julio 26—Cuba Vietnam y Nosotros Venceremos* (**PL. 9**) weds imagery of the Cuban Revolution—highlighting the reference to Fidel Castro's 26th of July Movement that toppled the presidency of Fulgencio Batista—and Vietnam, and suggests the Chicano struggle by adding the word *nosotros,* or "us," to the text. During college, Juan Fuentes visited Cuba as part of the Venceremos Brigade, a group of students from the United States who traveled to the island to assist in agricultural and architectural projects.[91] While there, Fuentes absorbed the visual culture of the revolution, from posters to billboards and photographs published in *Granma*, the official newspaper of the Communist Party in Cuba. Fuentes's prints about the Bay of Pigs invasion in 1961 in the port town of Playa Girón (**PL. 17**) and Palestine liberation (**PL. 44**) were based on published photographs he saw in Cuba.[92] His enthusiasm for Cuban political posters led him to collaborate with Susan Adelman to organize the first exhibition of Cuban graphics art in the Bay Area in 1974, an event that exposed more artists to the innovative strategies of Cuban artists.[93] Like Montoya, Herbert Sigüenza invoked the 26th of July Movement in a minimal graphic print of Fidel Castro's silhouette (**PL. 46**). Nancy Hom's *No More Hiroshima/ Nagasakis: Medical Aid for the Hibakushas* (**PL. 43**), which portrays two wailing figures against a bright red background, shows how she too adopted striking

color contrasts and silhouettes to heighten the emotional tenor of her work. Here Hom marshals these visual sources to advocate for many causes, including securing medical aid for survivors of the Hiroshima and Nagasaki atomic bombings.[94]

Chicanx artists and institutions, however, did not just absorb influences from the world; they also supported artists far and wide, and their nurturing had notable ripple effects. As Chicanx print centers and artists became more established—relatively speaking since they were always economically vulnerable—their programs incorporated artists of other regions and from many walks of life.[95]

Poli Marichal, the Puerto Rican artist who relocated to Los Angeles in the 1990s, found a home at Self Help Graphics. Marichal was drawn to the Chicano organization in part because of the long-standing links between Puerto Rican and Mexican art. In the 1950s, Puerto Rico's ascendant nationalist artists studied in Mexico and developed a politicized print tradition inspired by the Taller de Gráfica Popular.[96] Until her relocation back to Puerto Rico in 2017 due to Hurricane María, Marichal was a fixture at Self Help Graphics as both a solo printmaker and member of the Los de Abajo Printmaking Collective.[97] In works like *Santuario* (**PL. 112**), which portrays men, women and children protectively held within two strong arms, Marichal weaves the political and aesthetic legacies of Chicano, Mexican, and Puerto Rican printmaking in a single work.

Her title and imagery conjure sanctuary cities as places where undocumented immigrants can safely go about their lives with some protections and rights. Created in 2018, as President Donald Trump both threatened to defund sanctuary cities and implemented controversial policies against asylum seekers at the border, Marichal's print counters these positions with humanity. Her palette and linocut medium recall the work of Elizabeth Catlett (who had been a member of Taller de Gráfica Popular for fifty-five years), and her protective visual gesture joins the powerful legacy of Chicanx immigrant advocacy in the arts.

Texas-based artist Sam Coronado was a resident artist at Self Help Graphics in the 1990s and was so impressed with its residency model that he adopted it as a template for his own screenprint residency, the Serie Project in Austin. The Serie Project itself would go on to have its own legacy. In the late 1990s, Pepe Coronado, a Dominican American artist living in Austin, joined the Serie Project as the residency's master printer. Pepe later traveled with Sam to Los Angeles and visited Self Help Graphics. Both experiences were transformational. The collaborative spirit Pepe witnessed among Chicanx and other Latinx artists left a strong impression. When he settled in New York in 2010, Pepe founded the Dominican York Proyecto GRAFICA (DYPG), originally a twelve-member collective dedicated to using printmaking as the medium to explore Dominican diasporic life. His inspiration came from many sources, including the steadfast

history of Chicanx printmaking, which he witnessed firsthand with Sam Coronado, as well as other models he came to know in New York, like the Robert Blackburn Printmaking Workshop.[98] The DYPG's first portfolio, entitled *Manifestaciones* (**PLS. 66–77**), is modest in scale but bold in concept, tackling topics from the 1965 U.S. intervention in the Dominican Republic (**PL. 75**) to the persistence of racist colorism in Dominican society (**PL. 72**), the transplanting of island icons to a new, urban context (**PLS. 69, 70**), and the remapping of New York into a hybrid Dominican American space (**PLS. 66, 68**), subjects that conceptually relate to the bicultural and borderland undercurrents of Chicanx art.[99]

Sandra C. Fernández, the Ecuadorian American artist who relocated to Austin in 2004, also had a transformative experience at the Serie Project. Born in New York and raised in Ecuador until early adulthood, Fernández returned to the United States in the 1990s when

political persecution during the repressive government of León Febres Cordero (1984–88) forced her to leave the capital city of Quito.[100] She studied printmaking in the Midwest and created works that combined printing, photography, and craft and that explored her own feelings of displacement. Fernández discovered the Serie Project when she moved to Austin to teach at the University of Texas. She later reflected: "The Serie Project was pivotal to my growth and trajectory as an artist. It changed my life."[101] Her subject matter shifted dramatically after her encounter with Serie. She began more and more to address not her migration, but broader immigration debates in the United States. *¡Printing the Revolution¡* includes one of her most ambitious installations to date, *Mourning and Dreaming High: con mucha fé* (**FIG. 23, PL. 102**). She created the work two years after President Obama issued an executive branch memorandum establishing the Deferred Action for Childhood Arrivals program, commonly known as DACA. As noted earlier, this program provides protections for people who arrived in the United States not of their own free will, but as undocumented minors often accompanying parents and other adults. Fernández met several Dreamers while working in Texas. She was drawn to their stories and sense of hope that reminded her of her own youthful optimism in Quito. The work superimposes their solemn likenesses, often partially obscured through the printmaking process, onto the pages of an eighteenth-century

Por un compañero
en la lucha pa' la
libertad Cultural,
y todas otras
libertades

Carlos Frattez Koyokuuikatl

14 Diciembre 1982

FIG. 28

José Francisco Treviño, *Galería Sin Fronteras,* 1986, screenprint on paper, sheet: 40 ¼ × 26 in. Smithsonian American Art Museum, Gift of Gilberto Cárdenas and Dolores García, 2019.51.22. The print commemorates the opening of Gil Cárdenas's gallery in Austin, Texas, 1986.

that critically explore the changing dimensions of U.S. identity, history, and culture through the arts.[105]

Ybarra-Frausto was not alone. The other major donors that have generously gifted prints to SAAM, including Gilberto Cárdenas and Dolores Carrillo García, Ricardo and Harriett Romo, and the estate of Margaret "Margie" Terrazas Santos, exemplify a new kind of museum donor, whose contributions bring Latinx perspectives into the museum that effectively recalibrate notions of U.S. art, history, and culture. Like Ybarra-Frausto, these donors came of age during the civil rights movement, became educators, and devoted their personal and professional lives to public service and Latino cultural advocacy. Their motivations resonate with the effort to found Latinx alternative spaces and museums. Both private collectors and Latinx cultural institutions have sought to fill a void left by mainstream museums' lack of responsiveness to Latinx artists and culture.[106] The collectors highlighted here, however, took the next step. In donating their holdings to a public institution, they challenge previous exclusions and prepare the ground for future, more accurate and dynamic histories of U.S. art.

Gilberto Cárdenas's prolific cultural activism and efforts to build an institutional infrastructure for Latinx art is remarkable and noteworthy. His passion for Chicano and Latinx art began with his own art-making. While an undergraduate in Los Angeles, Cárdenas took up a camera and documented civil rights rallies and started informally collecting posters. His more intense cultural work began after he earned his PhD in sociology at the University of Notre Dame in 1977, and when he became a professor and later directed the Center for Mexican American Studies at the University of Texas at Austin. In the 1980s, Cárdenas met Sister Karen Boccalero, one of the founders of Self Help Graphics, and began acquiring prints, an experience he remembers transformed him

Galería Sin Fronteras

INAUGURAL EXHIBIT

José F. Treviño

OCTOBER , 1986 AUSTIN , TEXAS

into a more serious collector. Inspired and encouraged by Sister Karen, in 1986 Cárdenas founded the Galería Sin Fronteras in Austin in order to provide a platform for underrepresented artists living on either side of the U.S.-Mexico border, an idea visualized in José Treviño's inaugural exhibition print depicting a half westernized/half Native artist (FIG. 28).[107] In his gallery, Cárdenas represented many graphic artists like Treviño and often underwrote their print projects, a practice that contributed to his expansive print collection. When Cárdenas joined the faculty at Notre Dame in 1999, his commitment to the visual arts continued. He established the Institute for Latino Studies (ILS), which presented changing exhibitions, launched research projects in arts and culture, and housed a Latino library and archive.[108]

In the 1990s, Cárdenas became a highly sought-after cultural advocate focused on Latino issues. It was during this time that he became a trusted supporter and adviser to the Smithsonian Institution. He served as a member of the task force that produced *Willful Neglect: The Smithsonian Institution and U.S. Latinos* (1994), the damning internal report that called out the Smithsonian's lack of staff diversity and disregard for Latinx contributions, culture, and history. As a way to ameliorate this predicament, in 1994 Cárdenas developed a seminar program that brought Latino graduate students to Washington, DC, to both serve as a critical sounding board for Smithsonian staff and to pique the young scholars' interest in museum careers. He promoted the idea of a Latino center with Secretary Ira Michael Heyman; when it was established in 1997, he served as a board member and later as chair of the Smithsonian Latino Center. In 2009 he was appointed by President George W. Bush to the National Museum of the American Latino Commission. Together with colleagues from the Center for Puerto Rican Studies at Hunter College, Cárdenas worked to initiate the biennial conference Latino Art Now!, which still supports scholarship in Latinx art. While at Notre Dame, Cárdenas encouraged the formation of Consejo Gráfico, a network of Latino print centers that work together to advance their craft and the visibility of Latinx printmaking in the United States. Throughout this time, Cárdenas—and later, along with his wife, Dolores Carrillo García—built a massive collection and has generously donated hundreds of works to several museums, including the Snite Museum of Art, the Blanton Museum of Art, the National Museum of Mexican Art, and now SAAM, as a way to expand the representation of Chicano and Latinx artists in museum collections.[109]

Like Cárdenas, Ricardo and Harriett Romo were shaped by their experiences living through the Chicano civil rights movement in California. The couple attended graduate school in Los Angeles and San Diego, respectively, while they taught high school in East Los Angeles, at the time a marginalized neighborhood that was a major center of the growing

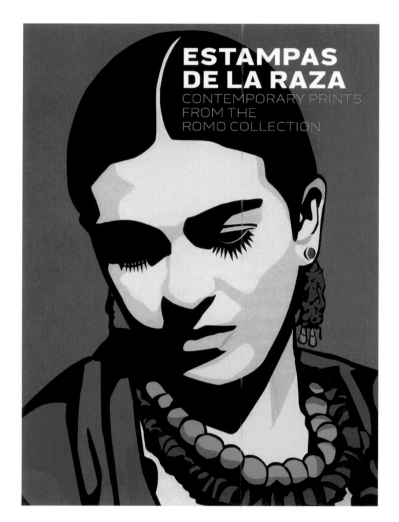

and interests as a couple. At institutions like Self Help Graphics, they discovered a thriving arts community, which they began to support as patrons. Their dedication continued and intensified as they advanced in their careers as professors and administrators at University of Texas schools at Austin and San Antonio. Their active patronage of Chicano artists extended to those based in Texas. The Romos amassed significant holdings and began to donate their collection to educational and cultural institutions that could make these works available to students and the public. They donated more than a thousand works to the Nettie Lee Benson Latin American Collection at the University of Texas at Austin, and over four hundred works to the McNay Art Museum, this later gift spawning two exhibitions (**FIG. 29**).[111] Their gift to SAAM marks a third time the Romos have given to an institution not exclusively dedicated to Chicano or Latinx art, and which has the means to share their collection with a wide range of visitors and researchers.

FIG. 29

Jacket cover of exhibition catalogue *Estampas de la Raza: Contemporary Prints from the Romo Collection* (2012) featuring a detail of Raul Caracoza's *Young Frida (Pink)* (2006). Courtesy McNay Art Museum, San Antonio, Texas.

Chicano civil rights movement.[110] They witnessed the intensity of the 1968 "blowouts," the protests led by Chicano high schools to demand educational equity, and the Chicano Moratorium of 1970, which resulted in violent clashes between protesters and the police, and ended with the tragic death of journalist Rubén Salazar. In Los Angeles they supported their protesting students—which for Ricardo included a young Richard Duardo—as well as the efforts of César Chávez and the UFW.

In Los Angeles, the Romos witnessed the flowering of a vibrant Chicano arts scene, which left its imprint on their lives

Margaret "Margie" Terrazas Santos (1942–2014) was a passionate activist, social worker, and institution builder who single-handedly developed an impressive collection of Chicano/a and Latino graphics (**FIG. 30**).[112] SAAM serendipitously came to know of her impressive collection and dedication to Chicano/a graphics.[113] As a young woman, Santos was a student activist at San José State University and fought to establish Chicano studies programs there. She wanted to become a medical doctor,

but her professors discouraged her on account of her gender and race. This experience informed her activism and desire to record the transformational impact of the Chicano civil rights movement on society. She became a social worker, an ethnic studies professor at St. Mary's College of California, and a leader within important Chicana political organizations like the Comisión Femenil Mexicana Nacional. She was deeply devoted to young people, and after college she worked with Latino youth in New Mexico through VISTA, a federal domestic program modeled after the Peace Corps. In 1977 she co-founded the Chicana Latina Foundation to provide scholarships for Latina college students. The foundation remains in existence today. An active member of the Bay Area cultural scene, she initiated the Día de los Muertos

celebrations in Oakland and worked with the Oakland Museum to establish theirs, and was for many years a staff member at the Mission Cultural Center for Latino Arts in San Francisco.[114] A proud Chicana, Santos actively collected graphics by and related to women, and spearheaded Chicana-only events in the Bay Area as a way to encourage female leadership. She also identified as *lesbiana* and actively collected graphics about HIV/AIDS harm reduction and lesbian convenings.

Santos was driven and serious about her collection. She acquired works directly from artists, and petitioned friends and acquaintances to donate prints that might be "rolled up and stored in the corner of your back room."[115] Santos intended to create her own poster and print archive, Calli Americas, which she described in her draft bylaws as

FIG. 30

(*From left*)
Margaret Terrazas Santos, Linda Baker, Nery Ordóñez, Deble Faulkner, René Castro, Yolanda López, Juan Pablo Gutierrez, and Mauricio Aviles Jr. Photograph courtesy of Yolanda Ronquillo.

a "Chicano-Latino poster archive [founded] to preserve the legacy and heritage of Chicano-Latino poster/serigraph creations."[116] Reflecting her own embrace of Chicano indigenism, Santos married the word *calli*, a Nahuatl term that means "house," with *Americas*, to convey how her archive documented the cultural links across two continents. Her failing health prevented her institution from becoming a reality. Santos's estate donated a portion of her collection to SAAM so that her goals of preservation, education, and dissemination could be achieved.[117]

The more than one hundred artworks featured in *¡Printing the Revolution¡* unite prints by major figures and emergent voices with a focus on artists who, in the spirit of social change and democratic civic discourse, engage audiences around ongoing national and global sociopolitical debates. The roots of this tendency undoubtedly lay not only in the civil rights origins of Chicanx graphics, but also in the struggle for justice that continues today. In light of renewed debates over immigration, LGBTQ+ rights, economic inequality, climate change, and the enduring impact of race in American society, the artists in this exhibition choose to engage with their times, and spur viewers to think critically about their own place in the world today.

This exhibition vividly demonstrates the enduring commitment of Chicanx artists to printmaking as a medium and site for these important, and evolving, dialogues. Since the 1960s, artists have not only dared to imagine and birth a new Chicanx world that questions our nation's entrenched social and racial hierarchies, but through their creativity they have also pioneered new relationships between audiences, contemporary art, and cultural institutions. Presenting this exhibition at the Smithsonian American Art Museum allows us to showcase this important history to new audiences and seasoned followers. Because of SAAM's status as a national museum, this exhibition also directly challenges established histories of U.S. printmaking that have sidelined Chicanx artists and their peers. That SAAM's Chicanx graphics collection was shaped, in part, by the generosity of donors who channeled their activism into philanthropy reveals how the civil rights origins of this lengthy artistic history is still alive and necessary today.

NOTES

EPIGRAPHS (p. 23)

Gil Scott-Heron, "The Revolution Will Not Be Televised (1970)," in *The Norton Anthology of African American Literature*, ed. Henry Louis Gates Jr. and Nellie Y. McKay (New York: W. W. Norton, 1996) 61–62.

Luis Valdez, "Notes on Chicano Theater," in *Aztlan: An Anthology of Mexican American Literature*, ed. Luis Valdez and Stan Steiner (New York: Knopf, 1972), 354–58.

Carlos Almaraz, "The Artist as a Revolutionary," *Chismearte* (Los Angeles) 1, no. 1 (Fall 1976): 50.

1 Rubén Salazar, "Who Is a Chicano? And What Is It the Chicanos Want?," *Los Angeles Times,* February 6, 1970. For more on Salazar and his writings, see Mario T. García, *Border Correspondent: Selected Writings, 1955–1970, Rubén Salazar* (Berkeley: University of California Press, 1995).

2 Chris Carlsson and Lisa Ruth Elliott, eds., *Ten Years That Shook the City: San Francisco 1968–1978* (San Francisco: City Lights Foundation Books, 2011). For more on López's print, see Tatiana Reinoza, "'No Es un Crimen': Posters, Political Prisoners, and the Mission Counterpublics," *Aztlán: A Journal of Chicano Studies* 42, no. 1 (Spring 2017): 239–56.

3 In this essay, I use the gender-neutral and nonbinary word Chicanx as an alternative to Chicano. I still use Chicano when referring to the historic civil rights movement and the related art movement that developed alongside it, which unfolded in the 1960s and 1970s. I also use Chicana when referencing women who fought for and prefer this designation. I also use the terms Latino (historic) and Latinx (gender-neutral and nonbinary) for similar reasons.

4 Studies of American printmaking largely fall into two camps: fine art printing, often supported by exhibitions in large art museums, and political printmaking, which tends to focus on screenprinting as a process and posters as a genre. Few artists of color are included in general museum surveys of American printmaking. See, for example, Karin Breuer, *An American Focus: The Anderson Graphics Arts Collection* (San Francisco: Fine Arts Museums of San Francisco, 2000); and Leah Lehmbeck, ed., *Proof: The Rise of Printmaking in Southern California* (Los Angeles: Getty Publications in association with the Norton Simon Museum, 2011). The exhibition *Three Centuries of American Prints from the National Gallery of Art* (2016) included only one Latinx, Mauricio Lasansky. See Judith Brodie, *Three Centuries of American Prints from the National Gallery of Art* (New York: Thames & Hudson, 2016). In 2017 the British Museum organized the print exhibition *The American Dream: Pop to the Present*, which included works produced through 2014 and featured only one Latinx artist, Enrique Chagoya. See Stephen Coppel, *The American Dream: Pop to the Present* (New York: Thames & Hudson, 2017). A handful of posters by Chicanx and African American artists are featured in Therese Thau Heyman, *Posters American Style* (Washington, DC: National Museum of American Art, Smithsonian Institution, and Harry N. Abrams, 1998). The one major exception to the racial exclusivity of print exhibitions is Deborah Wye's *Committed to Print: Social and Political Themes in Recent American Printed Art* (1988) presented at MoMA. This exhibition was noticeably gender and racially diverse. See Deborah Wye, *Committed to Print: Social and Political Themes in Recent American Printed Art* (New York: Museum of Modern Art, 1988). For an excellent case study of the impact of social segregation and the art world as it pertains to African American artists, see Ann Gibson, "Two Worlds: African American Abstraction in New York at Mid-Century," in *The Search for Freedom: African American Abstract Painting 1945–1975* (New York: Kenkeleba House, 1991), 11–14.

5 For a broad history of political graphics in the United States since the 1960s, see Lincoln Cushing, *All of Us or None: Social Justice Posters of the San Francisco Bay Area* (Berkeley, CA: Heyday, 2012); and Josh MacPhee, ed., *Paper Politics: Socially Engaged Printmaking Today* (Oakland, CA: PM Press, 2009). Helen Langa notes how silkscreen printing entered into more of a fine art realm during the WPA among leftist artists. Lincoln Cushing and Timothy W. Drescher argue that agitational art-making dampened during McCarthyism, only to be revived during the long sixties. See Helen Langa, *Radical Art: Printmaking and the Left in 1930s New York* (Berkeley: University of California Press, 2004), 26; and Lincoln Cushing and Timothy W. Drescher, *Agitate! Educate! Organize! American Labor Posters* (Ithaca, NY: Cornell University Press, 2009).

6 For more on this idea, see Michael Rossman, *Speak, You Have the Tools: Social Serigraphy in the Bay Area: 1966–1986* (Santa Clara, CA: de Saisset Museum, 1987). The exhibition and catalogue *Pressing the Point* explore the conceptual relationships between Puerto Rican and Chicano printmaking, showing how both sets of artists focused on cultural and political issues. See Yasmin Ramirez Hargrove, Henry C. Estrada, and Gilberto Cardenas, *Pressing the Point: Parallel Expressions in the Graphic Arts of the Chicano and Puerto Rican Movements* (New York: Museo del Barrio, 1999). Juan Fuentes, speaking of the work and perspective of Mission Gráfica in San Francisco, stated this point more emphatically: "Mission Gráfica had a cultural and artistic component that the political left didn't have. And Mission Gráfica and its atmosphere could give validation to the artistic expression and not just point a finger at you, as the political left sometimes did, and say, oh you want to be bourgeois and an artist. The artist community there gave value to their political work. But they also valued each other." Quoted from Art Hazelwood, "Mission Gráfica: Reflecting a Community in Print" (unpublished manuscript, 2017), 8.

7 Email communication between author and Luis C. González and Rodolfo O. Cuellar, September 15 and 16, 2019. An ad for the mail-order sale of Rupert García's prints appears in *Leviathan* 1, no. 2 (April 1969): n.p. I thank Lincoln Cushing for bringing this reference to my attention.

8 For a discussion of this tendency in relation to the 1993 Whitney Biennial, one of the most debated exhibitions of the late twentieth century, see Chon A. Noriega, "On Museum Row: Aesthetics and the Politics of Exhibition," *Daedalus* 128, no. 3 (1999): 57–81.

9 "Social practice" is the term most frequently used to describe this kind of artistic practice. In fact, Suzanne Lacy uses "new genre public art" in her important anthology on the subject. Additional terms used to describe social practice art include participatory art, relational art, community-based art, and interventionist art, among others. See Suzanne Lacy, ed., *Mapping the Terrain: New Genre Public Art* (Seattle: Bay Press, 1995), 19.

10 Tom Finkelpearl and Pablo Helguera, for example, focus mostly on performative modes of social practice art that are based in conversation and community engagement, and less on projects that result in non-ephemeral art objects that can be collected or displayed. The Royal Chicano Air Force was involved in multiple practices, from performances to collaborative interactions with community groups, and the production of art objects, i.e., prints that now circulate in a museum context. For more on this, see Tom Finkelpearl, *What We Made: Conversations on Art and Social Cooperation* (Durham, NC: Duke University Press, 2013); and Pablo Helguera, *Education for Socially Engaged Art: A Materials and Techniques Handbook* (New York: Jorge Pinto Books, 2011). For an excellent study of the boundary-defying practices and activism of the Royal Chicano Air Force, see Ella Maria Diaz, *Flying Under the Radar with the Royal Chicano Air Force: Mapping a Chicano/a Art History* (Austin: University of Texas Press, 2017).

11 Sister Kent mentored Sister Karen when the latter was a student at the Immaculate Heart College in Los Angeles. Sister Kent believed in the importance of unbridled creativity and critical thinking. For more on this, see Kristen Guzmán, "Art in the Heart of East Los Angeles," in *Self Help Graphics and Art*, ed. Colin Gunckel, 2nd ed. (Los Angeles: UCLA Chicano Studies Research Center Press, 2014), 6–7; and Damon Willick, "Handfuls of Creative People: Printmaking and the Foundations of Los Angeles Art in the 1960s," in *Proof: The Rise of Printmaking in Southern California,* ed. Leah Lehmbeck (Los Angeles: Getty Publications in association with the Norton Simon Museum, 2011), 207–11.

12 This earlier history encompasses the anarchist and transnational activities of the Flores Magón brothers, who founded and produced their amply illustrated *Regeneración* newspaper in Los Angeles in the early twentieth century. In the 1950s, Mexican American artist Domingo Ulloa—later honored as the father of Chicano art—created prints in the style of Mexico's Taller de Gráfica Popular that explored themes of union activism and anti-racism. And, a young Carlos A. Cortéz, whose family had deep links to the Industrial Workers of the World (IWW) union in the Midwest, illustrated the Wobbly newspaper *The Industrial Worker* as early as the 1940s. Like Ulloa, Cortéz later linked himself to the Chicano art movement, and his work from this post-1965 period is featured in the present exhibition. See *Regeneración: Three Generations of Revolutionary Ideology*, ed. Pilar Tompkins Rivas (Monterey Park, CA: Vincent Price Art Museum at East Los Angeles College, 2018); Terezita Romo, "Mexican Heritage, American Art: Six Angeleno Artists," in *L.A. Xicano,* ed. Chon A. Noriega, Terezita Romo, and Pilar Tompkins Rivas (Los Angeles: UCLA Chicano Studies Research Center Press, 2011), 3–28; Scott H. Bennett." Workers/Draftees of the World Unite! Carlos A. Cortéz Redcloud Koyokuikatl: Soapbox Rebel, WWII CO & IWW Artist/Bard," in *Carlos Cortéz Koyokuikatl: Soapbox Artist and Poet*, ed. Victor Sorell (Chicago: Mexican Museum of Fine Arts, 2002), 17. Some of Cortéz's work also appears in *Wobblies! A Graphic History of the Industrial Workers of the World*, ed. Paul Buhle and Nicole Schulman (London: Verso, 2005).

13 The milestone exhibition *Chicano Art: Resistance and Affirmation, 1965–1985*, which opened in 1990, also takes this date as a point of departure.

14 For a seminal article that sparked great debate about the role of Chicano art and artists, see Malaquias Montoya and Lezlie Salkowitz-Montoya, "A Critical Perspective on the State of Chicano Art," *Metamórfosis* (Seattle) 3, no. 1 (1980): 3–7.

15 García defined this choice as such: "one of the major roles of the artist was to publicly communicate, and in some instances quickly, the many critical issues of the Movement to the community. Their lack of control of the mass media and consequent limited ability to effectively publicly address these needs led to seeking of alternative communicating methods. Among the other avenues of creative production endeavors, the artist took to the walls." See Rupert García, "Chicano/Latino Wall Art: The Mural and the Poster," in *The Hispanic American Aesthetic: Origins, Manifestations, and Significance,* ed. Jacinto Quirarte (San Antonio: Research Center for the Arts and Humanities, University of Texas at San Antonio, 1983), 28.

16 Wye, *Committed to Print*, 7.

17 For two important exhibitions of Chicano/a and Latinx art that use "graphic arts" and "printmaking" interchangeably, see *¿Just Another Poster? Chicano Graphic Arts in California* (2001) and *San Juan Poly/Graphic Triennial: Latin America and the Caribbean* (2004).

18 For example, imagery related to Malaquias Montoya's iconic print *Viet Nam / Aztlan* (1973; see fig. 6, p. 81, in this volume) first appeared as illustrations in Lea Ybarra and Nina Genera's anti–Vietnam War pamphlet, *La Batalla Está Aquí: Chicanos and the War* (El Cerrito, CA: Chicano Draft Help, 1972), which offered young Chicano men strategies to avoid the draft. For more on this example, see E. Carmen Ramos, "Malaquias Montoya," in *Artists Respond: American Art and the Vietnam War, 1965–1975*, ed. Melissa Ho (Washington, DC: Smithsonian American Art Museum in association with Princeton University Press, 2019), 254–56.

19 Rupert García created his iconic print *No More o' This Shit* in 1969, when he was part of the San Francisco Poster Workshop at San Francisco State, and it may have been sold to raise funds for the student strike bail fund. It is now in the collection of the National Gallery of Art in Washington, DC, one of the most elite museums in the United States. During the civil rights era, many activist artists did not edition their prints, an

omission that reveals their lack of interest in art-world protocols. For more on García's prints and student strike bail fund, see Ramón Favela, *The Art of Rupert Garcia* (San Francisco: Chronicle Books and Mexican Museum, 1986), 19.

20 See Shifra M. Goldman, "A Public Voice: Fifteen Years of Chicano Posters," *Art Journal* 44, no. 1 (Spring 1984): 50–57. For an important, recent exhibition that distinguished between movement and post-movement artists, see Rita González, Howard N. Fox, and Chon A. Noriega, *Phantom Sightings: Art After the Chicano Movement* (Los Angeles: Los Angeles County Museum of Art and UC Press, 2008).

21 While the comprehensive exhibition and catalogue *¿Just Another Poster?* remains an important resource in the study, it subsumes artists like Herbert Sigüenza (b. El Salvador) and René Castro (b. Chile) into the Chicano category without exploring in a much more significant way their backgrounds or group history. The 2011 exhibition *Mapping Another L.A.: The Chicano Art Movement* documented Mura Bright's cofounding of Méchicano Art Center alongside Victor Franco. Cary Cordova's study of art in San Francisco delves concertedly into the Latinx context and participants of the Bay Area arts scene in the Mission District. See Chon A. Noriega and Pilar Tompkins Rivas, "Chicano Art in the City of Dreams: A History in Nine Movements," in *L.A. Xicano,* ed. Chon A. Noriega, Terezita Romo, and Pilar Tompkins Rivas (Los Angeles: UCLA Chicano Studies Research Center Press, 2011), 71–102; and Cary Cordova, *The Heart of the Mission: Latino Art and Politics in San Francisco* (Philadelphia: University of Pennsylvania Press, 2017).

22 For more on Chicano Park's status as a national landmark, see Gary Warth, "Chicano Park Named National Historic Landmark," *San Diego Union-Tribune*, January 11, 2017, https://www.sandiegouniontribune.com/news/politics/sd-me-chicano-historic-20170111-story.html.

23 Mario Torero, conversation with author, May 1, 2019.

24 For a period interview with Jos Sances and René Castro about Mission Gráfica, see "Mission Gráfica: Radical Art," *Arts and Entertainment* (Mendocino Art Center), April 1987, 6–10.

25 It is for this reason that Nancy Hom's work is discussed and amply illustrated in Art Hazelwood's manuscript, "Mission Gráfica" (see note 6, above).

26 "Dreamers" is a colloquial expression for a person who has lived in the United States without official authorization since coming to the country as a minor. Dreamers who meet certain conditions may be eligible for protection from deportation and work permits conferred by President Barack Obama in 2012 through an executive branch memorandum known as Deferred Action for Childhood Arrivals (DACA).

27 The only other museum on the East Coast with extensive Latinx graphics is El Museo del Barrio in New York. While they have an extensive collection of graphics by Puerto Rican artists, their representation of Chicanx artists amounts to sixty-five works. The Library of Congress, which is a library and not a museum, has a larger collection than SAAM, the bulk of it produced by the interrelated organizations La Raza Silkscreen Center, La Raza Graphics, and Mission Gráfica. Email communication between author and Noel Valentin, registrar, El Museo del Barrio, May 21, 2019; email communication between Katherine Blood, curator of prints at the Library of Congress, and author, May 16, 2019. To learn more about SAAM's Latinx collection and its recent growth since 2010, see E. Carmen Ramos, *Our America: The Latino Presence in American Art* (Washington, DC: Smithsonian American Art Museum in association with D Giles, 2014).

28 At the time, Emanuel Martinez was supporting Reies López Tijerina's land rights activism in New Mexico. The print was created in advance of Tijerina's raid of the Rio Arriba County Courthouse in Tierra Amarilla in 1967. The print was Martinez's first screenprint. Martinez, phone conversation with author, January 15, 2020.

29 This practice is documented in an audit commissioned at the behest of Governor Ronald Reagan by the Regents of the University of California in 1970. The report found that protesting students did not misuse campus resources but helped themselves to computer paper the university had marked for disposal. See *Special Report Relating to Boalt Hall, Wurster Hall, Eshleman Hall,* issued to the Regents of the University of California, September 11, 1970 (San Francisco: Haskins and Sells, 1970). See also Greg Castillo, "Design Radicals: Creativity and Protest in Wurster Hall," Fall 2014, UC Berkeley Environmental Design, https://frame works.ced.berkeley.edu/category/people/ced-alumni/page/3/.

30 See Max Benavidez, "Cesar Chavez Nurtured Seeds of Art," *Los Angeles Times*, April 28, 1993, https://www.latimes.com/archives/la-xpm-1993-04-28-ca-28278-story.html.

31 For more on this history, see Cushing and Drescher, *Agitate! Educate! Organize!*

32 The UFW's newspaper *El Malcriado* was named after a Mexican publication from the Mexican revolutionary period. The newspaper's editor, Bill Esher, has noted Chávez's awareness and interest in the art from the Mexican Revolution. See Doug Adair and Bill Esher, "The Origins of El Malcriado (2009)," The Farmworker Movement Documentation Project, UC San Diego Library, https://libraries.ucsd.edu/farmworkermovement/ufwarchives/elmalcriado/billEsher.pdf.

33 For more on El Teatro Campesino and its work inside and out of the UFW, see Yolanda Broyles-González, "El Teatro Campesino and the Mexican Popular Performance Tradition," in *Radical Street Performance: An International Anthology*, ed. Jan Cohen-Cruz (London: Routledge, 1998), 245–54; and James M. Harding, "El Teatro Campesino," in *Restaging the Sixties: Radical Theaters and Their Legacies*, ed. James M. Harding and Cindy Rosenthal (Ann Arbor: University of Michigan Press, 2006), 213–17.

34 Oral history interview with Carlos Almaraz, 1986 February 6–1987 January 29, Archives of American Art, Smithsonian Institution.

35 El Taller Grafico, Report to Department Heads, April 15, 1974, UFW Administration Department Records, Box 15, Folder 22, Walter P. Reuther Library, Archives of Labor and Urban Affairs, Wayne State University (hereafter cited as UFW Admin. Records).

36 The photo-based posters of Villa and Zapata are reproduced on mailers used to sell UFW paraphernalia. See UFW Admin. Records.

37 Florencia Bazzano-Nelson, "Xavier Viramontes," in *Our America: The Latino Presence in American Art* (Washington, DC: Smithsonian American Art Museum in association with D Giles, 2014), 339.

38 In a letter to the UFW, Viramontes notes that "Teamsters [hired] goons to harass the farmworkers." Xavier Viramontes to Mack Warner, March 26, 1974, UFW Admin. Records.

39 The UFW archives capture the back-and-forth between Viramontes and El Taller Grafico's leadership as they discuss the value of artwork within the struggle, and the particular terms of Viramontes's work with them. Viramontes received a percentage of revenue from the sale of the print. See Mack Warner to Xavier Viramontes, March 21, 1974, and Agreement between United Farm Workers of America and Xavier Viramontes, May 30, 1974; UFW Admin. Records.

40 For more on the UFW's environmental demands, see Robert Gordon, "Poisons in the Fields: The United Farm Workers, Pesticides, and Environmental Politics," *Pacific Historical Review* 68, no. 1 (February 1999): 51–77.

41 Early patents for barbed wire were issued in 1868 and 1873. Ranchers who had moved out West used barbed wire to contain their cattle and protect their crops. Barbed wire impacted nomadic Native Americans in the region, who could no longer move freely on the land. For more on barbed wire, see "Invention of Improved Barbed Wire Changes the West," The History Engine, accessed July 5, 2019, https://historyengine.richmond.edu/episodes /view/6265. In the years surrounding and after World War II, barbed wire routinely appeared in documentary photographs in relation to the Holocaust and the U.S. incarceration of Japanese Americans. In photographs of braceros (Mexican guest laborers who worked in the United States between 1942 and 1964), substandard living quarters commonly featured barbed wire.

42 For more on the categories of undocumented migrants named in the bill and the impact of the new law itself, see Wilbur A. Finch Jr., "The Immigration Reform and Control Act of 1986: A Preliminary Assessment," *Social Service Review* 64, no. 2 (June 1990): 244–60; and Michael J. White, Frank D. Bean, and Thomas J. Espenshade, "The U.S. 1986 Immigration Reform and Control Act and Undocumented Migration to the United States," *Population Research and Policy Review* 9, no. 2 (May 1990): 93–116.

43 Jesus Barraza and Melanie Cervantes, conversation with author, February 2019.

44 Muzaffar Chishti, Sarah Pierce, and Jessica Bolter, "The Obama Record on Deportations: Deporter in Chief or Not?," Migration Policy Institute, January 26, 2017, https://www.migration policy.org/article/obama-record -deportations-deporter-chief-or-not.

45 For a brief description of the Obama *Hope* poster by Shepard Fairey, see "Q and A with Shepard Fairey," Design Museum, accessed July 8, 2019, https://designmuseum.org/exhibitions /hope-to-nope-graphics-and-politics -2008-18/qa-with-shepard-fairey.

46 Chishti, Pierce, and Bolter, "Obama Record on Deportations."

47 George Lipsitz, "Not Just Another Social Movement: Poster Art and the Movimiento Chicano," in *¿Just Another Poster? Chicano Graphic Arts in California*, ed. Chon A. Noriega (Santa Barbara, CA: University Art Museum, 2001), 74.

48 For an excellent discussion of Magu's imagined worlds, see Karen Mary Davalos, "The Landscapes of Gilbert 'Magu' Luján," in *Aztlán to Magulandia: The Journey of Chicano Artist Gilbert "Magu" Luján*, ed. Constance Cortéz and Hal Glicksman (Munich: DelMonico Books, 2017), 37–56.

49 Davalos, "Landscapes of Gilbert 'Magu' Luján," 51. For more on science fiction and Latin American and Latinx artists, see Robb Hernandez, *Mundos Alternos: Art and Science Fiction in the Americas* (Riverside, CA: UCR ARTSblock, 2017).

50 Robin Adèle Greeley makes similar points in her analysis of Duardo's print. See Robin Adèle Greeley, "Richard Duardo's 'Aztlan' Poster: Interrogating Cultural Hegemony in Graphic Design," *Design Issues* 14, no. 1 (Spring 1998): 21–34.

51 See Ella Maria Diaz, *Flying Under the Radar with the Royal Chicano Air Force: Mapping a Chicano/a Art History* (Austin: University of Texas Press, 2017), 21.

52 For more on Lomas Garza's practice, see Constance Cortez, *Carmen Lomas Garza* (Los Angeles: UCLA Chicano Studies Research Center Press, 2010).

53 See Terezita Romo, "The Chicanization of Mexican Calendar Art," Smithsonian Latino Center, accessed June 30, 2019, http://latino.si.edu /researchandmuseums/abstracts /romo_abstract.htm.

54 Artist Francisco X Camplis noted that Galería de la Raza gave each contributing artist several copies of the full 1977 calendar to sell directly within their individual networks. Camplis sold his set to his coworkers. Francisco X Camplis, interview by E. Carmen Ramos, August 30, 2019.

55 Camplis, interview. For more on the Halcones, see Dolores Trevizo, "Political Repression and the Struggles for Human Rights in Mexico: 1968–1990s," *Social Science History* 38, no. 3–4 (Fall/Winter 2014): 483–511.

56 This practice is explored in Rossman, *Speak, You Have the Tools.*

57 For more on early Chicana activism against Chicano patriarchy, see Angie Chabram-Dernersesian, "I Throw Punches for My Race, But I Don't Want to Be a Man: Writing Us—Chica-nos (Girl, Us)/Chicanas—into the Movement Script," in *Cultural Studies*, ed. Lawrence Grossberg, Cary Nelson, and Paula A. Reichler (London: Routledge, 1992), 81–95; and Norma Alarcón, "Traddutora, Traditora: A Paradigmatic Figure of Chicana Feminism," in *Scattered Hegemonies:*

Postmodernity and Transnational Feminist Practices, ed. Inderpal Grewal and Caren Kaplan (Minneapolis: University of Minnesota Press, 1994), 110–33.

58 Ramón A. Gutiérrez, "Community, Patriarchy and Individualism: The Politics of Chicano History and the Dream of Equality," *American Quarterly* 45, no. 1 (March 1993): 55.

59 For a more thorough discussion of this print, see Adriana Zavala, "Ester Hernández," in *Art_Latin_America: Against the Survey,* ed. James Oles (Austin: University of Texas Press, 2019), 161–63.

60 This image proved highly controversial when it was exhibited at the Museum of International Folk Art in New Mexico in 2001. For more on the controversy, see Alicia Gaspar de Alba and Alma López, eds , *Our Lady of Controversy: Alma López's "Irreverent Apparition"* (Austin: University of Texas Press, 2011). Also see Guisela Latorre, "Icons of Love and Devotion: Alma Lopéz's Art," *Feminist Studies* 34, nos. 1/2 (2008): 131–50.

61 These early challenges, Emma Pérez has aptly noted, were imperfect and patriarchal, and constantly in need of revision. See *The Decolonial Imaginary: Writing Chicanas into History* (Bloomington: Indiana University Press, 1999).

62 See Rudolph O. de la Garza, Z. Anthony Kruszewski, and Tomás A. Arciniega, *Chicanos and Native Americans: The Territorial Minorities* (Englewood Cliffs, NJ: Prentice-Hall, 1973).

63 Rodolfo Gonzales and Alberto Urista, "El Plan Espiritual de Aztlán," *El Grito del Norte* 2, no. 9 (July 6, 1969): 5.

64 Here I rely on Colin Gunckel's concept of the Chicano/a photographic to signify the ways in which Chicanx artists across media mobilized photography "as visual evidence, as counterrepresentation, as documentation of artistic process, as the conceptual basis for other artworks, as aesthetic influence, as an archive or creative resource, and a reimagination of self or community." See "The Chicano/a Photographic: Art as Social Practice in the Chicano Movement," *American Quarterly* 67, no. 2 (June 2015): 377–78.

65 For more on his program and how Latinx organizations responded, see "Immigration: Carter's Anti-Labor Plan," *NACLA*, September 25, 2007, https://nacla.org/article/immigration -carter%27s-anti-labor-plan.

66 For a reproduction of Torres García's map, see Andrea Giunta, "Strategies of Modernity in Latin America," *Beyond the Fantastic: Contemporary Art Criticism from Latin America*, ed. Geraldo Mosquera (Cambridge, MA: MIT Press, 1996), 52–66. The surrealist map is reproduced in Josh R. Rose, "Surrealism, An Introduction," Smarthistory, accessed January 31, 2020, https:// smarthistory.org/surrealism-intro/.

67 See Donald R. Hickey, "A Note on the Origins of 'Uncle Sam,' 1810–1820," *New England Quarterly* 88, no. 4 (December 2015): 681–92.

68 African American artists and thinkers also responded skeptically to the Bicentennial. In 1976, Faith Ringgold created *The Wake and Resurrection of the Bicentennial Negro*, which is reproduced in Ken Tan, "The Fantastic Life of Faith Ringgold," Hyperallergic, January 1, 2019, https://hyperallergic.com /477794/the-fantastic-life-of-faith -ringgold/ For another African American response to the Bicentennial, see Audre Lorde, "Bicentennial Poem #21,000,000," in *The Collected Poems of Audre Lorde* (New York: W. W. Norton, 1997), 304.

69 Rodolfo "Corky" Gonzales, "Colorado Springs Bicentennial Speech of July 4, 1976," *Message to Aztlán: Selected Writings of Rodolfo "Corky" Gonzales* (Houston, TX: Arte Público Press, 2001), 82.

70 Rupert García, email correspondence with author, July 2, 2019.

71 Miranda Saylor, "'A Cry for Freedom,'" in *Found in Translation: Design in California and Mexico, 1915–1985*, ed. Wendy Kaplan (Los Angeles: Los Angeles County Museum of Art, 2017), 328.

72 Pedro Caban, "Cointelpro" (2015), Latin American, Caribbean, and U.S. Latino Studies Faculty Scholarship, 18, http://scholarsarchive.library.albany.edu /lacs_fac_scholar/18.

73 During the research phase of this exhibition, Herbert Sigüenza contacted SAAM to point out that while the print is historically attributed to him, he colored a design that was created by an unidentified artist. The Center for the Study of Political Graphics corroborates this account. Their website states that a black-and-white version was produced in Seattle by an unknown artist and the design was later reprinted in color by Sigüenza at La Raza Silkscreen. See "It's Simple Steve" Collection, Center for the Study of Political Graphics, accessed January 27, 2020, http://collectionpoliticalgraphics .org/detailphp?module=objectstype =browse&id=1&term=El+Salvador &page=1&kv=4936&record=4&module =objects.

74 Carol Wells describes these sources in "La Lucha Sigue: From East Los Angeles to the Middle East," in Noriega, *¿Just Another Poster?*, 183.

75 Sam Coronado, unpublished interview by Tatiana Reinoza, March 11, 2011.

76 Kency Cornejo, "US Central Americans in Art and Visual Culture," *Oxford Research Encyclopedia of Literature*, February 2019, http://dx.doi.org/10.1093 /acrefore/9780190201098.013.434.

77 For more on contemporary artists and archives, see Okwui Enwezor, *Archive Fever: Uses of the Document in Contemporary Art* (New York: International Center for Photography and Stedl, 2008).

78 Like Mederos, Jackson's print forms part of a series. He created it to teach students about key events in U.S. civil rights history. For more on Mederos, see Ken Brociner, David Kunzle, and Lincoln Cushing, "Rene Mederos, 1933–1996," Docs Populi, accessed December 17, 2019, http://www.docspopuli.org/articles /Cuba/MederosObit.html.

79 Chávez highlights the long history between Kennedy and the farmworker movement in this oral history: César Chávez, "Interview: Robert F. Kennedy (1970)," Farmworker Movement Documentation Project, UC San Diego Library, https://libraries.ucsd.edu /farmworkermovement/media /oral_history/CEC-RFK%20ORAL %20HISTORY.pdf and https:// libraries.ucsd.edu/farmworkermovement /media/oral_history/CEC-RFK %20ORAL%20HISTORY%20PT.2.pdf.

80 Lucy R. Lippard uses the term "ideological portraiture" to discuss Rupert García's work. She appears to be citing an earlier source, although she does not mention where this term first emerged. See Lucy R. Lippard, "Rupert García: Face to Face," Rupert García: Prints and Posters, 1967–1990 (San Francisco: Fine Arts Museums of San Francisco, 1990), 28–31.

81 For an excellent discussion of racial discourses and perspectives in nineteenth-century Cuba, see Ada Ferrer, Insurgent Cuba: Race, Nation, and Revolution, 1868–1898 (Chapel Hill: University of North Carolina Press, 1999).

82 García misspelled Tenayuca's name on the print.

83 Barbara Carrasco, interview by Karen Mary Davalos, August 30, September 11 and 21, and October 10, 2007, Chicano Studies Research Center Oral History Series, no. 3, http://www.chicano .ucla.edu/files/03Carrasco.pdf.

84 Cortéz slightly altered the lyrics from Hill's "Workers of the World Awaken," which are reproduced in their entirety at http://www.folkarchive.de/workers .html, accessed August 9, 2019.

85 The quote, "The most potent weapon in the hands of the oppressor is the mind of the oppressed," comes from a speech Biko gave in Cape Town in 1971. See Steven Biko, "White Racism and Black Consciousness," in The South Africa Reader: History, Culture, Politics, ed. Clifton Crais and Thomas V. McClendon (Durham, NC: Duke University Press, 2013), 361–66.

86 The line comes from King's "Beyond Vietnam" speech, which he presented at Riverside Church in New York on April 4, 1967. The full speech is reproduced online: The Martin Luther King, Jr., Research and Education Institute, Stanford University, accessed August 8, 2019, https://kinginstitute.stanford.edu /king-papers/documents/beyond -vietnam.

87 Andrea Castillo, "Must Reads: This Boyle Heights Teacher Is the Face of the L.A. Teachers' Strike," Los Angeles Times, January 17, 2019, https:// www.latimes.com/local/lanow /la-me-edu-teachers-strike-poster -20190117-story.html.

88 Rupert García, interview by Rena Bransten Gallery, 2011, https://ren- abranstengallery.com/artists /videos/rupert-garcia/magnolia -editions.

89 For more on the impact of Cuban posters on activist artists of the Bay Area in particular, see Terezita Romo, "¡Presente! Chicano Posters and Latin American Politics," Latin American Posters: Public Aesthetics and Mass Politics, ed. Russ Davidson (Santa Fe: Museum of New Mexico Press, 2006), 50–62; and Lincoln Cushing, One Struggle, Two Communities: Late Twentieth-Century Political Posters of Havana, Cuba, and the San Francisco Bay Area, Docs Populi, September 28, 2003, http://www.docspopuli.org /articles/Cuba/BACshow.html.

90 For more on Douglas and his exposure to Cuban posters, see Colette Gaiter, "What Revolution Looks Like: The Work of Black Panther Artist Emory Douglas," in Black Panther: The Revolutionary Art of Emory Douglas, ed. Sam Durant (New York: Rizzoli, 2007), 98–101.

91 See Teishan A. Latner, "'Agrarians or Anarchists?' The Venceremos Brigades to Cuba, State Surveillance, and the FBI as Biographer and Archivist," Journal of Transnational American Studies 9, no. 1 (2018): 119–40.

92 Juan Fuentes, interview by E. Carmen Ramos and Claudia E. Zapata, August 6, 2019.

93 Romo, "¡Presente!," 60.

94 To read a statement by Nancy Hom about her knowledge and admiration of Cuban posters, see Cushing, One Struggle, Two Communities.

95 Colin Gunckel has called out the extensive ways Self Help Graphics supported artists across ethnic and racial groups. See Colin Gunckel, "Art and Community in East L.A: Self Help Graphics & Art from the Archive Room," in Gunckel, Self Help Graphics and Art, 46.

96 On the relationship between Puerto Rican printmaking and the TGP, see Ramirez Hargrove, Estrada, and Cardenas, Pressing the Point. For more on Puerto Rico's print tradition, see Teresa Tió, El cartel en Puerto Rico (Mexico: Pearson Educación, 2003); and Teresa Tió, La Hoja liberada: El portafolios en la gráfica puertorriqueña (San Juan: Instituto de Cultura Puertorriqueña, 1996).

97 Los de Abajo Printmaking Collective (founded 2004) was named after Mariano Azuela's 1915 Mexican Revolution–era book of the same title. The group's title also referenced where they worked and met, in a space under the main office of Self Help Graphics. In addition to Poli Marichal, some of the artists affiliated with the group at one point or another include: Agustín Barón, Kay Brown, Judith Durán, Antonio Escalante, Sojin Kim, Nguyen Ly, Yvette Mangual, Don Newton, Isela Ortiz, Victor Rosas, Marianne Sadowski, and Branko Stanojevic. Poli Marichal left the group in 2017. In 2018 the group changed their name to Mono Gráfico Colectivo.

98 For more on the Robert Blackburn Printmaking Workshop, see Deborah Cullen, "Robert Blackburn (1920–2003): A Printmaker's Printmaker," American Art 17, no. 3 (Autumn 2003): 92–94; and Deborah Cullen, "Contact Zones: Places, Spaces, and Other Test Cases," American Art 26, no. 2 (Summer 2012): 14–20.

99 For more on the DYPG, see E. Carmen Ramos, "Manifestaciones: Expressions of Dominicanidad in Nueva York," in *Manifestaciones: Dominican York Proyecto GRAFICA* (New York: CUNY Dominican Studies Institute Gallery, 2010); and Tatiana Reinoza, "The Island Within the Island: Remapping Dominican York," *Archives of American Art Journal* 57, no. 2 (Fall 2018): 4–27.

100 For a brief discussion of Fernández's early work, see Tatiana Flores, "Latino Art and the Immigrant Artist: The Case of Sandra C. Fernández," *Diálogo* 18, no. 2 (Fall 2015): 167–72.

101 Sandra C. Fernández, conversation with author, November 30, 2018.

102 See Shifra M. Goldman and Tomás Ybarra-Frausto, *Arte Chicano: A Comprehensive Annotated Bibliography of Chicano Art, 1965–1981* (Berkeley: Chicano Studies Library Publications Unit, University of California, 1985).

103 Ybarra-Frausto first published this essay in 1989 in a catalogue for the exhibition *Chicano Aesthetics: Rasquachismo*. He later reprinted it in *Chicano Art: Resistance and Affirmation, 1965–1985*. Scholars Amalia Mesa-Bains and Ramón Garcia have revisited and expanded on his ideas. See Tomás Ybarra-Frausto, "Rasquachismo: A Chicano Sensibility," in *Chicano Aesthetics: Rasquachismo* (Phoenix, AZ: MARS, Movimiento Artístico del Río Salado, 1989), 5–8; Tomás Ybarra-Frausto, "Rasquachismo: A Chicano Sensibility," in *Chicano Art: Resistance and Affirmation, 1965–1985*, ed. Richard Griswold del Castillo, Teresa McKenna, and Yvonne Yarbro-Bejarano (Los Angeles: Wight Art Gallery, University of California, 1991) 155–62; Amalia Mesa-Bains, "Domesticana: The Sensibility of Chicana Rasquache," *Aztlan: A Journal of Chicano Studies* (Los Angeles) 24, no. 2 (Fall 1999), 157–67; and Ramón Garcia, "Against Rasquache: Chicano Identity and the Politics of Popular Culture in Los Angeles," *Critica: A Journal of Critical Essays* (San Diego) (Spring 1998): 1–26.

104 Translation: "For a partner in the struggle for cultural liberation and all other liberties." The artist signed as Carlos Cortéz Koyokuikatl, the indigenous name he adopted later in life.

105 Tomás Ybarra-Frausto, interview by E. Carmen Ramos, December 18, 2018.

106 For more on the motivations of Chicano collectors, see Karen Mary Davalos, "Chicana/o Art Collectors: Critical Witness to Invisibility and Emplacement," in *Chicana/o Remix: Art and Errata Since the Sixties* (New York: New York University Press, 2017), 151–80.

107 "Man on a Mission: Professor, Collector, Leader Gil Cárdenas," *Austin Chronicle*, August 18, 1995, https://www.austinchronicle.com/arts/1995-08-18/533955/.

108 For more on this, see Victor Alejandro Sorell and Gilberto Cárdenas, foreword to *Toward the Preservation of a Heritage: Latin American and Latino Art in the Midwestern United States*, ed. Olga U. Herrera, Institute for Latino Studies (Notre Dame, IN: University of Notre Dame, 2008), ix–xv.

109 Cárdenas's collection has been featured in several museum exhibitions, including *Cara Vemos, Corazones No Sabemos: Faces Seen, Hearts Unknown, The Human Landscape of Mexican Migration* (2006, Snite Museum of Art), and most recently *Arte Sin Fronteras: Prints from the Self Help Graphics Studio* (October 27, 2019–January 12, 2020), which displayed prints donated by Cárdenas to the Blanton Museum of Art.

110 I am grateful for Tatiana Reinoza's excellent scholarship on the Romos, which informs my brief synopsis. See "Collecting in the Borderlands: Ricardo and Harriett Romo's Collection of Chicano Art" (master's thesis, University of Texas at Austin, 2009); and "Printed Proof: The Cultural Politics of Ricardo and Harriett Romo's Print Collection," in *A Library for the Americas: The Nettie Lee Benson Latin American Collection*, ed. Julianne Gilland and José Montelongo (Austin: University of Texas Press, 2018), 145–55.

111 Carlos Francisco Jackson, "A Victory: Harriett and Ricardo Romo's Collection of Contemporary Art,' *Estampas de la Raza: Contemporary Prints from the Romo Collection* (San Antonio, TX: McNay Art Museum, 2012), 6.

112 I am grateful to Patricia J. and Rosa Terrazas, as well as Yolanda Ronquillo for sharing Margaret's story with me. The details laid out here were conveyed over several email and phone conversations between February and July 2019.

113 Around the time that Professor Tatiana Reinoza started working with SAAM on an essay for this catalogue, Rosa Terrazas, Margaret Terrazas Santos's niece, contacted her asking for advice on how to access her aunt's extensive collection. Reinoza put me in touch with Rosa Terrazas and her mother, Patricia J. Terrazas. I visited with the family in Oakland California, and subsequent discussions led to a gift to SAAM of fifty-seven prints.

114 For more on Margaret Terrazas Santos's involvement with Día de los Muertos events in Oakland, see Lauren Benichou, "A Brief History of Día de los Muertos in Oakland, California, 1970–2000," *Clio's Scroll: The Berkeley Undergraduate History Journal* 13, no. 1 (Fall 2011): 1–38.

115 Margaret Terrazas Santos, donation appeal letter, August 12, 1991, provided by Yolanda Ronquillo; Margaret Terrazas Santos, SAAM Donor file.

116 Calli Americas Bylaws, undated document provided by Yolanda Ronquillo; Margaret Terrazas Santos, SAAM Donor file.

117 The Santos estate is currently developing a website devoted to Margaret Terrazas Santos's life and artwork collection. See https://www.margaretsantos.com.

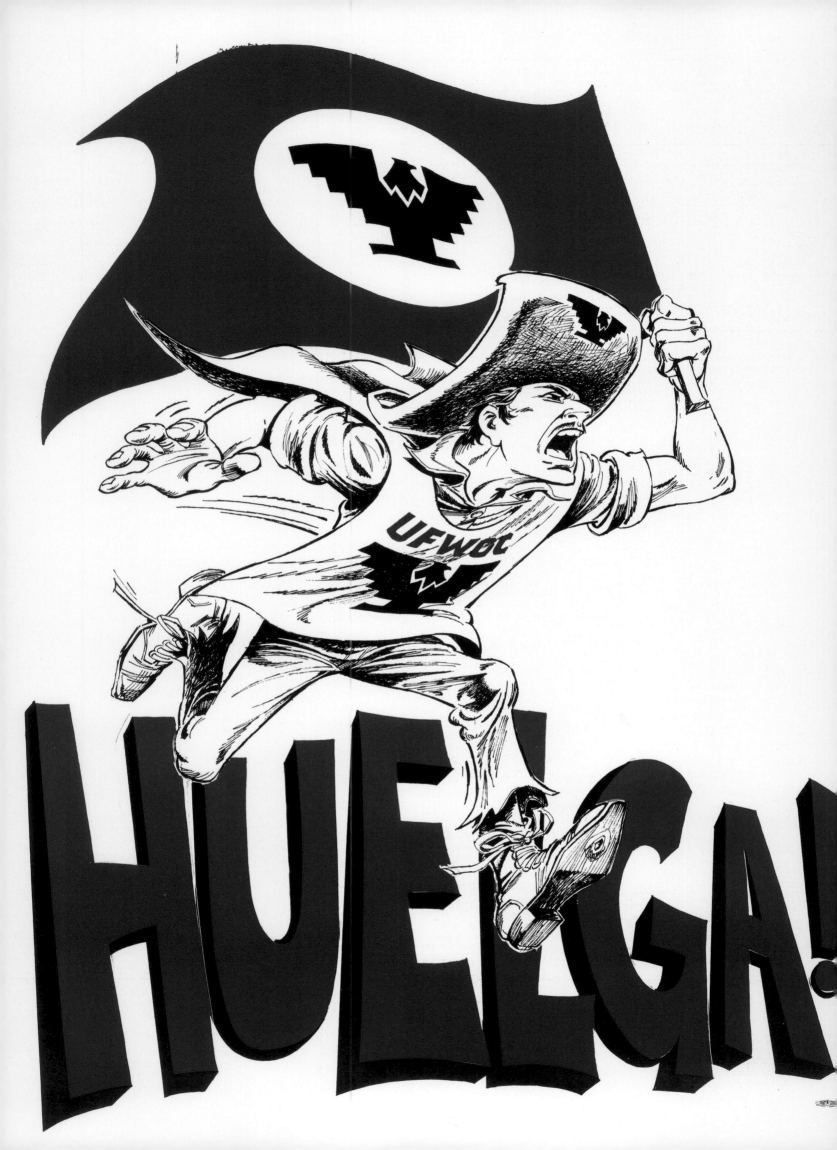

Terezita Romo

AESTHETICS OF THE MESSAGE

Chicana/o Posters, 1965–1987

This form [the poster] allows me to awaken consciousness,
to reveal reality and to actively work to transform it.
What better function for art? —Malaquias Montoya

By their very nature posters are public entities, messages made graphically visible in order to reach the largest number of viewers. During the 1960s, poster production exploded internationally as the medium of choice for political rebellions around the world. In the United States, posters were created for the national civil rights and university student liberation movements as well as the Vietnam War protests. Though labor-intensive to create, posters were inexpensive to produce, easy to transport, and relatively simple to distribute. They were carried in myriad marches, demonstrations, and boycott events (**FIG. 1**). They also were posted on storefront windows, walls, telephone poles—any surface that provided widespread visibility. Urban settings, however, proved a challenging environment, where layers of posters, leaflets, advertisements, and graffiti literally saturated cities, competing for viewers' attention. Thus, their success depended on the degree to which the "image and text are distilled to their essence, readable at a glance and assimilable on the deepest level."[1] During the Chicano civil rights movement of the mid-1960s, many artists turned to printmaking to promote an agenda of cultural affirmation and political change. In the process, they developed distinctive styles reflective of their multiple artistic influences, accentuated by their mastery of the medium.

Andrew Zermeño,
Huelga!, detail,
1966, pl. 2.

FIG. 1

George Rodriguez,
untitled photograph
of the Chicano
Moratorium,
Boyle Heights,
Los Angeles, 1970.

For Chicano posters, the merging of context along with composition and form developed into an aesthetics of the message in which the seamless integration of multiple dichotomies—artistic and political, artist and activist, personal and universal—"address not only the object of the design itself, but also and more important the circumstances in which that poster functions and is produced."[2] Chicano posters melded myriad national and international artistic influences, including pop art, psychedelic posters, Dada, and comic books, as well as graphic production in Mexico, China, and Cuba. All of these influences contributed to an aesthetics that allowed Chicana/o printmakers to incorporate diverse strident and subtle political statements "compatible in turn with multiple aesthetic interpretations."[3] Equally important, their ability to inter-

rogate previous rules of communication dominated by text-heavy messages permitted Chicano posters to blur art-print definitions.

During the first two decades of the Chicano movement, posters were produced by both established and aspiring Chicana/o artists. In the process, multiple graphic strategies were incorporated and transformed, with many artistic styles contributing to the formation of a multidimensional Chicana/o aesthetic. This can be seen in two posters regarding one of the movement's signature achievements, the United Farm Workers (UFW) labor union: Andrew Zermeño's *Huelga!* and Barbara Carrasco's *Dolores* (PLS. 2, 60). Zermeño's early offset poster, with its large image and prominent exhortative text, reflects his background as an illustrator. In 1999, Carrasco produced a screenprint portrait of UFW cofounder Dolores Huerta. A stylized rendering of Huerta's head and shoulders in vibrant pink and teal fills the frame, with "Dolores" at top behind her. The only other text is the barely visible union slogan, "Sí Se Puede" (yes we can), on Huerta's lapel button. Produced more than three decades after Zermeño's poster with its male protagonist, Carrasco communicates support for the UFW's celebrated female leader, identified only by her first name, in an intimate, pop-influenced print with minimal text. While both posters can be deemed political, they embody the divergent styles utilized during the early decades as artists sought to communicate—a key component of posters—initially

with persons within and, over time, outside the Chicano community. Yet the aesthetics of Chicano posters, as reflected in their choices of bicultural imagery, bilingual text, and strategic artistic influences, became a key component of the message and vice versa.

A VOICE FOR THE VOICELESS

As cultural-political strategy, artists assumed that the undermining of entrenched artistic hierarchies would create apertures for questioning equally rooted social structures.
—Tomás Ybarra-Frausto

Chicano posters began as a visual instrument of the Chicano movement in the mid-1960s.[4] Concentrated in the American Southwest and Great Lakes region, the movement was multilayered in its approach, with the multiple goals of attracting and uniting participants across age groups, socioeconomic backgrounds, and genders. Also known as El Movimiento, it brought together aspects of cultural affirmation and neo-indigenous spirituality with calls for political resistance and national liberation. Along with its involvement in the national civil rights movement, Vietnam War protests, and student activism, the movement included specific regional struggles, such as the Spanish land grant recuperation in New Mexico. It was the merger of national and regional activism with an anti-assimilationist stance that fueled the Chicano movement (**FIG. 2**). The agenda was not to protect a transplanted culture and heritage, but to enact an empowering education process to counteract the

FIG. 2

José Angel Gutierrez (*left*), founder of La Raza Unida political party in Texas; Reies López Tijerina, founder of the Alianza Federal de Mercedes in New Mexico; and Rodolfo "Corky" Gonzales, director of the Crusade for Justice in Colorado at La Raza Unida Party national convention, El Paso, Texas, September 4, 1972. Photograph by César Martinez.

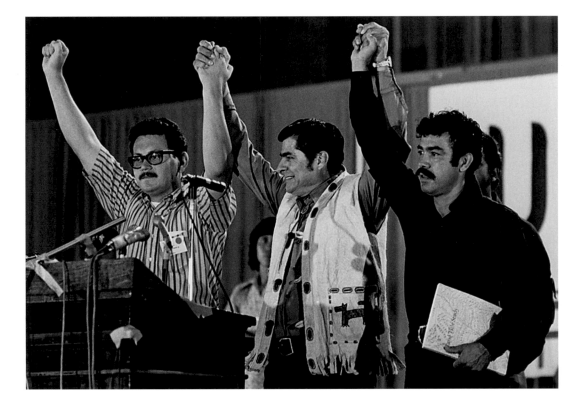

multiple layers of "internal colonization" inflicted first by the Spanish in Mexico and later by U.S. occupation after the Treaty of Guadalupe Hidalgo (1848).[5]

Mexican American artists were inspired to join the movement as well. According to artist and poet José Montoya, before the Chicano movement artists had been "forced to attend art schools and art departments which were insensitive to their ethnic backgrounds, made to cast off their ethnic background, and forced to produce from a worldview that was totally alien to them."[6] Established artists chose to forgo professional careers and the creation of "art for art's sake," instead pledging their creative skills to advance the movement's goals. For younger aspiring artists, a role enacting social change solidified their commitment to become artists. In all cases, it was a personal, life-changing decision that ultimately had far-reaching impact as Chicana/o artists joined community activists and transformed the movement's calls for sociopolitical change into murals and posters.

From the beginning of the Chicano movement, posters became a cost-effective medium to confront a "lack of control over mass media to efficiently articulate [the movement's critical issues]."[7] During the first two decades, artists created posters within three different yet complementary capacities. Some joined organizations advancing social and/or political goals specific to the movement that deemed the services of artists an integral tool for reaching their constituents.[8] Whether as staff or volunteers, these artists worked closely with the organization but generally were afforded artistic freedom in pictorializing their messages. A significant number of artists chose to work independently for specific causes. Not limiting themselves to movement organizations, they created posters addressing national and global issues, including those of other racial and ethnic groups. The majority of posters, however, were produced by artists working in *centros* (art centers) that had poster production as a primary activity. Established by artists from varied backgrounds, the underlying goal of *centros* was to create art for, and within, the community. These art centers provided paid positions, stocked materials, and creative time to produce posters for wide-ranging local and global causes as well as neighborhood events. Initially, Chicana/o artists in all three roles shared a commitment to creating posters that articulated the movement's political agenda and contributed to the formation and affirmation of a Chicano cultural identity. In visualizing this new identity, they were part of a larger politically infused artistic reclamation process to affirm Mexican historical and cultural antecedents, but through the lens of an American lived experience. Whether creating posters individually, within political organizations, or in art centers, over the first two decades the artist's aesthetic experimentation generated distinct Chicano posters and prints.

PICTORIALIZING THE STRUGGLE: ARTISTS WITHIN MOVEMENT ORGANIZATIONS

We must ensure that our writers, poets, musicians, and artists produce literature and art that is appealing to our people and relates to our revolutionary culture. —Emanuel Martinez

The earliest Chicano posters were created by Andrew (Andy) Zermeño for the United Farm Workers' (UFW) communication and mobilization efforts. César Chávez and Dolores Huerta's efforts in the mid-1960s to organize farmworkers in California allowed the many regional efforts to coalesce into a national Chicano movement and ignited La Causa, a cause dedicated to improving the working and living conditions of farmworkers. The transition of a labor strike into a key component of the Chicano civil rights movement was accelerated by the involvement of an unprecedented number of urban Mexican Americans who "began to rethink their self-definition as second-class citizens and to redefine themselves as Chicanos."[9] It also presented a challenge for artists trying to reach communities with geographic, linguistic, and generational differences in order to elicit cultural solidarity on behalf of unified action.

Zermeño was the first artist invited by Chávez to work with the new UFW union. Initially, he requested Zermeño's help with the refinement of their logo. "César sent me a letter that had a rough drawing of an eagle on yellow legal paper.

He requested that I redo it so that he could use it on the union newsletter."[10] However, it was Zermeño's idea to use cartoons in communicating the UFW's message more effectively that generated his most recognized and enduring artistic creation—Don Sotaco, a farmworker who takes on the growers and California's enormous agribusiness in his role as a striking union member.[11]

Zermeño's first poster for the UFW, *Huelga!* (see **PL. 2**), utilizes a minimal yet effective composition. His conscious use of the Spanish word for "strike," economy of graphics, and dominant main figure demonstrate that he understood his diverse audience. Even though Don Sotaco is dressed in tattered pants with a hole in his shoe, the honorific title of "Don" (esteemed; sir) and portrayal of the striker in motion with forceful facial expressions generate a sense of agency as well as urgency. "I was trying to show the spirit of the workers...who were attacking the status quo," Zermeño recalled. "And [that] they were eager to get in there, to do something for themselves."[12] Running with the unfurled UFW flag proclaiming the strike, Don Sotaco—and by extension the UFW— elicits action from farmworkers and their supporters. Based on its effectiveness with local farmworkers, the UFW distributed the poster as part of its strategy to reach a national audience, and it continues to be produced today.

In San Diego in 1978, Yolanda López created her iconic poster *Who's the Illegal Alien, Pilgrim?* (see **FIG. 15**, p. 42) while working with the Committee

FIG. 3

James Montgomery
Flagg, *I Want You for
U.S. Army*, ca. 1917,
lithograph,
40 ¼ × 29 ¾ in.
Library of Congress,
Prints and Photo-
graphs Division.

on Chicano Rights (CCR), a social jus-
tice organization directed by Herman
Baca. It was produced as part of CCR's
campaign on immigration rights and in
response to President Jimmy Carter's
Immigration Plan.[13] Initially, the CCR did
not want to produce the posters, citing
their uneasiness with the overly aggres-
sive image and text, but they eventually
relented.[14] The original posters were
circulated locally and at various college
and university conferences hosted
by MEChA (Movimiento Estudiantil
Chicano de Aztlán/Chicano Student
Movement of Aztlán).

 With its bold imagery, large text, and
sparse colors, López's poster harks back
to Zermeño's *Huelga!* of the previous
decade. However, in its sophisticated
incorporation of multiple political, pop-
ular, and cultural references, her image
"visually deconstructs traditional con-
cepts of national, cultural, and geo-

political North American identity."[15]
The Aztec warrior's stance recalls
James Montgomery Flagg's World War I
recruitment poster (revived for use
during World War II) that features an
old, bearded Uncle Sam with a pointed
finger urging, almost ordering, young
men to join the army (**FIG. 3**). In mimicking
Flagg's iconic image, López gave her
poster official, albeit subversive, govern-
mental authority. Her question directed
at "pilgrims" interrogates who can iden-
tify others as "illegal aliens," especially
since *Mayflower* settlers from Europe
also arrived without "papers." Simul-
taneously, the image of an indigenous
man with an Aztec headdress "epit-
omized 'Chicano/Mexicano' trans-
national sensibilities that imagined
a community of both Mexican immi-
grants and Mexican Americans."[16] By
depicting the Statue of Liberty with
a "thumbs-down" gesture, López utilized
another iconic figure to underscore the
directive in red to "STOP CARTER'S
IMMIGRATION PLAN."

 While created for a Chicano organi-
zation, López's poster—in its conscious
use of English and the Statue of Liberty,
allusion to the Uncle Sam poster, and
Pilgrims references—is also aimed at
Euro-Americans. "It was about Thanks-
givings and the imagery of the peaceful
dinner between the East Coast native
peoples and 'illegal' Pilgrims," López
explained. "Yet, as residents of a military
city [San Diego] with its conservative
stance on immigration, we Mexicans
and Mexican Americans were made to
feel afraid for our lives."[17] In visually (and

literally) questioning who does and does not belong in the United States, López sought to change the negative dynamics of the national immigration debate. In 1981, she redesigned the poster, which was published and distributed widely (see **PL. 39**).[18] Along with adding a frame around the central figure and rearranging the text on his chest, she eliminated the directive on Carter's plan, CCR logo, and Statue of Liberty. Nevertheless, with their U.S. military reference, Mexican indigenous figure, and provocative text, both posters remain aesthetically contemporaneous and continue to resonate with multiple audiences.

Denver-born artist Emanuel Martinez chose to serve several social justice organizations in support of the Chicano movement. A painter, muralist and sculptor, he joined Rodolfo "Corky" Gonzales's Crusade for Justice in 1966 as a youth organizer and assisted Gonzales with their nonprofit incorporation. That same year, he met Chávez and accepted his invitation to work for the UFW in Delano, California.[19] The following year, he joined Reies López Tijerina, the leader of the Alianza Federal de Mercedes (Federal Land Grant Alliance) in New Mexico. Upon his return to Denver in 1968, Martinez served as the art director for the Crusade. There he assisted with the coordination of the 1969 First National Chicano Youth Liberation Conference in Denver and helped write *El Plan Espiritual de Aztlán*, the seminal manifesto adopted by the participants. Martinez contributed the section of the manifesto that outlined the role of the Chicano artist within the movement.[20]

In 1967, Martinez produced *Tierra o Muerte* to support Alianza's land grant reclamation battles in southern Colorado and New Mexico (**FIG. 4** and **PL. 3**). Beginning in 1966, with the occupation of Kit Carson National Forrest, Tijerina and Alianza members forged a legal and activist battle to reclaim communal land rights guaranteed under the 1848 Treaty of Guadalupe Hidalgo. Martinez's poster utilizes a graphically powerful blend of text and image that captures the spirit of their efforts. A large stylized portrait of Emiliano Zapata, based on a famous photograph from 1911, is bounded at the top and bottom with the words *tierra o muerte* (land or death).[21] A hero of the Mexican Revolution of 1910, Zapata fought alongside other villagers for their land, which had

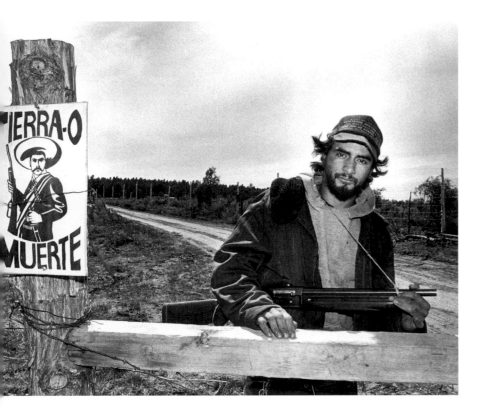

been routinely stolen by wealthy land-owners. Though the print does not overtly reference a specific Alianza action, it connects the land reform and wealth distribution of the Mexican Revolution to the Chicano movement's fight against political and social injustices.[22] Equally important, with its depiction of an iconic Mexican hero and dictum in Spanish, the image connected an older, Mexican population with younger Chicano activists' efforts. Aesthetically, Martinez's poster is not only one of the earliest graphic depictions of the revolutionary hero, but also experimental in its one-color composition. Rather than reproduce the original photograph, the artist created a crisp, high-contrast drawing that highlights Zapata's torso and frontal gaze along with his battle accoutrements (rifle, bandoliers, and sword handle), adding graphic weight to the large uppercase words, further uniting Alianza's activism with martyred Zapata's noble cause.[23]

INDIVIDUAL REBELS WITH A *CAUSA*

My art is committed to the paradox that in using mass-media…I am taking an art form whose motives are debased, exploitative and indifferent to human welfare, and setting it into a totally new moral context. —Rupert García

During the Chicano movement's first two decades, there were artists who chose to create posters independently in support of the movement's sociopolitical goals. Reflecting different geographic regions, ages, and genders, some put their artistic careers on hold, while others initiated what would become a lifelong dedication to an art of protest. Central to their choice was the autonomy to support multiple issues and greater freedom for artistic experimentation.

In California the San Francisco Bay Area's reputation for radical politics, as well as its avant-garde lifestyles and multiracial demographics, drew many political activists and art students to its major universities, including Chicana/o artists. There they became aware of international political struggles and aesthetic innovations taking place within the Bay Area's African American community, as well as in Latin America. The Chicano movement in general and Bay Area student activism shaped the political ideology and signature aesthetics of many of these artists. In the process, they contributed to the development of a new Chicano poster aesthetic unique to the Bay Area, one that drew from international and multiracial artistic sources mobilized for local community as well as global issues.

At San Francisco State in 1968, Rupert García joined the Third World Liberation Front (TWLF) student strikes as an artist activist, abandoning easel painting for screenprinting.[24] "Before the strike happened, I like most students had a romantic notion of being an artist. The strike helped me to reconsider what an artist is, what they are supposed to do, and how they are supposed to do it."[25] García was one of the organizers of the

student/faculty San Francisco Poster Workshop, which formed to support the striking students. Along with African American, Asian, and white members, he learned to screenprint and produced posters that were carried in student demonstrations, plastered on walls, and sold to raise bail funds.

Inspired by the nineteenth-century Mexican printmaker José Guadalupe Posada and members of the Taller de Gráfica Popular (People's Graphic Workshop), García's involvement with the Poster Workshop and the city's Mission District artists exposed him to the graphics of the Cuban, Russian, and Chinese revolutions, as well as the confrontational art of the Black Panther's Emory Douglas.[26] But it was pop art and its mining of commercial mass media for relevant ready-made images that García utilized as "images of mass advertising against themselves in devastating ways."[27]

These influences are evident in a poster he created for the first TWLF bail fund that featured Cuban Revolution icon Ernesto "Che" Guevara with the popular Black Power slogan, "Right On!" (**PL. 4**). Though lacking the bold colors of his later prints, it reflects what would become García's signature graphic style: a blend of pop art sensibilities and strident political statements mixed with the technical acuity of Cuban graphics. Historically important, *Right On!* (1968) is one of the first works by an American artist to render homage to Che, who is now an omnipresent figure in Chicano/Latino and American art.[28]

Beyond Chicano and Latin American visual media, García produced posters that exemplified his "understanding of pop art as a movement and [used] its techniques [as] an attack on its premises as well."[29] In solidarity with the Black Power movement, he created *No More o' This Shit!* (1969), which features the African American chef depicted on a popular breakfast product (**FIG. 5**). The poster sardonically counters the images of happy African Americans exploited by mainstream advertising, in this case to sell hot cereal. No longer a silent figure promoting a commodity, the chef speaks out and confronts the viewer with a strong message. The "shit" he cites is not necessarily directed at the product; rather, it's a broader indictment of racism's social order denounced by the civil rights movement. Once again enlisting colloquial speech, García utilized the power of subversive humor

to expose the U.S.'s political reality for the disenfranchised and condemn the country's hypocrisy. As artist Emory Douglas noted, "If we look around our community, what do we see? We see billboards, with advertising, that tell us what to buy. And we go out and buy—our own oppression."[30]

Though García's posters drew from pop art, including the comics and Warhol's iconic Campbell soup cans, they are "anti-pop" prints that counter the advertisement objective with sociopolitical content. Unlike Warhol's "neutral" depictions of everyday objects, García's poster is designed to elicit a reaction with its strident critique of exploitative commercial images.[31] The strategic incorporation of familiar figures from consumer culture circumvents the viewer's defenses, allowing the artist to subvert the work's advertisement role with vernacular language that is simultaneously empowering and politically charged.

Across the bay in Berkeley, Malaquias Montoya was a student on the UC campus during the TWLF strike in 1969. Because of his prior silkscreening experience, he was pulled out of picket lines to print posters sold for bail funds. As a result of his activism, Montoya met fellow Chicano artists Manuel Hernández, Esteban Villa, and René Yañez, and together they formed the seminal collective, the Mexican American Liberation Art Front (MALAF).[32] During meetings, Montoya was introduced to Che's writings and his revolution's solidarity with international human rights struggles and Cuban graphics.

One of the most iconic examples of Montoya's aesthetic amalgamation is his offset poster *Viet Nam / Aztlan* (**FIG. 6**). It was produced in 1973 to bolster the momentum of the Paris peace talks, which had resumed in 1972, and to support the Chicano Moratorium anti-war events held across California, organized by the Chicano Vietnam Solidarity Committee. The dense composition is divided into three horizontal panels featuring stylized portraits and arms with Spanish and Vietnamese text in various sizes and fonts. With its depiction of Chicano and Vietnamese male faces and brown and yellow arms in a fist bump, the poster proclaims solidarity between the two peoples. According to Montoya, "We had more in common with the Vietnamese than the ones sending us there to die."[33] While influenced by Cuban and Chinese revolution graphics, the poster reflects his training within an advertisement print shop in its clean yet visually laden design as well as his own eclectic typeface selections. It is also an early example of Montoya's commitment to a figurative art that literally "humanizes" struggles, which he has continued throughout his career. The committee produced one thousand offset prints, which were not only distributed statewide, but also sent to Vietnam, China, Korea, Algeria, Cuba, and France.[34]

During the decisive decade of the 1970s, Chicana artists influenced by the feminist movement sought to clarify their role within the movement as

FIG. 6

Malaquias Montoya, *Viet Nam / Aztlan,* 1973, offset lithograph on paper, image: 22 ½ × 17 ¼ in.; sheet: 26 × 19 in. Smithsonian American Art Museum, Museum purchase through the Frank K. Ribelin Endowment, 2015.29.3.

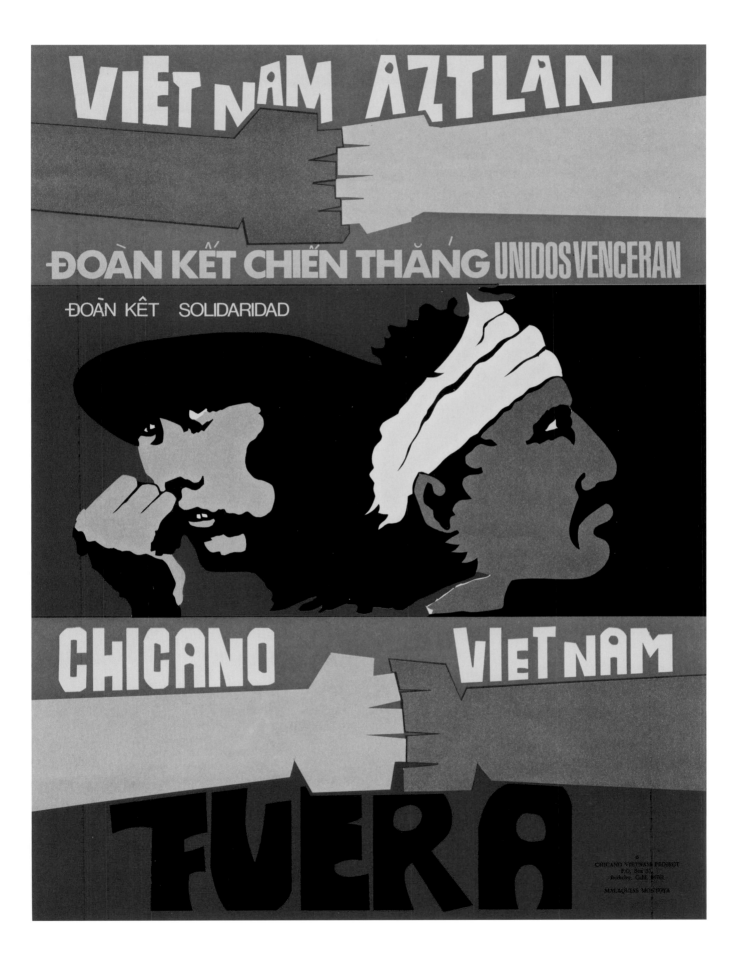

well as in society. While true that "the Chicano Movement sought to end oppression—discrimination, racism, and poverty—and Chicanas supported that goal unequivocally; the movement did not, however, propose basic changes in male-female relations or the status of women. Sensing their power, Chicanas began to speak out on their own behalf."[35] Like her male counterparts, Ester Hernandez's political convictions generated prints that exposed the exploitation of disenfranchised communities. More importantly, she also utilized a feminist lens to expose the persistent subjugation of women by religious dogma and cultural patriarchy.

Hernandez moved to the San Francisco Bay Area in 1971 to pursue a life as an artist, studying muralism and printmaking with Malaquias Montoya. But it was her Catholic upbringing that inspired her first major print. Images of the Virgin of Guadalupe were part of her daily life, much as they had been for the majority of Mexicans on both sides of the border. Nevertheless, the portrayal of the Virgen Morena (the Brown Virgin, another manifestation of Mary)—who appeared to a converted *indio* by the name of Juan Diego in 1531 at the sacred site of the Aztec goddess Tonantzin—as a passive, submissive and virginal woman, was perceived by many Chicanas as restrictive and self-serving. Hernandez and other artists delved further into the Virgin's hidden codes and inherent paradoxes, engendering a graphic exploration of

her within a discourse on gender and identity politics.

Hernandez's 1975 etching *La Virgen de Guadalupe Defendiendo los Derechos de los Xicanos* (The Virgin of Guadalupe Defending the Rights of Chicanos) is the earliest Chicana/o graphic image to arise from this pivotal exploration and reinterpretation of Virgin iconography (PL. 21). The print does not derive its significance from its politically charged title; in fact, it had no title for many years. Historically, the Virgin's image in Mexico had been used to "defend" against plagues, famines, and wars, as well as to advance political causes and civic wars.[36] Hernandez's print, however, strips the Virgin of her passive protector imagery and, equally significant, functions as a self-portrait. The star-studded veil and mandorla clearly identify her as the Virgin of Guadalupe, but she is dressed in a karate outfit and shown in a kicking stance. According to Hernandez, "the symbol of a Chicana Karate figure represents a woman becoming an active participant, breaking out of some traditional images—the colonial mentality, while maintaining her culture."[37] The etching's image is reminiscent of widespread black-and-white graphic representations in church pamphlets and in the popular broadsides of José Guadalupe Posada. But its minimalism serves to accentuate the radical change in the official garments and pious pose seen in religious images of the Virgin. As a self-portrait, Hernandez (as the Virgen) sheds the

FIG. 7

Cover of *La Razón Mestiza II* (Summer 1976) featuring Ester Hernandez's *La Virgen de Guadalupe...* (center, bottom). Emmanuel Montoya collection of Chicano publications (M1804), Department of Special Collections and University Archives, Stanford Libraries.

frozen mediator role and is depicted as an active protagonist for Chicano political rights as well as a symbol for Chicana empowerment. Visually underscoring the sense of motion, Hernandez prominently features an angel who, no longer needed to hold her up, is ready to join in the fight. Though not a poster, the image was widely distributed and reproduced in various publications, inspiring other Chicanas to create their own artistic interpretations (**FIG. 7**).[38]

Beyond California, artists in Texas also created posters independently in support of the Chicano movement's agenda. Initially a painter, Amado M. Peña Jr. was one of the first screenprinters in Texas. While working as the director of art at the Crystal (City) Independent School District from 1972 to 1974, he created posters that featured Mexican heroes Zapata and Francisco "Pancho" Villa, as well as Cuba's Che.[39] In 1973 he joined the San Antonio-based art collective Con Safo, which held artists meetings, organized exhibitions, and issued influential manifestos on the role of artists within the Chicano movement.[40] During this time, Peña became aware of the lettuce and spinach workers' strikes, and created several posters in support of the UFW efforts to unionize Texas farmworkers. He also explored important Mexican cultural concepts that underwent political transformation as a result of the Chicano movement. One of these is exemplified in his 1974 screenprint *Mestizo* (**PL. 13**).

Peña became aware of Mexican Americans as mestizos (Spanish and indigenous mixed-race persons) in the late 1960s. He was in graduate school and the Chicano movement was spreading across the nation, accelerated by the UFW boycotts. In addition to political images, Peña wanted to create strong, positive images underscoring the movement's affirmation of Chicanos' indigenous heritage. *Mestizo* is divided into two sections: the top half is dominated by brightly colored geometric patterns

reminiscent of the Americas' Native textiles and wall designs; the bottom portion features a tri-face figure, with stylized Spaniard and indigenous profiles facing away on each side and the mestizo face in the middle. Within its compact composition, the circular shape and fluid lines of the tri-face contrast with the sharp-edged grid pattern above, pushing forward the faces for visual impact and creating a salient example of Peña's ability to transfer his skills as a painter to printmaking.

Peña's *Mestizo* was part of a major series of some fifty posters the artist produced during the early 1970s, when he was still pursuing painting. According to him, the print was a tribute to "the tri-culture aspect of Chicanos, the mixture of Indigenous and Spanish to produce a Mestizo," and by extension Chicanos.[41] Originally, *mestizo* was one of the racial designations developed by the Spanish as a way to quantify racial mixtures in the Americas after the Conquest (1519–21). During the Chicano movement, however, the term took on an added dimension as the symbol for Chicanos, the product of a Mexican heritage and U.S. lived experience. By transforming a racial designation into a sociopolitical concept that incorporates indigenous roots, Mexican heritage, and American influences, the movement created a proud new Chicano identity, one that Peña captured with the print's integration of graphically flat, Native American–inspired shapes and recognizable tri-face image within a colorful painterly composition.

The national reach of the Chicano movement impacted artists in the Midwest as well. In Chicago, Carlos A. Cortéz (1923–2005) dedicated his talents in support of various social and labor causes during his long career as a poet, illustrator, and printmaker. Born in Milwaukee to a Mexican indigenous labor organizer father and a German-American social pacifist mother, his influences included Posada, the German Expressionists Edvard Munch and Kathë Kollwitz, as well as the American political cartoon tradition of the Industrial Workers of the World (IWW).[42] Cortéz was also one of the few Chicano artists who focused on block relief rather than screenprinting. Along with his distinctive blend of graphic expressions, Cortéz is recognized nationally as one of the artists who paved the way for the Chicano art movement in the Midwest.[43]

Cortéz honed his political ideology and artistic repertoire in the late 1940s after joining the IWW, where he produced posters and poems, and worked as the illustrator for their newspaper, *Industrial Worker* (**FIG. 8**).[44] After leaving the newspaper and moving to Chicago in 1965, he continued to produce graphic art in support of multiple racial and political causes as well as artistic and literary organizations. He also began to sell his prints, which espoused his political convictions, advocated his anti-military stance, and illustrated the collective power of unions. For Cortéz, "There is no such thing as non-political art. There are those who strive to be non-political, but they are only voicing

viewer, and looking over his shoulder is La Catrina, the skeleton diva with a fancy hat that Posada popularized in his penny broadsides in the 1910s.[46] In his portrait of Posada with his most famous creation behind him, Cortéz paid tribute to a significant influence on numerous Chicana/o artists. By showing her with her hand upon his shoulder and alluding to her speaking into his ear, Cortéz could also be signaling La Catrina's role as Posada's muse. However, with Posada and La Catrina's close association with the annual Día de los Muertos (Day of the Dead) observance, Cortéz is following in the graphic steps of his "artistic godfather," providing a humorous yet stark reminder of humanity's transience. The print also reflects the simultaneous creation of personal, cultural, and political prints by Chicana/o artists, which would increase in the 1980s.

ARTISTS IN *CENTROS* OF INFLUENCES

The most interesting posters have been those that illustrate an important event and because of their personal meaning to the artist transcend the "advertising" of the event into the production of art.—Linda Zamora Lucero

Not surprisingly, the majority of Chicano posters were created at community art centers with a screenprinting component. Artists were attracted to centers not only for the supportive and collaborative peer environment, but also for the access they offered to quality paper

their vote of confidence for the status quo."[45] He often incorporated humor, multilingual text, and multiracial figures in his art to advance his belief in universal human rights to a wider audience.

Cortéz's prints also celebrate important artistic and cultural influences, as can be seen in *José Guadalupe Posada*, a linocut portrait of the Mexican print-maker that he considered one of his masterpieces (**PL. 38**). Reminiscent of Leopoldo Méndez's 1953 homage print, Posada holds one of his zinc plates. Cortéz's Posada, however, faces the

stock, inks, and equipment. Several centers received funding from the Comprehensive Employment and Training Act (CETA), a federal program created in 1973 that allowed them to hire and train graphic artists to provide the community with free posters and workshops. While functioning as central promoters of cultural reclamation activities, these poster production centers also became laboratories for printing techniques and artistic experimentation.

From the beginning of the Chicano movement, California was an epicenter for poster production, which reflected the state's multiracial demographics. In Sacramento the Rebel Chicano Art Front (later Royal Chicano Air Force/ RCAF) established the Centro de Artistas Chicanos to produce posters for community events and political campaigns, as well as for the UFW's statewide unionizing efforts. San Francisco's La Raza Silkscreen Center (later La Raza Graphics) and the Mission Cultural Center for Latino Arts' Mission Gráfica brought together artists from the Bay Area's Latino and significant Latin American population.[47] Self Help Graphics & Art (SHG) and Méchicano Art Center offered Chicano artists in Los Angeles a place to collaborate and experiment with the silkscreen printing process. In Phoenix, Arizona, the Movimiento Artístico del Río Salado/MARS initiated a national residency program, modeled on SHG's atelier as well as the Gemini G.E.L. (also in LA) and University of New Mexico's Tamarind Institute, to promote the visibility and encourage

the collection of Chicano art prints. Irrespective of the administrative models, the centros' financial support and facilities that enabled technical experimentation resulted in an artistic renaissance that expanded the definition of Chicano graphics.

One of the earliest centers dedicated to poster production was established in 1970 by the Rebel Chicano Art Front. The collective was composed of professors José Montoya and Esteban Villa and several of their students at Sacramento State College (now California State University, Sacramento). In 1972, they moved off campus and launched the Centro de Artistas Chicanos (Centro), focusing on mural and poster production for the community.[48] As was true of other collectives, their posters were not individually signed, but marked with the group's initials: RCAF. Owing to the confusion with the Royal Canadian Air Force, they decided to call themselves the Royal Chicano Air Force/RCAF, adopting military regalia and incorporating flight imagery in their murals and posters.

The RCAF's Centro operated a print workshop staffed by CETA-funded artists who produced posters and taught classes on poster design and printing.[49] They generated thousands of posters that ranged from simple two-color announcements to multi-colored and photo-silkscreen prints, many with one hundred copies. The RCAF developed a reputation for prints that challenged screenprinting techniques as well as for their incorporation of humorous and incongruent

FIG. 9

Ricardo Favela, *El Centro de Artistas Chicanos*, 1975, screenprint on paper, image: 22 ¼ × 16 in.; sheet: 25 × 19 in. Smithsonian American Art Museum, Gift of Tomás Ybarra-Frausto, 1995.50.40.

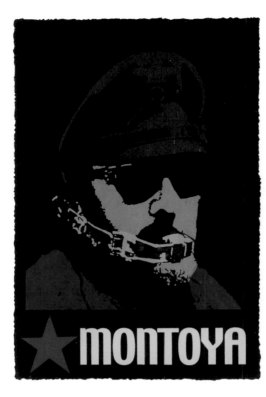

FIG. 24

Xico González,
José Montoya, 2004,
screenprint on paper,
image: 18 × 12 in.;
sheet: 20 ½ × 14 ⅜ in.
Smithsonian American
Art Museum, Museum
purchase through the
Lichtenberg Family
Foundation,
2020.19.1.

FIG. 25

Xico González,
Favela, 2004,
screenprint on paper,
image: 17 ¼ × 12 in.;
sheet: 20 × 14 ¾ in.
Smithsonian American
Art Museum, Museum
purchase through the
Lichtenberg Family
Foundation,
2020.19.2.

English law book documenting cases of treason, high crimes, and misdemeanors, an implied reference to how Dreamers and other undocumented immigrants are criminalized in today's public sphere. The intensely worked prints include bits of paper, *milagros*—small metal objects in the form of saints and other symbols that are believed to impart protection in times of need—and the artist's own stitching, to emphasize the humanity and vulnerability of her anonymous sitters. Fernández has also printed text from the Codex Mendoza (1541–42), one of the most important Spanish colonial-era codices ever created. The text appealed to the artist because it raises the specter of the Conquest as a starting point to the crises of the modern world—forced migration, border-making, and political strife. By installing the prints in the shape of a thirteenth-century Jerusalem cross—that presents Dreamers as the new Crusaders—the artist conjures several temporalities at once, encouraging

viewers to consider how the future will judge our collective actions or inaction.

The works in SAAM's collection map a dense matrix of relationships that reveal the importance of intergenerational support structures and far-reaching Chicanx networks. Simply recording the mentor-mentee relationships that have sustained the field is an illuminating exercise. Rupert García mentored Juan Fuentes, who later taught Jesus Barraza, who went on to found Dignidad Rebelde with Melanie Cervantes. Malaquias Montoya mentored Carlos F. Jackson, and together they cofounded the Taller Arte del Nuevo Amanecer (TANA) in Woodland, California. RCAF artists Ricardo Favela and José Montoya nurtured the prolific talents of Xico González in Sacramento. The younger artist later honored his mentors with two portraits (**FIGS. 24, 25**). Yreina D. Cervántez taught and encouraged a young Favianna Rodriguez, who cofounded Taller Tupac Amaru in the Bay Area with Jesus Barraza in 2003.

FIG. 26

Panel discussion on Chicano art and culture, University of California at Santa Cruz, 1982. (*From left*) Tomás Ybarra-Frausto, José Montoya, Carmen Lomas Garza, Pedro Castillo, Sue Martinez, and Harry Gamboa Jr. Tomás Ybarra-Frausto research material on Chicano art, Archives of American Art, Smithsonian Institution.

FIG. 27

Carlos A. Cortéz, *Untitled (arm with hand holding red flower)*, 1971, hand-colored linoleum cut on paper, image: 18 ⅛ × 12 in.; sheet: 22 ⅛ × 17 ⅛ in. Smithsonian American Art Museum, Gift of Tomás Ybarra-Frausto, 1995.50.12.

She later spearheaded other groups, like CultureStrike, that have led the way in digital graphics advocacy. Rodriguez herself continues to nurture the next generation, including Julio Salgado and Oree Originol.

ACTIVIST COLLECTORS, ACTIVIST DONORS

The idea for this exhibition originated from my own realization that SAAM's Chicano graphics holdings received a boon when Tomás Ybarra-Frausto donated his collection of sixty civil rights–era works in 1995. Ybarra-Frausto is a legend in the field of Chicano and Latinx art (**FIG. 26**). In publications like *Arte Chicano: A Comprehensive Annotated Bibliography of Chicano Art, 1965–1981* (1985), which he coauthored and compiled with Shifra M. Goldman, Ybarra-Frausto laid the foundations of the field.[102] In 1989 he authored the seminal and still influential essay "Rasquachismo: A Chicano Sensibility," which artfully probes and defines an underdog and bicultural ethos that undergirds Chicano popular culture and informs critically and socially minded Chicano art across disciplines.[103] Ybarra-Frausto was also a key member of the curatorial team that organized the groundbreaking exhibition *Chicano Art: Resistance and Affirmation* (1990), the first major survey to broadly capture the surge of Chicano art since the civil rights era. Over the course of his life, and with the support of his longtime partner Dudley Brooks, Ybarra-Frausto safeguarded a major collection of graphics, including iconic works like Xavier Viramontes's *Boycott Grapes* and Ester Hernandez's *Sun Mad* (see **PLS. 11, 40**), which were gifted to him directly by the artists. While he did not set out to build a comprehensive collection, and in many ways his collection was amassed and not chosen, Ybarra-Frausto's holdings grew out of his intellectual activism to value, document, and interpret Chicano art and culture. His donation includes one poignant print by Carlos A. Cortéz that gets to the heart of this idea (**FIG. 27**). Cortéz wrote directly on the print: "Por un compañero en la lucha pa' la libertad cultural y todas otras libertades."[104] Cortéz, who was a lifelong labor activist, lionized Ybarra-Frausto as a partner in the struggle. Ybarra-Frausto's donation to SAAM should be seen within this activist frame, for he was keenly aware that his gift both affirmed Chicano art as American art and could inspire future projects

FIG. 12

René Castro,
*The 17th Annual Dia
de los Muertos*, 1987,
screenprint on paper
mounted on paperboard,
image: 27 × 20 in.;
sheet: 30 ⅛ × 22 ⅛ in.
Smithsonian American
Art Museum, Gift of
Tomás Ybarra-Frausto,
1995.50.3.

FIG. 13

Oscar Castillo, untitled
photograph of Leonard
Castellanos (*left*) working
on his poster with area
resident Carmen Gonza-
lez, Méchicano Art Center,
Los Angeles, ca. 1972.
Courtesy of the artist
and the UCLA Chicano
Studies Research
Center, Oscar Castillo
Photograph Collection.

expanded to include etching, mono-printing, and woodblock printing. Along with an international footprint, they welcomed Asian American artists after the displacement of Kearny Street Workshop and Japantown Art Media curtailed their operations in the early 1980s. In this respect, MG represented the unique multiracial collaborations among poster artists in the Bay Area.[59]

Along with serving as its director and a screenprint instructor, Chilean exile René Castro created myriad prints during his tenure at Mission Gráfica.[60] The vast majority were announcement posters for the MCCLA's programming, which included literary, performing arts, and exhibition events related to the Bay Area's Latin American diaspora and in support of social justice movements internationally. Castro's posters also reflect his absorption of Chicano icono-graphy, as seen in *The 17th Annual Dia de los Muertos* (Day of the Dead) (FIG. 12). His transformation of two local cholos (street youth) into skeletons, with halos, bandannas, and arms in stylized poses, engaging in a conver-sation gestures toward Posada's influ-ence on Chicano art. Castro's text at the bottom, "24th Street Cholo Saints after the Missouri nuclear accident," also continued Chicano/Latino artists' utili-zation of Día de los Muertos as a vehicle for political statements.[61] Furthermore, Castro's depiction of cholos as "saints" contrasted with their portrayal in main-stream media at the time as criminals. In its imagery and message, the poster exemplifies the reciprocal artistic inter-change between Chicano and Latin American poster artists within Bay Area graphic institutions.

In Los Angeles, the Méchicano Art Center was established by artists in 1969 to provide a viable exhibition space in the city's gallery row district on La Cienega Boulevard.[62] When they relo-cated in 1971 to East LA their director and printmaker, Leonard Castellanos, instituted a graphic arts component to complement their plans for a "multime-dia center that would produce theater, music, and visual and performing arts."[63] With support from the National Endow-ment for the Arts, Castellanos trained one to two artists who were hired to oversee screenprinting and super-graphic art classes as well as create posters for the community (FIG. 13).[64] One of the first screenprint workshops

in East LA, it moved to a final site in Highland Park in 1976, where it solidified its historical significance as "the only venue consistently producing fine-art serigraphs by Chicana/o artists in Los Angeles."[65] Closing in 1978, their screenprinting equipment was donated to Self Help Graphics.

A noteworthy contribution to Chicano graphics is Méchicano's 1977 calendar, which reflects an aesthetic spectrum of the sociopolitical interests and artistic styles of each participating artist, many of whom were not printmakers. Though inspired by the Mexican calendars that were given out by neighborhood businesses, Chicana/o artists revised its single-image format, offset medium, and commercial objective. Chicano calendars, instead, were created by seven to thirteen different artists as screenprints to promote Chicana/o artists and educate the community about Chicano culture and history.[66]

Judithe Hernández, was one of the guest artists invited to contribute to the 1977 calendar. A member of the influential Los Four collective and renowned for her drawings, paintings, and murals featuring women, she produced *Reina de la Primavera* (Queen of Spring) (FIG. 14) for the month of May. Rendered in various shades of brown to accentuate her indigenous roots, a woman with chiseled features is depicted with a direct frontal gaze and nopales (cactus) ripe with fruit forming wings. Within the month's stylized letters and numbers, Hernández created a pattern reminiscent of a huipil, a traditional blouse with intricately woven ancient patterns. With its title and allusion to seasonal rebirth, Hernández's calendar poster functions as a portrait of the beauty, strength, and resilience of Native women and, by extension, Chicanas.

Méchicano's calendar project was undertaken as a means to generate income and "further establish this medium as a fine arts print."[67] Fellow Angelino Richard Duardo (1952–2014) had the same goal, which he achieved initially within two *centros*. In 1977 he

cofounded the Centro de Arte Público (CAP) and established their screenprinting facility.[68] While at CAP Duardo created an art print studio and imprimatur, Hecho en Aztlán, in 1979. Consciously using Spanish and incorporating the Chicano's name for the American Southwest, he was declaring his support for the movement, though years later, he would recall that his imprint's name (Made in Aztlán) might denote a specific iconography: the "image might be of a...punk with a Mohawk. But at least that little stamp created the opportunity to have that conversation [regarding what constituted Chicano imagery]."[69] That same year, Duardo also set up the first silkscreen print shop at Self Help Graphics & Art (SHG), a community art center founded by a Franciscan nun, Sister Karen Boccalero, and artists Carlos Bueno

and Antonio Ibáñez.[70] In 1980, Duardo received a small-business loan and established Aztlán Multiples, a commercial shop where he created hundreds of posters for international advertisers and art galleries, "with the intention of providing interior decorators with fine posters that, for the first time, would include those of Chicano artists."[71] In the process, Duardo became recognized internationally as a master of the silkscreen medium and a renowned aesthetic innovator within Chicano art until his untimely death in 2014.

From the beginning, Duardo set out to expand Chicano graphics with his fusion of disparate urban, cross-cultural imagery and artistic influences, including Warhol. Along with reinterpreting symbols of the Chicano movement, he incorporated elements of Asian and Hollywood pop culture as well as the young, hip New Wave and punk rock scenes (**FIG. 15**). Ostensibly an announcement poster for a punk music event held at SHG, his *Punk Prom* (1980) is an excellent example (**FIG. 16**).[72] With the event information confined to the lower third of the composition, Duardo's design incorporates seemingly random geometric shapes, "Dada" text, and an open palm print. In the center is a red flaming heart with its layered cultural references: along with representing the Catholic Sacred Heart of Jesus, "flaming" hearts were tattooed on barrio males, some for protection and others to communicate eternal love/passion. In his syncretism of personal and cultural imagery to promote a punk version of a traditional student rite of

FIG. 15

(*From left*) Richard Duardo with Tito Larriva of the punk rock band Plugz and Dan Segura, 1981. Duardo's posters, including *Punk Prom* (1980), are behind them. Photograph by Ken Papaleo/Herald Examiner Collection/Los Angeles Public Library.

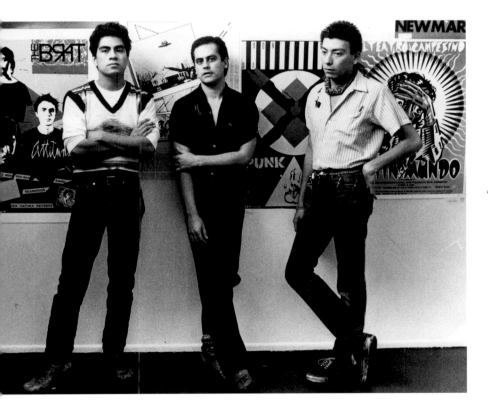

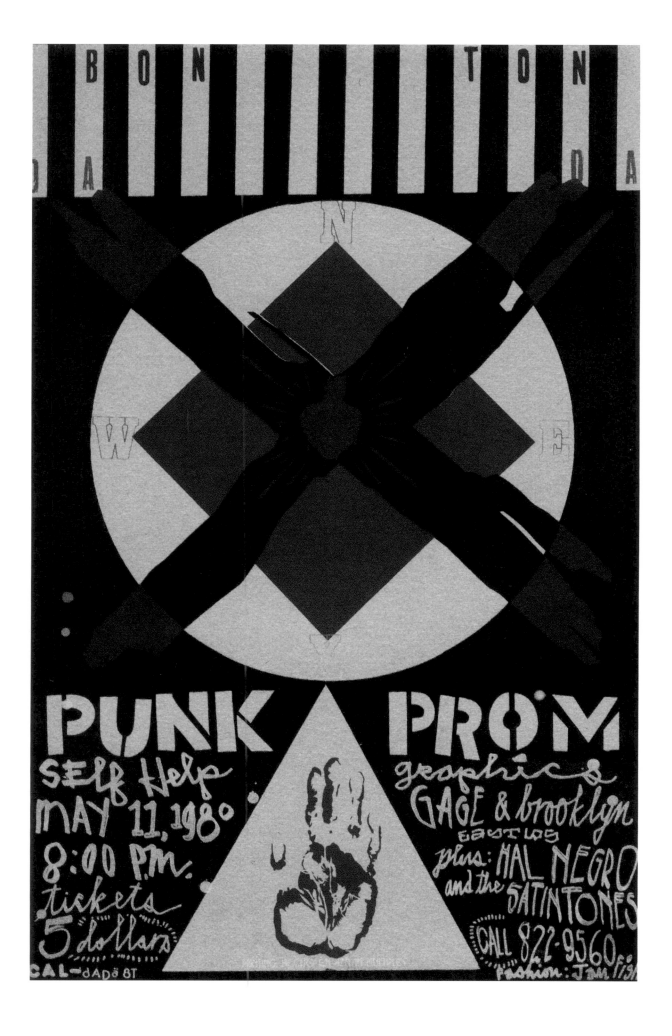

Día de los Muertos, Commemorative Poster

SHG ⓒ

Día de Los Muertos
Day of the Dead, 10th Anniversary

November 7, 1982, Self-Help Graphics, Los Angeles, CA
Partially Funded by N.E.A.

FIG. 16

Richard Duardo, *Punk Prom*, 1980, screenprint on paper, sheet and image: 35 × 23 in. Courtesy the Estate of Saul Richard Duardo.

FIG. 17

Gronk, *Día de los Muertos, (Commemorative Poster)*, 1981, screenprint on paper, sheet: 25 ¼ × 19 in. Smithsonian American Art Museum, Gift of Gilberto Cárdenas and Dolores García, 2019.51.3.

FIG. 18

Gronk, *Dia de los Muertos 10th Anniversary*, 1982, screenprint on paper, sheet: 30 ¾ × 23 ¼ in. Smithsonian American Art Museum, Gift of Gilberto Cárdenas and Dolores García, 2019.51.49.

passage, Duardo provided a symbol-laden poster that challenged preconceived notions of Chicano culture and, by extension, its aesthetics.

Before Duardo established a screenprinting space at Self Help Graphics, the organization had been conducting onsite and mobile programs to make art accessible to the East LA community since 1971. A student of well-known screenprint artist Sister Corita Kent, Sister Karen Boccalero took over SHG's screenprinting operations after Duardo's departure in 1981. She invited painter, muralist, and Asco member Gronk to produce a series of limited-edition screenprints to "sell in both the ethnic and Anglo-buying art markets."[73] The suite of prints featured imagery by Gronk derived from his canvas and mural work. Like his fellow artists within the conceptual art collective Asco, Gronk's iconography reflected

the influences of Mexican/Latino art as well as Hollywood B movies.[74] Gronk also channeled his own experiences of childhood poverty and cultural disenfranchisement within Los Angeles' urban environment into his 1982 prints titled *Iceberg, Molotov Cocktail*, and *Exploding Cup of Coffee*.[75] Thus, Sister Karen's goal to garner mainstream art attention with Gronk's posters constituted an aesthetic as well as a financial experiment.

In their composition and iconography, Gronk's prints reflect his style as a painter and muralist. His initial Day of the Dead commemorative poster, produced in 1981, is dominated by a caricature-like female figure with a skeleton face in a shoulder-less dress holding red roses (**FIG. 17**). In its incorporation of minimal skeletal features and elements of life (hair, lips, flowers), the print presents a humorous yet

contradictory commemoration for the deceased. As part of SHG's "Special Project" the following year, Gronk continued this life-affirming imagery in a print to mark the celebration's tenth anniversary (**FIG. 18**). He repeated the playful image of a woman, however this version relies mainly on black ink on white paper to create a face with curly hair, accentuated with large bright-red lips. The only references to death are the two skull-shaped earrings, which Gronk incorporated for a sense of glamour. "You could say almost that it's like a lot of the women I grew up with...[artist] Patssi Valdez had a look like that."[76] With their focus on imagery, his posters provided an aperture for aesthetic experimentation within an atelier process, which became a model for future Chicano graphic production.

SHG's formula of combining a well-known artist, a master printer for quality control, and marketing to Chicano and mainstream collectors proved financially successful. In 1983, with funds from the sale of Gronk's prints, Sister Karen initiated the first Experimental Atelier Program with nine artists, including herself.[77] Now in its thirty-seventh year, the Professional Print-making Program continues to produce prints and is no longer limited to Chicano/Latino artists. Equally important, its focus on collectors has resulted in the inclusion of Chicano posters within museums nationally, and its exhibition program has facilitated the dissemination of Chicano graphics internationally.

Duardo's and Gronk's prints created another defining moment in the production of Chicano posters, building on the aesthetic experimentation of individual artists such as Rupert García and Luis González in the 1970s. No longer bound by preconceived definitions of Chicano graphics, artists were free to create prints that incorporated their individual (artistic, political, and cultural) experiences and aesthetic choices. For art organizations, producing their own culturally infused "art prints" provided an additional funding stream, which became crucial as government support dwindled in the late 1980s. This induced other art organizations to adopt SHG's atelier model, including Movimiento Artístico del Río Salado/MARS in Phoenix, Arizona.[78]

Established in 1978 by an artist collective as an exhibition space, MARS's mission was to "promote and develop interest and support for the visual arts, and to establish an alternative space art gallery in the Chicano community."[79] In 1981, they opened MARS Artspace and initiated their Mexican/American Print Series the following year.[80] Though based on SHG's atelier program, MARS chose lithography as its medium and focused on nationally known Chicana/o artists to "participate in an artist-in-residence program, which includes a solo exhibition at the MARS Artspace and a one-week residency with master printer, Joe Segura of Segura Publishing Company."[81] The limited-edition prints were marketed for sale nationally and

exhibited as part of their permanent collection.

Sculptor and printmaker Luis Jiménez participated in the first MARS Print Series residency in 1983 and produced *The Rose Tattoo* (**FIG. 19**). His polychromatic depiction of a couple in the back seat of a car pulses with the lush red of the woman's dress and vibrant yellow of the man's shirt, the reds repeated in the tuck-and-roll upholstery and tattoos—including a rose—on the man's arm.[82] According to Jiménez, the print stemmed from the Lowrider Series of drawings he created with his daughter, Elisa, after both attended a wedding in the mid-1970s.[83] He drew multiple scenes of tattooed males in elaborately painted lowrider cars, images he merged in his MARS lithograph. Jiménez's aesthetic influences included pop art, neon signs, and new figuration, which he had transformed into iconic, and many times controversial, sculptures, drawings, and prints.[84] One can also see in *The Rose Tattoo* the influences of Mexican muralist José Clemente Orozco in Jiménez's rendering of the figures and facial expressions. Replete with detail, the composition mimics a staged, cropped photograph even though its origins as a drawing are readily apparent. A graphic continuation of his fascination with cars as a reflection of American culture, Jiménez's depiction of a young lowrider couple was also another example of his "affirmative

celebration of ordinary working people made extraordinary."[85]

The Rose Tattoo sold out quickly and solidified MARS's commitment to its atelier program until it closed its Artspace in 2001.[86] Yet even with the increasing commercial appeal of Chicano graphics, as personified by the atelier models, not all artists abandoned posters with social justice messages. However, the critical acclaim and financial viability of SHG's and MARS's print programs altered the role of Chicano posters, which continues to date.

RECALIBRATING THE CANON

That our art is too political and that it is only propaganda, therefore not universal...Hasn't all great art always espoused ideas? Why can't political and social messages be just as aesthetically acceptable as cans of Campbell soup or Mickey Mouse?
— José Montoya

Chicano posters emerged in the mid-1960s as an integral component of the sociopolitical Chicano movement, providing artists with a role in which to amplify their support and advocacy. Their posters and, later, art prints transcended the limitations of ink on paper to enact change (locally and globally) as well as reclaim public space with affirming bicultural imagery and bilingual text. As activist communicators, poster artists from the beginning

integrated aesthetics and message; they did not see them as mutually exclusive, although some prints required a more complex reading from viewers. Through their synthesis of myriad artistic influences and bicultural heritage, Chicana/o artists created a new visual vocabulary to counteract the onslaught of negative stereotypes as well as to promote personal agency in their communities and solidarity with international struggles. Equally significant, though challenged by gender constrictions, Chicana artists created some of the most influential prints that contested aesthetic and cultural boundaries. However, with their shared belief in the power of images to shape society, Chicana/o artists consciously operated within "a space between social function and aesthetics" that allowed them to "drop in and out of art historical styles, while still maintaining a trajectory that would illustrate the movement within" (and, as the present catalogue demonstrates, outside of) "the canons of contemporary art."[87] In the process, artists made posters and prints multifunctional, a source of information, reflection, indictment, inspiration, and beauty. Whether as individuals or staff within political organizations and art *centros*, during the pivotal first two decades of the Chicano movement Chicana/o poster artists forged a distinct aesthetics of the message that engendered an important tributary of American art.

NOTES

EPIGRAPH (p. 71)

Malaquias Montoya, quoted in Lincoln Cushing, *One Struggle, Two Communities: Late Twentieth-Century Political Posters of Havana, Cuba, and the San Francisco Bay Area*, Artist's Statements, accessed May 24, 2019, http://www.docspopuli.org/articles /Cuba/BACshow.html.

1 Therese Thau Heyman, *Posters American Style* (Washington, DC: National Museum of American Art and Harry N. Abrams, 1998), 7.

2 Robin Adèle Greeley, "Richard Duardo's 'Aztlan' Poster: Interrogating Cultural Hegemony in Graphic Design," *Design Issues* 14, no. 1 (Spring 1998): 23.

3 Michael Kelly, "The Political Autonomy of Contemporary Art: The Case of the 1993 Whitney Biennial," in *Politics and Aesthetics in the Arts*, ed. Salim Kemal and Ivan Gaskell (Cambridge: Cambridge University Press, 2000), 242.

EPIGRAPH (p. 73)

Tomás Ybarra-Frausto, "*Califas*: California Chicano Art and Its Social Background" (unpublished manuscript), 20–21, prepared for Califas Seminar at Mary Porter Sesnon Gallery, University of California, Santa Cruz, April 16–18, 1982.

4 There is no single definition of "Chicano" and it is very much a self-designated term. According to the slain *Los Angeles Times* journalist Rubén Salazar, "A Chicano is a Mexican American with a non-Anglo image of himself." "Who Is a Chicano? And What Is It the Chicanos Want?," *Los Angeles Times*, February 6, 1970. A former pejorative term, it was adopted by young politicized Mexican Americans as a badge of pride.

5 In the Treaty of Guadalupe Hidalgo (1848), Mexico ceded 55 percent of its territory (present-day Arizona, California, New Mexico, Texas, and parts of Colorado, Nevada, and Utah) to the United States in exchange for $15 million in compensation for war-related damage to Mexican property. Historian Rodolfo Acuña delineated the "colonial" condition that resulted after the Mexican-American War (1846–48): the Mexican homeland was invaded by outsiders; the original inhabitants became involuntary subjects of the United States; an alien culture, government, and language were imposed; the Mexicans (now Americans) were rendered powerless and relegated lower-class status; and finally, the invading American

government justified its actions by virtue of its victory. Rodolfo Acuña, *Occupied America: The Chicano's Struggle Toward Liberation* (San Francisco: Canfield Press, 1972), 223–24. For other in-depth examinations of the internal colonialism concept, see Mario Barrera, Carlos Muñoz, and Carlos Ornelas, "The Barrio as an Internal Colony," in *People and Politics in Urban Society*, ed. Harlan Hahn (Beverly Hills, CA: Sage, 1972), 281–301; and Alfredo Mirandé, *The Chicano Experience: An Alternative Perspective* (Notre Dame, IN: University of Notre Dame Press, 1985). The seminal concept has also been contested by Chicano historians, including G. G. González, "A Critique of the Internal Colony Model," *Latin American Perspectives* 1, no. 1 (Spring 1974): 154–61; and Ramón Gutiérrez, "Internal Colonialism: An American Theory of Race," *Du Bois Review: Social Science Research on Race* 1, no. 2 (2004): 281–95.

6 José Montoya and Juan M. Carrillo, "Posada: The Man and His Art. A Comparative Analysis of José Guadalupe Posada and the Current Chicano Art Movement as They Apply Toward Social and Cultural Change. A Visual Resource Unit for Chicano Education" (unpublished master's thesis, California State University, Sacramento, 1975), 36.

7 Rupert García, "Chicano/Latino Wall Art: The Mural and the Poster," in *The Hispanic American Aesthetic: Origins, Manifestations, and Significance*, ed. Jacinto Quirarte (San Antonio: Research Center for the Arts and Humanities, University of Texas at San Antonio, 1983), 28.

8 In New Mexico, Reies López Tijerina formed the Alianza Federal de Mercedes (Federal Land Grant Alliance) in 1963 to fight for the return of Spanish land grants lost after the Mexican-American War. In California, César Chávez and Dolores Huerta's fledgling union joined the striking Filipino farmworkers in 1965, which led to the formation of the United Farm Workers union and brought all the regional efforts together into a national Chicano movement. In 1966, Rodolfo "Corky" Gonzales established La Crusada por Justicia (The Crusade for Justice) in Colorado, which operated a cultural center that included a school, art gallery, newspaper (*El Gallo*), and credit bureau. In Texas, José Angel Gutiérrez in 1970 formed La Raza

Unida Party, a national political party that promoted greater economic, social, and political self-determination for all Mexican Americans.

EPIGRAPH (p. 75)

Emanuel Martinez, quoted in Victor Alejandro Sorell, "The Persuasion of Art—The Art of Persuasion: Emanuel Martinez Creates a Pulpit for El Movimiento," in *Emanuel Martinez: A Retrospective*, ed. Teddy Dewalt (Denver, CO: Museo de las Américas, 1995), 27.

9 "Walkout in Albuquerque," *Carta Editorial* 3, no. 12 (April 8, 1966), reprinted as "Walkout in Albuquerque: The Chicano Movement Becomes Nationwide," in *Aztlan: An Anthology of Mexican American Literature*, ed. Luis Valdez and Stan Steiner (New York: Knopf, 1972), 211–14.

10 UC San Diego Library, Farmworker Movement Documentation Project, accessed July 12, 2019, https://libraries .ucsd.edu/farmworkermovement /gallery/index.php?cat=66).

11 Zermeño spent fourteen years as a volunteer UFW illustrator while living in Los Angeles. In 1970 he moved his family to their headquarters located in Keene, a small town north of Los Angeles. For a year, he worked as the UFW's staff cartoonist for their bilingual newspaper, *El Malcriado*, creating a number of characters based on a political cartoon style popular at the time in the United States and Mexico. *El Malcriado* also reproduced prints by the Mexican engraver José Guadalupe Posada and artists of the Taller de Gráfica Popular, thus popularizing the *calavera* (skeleton) image within Chicano art and bringing Mexican social protest art to the attention of Chicano artists. See Tomás Ybarra-Frausto and Shifra M. Goldman, "Outline of a Theoretical Model for the Study of Chicano Art," in *Arte Chicano: A Comprehensive Annotated Bibliography of Chicano Art, 1965–1981* (Berkeley: Chicano Studies Library Publications Unit, University of California, 1985), 34.

12 Andrew Zermeño, interview by the Center for Study of Political Graphics, February 12, 2012. The interview accompanied the exhibition *Decade of Dissent: Democracy in Action 1965–1975*, which opened at Arena 1 gallery in Santa Monica, California, in 2013. See YouTube video, 10:10, https://www.youtube.com/watch?v =ht7HG68Vwdk.

13 Karen Mary Davalos, *Yolanda M. López* (Los Angeles: UCLA Chicano Studies Research Center Press, 2008), 55. Carter's plan called for constructing a wall along the U.S.-Mexico border, granting different degrees of amnesty to undocumented persons, and issuing worker identification cards. For more information on the Committee for Chicano Rights/CCR and their activities, see Jimmy Patiño, *Raza Sí, Migra No: Chicano Movement Struggles for Immigrant Rights in San Diego* (Chapel Hill: University of North Carolina Press, 2017).

14 Davalos, *Yolanda M. López,* 53. The image was from a pen-and-ink drawing López created while pursuing an MFA at University of California, San Diego, in 1978. López derived the figure from an advertisement for Azteca Beer and not the WWI and WWII posters. Nevertheless, "the familiar iconography of an assertive finger-pointing man presents an accusatory challenge to Manifest Destiny and its racial supremacist undertone." Davalos, *Yolanda M. López,* 55.

15 Judith Huacuja Pearson, *Chicana Critical Pedagogies: Chicana Art as Critique and Intervention*, Smithsonian Institution, accessed May 28, 2019, http://latino.si.edu/researchandmuseums/presentations/huacaya.html (site discontinued), copy of paper in author's research files.

16 Patiño, *Raza Sí, Migra No*, 202.

17 Yolanda López, interview by Terezita Romo, June 15, 2019.

18 According to Lincoln Cushing, San Francisco's Galería de la Raza "produced a revised edition of 2,000 posters" without the CCR logo, reference to President Carter's plan, and Statue of Liberty image. Lincoln Cushing, *All of Us or None: Social Justice Posters of the San Francisco Bay Area* (Berkeley, CA: Heyday, 2012), 52. López's image continues to be replicated on posters, buttons, and T-shirts.

19 "Chronology," in Dewalt, *Emanuel Martinez: A Retrospective*, 11.

20 Sorell, "Persuasion of Art," 27.

21 Originally published in a Mexican newspaper in 1913, the photograph of Zapata had been attributed to Mexican photographer Agustín Casasola. Years later, scholars credited the German photographer Hugo Brehme, who moved to Mexico in 1905. However, in 2009, Mexican researcher Mayra Mendoza Avilés from the Fototeca Nacional declared that neither was the photographer. Though not able to identify the photographer, she stated that it most likely was an American journalist covering the Mexican Revolution. See Mayra Mendoza Avilés, "El Zapata de Brehme: El análisis de un caso," *Alquimia* 36 (2009): 83–84; and Ken Ellingwood, "Zapata Photo Shrouded in Mystery," *Los Angeles Times*, December 6, 2009, https://www.latimes.com/archives/la-xpm-2009-dec-06-la-fg-mexico-zapata6-2009dec06-story.html.

22 In addition to reforms to Mexico's political process, Zapata's "Plan de Ayala" (1911) called for land taken by landlords to be returned to owners who could prove title and the land owned by monopolies to be redistributed to the landless poor. John Womack Jr., *Zapata and the Mexican Revolution* (New York: Knopf, 1969), 400–404. His followers' rally cry of "Libertad, Justicia y Ley" was shortened after Zapata's death to "Tierra y Libertad."

23 As a testament to the potency of Zapata's image, in 1994 the indigenous people of Chiapas in southern Mexico also adopted Zapata as their inspiration. Calling themselves Ejército Zapatista de Liberación Nacional (EZLN; Zapatista Army of National Liberation), they too fight for democracy, self-determination, and land reform.

EPIGRAPH (p. 78)

Rupert García, "Media Supplement, 1969–1970" (unpublished master's thesis, Department of Art, San Francisco State College, 1970), 13.

24 At San Francisco State University, the Black Students Union, Latin American Students Organization, Filipino-American Student Organization, and El Renacimiento, a Mexican American student group, formed the Third World Liberation Front (TWLF). The TWLF carried out a strike in 1968 to demand the creation of ethnic studies departments and the recruitment of faculty members of color. The following year, a sister TWLF organization composed of the Afro-American Student Association, Mexican American Students Confederation, Asian American Political Alliance, and Native American Students Union held their strike at UC Berkeley, to issue a similar demand for an autonomous Third World College. "The Third World Liberation Front Strike circa 1969," *Third World Forum* 24, no. 2 (February 2003): 6.

25 Rupert García, interview by Terezita Romo, July 25, 2005.

26 Peter Selz, *Art of Engagement: Visual Politics in California and Beyond* (Berkeley: University of California Press, 2006), 45.

27 Thomas Albright, "Oakland Museum: A Wide Range of Latin Art," *San Francisco Chronicle*, September 12, 1970, 33.

28 Ramón Favela, *The Art of Rupert Garcia* (San Francisco: Chronicle Books and Mexican Museum, 1986), 9. Emanuel Martinez reproduced the image of Che from a Cuban banner as a 12 × 9-inch screenprint in 1968; see Dewalt, *Emanuel Martinez: A Retrospective*, 32.

29 Favela, *Art of Rupert Garcia*, 19.

30 Emory Douglas, "Art for the People," *Black Panther* 1, no. 1 (Spring 1991): n.p.

31 Even in his "Electric Chair" screenprint series (1963–71), Warhol privileged the instrument of death—the electric chair. The prints were derived from a 1953 photograph of the death chamber at the Sing Sing Correctional Facility, which he cropped and reproduced in different colors. The repetition combined with the absence of the persons being electrocuted created a distance in the viewers' emotions, diminishing their adverse reaction to executions. Even when asked about these prints, Warhol's response was "No meaning. No meaning."

32 Formed in 1968, the Mexican American Liberation Art Front (MALAF) lasted for only a year and a half, but it held many meetings that provided rich opportunities for discussion and debate regarding the role and definition of Chicano art. See Terezita Romo, *Malaquias Montoya* (Los Angeles: UCLA Chicano Studies Research Center Press, 2011); and Jacinto Quirarte, *Mexican American Artists* (Austin: University of Texas Press, 1973), which features an interview with cofounder Esteban Villa.

33 Malaquias Montoya, interview by Terezita Romo, November 8, 2008; and Romo, *Malaquias Montoya*, 10.

34 Ernesto Colosi, interview by Terezita Romo, November 8, 2008; and Romo, *Malaquias Montoya*, 10.

35 Shifra M. Goldman and Tomás Ybarra-Frausto, "The Political and Social Contexts of Chicano Art," in *Chicano Art: Resistance and Affirmation, 1965–1985*, ed. Richard Griswold del Castillo, Teresa McKenna, and Yvonne Yarbro-Bejarano (Los Angeles: Wight Art Gallery, University of California, 1991), 90

36 Art historian Victor Alejandro Sorell cites two circa 1933 Mexican paintings of La Virgen (defendiendo) la niñez mexicana by Gonzalo Carrasco, a Jesuit. Paintings from Iglesia de la Compañia in the city of Puebla "are companion canvases painted in oils and relating a combat between La Morenita and a host of anthropomorphic dragons from whose apparently evil threat six children are rescued." *Her Presence in Her Absence: New Mexico Images of La Guadalupana*, (Albuquerque: Southwest Hispanic Research Institute, University of New Mexico, 1994), 27. See also Jacinto Quirarte, "Sources of Chicano Art: Our Lady of Guadalupe," *Explorations in Ethnic Studies* 15, no. 1 (January 1992): 13–26; Yvonne Yarbro-Bejarano, "Ester Hernández and Yolanda López," *CrossRoads* (Oakland, CA), no. 31 (May 1993): 15, 17; Catha Paquette, "(Re)Visions: Sacred Mothers and Virgins," in *Mex/L.A.: "Mexican" Modernism(s) in Los Angeles, 1930–1985*, ed. Museum of Latin American Art, Long Beach, CA (Ostfildern: Hatje Cantz, 2011), 48–57; and Jeanette Favrot Peterson, *Visualizing Guadalupe: From Black Madonna to Queen of the Americas* (Austin: University of Texas Press, 2014).

37 Dorinda Moreno, "Ester, Lupe y La Chicana en el Arte," special edition, *La Razón Mestiza II* (Summer 1976): n.p. Hernandez was studying karate at the time. In 1978, Yolanda López painted a triptych depicting her grandmother, her mother, and herself as contemporary personifications of the Virgen de Guadalupe. Hernandez's and López's works on paper continued the dramatic shift initiated by Los Angeles Asco member Patssi Valdez, who dressed as the Virgen de Guadalupe as part of the conceptual art group's Walking Mural parade in 1972. For her performance art interpretation, Valdez created a stylish outfit that incorporated the "Vírgen fashion" of church statues with her Hollywood-derived sense of glamour. It was the first significant artistic reinterpretation of the Virgen de Guadalupe in the United States and Latin America, as well as

within Chicana/o art. See Terezita Romo, "Conceptually Divine: Patssi Valdez's Vírgen de Guadalupe Walking the Mural," in *Asco: Elite of the Obscure: A Retrospective, 1972–1987*, ed. C. Ondine Chavoya and Rita Gonzalez (Ostfildern: Hatje Cantz, 2011), 276–83.

38 The print was first reproduced as part of a collage on the cover page of the 1976 summer special edition of Dorinda Moreno's San Francisco Mission District community paper, *La Razón Mestiza*. It was also included in *Bibliography of Writings on La Mujer*, comp. Cristina Portillo, Graciela Rios, and Martha Rodriguez (Berkeley: Chicano Studies Library, University of California, 1976).

39 "Arte Amado Peña," *Magazín*, October 1972, 26, cited in Ruben C. Cordova, *Con Safo: The Chicano Art Group and the Politics of South Texas* (Los Angeles: UCLA Chicano Studies Research Center Press, 2009), 86n66.

40 Peña, César Martinez, and Carmen Lomas Garza left the group in 1974 when disagreements arose as to the definition of Chicano art and the role of artists, which they believed was "to expand perceptions...rather than limiting them." Cordova, *Con Safo*, 48. For a detailed account of the group's history, its members, and art-historical legacy, See Cordova, *Con Safo*.

41 "Our America—Amado M. Peña, 'Mestizo,'" Smithsonian American Art Museum, December 30, 2013, audio podcast, 2:37, https://americanart .si.edu/videos/our-america-audio -podcast-amado-m-pena-jr-mestizo -154048.

42 "The IWW [Industrial Workers of the World] was the chief exponent of industrial unionism in the U.S. in the early decades of the century. Founded in Chicago in 1905, the IWW or 'Wooblies' believed in the revolutionary potential of the General Strike." John Pitman Weber, "Carlos Cortez," in *Culture, Politics and Art: Expressions in the Dance of Life* (Evanston, IL: Northwestern University, 1995), 8n1.

43 Cortéz along with José G. González founded the Movimiento Artístico Chicano / MARCH, the first Chicano arts organization in Illinois in 1975. It was originally formed in 1972 in Indiana as El Movimiento Artístico de la Raza Chicana. Raye Bemis Mitchell, "MARCH to an Aesthetic of Revolution," *New Art Examiner* 4, no. 5 (February 1977): 11.

44 Weber, "Carlos Cortez," 6. Cortéz joined the IWW in 1947 after having served a two-year sentence for being a conscientious objector during World War II.

45 Coral Gilbert and Ricardo Frazer, "Interview with Carlos Cortez," *Cultural Crossroads* 6, no. 1 (November 1995): 1.

46 In Posada's humorous and political applications, *calaveras* (skeletons) acted out the daily trials and successes of the everyday people of Mexico City, and critiqued the hypocrisy of politicians, often as a theater of the absurd.

EPIGRAPH (p. 85)

Linda Lucero, quoted in Shifra M. Goldman, "A Public Voice: Fifteen Years of Chicano Posters," *Art Journal* 44, no. 1 (Spring 1984): 51, 57n3.

47 Artists at Galería de la Raza in San Francisco used a color Xerox machine to create art prints, calendars, and cards, which were sold in Studio 24, the Galería's shop.

48 Core poster artists at the Centro de Artistas Chicanos were Juan Cervantes, Armando Cid, Rodolfo O. "Rudy" Cuellar, Ricardo Favela, Max E. Garcia, Luis C. ("Louie the Foot") González, Juan Orosco, and Stan Padilla. Cofounders José Montoya and Esteban Villa remained at Sacramento State but contributed posters as well. Though initially formed by visual artists, over time the RCAF expanded to include educators, community activists, politicians, filmmakers, writers, musicians, and dancers. In the 1970s, the Centro partnered with the Breakfast for Niños, La Raza Bookstore (RCAF's bookstore), and City of Sacramento Alkali Flat [Redevelopment] Project Area Committee to form the Cultural Affairs Committee, which organized year-round cultural activities. For more information on this aspect of the RCAF, see Ella Maria Diaz, *Flying Under the Radar with the Royal Chicano Air Force: Mapping a Chicano/a Art History* (Austin: University of Texas Press, 2017).

49 For a detailed evaluation of the role of CETA within the arts, see Mirasol Riojas, *The Accidental Arts Supporter: An Assessment of the Comprehensive Employment and Training Act (CETA)*, report no. 8 (Los Angeles: UCLA Chicano Studies Research Center Press, 2006). According to Riojas, "Although it was not conceived as an arts program, CETA proved to be one of the most

substantial sources for federal funds in addition to the NEA. It provided artists with new possibilities and a sense of hope and generated an intense interest in finding ways to secure CETA funds." Riojas, *Accidental Arts Supporter,* 5. Unfortunately, CETA's demise in the early 1980s destabilized many arts organizations that depended on it for their staffing.

50 Luis C. González, interview by Terezita Romo, April 18, 2019.

51 After September 11, 1973, thousands of Chileans escaped the brutal government coup that murdered the democratically elected socialist president Salvador Allende and ushered in Augusto Pinochet's military dictatorship. During the late 1970s, the Bay Area experienced an influx of Argentines and Nicaraguans who were joined in the 1980s by refugees from Guatemala and El Salvador escaping oppressive military regimes that were supported by the U.S. government.

52 Jason Ferreira, "'Our Frontiers Are in the Realm of Ideas': Identity, Solidarity, and the Meaning of Raza Radicalism in Late 20th-Century America" (paper presented at the annual meeting of the Organization of American Historians & National Council on Public History, Washington, DC, April 20, 2006).

53 Goldman, "Public Voice," 52. The founders of La Raza Silkscreen Center were Al Borvice, Oscar Melara, and Pete Gallegos.

54 Along with providing artists with the space and supplies to produce posters to inform the community about relevant issues and cultural events, La Raza Silkscreen Center offered youth and adult classes in "design, illustration, layout and silkscreen printing skills while also providing informal tutoring in Raza history and culture." Tomás Ybarra-Frausto, "*Califas*: Socio-Aesthetic Chronology of Chicano Art" (unpublished manuscript, ca. 1983), 11.

55 In 1954, Lolita Lebrón was one of four activists who opened fire on the U.S. House of Representatives in order to draw attention to their call for Puerto Rico's independence. Sentenced to fifty-six years in a federal prison, she served twenty-five years. Lebrón died in 2010 at the age of ninety.

56 The quote in Spanish is: "Todos somos pequeños, solo la patria es grande y está encarcelada." The poster was produced the year Lucero returned from Cuba, where she worked alongside Puerto Ricans as part of the Venceremos Brigade. Linda Lucero, "Lolita Lebrón: Viva Puerto Rico Libre!," in *FEMINAE: Typographic Voices of Women, by Women,* ed. Gloria Kondrup (Pasadena, CA: Hoffmitz Milken Center for Typography, 2018), 22–25. See also Carol A. Wells, "La Lucha Sigue: From East Los Angeles to the Middle East," in *¿Just Another Poster? Chicano Graphic Arts in California,* ed. Chon A. Noriega (Santa Barbara, CA: University Art Museum, 2001), 180–81.

57 Holly Barnet-Sanchez, "Where Are the Chicana Printmakers?," in Noriega, *¿Just Another Poster?*, 126.

58 René Castro, "Mission Gráfica: Un Taller Humilde en el Barrio de la Mission," in *Corazón del Barrio: 25 Years of Art and Culture in the Mission* (San Francisco: Mission Cultural Center, February 2003), n.p.

59 As noted by Lincoln Cushing, Mission Gráfica was "run by Sances, of Sicilian descent, and Castro, a Chilean refugee, serving a pan-Hispanic community, and printing the work of Asian American artists." Lincoln Cushing, "The Evolution of the Social Serigraphy Movement in the San Francisco Bay Area, 1966–1986," accessed June 7, 2019, http://www.foundsf.org/index.php?title=Evolution_of_the_Social_Serigraphy_Movement_In_the_San_Francisco_Bay_Area,_1966-1986.

60 In 1975, René Castro was forced into exile from his native Chile after serving two years in a concentration camp. He was director of Mission Gráfica from 1982 until 1996, when he was not rehired after a yearlong leave of absence. In 1997, Juan Fuentes assumed directorship until 2007. Cushing, *All of Us or None*, 132.

61 Castro was citing St. Louis's role in the production of uranium needed to develop the atomic bomb during World War II and Missouri's efforts in the late 1980s to remove the stored radioactive waste, which was also a national issue impacting future generations, including San Francisco's youth. For more on the Chicano artist's role in bringing Mexico's Day of the Dead celebration to the United States as part of the Chicano movement, see Terezita Romo, *Chicanos en Mictlán: Día de los Muertos in California* (San Francisco: Mexican Museum, 2000); and Cary Cordova, *The Heart of the Mission: Latino Art and Politics in San Francisco* (Philadelphia: University of Pennsylvania Press, 2017).

62 Mechicano founders were artists Victor Franco and Leonard Castellanos along with Mura Bright, a Russian emigrant and owner of a papier-mâché shop, who contributed funds, served on the board, and was one of its early directors. Leonard Castellanos, "Chicano Centros, Murals and Art," *Arts in Society* (Madison, WI) 12, no. 1 (1974), 38–43. See also Chon A. Noriega and Pilar Tompkins Rivas, "Chicano Art in the City of Dreams: A History in Nine Movements," in *L.A. Xicano,* ed. Chon A. Noriega, Terezita Romo, and Pilar Tompkins Rivas (Los Angeles: UCLA Chicano Studies Research Center Press, 2011), 71–102.

63 Karen Mary Davalos, *Chicana/o Remix: Art and Errata Since the Sixties* (New York: New York University Press, 2017), 74.

64 Reina Alejandra Prado Saldivar, "On Both Sides of the Los Angeles River: Mechicano Art Center," in Noriega, Romo, and Tompkins Rivas *L.A. Xicano,* 47.

65 Prado Saldivar, "On Both Sides," 48. See also "La Historia de Méchicano," *La Gente de Aztlán* (University of California, Los Angeles) 8, no. 1 (November 2, 1977): 14, which traces its history through 1977. Though unattributed, the UCLA student newsmagazine article in Spanish reads as if written by a member of Méchicano.

66 The Galería de la Raza in San Francisco launched a screenprint calendar project in 1975. In the two subsequent years, the Galería and Sacramento's RCAF jointly produced Calendario de Comida (1976) and History of California (1977), calendars based on an overall theme in which artists from both organizations designed a month and the cover.

67 Reina Alejandra Prado Saldivar, "Mechicano Art Center: Defining Chicano Art for Los Angelenos" (unpublished manuscript, 2011), 14. The director at the time, Joe Rodriguez, selected the artists he thought would help "raise enough monies to have Mechicano stay open for at least another year." Prado Saldivar, "Mechicano Art Center," 20.

68 In addition to Duardo, Centro de Arte Público cofounders were Carlos Almaraz, Guillermo Bejarano, Barbara Carrasco, Frank Romero, and John Valadez. See "Centro de Arte Público/Public Art Center, 1977–1980," in Noriega, Romo, and Tompkins Rivas, *L.A. Xicano,* 184.

69 Richard Duardo, interview by Karen Mary Davalos, November 5, 8, and 12, 2007, Los Angeles, CSRC Oral Histories Series, no. 9 (Los Angeles: UCLA Chicano Studies Research Center Press, 2013), 56.

70 Margarita Nieto, "Across the Street: Self-Help Graphics and Chicano Art in Los Angeles," in *Across the Street: Self-Help Graphics and Chicano Art in Los Angeles* (Laguna Beach, CA: Laguna Art Museum, 1995), 30.

71 Goldman, "Public Voice," 57. Aztlán Multiples was followed by Multiples Fine Art; Future Perfect; Art & Commerce; and his last studio, Modern Multiples, Inc. See Duardo, interview.

72 Along with its screenprinting facilities, gallery, and annual Day of the Dead activities, Self Help Graphics hosted punk rock concerts in its second-floor Vex space, which was established in 1980 as an all-age venue. See Josh Kun, "Vex Populi," *Los Angeles Magazine*, March 2003, 62–70; and C. Ondine Chavoya, "The Vex and Unpopular Cultures," in Chavoya and Gonzalez, *Asco: Elite of the Obscure*, 346–55.

73 Reina Alejandra Prado Saldivar, "Self-Help Graphics: A Case Study of a Working Space for Arts and Community," *Aztlán: A Journal of Chicano Studies* 25, no. 1 (Spring 2000): 174.

74 Sister Karen had been acquainted with Gronk and the other members of Asco since 1974, when they first participated in the annual Day of the Dead celebrations. See Max Benavidez, *Gronk* (Los Angeles: UCLA Chicano Studies Research Center Press, 2007); and Harry Gamboa Jr., "Those Were the Days (of the Dead)," in Romo, *Chicanos en Mictlán*, 56–62.

75 Steven Durland and Linda Burnham, "Gronk," *High Performance* 9, no. 3 (1986): 57.

76 Self Help Graphics & Art, "Self Help Graphics Dia de los Muertos 10th Anniversary by Gronk 1982," June 30, 2017, https://www.selfhelpgraphics .com/pst-featured-works-1/2017/6 /30/dia-de-los-muertos-10th -anniversary-by-gronk-1982. See also Self Help Graphics & Art/*SHG TV*, "Día de los Muertos: A Cultural Legacy, Past, Present & Future: Gronk," September 7, 2017, YouTube video, 1:39, https://www.youtube.com /watch?v=zbPTo4N7JGw&feature =youtu.be.

77 Over the years it has been called the Mexican American Master Printer's Program, Experimental Ateliers, Experimental Printmaking Atelier, and Screenprint Atelier Program. In 1983 the printmaking program was established "as a commercial venture through which artists could independently sell their work. The agreement between the organization and the artist determine[d] the price, the split of the edition, and the conditions of sale." Davalos, *Chicana/o Remix*, 93. This provided an important revenue stream during a period when the arts in general were experiencing a decline in both state and federal funding. See also Reina Alejandra Prado Saldivar, "Más Production of Art for the Masses: Serigraphs of Self-Help Graphic Arts, Inc.," in *Latinos in Museums: A Heritage Reclaimed*, ed. Antonio Jose Ríos-Bustamante and Christine Marin (Malabar, FL: Krieger, 1998), 119–30; and Kristen Guzmán, "Art in the Heart of East Los Angeles," in *Self Help Graphics & Art: Art in the Heart of East Los Angeles*, ed. Colin Gunckel, 2nd ed. (Los Angeles: UCLA Chicano Studies Research Center Press, 2005), 1–30.

78 Texas artist Sam Coronado participated as a resident artist at Self Help Graphics in 1988 and 1991. Upon his return to Austin in the early 1990s he established Coronado Studio and his serigraphy program, Serie Print Project, based on the SHG model. Lalo Lopez, "Power Prints," *Hispanic* 8, no. 9 (October 1995): 72.

79 Chicano Research Collection, "Movimiento Artístico del Río Salado (MARS) Records 1974–1992," ASU Library, Arizona State University, accessed January 14, 2020, http:// www.azarchivesonline.org/xtf /view?docId=ead/asu/mars.xml &doc.view=print;chunk.id=0.

80 In the 1980s, MARS expanded its membership to include non-Chicanos/ Mexican Americans.

81 MARS Artspace, accessed June 30, 2019, http://www.mars-artspace.org /info/history.jsp?chapter=8 (site discontinued).

82 The image was reproduced from two previous lithographs of the same title. Luis Jiménez, *Man on Fire: Luis Jiménez* (Albuquerque, NM: Albuquerque Museum, 1994), 85.

83 Jiménez, *Man on Fire*, 88. Jiménez credits his daughter, Elisa, with developing the "fantasy situation of the man and the woman" after they saw a car with a full bar in the back seat.

84 According to art historian Shifra M. Goldman, "The sensibility of Luis Jiménez can actually be located in four distinct artistic sources: pop art, new figuration (both of the 1960s), Mexican social realist muralism and the New Deal artists it influenced (1920s and 1930s), and the aesthetics of *rasquachismo*, which is particularly Chicano and harks back to even older traditions in Mexican communities of the Southwest." Shifra M. Goldman, "Luis Jiménez: Recycling the Ordinary into the Extraordinary," in Jiménez, *Man on Fire*, 7. However, Jiménez also cited working in his father's neon sign and car decal shop in El Paso, Texas, as an artistic influence.

85 Goldman, "Luis Jiménez," 9.

86 Subsequent participating artists at MARS's atelier program were Alfredo Arreguín (1986), Rupert García (1987), Carmen Lomas Garza (1988), Gilbert "Magu" Luján (1989), and César Martínez (1990). The last print was created by Phoenix-born Frank Ybarra in 2000. MARS Artspace, "Artists Index," accessed May 14, 2007, http://www.mars-artspace .org/info/history.jsp?chapter =8 (site discontinued), copy of pages in author's research files. When their Artspace closed in 2001, MARS became a cyber art space; Tempe Center for the Arts, "Mars Artspace: Mexican/American Print Series Lithographs," accessed June 30, 2019, https:// www.tempecenterforthearts.com/Home /ShowDocument?id=4100.

EPIGRAPH (p. 98)

José Montoya, "Rupert Garcia and the SF Museum of Modern Art," *RAYAS*, no. 2 (March/April 1978): 11.

87 Noriega and Tompkins Rivas, "Chicano Art in the City of Dreams," 92.

Tatiana Reinoza

WAR AT HOME

Conceptual Iconoclasm
in American Printmaking

In the mid-2000s, a group of artists gathered in San Francisco's Mission District to print images of pop culture icons onto tortillas.[1] It was a tongue-in-cheek performance that referenced José Montoya's tortilla art and gently mocked the gravitas of an earlier wave of sociopolitical graphics. Dressed in white lab coats, Art Hazelwood, Jos Sances, René Yañez, and Rio Yañez worked diligently to produce tortillas of Frida Kahlo, Morrissey, and Hello Kitty.[2] The crowds of people, who lined up to receive in what looked like the Holy Communion ritual, compelled the artists to perfect their ink recipe and to found the edible-art collective known as the Great Tortilla Conspiracy.[3] Among these notable and elaborate performances, the conspirators screenprinted the image of the Virgin of Guadalupe onto the corn surface and asked their audiences to cannibalize the body of the patroness of the Americas (FIG. 1). The woman in prayer known as an emblematic figure of colonization and rebellion perhaps subtly reminding those chewing on her mandorla that the very land they stood on was once Mexico.[4] The virgin deity likewise recalls the erasure of her indigenous counterpart, the Aztec goddess Tonantzin, whose temple according to legend had been destroyed at the hands of Spaniards on the hill of Tepeyac. The materiality of their actions, spread with a mixture of chocolate over corn, may have sought to invoke a critique of neoliberalism that had advanced to destroy sacred native seed through GMO engineering, abolished Mexico's tortilla subsidies, and driven farmers north in search of work. To commune on the edible Virgen María was also an opportunity to reminisce on a banner of the Virgin that César Chávez and the farmworkers had carried through the historic Delano grape strike in 1965, at the apex of the Chicano civil rights movement.

The conceptual iconoclasm of the Great Tortilla Conspiracy's edible art is the kind of aesthetic sensibility this essay examines in the varied corpus of prints that comprise the exhibition *¡Printing the Revolution¡* Historically, iconoclasm refers to the destruction of icons during war or conquest, or for religious or political reasons. But as *¡Printing the Revolution¡* demonstrates, there is a conceptual iconoclasm that dematerializes destruction and spreads through experimental print practices. Often in a turn of phrase, an ironic reversal, or an invocation to perform a speech act, these post-conceptual prints incite revolution. Their iconoclasm foments an attack on the colonial origins of U.S. nationalism to lay bare the violence of its present-day legacies in a country that has been at war with the Indian, the poor, the immigrant, the racialized, the queer since its founding.

This essay intervenes historiographically on two fronts. First, it proposes an alternative genealogy for this type of cultural production, one that foregrounds the aesthetic contributions Chicanx artists made to the history of conceptualisms.[5] The dominant trend in Latinx art histories to emphasize the role of print culture in social movements, and to implement a framework linked to social history and identity politics, often obscures aesthetic practices that have pushed conceptualism much further and in fact altered what is understood as its mainstream image.[6] Conceptualism is the style without a

style, a set of practices that break away from the pleasure and sublimity of the purely visual. The conceptual turn, hard to pin down into a fixed chronology, defied not only the primacy of visuality, but also studio production, commodification, and distribution.[7] Conceptualists rejected the modernist values of taste and connoisseurship, turning their attention instead to the realms of language, legality, and institutional discourse.[8] They challenged the notion of aesthetic autonomy, an objecthood said to be independent of the social or political, and brought art closer to everyday life. "War at Home" emphasizes the post-conceptual not only to signal a post-1960s chronology, but also to indicate the self-reflexive and critical stance with which these artists approached the new American avant-garde.

Second, this essay adds to the critiques of canonical historiographies that insist on a binary between a cool, detached North American conceptualism and a politicized conceptualism in Latin America.[9] One need only look at how often critics cite the linguistic experiments of Joseph Kosuth, and the counter-information campaign of Tucumán Arde in 1968 (which exposed the plight of Argentine farmers under dictatorship) to witness how art-historical writings emphasize this binary.[10] The hemispheric framework of this essay helps contextualize subversive print tactics that demonstrate sociohistorical links between U.S. military interventions in Latin America and the structural violence endured by Latinx communities in the States.

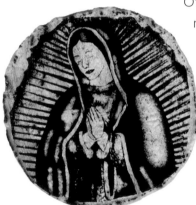

FIG. 1

The Great Tortilla Conspiracy (Art Hazelwood, Jos Sances, René Yañez, and Rio Yañez), *Virgen de Guadalupe*, ca. 2006, printed corn tortilla, ca. 5 in. diam. Courtesy of Rio Yañez.

Through iconographic inversions, insertions in the public sphere, erasures, and satire, Latinx artists exposed the weight of two colonial empires in a country often called the "land of the free and the home of the brave." Their work undoes the dualistic thinking behind these oppositional categories, showing how the violence abroad—the conflict in Vietnam, the rise of authoritarian regimes in Latin America—paralleled the coercive system they inhabited in the war at home.

The sections that follow examine interrelated artistic practices from the Americas that pivot on this aesthetic sensibility. They are arranged in thematic clusters, or what Mari Carmen Ramírez and Héctor Olea call "constellations," corresponding to specific modes of engagement. The first section considers artists who responded to the rise of the U.S. military-industrial complex during the Vietnam War as an extension of the home, and as a way of demarcating who belongs in the homeland. Historicizing the war at home takes us to the second cluster of artists, who tackle the myths of the western frontier and how this image of America was sold across the hemisphere. The constellation of works that follow are based on provocative gestures of refusal that seek to produce counterpublics, alternative spheres of meaning and influence that emerge in response to exclusion. The final section considers the psychological dimensions of the war at home and looks at the print tactics artists used to combat silences and erasures.

THE HOME IN HOMELAND

In 1969, during the Vietnam War, a radical activist named John Jacobs penned a manifesto opposing U.S. intervention in Southeast Asia by calling for a domestic armed conflict, a revolutionary movement in the United States to address inequalities and imperialism's ills. His expression "bring the war home" became a catchphrase of the anti-war movement that sparked the imagination of Martha Rosler, who began a photomontage series, *House Beautiful: Bringing the 'War Home* (**FIG. 2**).[11] In these works which she photocopied to hand out at anti-war marches, "Rosler brought the American war and the American home together not only to examine the war's effects on the home but to stage the ntimacy

FIG. 2

Martha Rosler, *Balloons*, from the series *House Beautiful: Bringing the War Home*, ca. 1967–72, photomontage, 23 ¹¹/₁₆ × 18 ⅞ in. Courtesy of the artist and Mitchell-Innes & Nash, New York.

that already existed between the two."[12] As the Vietnam War played out in televised broadcasts in American living rooms, Rosler asked viewers to draw connections between American consumerism, U.S. imperialism abroad, detached spectatorship, and heteronormative gender roles, all of which enable military atrocities. But for her MFA student, the artist Yolanda López, bringing the war home meant something slightly different.[13] López thought about Uncle Sam's "I Want You" war propaganda poster, the domineering figure in an Azteca beer advertisement, and the hateful phrase "illegal alien" circulating in the media. She remixed these signs and icons, and in 1978 created the confrontational *Who's the Illegal Alien, Pilgrim?* (see **FIG. 15**, p. 42), a poster that questions the links between militarism and the demarcation of the homeland.

Although their works are visually distinct, Rosler and López share a conceptual approach to iconoclasm that critiques the rise of the U.S. military-industrial complex and its justification of protecting the home or homeland. Their choice to tackle one of the bastions of U.S. nationalism reflects the politics of their locality (the city and county of San Diego, home to a number of prominent military bases), covert research labs, and weapons production facilities.[14] But locality also reflects their conceptual ties to the University of California, San Diego, in the 1970s, when "disciplinary boundaries were porous, politics were ubiquitous, and there was no clear hierarchy of

faculty and students."[15] It was a moment when artists emphasized concepts and information over traditional art objects, rejected the hierarchies of artistic mediums, and questioned the principles of the art market. Rosler set aside her camera and cut up pages from popular magazines; López put down her brushes, picked up a pen, and sent a layout to an offset printer. Somewhere in an affective register, they share a dark humor, a delightful irreverence for the norms of authority. In a field often dominated by the "heroics" of male artists, women artists have been at the forefront of developing a sustained critique of U.S. nationalism. However, it is also worth considering how their works differ, why one points to an external conflict deeply embedded in the operations of the normative American household, while the other points to an ongoing internal conflict that justifies militarization to protect the homeland from the perceived threat of the foreign or nonwhite. This addition of a critical lens on race, even if invoked through the uncritical appropriation of indigeneity in this instance, would become a key theme for conceptual works by African American artists, including David Hammons, Adrian Piper, and Faith Ringgold.[16] Rosler's project, made at the tail end of conceptualism's peak in the 1960s, might be read as a critique of the style's rigid avoidance of sociopolitical themes, whereas López's poster suggests how that critique did not go far enough because the country had been at war since the founding of the colonies.

In the 1970s, while much of America was still reeling from the effects of the war in Southeast Asia, artists like López used visual and linguistic puns to expose the domestic conflict. In the title *Who's the Illegal Alien, Pilgrim?*, her reference to the English colonists who sailed on the *Mayflower* in 1620 recalls a scene from a famous Hollywood Western, *The Man Who Shot Liberty Valance* (1962), where a frontier rancher (John Wayne) looks at the recently ambushed East Coast lawyer (Jimmy Stewart) and asks, in a mocking tone, "Think you can make it, pilgrim?" Throughout the film the two men vie for the affection of a blond-haired damsel (Vera Miles) who perhaps represents the archetypal Columbia (female personification of the United States). As a revisionist Western, the film critiques not only the role of the press in promoting the mythology of the American West, but also the nostalgia for a genre that had, for much of the early twentieth century, often glorified expansionism, when the United States undertook military campaigns against indigenous populations and fought a war with Mexico to secure territorial domain "from sea to shining sea." However, this national narrative continues to privilege the white and male version of history, and upholds the legal democratic system as central to taming the West. López asks viewers to make connections between the violence of the nineteenth-century frontier and how that violence evolved into a xenophobic legal system that now calls the descendants of these populations "illegal aliens." Her systematic inversion of signs and icons central to U.S. nationalism likewise positions U.S. military tactics used in Vietnam as indistinct from the ones used to quell the insurrection of student movements in the 1960s and '70s (in which she actively took part) and that would in subsequent decades militarize the U.S. border for the apprehension of migrants.[17]

SELLING THE AMERICAN WEST

The semiotic inversions of López's *Who's the Illegal Alien, Pilgrim?* exposed the use of militarism at home and paved the way for pop-influenced conceptualisms that interrogated the selling of the American West. Through the appropriation of commercial iconography artists across the Western Hemisphere developed critiques of Manifest Destiny, the gendering of expansionism, and the economic drivers for U.S. imperialism. A hemispheric approach to the work of Ricardo Duffy, Richard Prince, and Antonio Caro blurs the binaries between margin and center, north and south, political and detached, and provides a more dynamic stage on which to visualize conceptual breakthroughs. This is due in part to the vexed position "at the heart of the grandest hemispheric claim to 'America'" that Latinx artists occupy.[18] Their use of conceptual iconoclasm exposes not only the colonial thinking that undergirds U.S. nationalism and U.S. interventions in Latin America, but also how the violence of American expansionism structures our contemporary life.

Following the ratification of the North American Free Trade Agreement in 1994, Ricardo Duffy returned to advertising images Marlboro had designed to market its cigarettes to denounce their fabrications and promotions of a fictitious desolate frontier that obscures indigenous death and displacement.[19] In his print *The New Order* (**FIG. 3**), a blue-eyed George Washington looks toward the viewer as a thought bubble references the Persian Gulf crisis of the early 1990s.[20] Duffy juxtaposes the panoramic vista of an idyllic sun-kissed mountain range with the visual excess of a mountain of skulls over which the U.S. Border Patrol's Ford Bronco and a silhouetted cowboy ride. They ride toward a yellow caution sign, a familiar sight on borderland highways, where motorists are asked to beware of family crossings. At the lower left are the faint outlines of a young Native mother with a child strapped to her back. With a cigarette in his mouth, *calaveras* (skeletons) and a Nazi Iron Cross on his American currency–colored coat, Washington justifies westward expansion as his God-given right to spread democracy and capitalism across the North American continent. But unlike the romanticized visions of the West's rugged, wide-open spaces in the Marlboro commercials—representations that make up nineteenth-century paintings of Manifest Destiny—Duffy's monstrous country asks viewers to connect

the death and displacement of indigenous populations to the contemporary forms of tracking that round up undocumented immigrants like animals.[21]

Duffy's witty and irreverent print winks at Richard Prince's *Cowboys* series (1980-), which pirates the big-budget Marlboro magazine ads and repackages them as high art. Prince's *Untitled (Cowboy)* (1997) is a large-scale reproduction of a Marlboro advertisement that shows a cowboy astride a horse with lasso in hand, descending a hilltop onto a canyon. The rider stands out against the dark void that frames their path. Prince's thievery invokes the contradictions and desires embodied in the figure of the cowboy, a masculinist vision of American expansionism now dying as a result of smoking-related illnesses.[22] Duffy, on the other hand, adopts the view of the vanquished seen in the work of Yolanda López, privileging indigenous claims to land, sovereignty, and mobility, and subtly reminding us of the New World origins of tobacco.

It is no coincidence that Duffy and Prince returned to the subject of Marlboro advertising in the late 1990s. Both artists are interested in the cult of celebrity, as well as the media spectacle of Big Tobacco's legal disputes. The lawsuits began in the mid-1990s when more than forty states brought suits against the four major U.S. cigarette manufacturers: Philip Morris (which owns Marlboro), R. J. Reynolds, Brown and Williamson, and Lorillard. Faced with a public health crisis, the states sought billions in reparations for treating smoking-related illnesses with taxpayer dollars. In 1998 the Master Settlement Agreement settled the state lawsuits, creating new restrictions in the marketing and advertising of cigarettes such as banning public billboards, and the tobacco industry agreed to pay out more than $200 billion to the states over the next twenty-five years. It is not only the largest civil litigation settlement in U.S. history to date, but it also marked the end of an era of a particular kind of image-making.

Artists in Colombia likewise felt compelled to critique the undiscerning consumption of American goods and corporate imagery. Colombian artists "turned to text as a main element in their work," culling from advertising, journalism, political campaigns, and protest signs "in attempts to subvert systems of control."[23] Similar to Prince's work in the magazine emporium of *Time*, Antonio Caro worked in an advertising agency in the early 1970s and subsequently created two important series based on Marlboro and Coca-Cola logos, as they "epitomized the impact of U.S. goods in Colombia."[24] Caro's *Colombia Marlboro* (**FIG. 4**) not only critiques corporate imperialism, but more importantly, it awakens the viewer to the incongruence between the idealized imagery conjured in Marlboro Country ads and the harsh reality of Colombia's impoverished present. While it was championed as the aesthetic moves of an international art scene, his work was firmly rooted in the local, particularly the children selling

FIG. 4

Antonio Caro,
Colombia Marlboro, 1974,
collage, P/A, 11 ⁴⁄₅ × 16 ½ in.
Colección del
Museo de Arte Moderno
de Bogotá–MAMBO.

FIG. 5

Antonio Caro, *Colombia
Coca-Cola*, 1976, enamel on
sheet metal, edition 11/25,
19 ½ × 27 ½ in. Collection
of the MIT List Visual
Arts Center, Cambridge,
Massachusetts.

smuggled cigarettes in Bogotá's streets.[25] The way consumerism became entangled with *cultura popular* was pivotal for Caro's *Colombia Coca-Cola* (**FIG. 5**). Citing artisanal traditions of handmade signs on tin, Caro mimicked Coca-Cola's calligraphy style to write out his country's name. The reworking of these advertisement images from mass media should be understood as "commercial icons whose history in the southern part of the hemisphere is inseparable from imperialist and neoliberal political interventions."[26]

No one would suppose artistic homogeneity, not when context varies greatly between these practices, and for that reason it is important to understand how these artists targeted different institutional discourses. One of the most often cited works of institutional critique is Hans Haacke's *MoMA-Poll* (**FIG. 6**). The installation at New York's Museum of Modern Art called out then New York governor Nelson Rockefeller, who at the time was also a trustee of the Modern, for supporting America's covert bombing of Cambodia, making visible the ties between art, capital, and political structures. Skewering a single art institution might strike the artist Luis Camnitzer as too narrow a focus when in 1970s Latin America the aim was institutional critique that could radically change society.[27] However, in the case of Colombia, scholars have shown that conceptualism was not about deinstitutionalization, but about "artists [who] wanted to challenge the status quo in broader social terms and

FIG. 6

Hans Haacke, *MoMA-Poll*, 1970, 2 transparent acrylic ballot boxes with automatic counters, color-coded ballots; each box: 40 × 20 × 10 in.; paper ballot: 3 × 2 ½ in. Courtesy of the artist and Paula Cooper Gallery, New York.

were happy to use art institutions as a means of doing so."[28] In these same decades, artists in U.S. Latinx communities, for the most part, operated outside of traditional institutional structures. This was not by choice. Because of institutional indifference and exclusion, they had no other recourse but to create their own community-based institutions, newspapers, and print workshops—which by the 1980s and '90s had become established infrastructure to support artistic communities. Duffy's print, made at the flagship Self

Help Graphics workshop in East Los Angeles, was in alignment with the political values of that institution, and railed against the broader social issues that affected those inhabiting the war at home. When the Los Angeles County Museum of Art acquired the work in 1997 and displayed it prominently in *Made in California*, their millennium blockbuster exhibition, *The New Order* gained a larger platform from which to deconstruct the iconic, mythical, and corporate West.

THE POLITICS OF REFUSAL

While many of the artists mentioned so far seek to align their work with a sympathetic public, there are several notable for fashioning artistic provocations that negate any notion of a shared politics or unifying identity. Working within a post-conceptual framework, these artists expound a politics of refusal that incites counterpublics. Their projects have garnered national and international attention, and have been associated with widely recognized Latinx conceptual art groups such as Asco and the Border Art Workshop.[29] The work of these artists seeks to question how norms of gender, race, and class pervade the public sphere.

One example is Patssi Valdez, whose art has recently been characterized as invested in an "aberrant femininity that does not always align with the representational aesthetics of fellow [Chicano] movement artists, or even feminist artists."[30] This tendency

to not conform was most apparent in
her transgressive performances with
Asco, the East Los Angeles art collec-
tive she cofounded with Gronk, Willie
Herrón, and Harry Gamboa Jr., whose
photo-documentation often depicted
her as a glamorous muse. But to read
Valdez as objectified muse obscures
how much of her artistic vision informed
Asco's refusal to be subsumed into
an essentialized, nationalistic, and
patriarchal paradigm of Chicano
identity. In performances like Asco's
Walking Mural (1972) she refashioned
the movement's faith-based liberation
icon of Guadalupe into a dynamic
goth Virgin closer to the occult than
the divine.[31] Her ability to shift from
high-glamour object to mischievous
subject in performances like *À La Mode*
(**FIG. 7**) was likewise misunderstood
by feminist movements that ques-
tioned her reliance on the aesthetics

of makeup and male-gaze-oriented
modes of display.[32]

In 1987, when Self Help Graphics
invited Valdez to be part of their exper-
imental atelier residency program,
which focused on the theme of the
border, she drew on these forms of
refusal. Reminiscent of neo-Dada
and punk aesthetics, *LA/TJ* (**PL. 52**) is
a silkscreen photo-collage where the
artist reflected on the psychic borders
of being a bicultural, alienated urbanite.[33]
Her full-bleed stenciled initials of Los
Angeles and Tijuana create movement,
evoke sound, and frame the central
composition. The black-and-white
montage shows a series of urban snap-
shots, photography being the artist's
primary medium in the 1980s before
shifting to painting. LA's iconic city
hall building with its pyramidal rooftop
guides viewers to a self-portrait of
Valdez split at the middle. The torn

For a long time I didn't realize we were poor at all. We lived in that part
of Harlem called Sugar Hill, where there were lots of parks and big houses th
at had once been mansions but had then been converted into hotels or funeral
homes. When I was little it was nice. Boys didn't start loitering in the ha
llway of my building singing four-part harmony until I was around eight. Aft
er that it got seedy very quickly. Around the same time many of the girls in
school started wearing shoes from Papagallo's and coats from Bonwit Teller's.
Suddenly I began to notice that they all had maids and doormen and lived in a
partments bigger than my whole building. I hadn't noticed it before because
it hadn't determined who was popular before. Before it had been how smart an
d nice and good at sports you were. Nobody had talked about where they bough
t their clothes, or how many servants they had. It was difficult, but becaus
e I was an only child, my parents could keep up with a lot of this. My mothe
r had a very good, steady job as a secretary at City College, and my father h
ad a very unsteady real estate law practice in Harlem, where people paid him
for defending them against unscrupulous landlords by mending his shirts or co
oking things for him or fixing his car. My parents spent all their money on
me. They put me through twelve years of New Lincoln (a fancy private prep sc
hool). They gave me ballet and modern dance lessons at Columbia University.
I took piano lessons first from a neighbor, and later from a teacher at Juil
liard. I got art lessons from the Museum of Modern Art and the Art Students'
League. Once I even got a coat from Bonwit Teller's. Although my mother nor
mally took me on shopping trips only to places like Macy's or Gimbel's, I dre
ssed as well as anyone else in the class and was invited to all the parties a
nd had cute white boyfriends. But I became ashamed to invite people over or
have my boyfriends pick me up because I lived so far away and my neighborhood
and everyone in it seemed so alien and sinister next to my rich white New Lin
coln friends. I could have stood not having had any servants if we at least
had had a big apartment in a large building with an awning and a doorman. At
least an awning. The final blow came when I was eleven. I had been too emba
rrassed by my house and neighborhood to give a party although all the other p
opular kids in my class had. So I had started noticing all the advertised va
cant apartments on Fifth Avenue, Park Avenue, and Central Park West as I came
home from visiting my friends who lived there. And one day I said to my moth
er, Why don't we move? I just saw a sign for a lovely twelve-room apartment
at Fifth Avenue and Eighty-Sixth Street, and it's so small and dark and crowd
ed here. My mother laughed a very angry and bitter laugh and said, Get that
idea out of your head right now. We don't move to Fifth Avenue because we do
n't and never will have that kind of money. I was shocked and didn't believe
her at first. I thought she was just in a bad mood the way she always was wh
en I asked her for new clothes, and that she was that way because she just di
dn't want me to have them. But when I brought it up again, carefully, a few
days later, she saw that I really didn't understand. So she explained very p
atiently and carefully that we lived where we did because we had to, not beca
use we wanted to. She explained about Daddy's deciding to serve his community
and getting paid in apple pies and embroidered shirts when he got paid at all
, and about how many weeks of a secretary's salary a coat from Bonwit Teller'
s cost. I was stunned. I became very depressed. Reality began to look very
different after that. I started becoming more and more estranged from my sch
ool friends. I saw that I would never be able to keep up with them economica
lly and was almost relieved to drop out of the race. I realized that all alo
ng, they had inhabited a world which I had never in fact had access to. It d
isgusted me to think that I had tried so hard to emulate them. I began dress
ing arty rather than junior miss, and to spend time at home listening to clas
sical music and reading novels rather than going to school parties. I found
that I didn't miss those parties at all. I spent a lot of my free time in li
braries and museums. I became reflective and started to keep a journal. Tha
t was when I began to understand the choices and sacrifices my parents had ma
de in order to educate me, and the inner resources they had insisted that I d
evelop. Those resources became a refuge for me now. I learned to be self-su
fficient, and to revel in my solitude. But by that time my self-image had be
en too strongly affected and formed by my school associations, as much as by
the complexities of my total environment. I still have tastes I can't afford
to satisfy except by getting into debt, which I do, and then feel simultaneou
sly guilty and frustrated for having them. My standard of living seems to me
excessive for an artist and an academic, even though I know I would find anyt
hing less barren and depressing. I dream unrealistically of the political an
d economic purity of the ascetic's life, and of the revolution which will red
istribute the wealth my classmates so undeservedly enjoyed. I fear having mo
re money because I know my taste for books, records, art, clothes, and travel
will increase, leaving me with none of the extra cash I now give to support t
hat revolution. I watch with detached anxiety as I sink further into the mor
ass of proliferating material desires at the same time as I ascend the ladder
of material affluence. And my radical political sentiments seem cheap for th
e asking by comparison.

Political Self-Portrait #3 © Adrian Piper 1980

portrait emanates into small gashing lines that descend into the urban fabric of modern high-rises and a disorienting array of diagonals that mark the ever-present traffic-riddled highways of Southern California. In this chaotic, compressed space, one senses how even the most populated of places can produce such profound feelings of loneliness. Her portrait of Gamboa at center evokes that precarious condition. A barbed wire fence draws the viewer's gaze downward to a scene of men wearing fedoras, perhaps in reference to the mass deportation of Mexican nationals during the Great Depression. Valdez does not provide a straightforward narrative or advocate a particular ideological position. To be torn between these sites is an emotional geography much like the poignant one inhabited in Adrian Piper's *Political Self-Portrait #3 (Class)* (**FIG. 8**), where she describes the dissonance of growing up in Harlem and attending an elite preparatory school with children who had maids and doormen. But *LA/TJ* revels in the ambiguity of not belonging, because sometimes belonging, even to the norms of one's own ethnic culture, is what is most dangerous.

In 1988, a year after Valdez's residency, artists Elizabeth Sisco, Louis Hock, and David Avalos took up the issue of the border in a much more public light. They appropriated the corporate advertisement spaces of San Diego transit buses to expose the exploitative foundations of the city's tourism economy. Their poster project, *Welcome to America's Finest Tourist Plantation* (**PL. 53**), circulated in San Diego County for over a month aboard one hundred buses.[34] The unusually long title was a fierce rebuttal to San Diego's nickname, "America's Finest City," coined by then mayor Pete Wilson (later California's infamous governor) when the city was planning to host the 1972 Republican National Convention.[35] The poster shows three scenes in black and white with the stark contrast of brown hands that represent exploited labor. From left, a dishwasher cleans food scraps off a plate, an armed guard handcuffs a subject, and a hand reaches for a hotel door with a placard requesting housekeeping. The jobs are entirely banal, part of the service sector that supports the city, but Sisco, Hock, and Avalos alter their meaning through strategic wordplay. The viewer expects the tourism greeting but does a double take at the word *plantation*, suggesting a slave economy that fuels the city's growth. The brown hands racialize that labor pool, and their apprehension by law enforcement suggests their undocumented status. Through image and text, these artists challenged the exceptional U.S. narrative of a "nation of immigrants."[36]

While conceptualism can be a stand-in for forbidden speech, a vehicle for dissent, a shift in object status to a prioritization of language, *Welcome to America's Finest Tourist Plantation* shape-shifts from printed object to public performance to media spectacle.[37] The image builds on the radical reappropriations of public space seen

that call for inclusion, *LA/TJ* and *Welcome to America's Finest Tourist Plantation* refuse admission, acknowledgment, belonging. They refuse to be part of a homeland based on a colonial system of exclusion, but their refusal is not solely a response to oppression. The artists engage in printing the revolution also for "the artistry, the fun, the games-manship that continues to exist, if not thrive, in a world marked by survival and struggle."[38]

FIG. 9

Guerrilla Girls, *Do women have to be naked to get into the Met. Museum?*, from the series *Guerrilla Girls' Most Wanted: 1985–2006*, 1989, color offset lithograph on illustration board, 11 × 28 in. National Gallery of Art, Washington, Gift of the Gallery Girls in support of the Guerrilla Girls.

FIG. 10

Gran Fury, *Kissing Doesn't Kill*, 1989. Gran Fury Collection, Manuscripts and Archives Division, The New York Public Library.

in the work of Colectivo Acciones de Arte, which in 1979 responded to both the military dictatorship and the per-ceived complacency of Chilean artists by using milk trucks and a large white canvas to block the entrance to the National Museum of Fine Arts in Chile; the Guerrilla Girls bus posters that called out the willful neglect of New York's Metropolitan Museum of Art to acquire works by female artists (**FIG. 9**); and Gran Fury's urban interventions that challenged U.S. government in–action during the height of the AIDS crisis (**FIG. 10**). These works disrupt the public sphere, holding viewers momentarily captive in a traffic jam or on a busy subway. But unlike works

THE SILENT WAR, THE WAR OF ERASURE

The war at home also triggered psycho-logical dimensions for artists willing to speak out about government silence and erasure. In *It's Simple Steve* (**PL. 37**), Herbert Sigüenza, working from an unidentified artist's design, denounced the violence that had displaced his own Salvadoran family and that of many Mission District residents in San Fran-cisco who were desperately fleeing Central America in the 1980s. The poster critiqued the aggressive U.S. foreign policy, often kept from public view, that unleashed military and foreign intelligence agencies in the

just get the fuck out of El Salvador."
Sigüenza was only a teenager when
he started taking printmaking classes
at La Raza Silkscreen Center in the
Mission District. The Third World
Marxist political orientation of this
community-based workshop informed
his early production in the graphic arts,
working alongside Linda Zamora Lucero,
Oscar Melara, and Pete Gallegos.[40] He
would go on to earn a BFA in printmak-
ing at the California College of the Arts
before altering his creative path and
cofounding, in 1984, the famed perfor-
mance troupe Culture Clash.

It's Simple Steve is part of a larger
cultural sphere of oppositional aesthetic
practices that openly confronted American
intervention in Latin America in the 1980s.
Among the most notable projects were
Group Material's *Subculture* (**FIG. 11**), which
inserted printed placards with images
of the Salvadoran Civil War in New York
City subways, and the subsequent Artists
Call Against U.S. Intervention in Central
America, which took the country by
storm in 1984 with public protests in
more than twenty-five cities. Claes
Oldenburg's poster marks the launch
in New York and lists over a thousand
participants (**FIG. 12**). Lucy R. Lippard
served as one of the primary organizers
mobilizing artists and activist networks.
As one of the art critics who championed
conceptual and feminist art, Lippard
undoubtedly influenced the organiza-
tion's output.[41] Artists Call strategically
deployed art as information in order
to uncover U.S. economic and military
ties undermining Central American

FIG. 11

Group Material,
Subculture,
September 1–30,
1983, interior of
IRT subway cars,
New York.
Photograph by
Doug Ashford.

FIG. 12

Claes Oldenburg,
*Artists Call Against
U.S. Intervention in
Central America*,
1984, offset, 37 × 24 in.
Courtesy Center
for the Study of
Political Graphics.

so-called banana republics as a Cold
War effort to prevent the "threat" of
communism. Sigüenza cleverly appro-
priated two characters from Milton
Caniff comics: the Dragon Lady and
Steve Canyon.[39] The highly visible
Ben-Day dots on the figures recall
Roy Lichtenstein's pop canvases, but
unlike images meant to jolt viewers
into awareness of the horrors of war
taking place in these remote locations,
Sigüenza parodies the military might
of Reagan-era politics. The Dragon Lady
looks angrily at her male counterpart
and utters the bold phrase, "It's simple
Steve, why don't you and your boys

ARTISTS CALL AGAINST U.S. INTERVENTION IN CENTRAL AMERICA

IF WE CAN SIMPLY WITNESS THE DESTRUCTION OF ANOTHER CULTURE, WE ARE SACRIFICING OUR OWN RIGHT TO MAKE CULTURE. ANYONE WHO HAS EVER PROTESTED REPRESSION ANYWHERE SHOULD CONSIDER THE RESPONSIBILITY TO DEFEND THE CULTURE AND RIGHTS OF THE CENTRAL AMERICAN PEOPLE.

THE ARTS ARE USED BY OUR GOVERNMENT AS EVIDENCE OF CREATIVE FREEDOM, AND THE LACK OF CENSORSHIP IN A DEMOCRACY. AT THE SAME TIME, THE REAGAN ADMINISTRATION DENIES THE PEOPLE OF CENTRAL AMERICA THE RIGHT TO SELF-DETERMINATION AND TO INDEPENDENCE.

IT IS OF THE UTMOST IMPORTANCE THAT THE PEOPLE OF NORTH AMERICA EXPRESS NOW OUR DEEP CONCERN FOR PEACE AND FREEDOM IN CENTRAL AMERICA, WHERE THE SITUATION BECOMES MORE CRITICAL EACH DAY.

THE U.S. GOVERNMENT CONTINUES TO AMPLIFY ITS MILITARY PRESENCE IN THE REGION, AND IN THE CASE OF NICARAGUA, TO IMPOSE UNJUST ECONOMIC SANCTIONS THAT MAKE LIFE EVEN HARDER FOR ITS INHABITANTS. HONDURAS HAS BEEN TRANSFORMED INTO A GIGANTIC MILITARY BASE, THE ONGOING GENOCIDE OF GUATEMALAN INDIANS IS IGNORED, AND AN UNDECLARED OVERT WAR IS BEING WAGED AGAINST NICARAGUA. EXTENSIVE MILITARY ASSISTANCE IS GIVEN TO A GOVERNMENT IN EL SALVADOR THAT VIOLATES INTERNATIONALLY RECOGNIZED HUMAN RIGHTS BY SUBJECTING PRISONERS TO INHUMANE PUNISHMENT, BY CLOSING THE NATIONAL UNIVERSITY AND BY TOLERATING POLITICAL ASSASSINATIONS BY RIGHT-WING DEATH SQUADS.

ACCORDING TO A REPORT SUBMITTED BY AMNESTY INTERNATIONAL TO THE COMMITTEE ON FOREIGN AFFAIRS OF THE U.S. CONGRESS ON JULY 26, 1983, TEACHERS AND ACADEMICS IN PARTICULAR HAVE BEEN TARGETED FOR REPRESSION BECAUSE, AS POTENTIAL COMMUNITY LEADERS, THEY FOCUS OPPOSITION TO THE AUTHORITIES. ARTISTS, WRITERS, POETS, MUSICIANS, JOURNALISTS, WORKERS, UNION MEMBERS AND MEDICAL PERSONNEL ARE ALSO AMONG THE 35,000 VICTIMS OF MURDER AND TORTURE BY THE U.S.-BACKED FORCES IN EL SALVADOR IN THE LAST THREE YEARS. OVER 1000 PEOPLE, MANY OF THEM INNOCENT CIVILIANS, HAVE BEEN KILLED BY THE U.S.-BACKED COUNTER-REVOLUTIONARIES IN NICARAGUA IN THE LAST YEAR.

THE U.S. GOVERNMENT RECOGNIZES HUMAN RIGHTS LAWS AS BINDING ON THE INTERNATIONAL COMMUNITY AND AT THE SAME TIME GIVES MILITARY AND ECONOMIC SUPPORT TO A GOVERNMENT IN EL SALVADOR THAT OPENLY VIOLATES THESE LAWS. THE U.S. GOVERNMENT RECOGNIZES THE RIGHT TO NATIONAL SELF-DETERMINATION, AND AT THE SAME TIME, SUPPORTS DAILY INCURSIONS INTO NICARAGUA.

WE CALL UPON THE REAGAN ADMINISTRATION TO HALT MILITARY AND ECONOMIC SUPPORT TO THE GOVERNMENTS OF EL SALVADOR AND GUATEMALA, TO STOP THE MILITARY BUILDUP IN HONDURAS AND TO CEASE SUPPORT OF THE CONTRAS IN NICARAGUA.

INTERVENTION BY THE U.S. GOVERNMENT INEVITABLY REINFORCES COLONIALIST AND OLIGARCHICAL ELEMENTS HOSTILE TO THE PEOPLE, AS THE INVASION OF GRENADA DEMONSTRATES. THEREFORE, WE CALL UPON THE REAGAN ADMINISTRATION AND THE U.S. CONGRESS TO RESPECT THE RIGHT OF THE CENTRAL AMERICAN PEOPLES TO SELF-DETERMINATION AND TO STOP INTERFERING IN THEIR INTERNAL AFFAIRS. WE MUST SPEAK OUT AGAINST THESE BURNING INJUSTICES NOW AND WE WILL CONTINUE TO DO SO AS LONG AS IT IS NECESSARY.

ARTISTS CALL AGAINST U.S. INTERVENTION IN CENTRAL AMERICA IS A NATIONWIDE MOBILIZATION OF ARTISTS ORGANIZING OUT OF NEW YORK CITY. A HUGE SERIES OF EXHIBITIONS AND EVENTS WILL BE CENTERED AROUND JANUARY 22ND—THE 52ND ANNIVERSARY OF THE 1932 MASSACRE IN EL SALVADOR WHICH MARKED THE BEGINNING OF THE SYSTEMATIC DESTRUCTION OF THE SALVADORAN CULTURE. IN CONJUNCTION WITH THE INALSE (THE INSTITUTE FOR THE ARTS AND LETTERS OF EL SALVADOR IN EXILE) AND IN COOPERATION WITH THE ASTC (THE SANDINISTA ASSOCIATION OF CULTURAL WORKERS)— ARTISTS CALL WILL JOINTLY EXHIBIT ART FROM CENTRAL AMERICA, ART ABOUT CENTRAL AMERICA AND ART IN SUPPORT OF CENTRAL AMERICA, AS A POLITICAL AND ESTHETIC STRATEGY TO CALL ATTENTION TO CENTRAL AMERICAN ISSUES. ARTISTS CALL REPRESENTS THE OUTRAGE OF THOUSANDS OF ARTISTS AND INTELLECTUALS CONCERNED WITH THE REPRESSION OF THE CRUCIAL CULTURAL RIGHTS OF ALL PEOPLE.

ARTISTS CALL GENERAL STATEMENT, JANUARY 1984

sovereignty. Many of the artists who took part in this public campaign came of age during the Vietnam conflict. Much like Martha Rosler's insistence in drawing connections between impe-rialism and the way American homes reproduced and enabled this militarism abroad, Artists Call artists saw U.S. intervention in Central America as a continuation of Cold War politics that disguised imperialism as benevolence. But while these artistic actions garnered much attention as collective and cre-ative bursts of civil disobedience, such oppositional practices owed their intel-lectual origins in large part to artists like Sigüenza, and poets such as Nina Serrano, Roberto Vargas, and Alejandro Murguía, whose public forms of protest denounced the violence that had forced them to flee to the United States.[42]

The conceptual goal of combating misinformation harks back to anti-war interventions of the 1960s that pro-moted expanded horizons of possibility. Yoko Ono and John Lennon's poster *War Is Over! If You Want It* (**FIG. 13**) is one such gesture that publicly proclaims peace as a viable alternative to endless war. The Texas–based artist Vincent Valdez revisits their work in *Thanks Anyway, John & Yoko* (**FIG. 14**). Produced at Austin's Coronado Studio, *Thanks Anyway* is a cheeky riff on Lennon and Ono's newspaper publication. Part homage, part painful surrender, Valdez's print reflects on America's ongoing wars in Iraq and Afghanistan, and the effects of these experiences on U.S. soldiers: in 2009, post-traumatic stress

FIG. 15

Vincent Valdez,
Home, video still from
the series *Excerpts
for John*, 2012,
single-channel video;
color, sound, running
time 09:16 mins.
Smithsonian American
Art Museum, Museum
purchase through
the Frank K. Ribelin
Endowment, 2019.37.

disorder claimed the life of his friend John Holt. In a single-channel video made in 2012, Valdez brought the war home in the form of his friend's casket (**FIG. 15**).[43] Draped in an American flag, the coffin floats through San Antonio's streets in an act of mourning.

Valdez's memorial to the loss of his friend, and the silence that surrounds these deaths, places us within a post–9/11 context when the United States went to war after a shocking terrorist attack on American soil. But the War on Terror masked another aspect of the war at home: September 11 gave rise to an intense wave of U.S. nationalism and its underside of xenophobia, which had not been witnessed since the 1930s. The nation quickly redrew its borders, revised security procedures at ports of entry, and launched Immigration and Customs Enforcement for internal policing and what can only be described as an Orwellian system of surveillance.

Muslim Americans were the first target, and their allegiance deeply questioned, though soon this suspicion spread to other racialized immigrant groups. An infamous tweet from the White House in 2019 about prayer rugs found at the southern border, and the government shutdown that same year, are but symptoms of how the state deploys "racial scripts" to associate immigrants with criminality.[44] While protecting the homeland, the state worked diligently to criminalize illegal entry, and undocumented immigrants of Latin American descent became the target of a deportation machine.

Among the reasons that illegal entry at the southern border has been conflated with criminality are the effects of the War on Drugs. When the United States began to pursue Colombian cartels in the 1980s and '90s, smuggling operations began to alter their routes to pass through Central America and

FIG. 16

Miguel A. Aragón,
Letrero, from
the series *Memoria
fracturada*, 2012,
burnt residue em-
bossing, 22 × 30 in.
Courtesy of
the artist.

Mexico. The U.S.-Mexico border
became the primary entry point for
illegal drug trafficking, and the United
States eventually responded with in-
creased militarization, and pressured
the Mexican state to do the same.
These economic and military forces
converged dramatically in the city of
Juárez, across from El Paso, Texas,
a trans-frontier metropolis of over two
million that in 2010 became the dead-
liest city in the world.[45] When president
Felipe Calderón deployed federal
troops to combat the Juárez, Sinaloa,
and Zetas cartels, the murder rate
doubled in Juárez.[46] The media spec-
tacle followed, and gruesome images
of public executions, lynched bodies
hanging off of bridges, armored vehi-
cles filled with young men carrying

assault rifles purchased in U.S. border
states, and pink crosses for murdered
women filled the newspapers and daily
broadcasts. The imagery seeped into
popular culture narratives all too fam-
iliar in Hollywood depictions such as
Sicario (2015) and television dramas
such as the popular series *Narcos*
(2015). For the artist Miguel Aragón,
who was born in Juárez, these images
were burned into the popular con-
sciousness. Toward the end of his
MFA in printmaking at the University
of Texas at Austin, he began to exper-
iment with laser-cut burnt residue
embossing and mined the archive of
Juárez newspapers that covered the
Drug War. The results are seen in his
ongoing *White Juárez* series, which
are poignant reminders of how the

U.S. demand for illicit drugs and sale of legal assault weapons fuels the ongoing violence.

In *Letrero*, part of the series *Memoria fracturada*, Aragón brings the war home in the form of an erasure (**FIG. 16**). He takes the hypervisibility of narco violence and through a process of extraction renders only minor details using burning and embossment. The viewer must work hard, moving forward and backward until they can gradually make out a body, a menacing note, an abandoned and window-blasted vehicle. Unlike Teresa Margolles's more overt references to bloodshed and slaughter, most evident in her installation piece at the Mexican Pavilion of the 53rd Venice Biennale in 2009 (**FIG. 17**), Aragón erases the spectacle of death that has become widely accepted as the representation of the real. He erases much of the photographs in order to make visible the biopolitical framework that renders these deaths meaningless and necessary. The iconoclasm of erasure recalls an earlier work by Robert Rauschenberg. In *Erased de Kooning Drawing* (**FIG. 18**) he sought to remove the marks of a master artist through laborious erasure. Rauschenberg's homage and assault forced many to question the ontology of art. Aragón is likewise quoting these erasures. But rather than question the nature of art, he calls on the viewer to question the fabricated nature of these newspaper images, their power to spread stereotypical representations about immigrant populations, their power to hide the larger economic forces that shape border violence.

FIG. 17

Installation view of Teresa Margolles, *Narcomessages*, fabric soaked with blood gathered from sites where murders took place, progressively embroidered with message stitched in gold thread, *What Else Could We Talk About?*, Mexican Pavilion, curated by Cuauhtémoc Medina, 53rd Venice Biennale, May 2009.

CREATIVE DESTRUCTION

What most of these artists point out through formal means, textual interventions, insightful art-historical allusions, and wicked humor is that John Jacobs's call to "bring the war home" failed to acknowledge that the war was already here. It did not have the hypervisibility of the Vietnam War or the overt violence of South America's dictatorships. The war at home was slow, systematic, sustained, forcible, legal, and eventually normalized. Artist Ramiro Gomez dwells on the latter in *All About Family* (**PL. 104**), a large-scale reproduction of a lifestyle magazine cover in which he meticulously reinserted the image of a dark-skinned nanny pushing a stroller with two white children. Reminiscent of Martha Rosler's now iconic montage series, Gomez's work grew out of his personal interest to document the workforce of predominantly Latinx immigrants who, like himself, tended the homes, children, and gardens of affluent Los Angeles.[47] This play on scale, along with the text and incongruence of the painted figures, is designed to capture viewers' attention and prompt them to reflect on the invisible lives and shadow

economies that fuel that lifestyle. Gomez is an heir to the conceptual iconoclastic practices discussed in this essay. Working in a variety of styles and repertoires, these artists are notable for denouncing the war at home and revealing the pernicious way it operates on a day-to-day basis. Through experimental print practices that dematerialize destruction, they push viewers to question the icons of U.S. nationalism based on empire and white power. They do so not only as an oppositional response to exclusion, but as a way of creating social life otherwise.

This trend of conceptual iconoclasm in printmaking attests to what curator Chon A. Noriega calls the "meanwhile" because, while waiting for justice, these artists have been carrying out creative destruction all along, and in the process have transformed the rubric of conceptual art in the Americas.[48] It is now our task to return to the earliest iterations of this print renaissance both to show how printmaking is a purveyor of conceptual breakthroughs, and to question their place in art history.[49] Their counter-propositions are part of the canon of American printmaking that must be understood as indeed transnational and hemispheric.[50]

FIG. 18

Robert Rauschenberg, *Erased de Kooning Drawing*, 1953, traces of drawing media on paper with label hand-lettered in ink, and gilded frame, 25 ¼ × 21 ¾ × ½ in. San Francisco Museum of Modern Art, Purchase through a gift of Phyllis C. Wattis.

NOTES

1 Jos Sances, phone interview with author, September 4, 2019.

2 Cary Cordova, *The Heart of the Mission: Latino Art and Politics in San Francisco* (Philadelphia: University of Pennsylvania Press, 2017), 235.

3 Current members include Rio Yañez, Art Hazelwood, Jos Sances, and Lucia Pulido.

4 Here I am invoking the power of baroque images addressed by Serge Gruzinski, *Images at War: Mexico from Columbus to Blade Runner (1492–2019)*, trans. Heather MacLean (Durham, NC: Duke University Press, 2001). I am grateful to an anonymous peer reviewer who also pointed out that the image may gesture to Juan Diego's *tilma* (cotton blanket), where the Virgin is said to have appeared in 1531, as the first print in the Americas.

5 Curatorial projects such as *Phantom Sightings: Art After the Chicano Movement* (2008) and *Asco: Elite of the Obscure* (2011) have been at the forefront of reorienting the historiographical narrative to push past rigid tenets of cultural nationalism and highlight conceptual practices.

6 One significant example of this trend is an essay that I often use in my teaching, George Lipsitz, "Not Just Another Social Movement: Poster Art and the Movimiento Chicano," in *¿Just Another Poster? Chicano Graphic Arts in California*, ed. Chon A. Noriega (Santa Barbara, CA: University Art Museum, 2001), 71–89.

7 There are differing viewpoints on the exact chronology of conceptualism. In their book *Global Conceptualism*, Luis Camnitzer, Jane Farver, and Rachel Weiss frame their chronology between the 1950s and 1980s. Benjamin H. D. Buchloh subscribes to a more rigid periodization between 1962 and 1969 in what has come to be regarded as the height of North American and European conceptualism. Meanwhile, Alexander Alberro extends this chronology a bit further, from 1966 to 1977, and cites three phases: the development of serial and highly schematic structures; the dematerialization of objects where visuality and quality were challenged and textual forms expand; and the placement of art in a particular site/environment, sometimes within a public context or a distributive mode.

8 Benjamin H. D. Buchloh, "Conceptual Art 1962–1969: From the Aesthetic of Administration to the Critique of Institutions," *October* 55 (Winter 1990): 134.

9 See, for example, Miguel A. López and Josephine Watson, "How Do We Know What Latin American Conceptualism Looks Like?," *Afterall: A Journal of Art, Context and Enquiry*, no. 23 (2010): 5–21; and Carla Macchiavello, "Appropriating the Improper: The Problem of Influence in Latin American Art," *ARTMargins* 3, no. 2 (2014): 31–59.

10 See, for example, Alexander Alberro, "Reconsidering Conceptual Art, 1966–1977," in *Conceptual Art: A Critical Anthology*, ed. Alexander Alberro and Blake Stimson (Cambridge, MA: MIT Press, 1999), xvi–xxxvii; Mari Carmen Ramírez, "Tactics for Thriving on Adversity: Conceptualism in Latin America, 1960–1980," in *Global Conceptualism: Points of Origin 1950s–1980s*, ed. by Luis Camnitzer, Jane Farver, and Rachel Weiss (New York: Queens Museum of Art, 1999), 53–71; and the popular textbook by Jacqueline Barnitz, *Twentieth-Century Art of Latin America* (Austin: University of Texas Press, 2001), 275–97.

11 Rosler's photomontage series began as anti-war flyers when the artist was still living in New York. As the series progressed, the title was added at a later date. Martha Rosler, email communication with author/editor, November 20, 2019. See also Melissa Ho, ed., *Artists Respond: American Art and the Vietnam War, 1965–1975* (Washington, DC: Smithsonian American Art Museum in association with Princeton University Press, 2019).

12 Rosalyn Deutsche, "Unrest," in *Martha Rosler: Irrespective* (New York: Jewish Museum in association with Yale University Press, 2018), 22.

13 For a discussion of López's conceptual art training at UCSD, see Karen Mary Davalos, *Yolanda M. López* (Los Angeles: UCLA Chicano Studies Research Center Press, 2008), 58–62.

14 Rosler, email communication.

15 Darsie Alexander, introduction to *Martha Rosler: Irrespective*, 11.

16 The dynamic parallels and synchronicities between African American and Latinx artists are further explored in Jennifer González, *Subject to Display: Reframing Race in Contemporary Installation Art* (Cambridge, MA: MIT Press, 2008), and are a central concern for a new wave of scholars in the field, including Rose Salseda, Mary Thomas, and J. V. Decemvirale.

17 Davalos, *Yolanda M. López*, 35.

18 Esther Gabara, "Contesting Freedom," in *Pop América, 1965–1975*, ed. Esther Gabara (Durham, NC: Nasher Museum of Art at Duke University, 2018), 10–11.

19 Ricardo Duffy, interview with author, February 24, 2018.

20 George H. W. Bush, "Address Before a Joint Session of the Congress on the Persian Gulf Crisis and the Federal Budget Deficit," September 11, 1990, George H. W. Bush Presidential Library and Museum, College Station, TX, https://bush41library.tamu.edu/archives/public-papers/2217.

21 This focus on indigeneity and its origins in the mythic homeland of Aztlán are explored further in Rafael Pérez-Torres, "Remapping Chicano Expressive Culture," in Noriega, *¿Just Another Poster?*, 165–67.

22 Nancy Spector, *Richard Prince* (New York: Guggenheim Museum, 2007), 33; *Untitled (Cowboy)* is on p. 88. For a discussion of Marlboro's cowboy models, see Adrian Shirk, "The Real Marlboro Man," *Atlantic*, February 17, 2015, https://www.theatlantic.com/business/archive/2015/02/the-real-marlboro-man/385447/.

23 Gina McDaniel Tarver, *The New Iconoclasts: From Art of a New Reality to Conceptual Art in Colombia, 1961–1975* (Bogotá: Universidad de los Andes, 2016), 210.

24 Tarver, 263.

25 Tarver, 266.

26 Camila Maroja, "Pop Goes Conceptual: Visual Language in América," in Gabara, *Pop América*, 43.

27 Luis Camnitzer, *Conceptualism in Latin American Art: Didactics of Liberation* (Austin: University of Texas Press, 2007), 14.

28 Tarver, *New Iconoclasts*, 211.

29 For more on Asco, see C. Ondine Chavoya and Rita Gonzalez, eds., *Asco: Elite of the Obscure* (Ostfildern: Hatje Cantz, 2011); Chon A. Noriega, "'Your Art Disgusts Me': Early Asco, 1971–75," *Afterall: A Journal of Art, Context and Enquiry*, no. 19 (2008): 109–21. For the Border Art Workshop, see Jo-Anne

Berelowitz, "Conflict over 'Border Art,'" *Third Text* 11, no. 40 (1997): 69–83; and Ila N. Sheren, *Portable Borders: Performance Art and Politics on the US Frontera since 1984* (Austin: University of Texas Press, 2015), 23–58.

30 Leticia Alvarado, "Malflora Aberrant Femininities," in *Axis Mundo: Queer Networks in Chicano L.A.*, ed. C. Ondine Chavoya and David Evans Frantz (Los Angeles: ONE National Gay & Lesbian Archives at the USC Libraries with DelMonico/Prestel, 2017), 97.

31 Terezita Romo, "Conceptually Divine: Patssi Valdez's Vírgen de Guadalupe Walking the Mural," in Chavoya and Gonzalez, *Asco: Elite of the Obscure*, 276.

32 Oral history interview with Patssi Valdez, 1999 May 26–June 2, Archives of American Art, Smithsonian Institution.

33 Josh Kun, "The Personal Equator: Patssi Valdez at the Border," in Chavoya and Gonzalez, *Asco: Elite of the Obscure*, 359–60.

34 C. Ondine Chavoya, "Collaborative Public Art and Multimedia Installation: David Avalos, Louis Hock, and Elizabeth Sisco s *Welcome to America's Finest Tourist Plantation* (1988)," in *The Ethnic Eye: Latino Media Arts*, ed. Chon A. Noriega and Ana M. López (Minneapolis: University of Minnesota Press, 1996), 208–27.

35 Amy Sara Carroll, *REMEX: Toward an Art History of the NAFTA Era* (Austin: University of Texas Press, 2017), 207–3; for an interview of the artists, see Cylena Simonds, "Public Audit: An Interview with Elizabeth Sisco, Louis Hock, and David Avalos," *Afterimage* 22, no. 1 (Summer 1994): 8–11. The 1972 Republican National Convention was relocated to Miami following a campaign financing scandal and inadequate hotel space.

36 Chavoya, "Collaborative Public Art," 211.

37 This is how the authors of *Global Conceptualism* define the style. Camnitzer, Farver, and Weiss, *Global Conceptualism*, vii.

38 Robin D. G. Kelley, *Yo' Mama's Disfunktional! Fighting the Culture Wars in Urban America* (Boston: Beacon Press, 1997) 4. For an image of the 1979 milk truck protest, see http://www.memoriachilena.gob.cl/602/w3-article-72755.html.

39 Carol A. Wells, "La Lucha Sigue: From East Los Angeles to the Middle East," in Noriega, *¿Just Another Poster?*, 183.

40 Tatiana Reinoza, "'No Es un Crimen': Posters, Political Prisoners, and the Mission Counterpublics," *Aztlán: A Journal of Chicano Studies* 42, no. 1 (Spring 2017): 239–56.

41 Lippard's *Six Years* is among her most-cited published works. A curatorial archive project, the book catalogued the emergence of conceptual art across the globe through critical writings, interviews, and photographs. Lucy R. Lippard, *Six Years: The Dematerialization of the Art Object from 1966 to 1972* (New York: Praeger, 1973). See also its critical engagement through the Brooklyn Museum's exhibition and publication *Materializing "Six Years": Lucy R. Lippard and the Emergence of Conceptual Art*, ed. Catherine Morris and Vincent Bonin (Cambridge, MA: MIT Press, 2012).

42 Cordova, *Heart of the Mission*, 152–77.

43 Taína Caragol, "When War Hits Home," *Face to Face* (blog), National Portrait Gallery, Smithsonian Institution, https://npg.si.edu/blog/when-war-hits-home. For the video, visit: https://vimeo.com/50871322.

44 Natalia Molina, *How Race Is Made in America: Immigration, Citizenship, and the Historical Power of Racial Scripts* (Berkeley: University of California Press, 2014), 7.

45 Sarah Hill, "The War for Drugs: How Juárez Became the World's Deadliest City," *Boston Review* (July/August 2010), http://bostonreview.net/archives/BR35.4/hill.php.

46 For more on the violence in Juárez, see Charles Bowden, *Murder City: Ciudad Juárez and the Global Economy's New Killing Fields* (New York: Nation Books, 2011); Peter Watt and Roberto Zepeda, *Drug War Mexico: Politics, Neoliberalism, and Violence in the New Narcoeconomy* (New York: Zed Books, 2012); and Stephen Eisenhammer, "Bare Life in Ciudad Juárez: Violence in a Space of Exclusion," *Latin American Perspectives* 41, no. 2 (March 2014): 99–109.

47 Lawrence Weschler, *Domestic Scenes: The Art of Ramiro Gomez* (New York: Abrams, 2016), 9.

48 At a recent panel, Chon A. Noriega encouraged scholars of Latinx art histories to create alternative historiographies, ones that shine a light in ways that can pierce through rigid canon formations. He concluded his commentary with the message, "Do not accept exclusion as the framework with which you speak, start with the meanwhile." This essay takes his advice to heart in order to show the unique contributions to conceptualism that the artists of *¡Printing the Revolution¡* produced both in tandem with and sometimes prior to more canonical examples. Chon A. Noriega, "Decolonizing American Art: Chicanx Art and Wars of Influence" (paper presentation, Latino Art Now! Conference, Houston, TX, April 6, 2019).

49 The medium of printmaking, with its focus on technique and craft, is rarely heralded as a purveyor of conceptualism's breakthroughs. Rare examples of research connecting printmaking to conceptualism's avant-gardes include Gabriel Pérez-Barreiro, Ursula Davila-Villa, and Gina McDaniel Tarver, eds., *The New York Graphic Workshop, 1964–1970* (Austin: Blanton Museum of Art, University of Texas at Austin, 2009); Karin Breuer, *Thirty Five Years at Crown Point Press: Making Prints, Doing Art* (San Francisco: Fine Arts Museums of San Francisco, 1997); Elizabeth C. DeRose, "León Ferrari's *Heliografías*," *Art in Print* 5, no. 3 (September–October 2015), 27–31; and monographs on artists such as Ed Ruscha and John Baldessari. The question of their place in art history was first posed by Noriega when he remarked, "This poster [Luis C. González, *This Is Just Another Poster*, 1976] offers an astute and deeply ironic commentary on its own place in art history...it is a poster about being a poster," and therefore somewhere between the modern and the postmodern condition. Chon A. Noriega, "Postermodernism; or Why This Is Just Another Poster," in Noriega, *¿Just Another Poster?*, 20–21.

50 I thank the three anonymous peer reviewers whose insightful comments brought clarity and depth to my analysis. I would also like to acknowledge Ana Báez, Mary Coffey, and Robb Hernández for reading an early draft of this essay. Finally, I have two wonderful research assistants to thank, Alondra Alonso and Isabella Di Bono Becerra, who kindly assisted me in tracking down sources.

Claudia E. Zapata

CHICANX GRAPHICS IN THE DIGITAL AGE

n July 1989, César Chávez stood with Chicana artist Barbara Carrasco (**FIG. 1**) as he looked up at the Spectacolor lightboard and said, "Is your work really going up there?"[1] The lightboard was an 800-square-foot digital billboard in the middle of New York's Times Square.[2] From 1982 to 1990, the Public Art Fund invited eight-four contemporary artists to present computer-generated works on thirty-second spots in between advertisements.[3] Carrasco created *Pesticides!*, an animation expressing the dangers in agribusiness (**PL. 55**).[4] Frame by frame Carrasco "electronically shouted" the harmful effects of the toxic chemicals, following their path from a dust cropper spraying fields, to a farmworker picking grapes and falling ill, and finally to consumers' rejection and subsequent boycott of the "poisoned" grapes.[5] The experience greatly affected Carrasco's incorporation of digital strategies in her work and would herald a changing practice among Chicanx artists to come.[6]

The digital revolution of the 1980s brought influential technological advancements for Chicanx artistic production.[7] Much more than providing additional tools, such innovation has changed the very nature of art-making. Media theoretician Oliver Grau has called for moving beyond a medium-as-tool metaphor, and instead proposes viewing digital arts as a dialogue between artist and their chosen media.[8] Personal computing, the smartphone, the internet, and the web represent the ever-changing resources that have allowed Chicanx artists to champion underserved communities and cultivate audience interactivity, in the process redefining graphic forms for the greater good of solidarity.

Oree Originol,
*Justice for
Layleen Polanco,*
from *Justice for
Our Lives,*
2014–present,
pl. 119.

FIG. 1

César Chávez and Barbara Carrasco standing in front of the Spectacolor lightboard, Times Square, New York, 1989. Courtesy of Barbara Carrasco.

This socially engaged practice has not replaced canonical Chicanx art forms, such as the political print or public mural; rather, digital platforms help Chicanx artists diversify graphic outputs in order to continue the advocacy objectives of protesting injustice, improving education, cultural self-

reflection, and solidarity with oppressed populations formalized since the early Chicano movement of the 1960s and 1970s. Historically, Chicano graphics or graphic arts refers to the Chicano poster and print.[9] The two-dimensional work on paper is the hallmark of the Chicanx artistic canon, and printmaking continues to be one of Chicanx artists' major contributions to the field of art history and activism. As Terezita Romo states, "Chicano poster artists [in the 1960s and 1970s] functioned as the unofficial conscience of the country."[10]

Today, Chicanx artists participate in technological exchange centers, distribute their works online, and weave augmented reality (AR) and virtual reality (VR) technology into their artistic practice as a way to broaden interpretations of the graphic form.[11] Definitions of Chicanx graphics should continue to expand in order to recognize the value and role of the graphical user interface, computer-based artistic processes, and communication networks, and to capture the diversity and shared creativity of contemporary political graphic arts. New media theorist Lev Manovich argues that the structure of computer-generated, or digital, images exists in both a "cultural layer" and the "computer layer."[12] The data structures that define the computer layers and the cultural context of the digitally represented iconography together result in a new composite experience. For Chicanx digital graphics, the "cultural layer" is the foundational objective, which prioritizes urgent visual messages

as a form of political resistance begun in the Chicano movement.

Contemporary Chicanx political graphics often encompass both digital and analog media. As Carol Wells reminds, "You're not going to walk into a protest with your computer monitor, or on your lawn. Even in this hi-tech age, posters need to be printed."[13] And in the 1960s, media analyst Marshall McLuhan noted that a "new medium is never an addition to an old one, nor does it leave the old one in peace. It never ceases to oppress the older media until it finds new shapes and position for them."[14] For Chicanx artists, paper-based political graphics are not waning because of the digital age. Instead, digital modalities offer new opportunities to visualize political resistance, and they define the ongoing adaptive role of the artist as cultural agitator.

Conceptually, these new Chicanx digital forms may be incorporated into new media art, digital art, net art, post-internet art, virtual art, cyber art, computer art, and other technologically adjacent artistic genres.[15] Early forms of computer art emerged in 1995 with Lucia Grossberger-Morales's *Sangre Boliviana*, a personal narrative about her native Bolivia in the form of a digital anthology "art disk."[16] In 1998, Electronic Disturbance Theater staged a virtual sit-in using the online tool FloodNet, in support of the Zapatistas that had users crash the websites of the U.S. Pentagon, Mexican president Ernesto Zedillo, and the Frankfurt Stock Exchange.[17] The 2001 exhibition *Cyber Arte: Where Tradition Meets Technology*, curated by Tey Marianna Nunn, highlighted artists blending "folk" images and technology, such as Teresa Archuleta-Sagel's digital tapestries.[18]

Chicanx artists have actively participated in each technological paradigm shift, unearthing and connecting these digitally informed efforts to lay the foundation for a new lens of Chicanx study. What is striking is how the rally cries of disruption, empowerment, and resistance of previous generations reverberate in such efforts. This conceptual relationality among critical advancements in technology underscores the shared objective of shaping a decolonial consciousness, to infiltrate and dismantle systems of oppression by whatever means necessary.

TECHNOLOGICAL EXCHANGE CENTERS

In 1989, Barbara Carrasco participated in the Public Art Fund's outdoor computer animation series called Messages to the Public.[19] The program offered selected artists a unique opportunity to partner with computer programmers and develop animated sequences for display on the public Spectacolor lightboard in New York's Times Square. Carrasco used the occasion to continue her longtime support of the United Farm Workers (UFW).[20]

By 1989, the UFW was undertaking César Chávez's third and last major strike, known as the Wrath of Grapes Boycott.[21] The decade saw the UFW campaigning

against the dangers of agricultural pesticides, focusing their efforts on "high tech boycott" initiatives that used computer technologies and new media for dispersing their message.[22] Carrasco echoed this contemporary cause. She worked with the Public Art Fund programmer to create the final sequence for her work, *Pesticides!*[23] Her unnamed characters represent the various constituents adversely affected by pesticides used on the "poisoned" grapes, from farmworkers to consumers. As the animation unfolds and each figure is introduced, the deviant foodways are revealed.

Carrasco's figures are not elaborate or sophisticated, a result of the limited number of pixels available on the lightboard screen.[24] The animation's pacing creates a framed storytelling, like an animated comic book, with fades and dissolves added between actions. The combination of red, blue, green, and white bulbs to create "illusions" of colors such as purple aides the narration and situates the characters' settings, from the green farm fields to the purple grapes.[25]

Despite its technological constraints, Messages to the Public animations increased exposure to the selected artists, but most importantly the series acted as a center of exchange. Like the earlier brick-and-mortar Chicanx printmaking centers such as Self Help Graphics and their efforts in supporting artist residencies in screenprinting, Messages to the Public became a creative space for artists to experiment in

a digital medium under the tutelage of a master technician, in this case a computer programmer.[26] Carrasco used the opportunity to continue the UFW's boycott efforts and, like the UFW, to diversify the methods of spreading awareness. The project effected a shift in resistance media from the handmade poster and "agitprop in the open fields" to the far-reaching scope of digital capabilities in a public, urban landscape.[27]

Early adoption of emergent digital strategies is further illustrated in the artistic partnership of Rupert García and Magnolia Editions in Oakland, California (**FIG. 2**). Initially hesitant to incorporate digital tools into his graphic practice, García began to print at Magnolia Editions in the 1990s, working with owner Donald Farnsworth.[28] García viewed digital strategies as part of a commercial practice, that it would corrupt the purity of fine art.[29] Digital's print possibilities would have remained unexplored had Farnsworth not coaxed García into "contaminat[ing] my purity," as the artist noted. García, like Carrasco, eventually embraced the speed of artmaking with digital tools, and has no more interest in the time-consuming process of hand-cutting stencils to create print multiples. "Digitally I can think quicker about color," García explains, and he now believes the "computer is like an extension of the mind."[30]

García embraced this technological change to the point he proclaimed he did not need to do hand printing anymore.[31] His renouncement of hand printing seems paradoxical in a screen-

FIG. 2

Rupert García and Tallulah Terryll at Magnolia Editions in Oakland, California, 2008. Magnolia Editions, where the artist began working in the 1990s, introduced García to digital printing, transforming his graphic practice

printing career that spans several decades, yet it also defines García's practice in the digital age. His artwork with Magnolia Editions reflects artistic adaptation and curiosity in new techniques that afford a newfound speed, but most importantly it highlights García's ongoing efforts to address themes of social justice he has touched upon since the 1960s.

García's *Obama from Douglass* continues his multigenerational practice of Black solidarity and historical portraiture with a dedicatory triptych to political leaders Barack Obama and Frederick Douglass (PL. 78). The panel features a photograph of Douglass from 1879 taken by George Kendall Warren and an illustrated portrait of Obama.[32] Douglass was one of the greatest change makers in modern history, a major figure in the nineteenth-century abolitionist movement and the

first African American to receive several governmental appointments.[33] García originally wanted to do a solo portrait of Obama but realized his idea wanting, so he expanded the print's composition to include a portrait of Douglass, broadening his work into a creative space dedicated to influential presence.[34]

García's portrait of Barack Obama, the first Black president of the United States, continues his stylistic tradition of zoomed-in, brightly colored blocked historical portraiture. The panel situated between the two figures is a photograph of a print-trimming mat at the Magnolia Editions studio.[35] Both men represent historical firsts in their lifetime, but the central abstraction expresses the absurdity of a clean, linear evolutionary line connecting these occurrences. The repetitive mark-making is loose and abstract, gestural and unwieldy, while the flanking images are stoic and heroic. The central break undergirds the two figures and acts as a faceless archive of motion that parallels the indelible marks each man made on the United States.

Magnolia Editions and García produced *Obama from Douglass* as a pigmented inkjet print. The inkjet and software capabilities that made this possible are relatively recent, demonstrating the turn toward digital printing that began in the 1990s.[36] Inkjet is a non-impact printing method. Fine nozzles spray multicolored ink as they pass over support media, building up the image and creating a dense matrix of color

dots; the higher print quality has more dots per inch (dpi).[37] Inkjet's ability to achieve photographic-quality output and color accounts for its popularity over laser printing, making it best suited for multimedia-sourced works such as *Obama from Douglass* that include photographs. *Obama from Douglass* represents Magnolia Editions' diversification of the traditional print center and the newfound technical masteries that a master printer like Farnsworth can support.

Printmaker Daniel González's collaboration with Manny Torres of 2ndwnd studio showcases a similar partnership in realizing unprecedented digital possibilities. 2ndwnd, an "interdisciplinary design studio," assisted in the creation of González's laser-cut screenprint *Arte es Vida* (**PL. 100**).[38] Commissioned by Self Help Graphics & Art in Los Angeles, *Arte es Vida* is the fortieth-anniversary commemorative print for their Día de los Muertos (Day of the Dead) celebrations. The Chicano civil rights movement played a large role in shaping Day of the Dead in the United States, which was, according to Terezita Romo, "a momentous statement of cultural affirmation."[39] Community centers and graphic arts spaces such as Self Help are at the forefront of both preserving and redefining Day of the Dead's artistic objective. As scholar Karen Mary Davalos suggests, "Self Help Graphics & Art (SHG) created and continues to create an avant-garde multimedia art experience through Día de los Muertos."[40]

Since 1983, Self Help Graphics has contributed their transmedia support of the holiday through its Day of the Dead print commission program.[41] For his addition to this commemorative print legacy, González wanted to take Self Help in a "new direction" with his laser-cut screenprint.[42] This new approach to the print, like Day of the Dead itself, moves between past and present, honoring tradition while celebrating the new. In *Arte es Vida*, González reflected on Self Help's past forty years, the Mexican paper tradition of *papel picado* (punched paper), and new technological processes in printmaking.

Ornamental *papel picado* is prevalent among secular and religious outdoor celebrations, and modern Day of the Dead altars constructed of elements that move with the wind.[43] Artisans typically cut symmetrical designs on stacks of thin tissue paper with *fierritos* (chisels) and special cutting blades.[44] As a homage to this tradition, González re-created this paper-cutting effect with computer-based laser technology provided by Torres of 2ndwnd.[45] 2ndwnd works as a commercial design studio, focusing on everything from architectural design and fabrication to jewelry making, and despite the diversity of his clientele, before González's *Arte es Vida*, Torres had never used laser to cut a fine art print. To accommodate the screenprint paper, Torres adjusted his laser's settings, increasing the speed and lowering power.[46] After several experimentations, Torres and González produced the *papel picado* effect, printing up to

six at a time. This new computer-based technology and laser-cutting tool allowed González to transform his original screen-print and achieve unparalleled precise, fine cuts. Although there are aesthetic similarities with the traditional tissue-paper *papel picado,* Torres's screenprint completely rethinks Day of the Dead. González conceptualized his *papel picado* graphic as a broader reference to the holiday's principal belief of a coexistence among the dead and the living.[47] He echoed this duality in his chosen materials, using the print's negative space as an elegiac lamentation.

González's composition offers "a stunning visual narrative of the history of [Self Help Graphics] and Chicana/o art within the greater East Los Angeles community."[48] The com-position features canonical allegories to life and death, with the central skel-etal figure embedded within a tree. The foreground includes iconographic references to Self Help cofounder Sister Karen in the form of the Sacred Heart; the hypodermic needle refers to an earlier costume work by performance group Asco as a necropolitical com-mentary on the violence in East Los Angeles; the lowrider cites East LA Chicano artist Gilbert "Magu" Luján; and the goggle-eyed Mesoamerican water god Tlaloc symbolizes the ancient world that is ever present in Chicanx and Mexican culture.[49] The print acts as a graphic Day of the Dead altar, forming a dedicatory space to Self Help Graphics and using the negative space form of *papel picado.*

WEB 1.0

Al Gore did not invent the internet. However, as the internet architects Robert Kahn and Vinton Cerf recog-nized, he was "the first elected official to grasp the potential of computer communications to have a broader impact than just improving the conduct of science and scholarship. Though easily forgotten, now, at the time this was an unproven and controversial concept."[50] Over the past thirty years, an overwhelming number of people and moments have advanced the devel-opment and influence of the internet as a major form of mass communication. In the 1960s, decades before the inter-net became a reality, computer scientist J. C. R. Licklider conceived of a "Galactic Network" that would connect comput-ers and share information on a global scale.[51] Sir Tim Berners-Lee, who cre-ated the World Wide Web in 1989, saw the web as an "information space," and the introduction of the browser Mosaic in 1993 popularized the web and furthered its development.[52]

Early internet artists explored these emergent technologies and began carving out their own artistic space during the era known as Web 1.0, referred to as the "read-only Web" that defined the 1990s and the early 2000s.[53] This iteration of the web was about the passivity of its users viewing and down-loading content from a select number of publishers.

Chicana artist Jacalyn Lopez Garcia recalls "discovering" the internet and its

ability to offer "artists a different kind of imaginative viewer for their viewers."[54] Working with personal photography and influenced by the African American artist Lorna Simpson's exploration of identity construction, Garcia approaches website construction as a postmodern, auto-biographical exercise.[55] Lev Manovich, the new media theorist, challenges the ambivalence of postmodernity as an accused era of unoriginality, positing instead that computers generally and web pages specifically facilitate greater self-reflection by "borrow[ing] elements from existing objects."[56]

Using accumulated biographical material, in 1997 Garcia developed *Glass Houses*, an interactive multimedia website featuring digitized family photographs with introspective captions and digital art.[57] The site functions as a guided tour of the artist's personal history and memories where users are invited to explore her "house" by clicking on a *"chanclas"* (slippers) button, leading them through linked sub-pages of her digital home, such as ENTRANCE: Opportunity, and LIVING ROOM: History.[58] Garcia offers the "visitor" several linear and nonlinear sequences to wander through, allowing users to visualize the idiomatic expression "mi casa es su casa" (my house is your house), to journey through her digitized photos. Each "room" showcases photographs that act as the conceptual centerpiece and contextualize Garcia's doubt and apprehension about her identity.

On the last page of the "living room" sequence Garcia features three photographs of herself at different ages set against a floral wallpaper: the earliest, as a child, includes a caption-cum-self-identity of "Mexican"; the next, a teenaged version of the artist, identifies as "Mexican-American"; and for the adult portrait, Garcia settles on "Chicana" (**FIG. 3**). Underneath this self-taxonomy, Garcia poses the question: "How do we survive in a world driven by assimilation and maintain our cultural identity?"

The click-centered sequence builds to a crescendo, leading to her featured personal trifecta of political nomenclature. These photographs punctuate several generations' worth of contemplation and self-imposition, ultimately sharing an intimacy with the users who have digitally traveled her story. Garcia aims for vulnerability in the digital space in order to challenge early assumptions about technology: "As a web author I felt motivated to challenge the cold and impersonal environment often associated with the computer."[59] Garcia relied on the metaphor of the virtual space to create the illusion of a user's autonomy, using the site's graphical user interface, or icons such as *chanclas* or a keyhole, to connote personal choice, suggesting comparable personal journeys.[60]

Artists also looked to email, the early internet's "killer app," as a vital conduit for Chicana artistic exploration and the emergence of Chicanx digital networks.[61] Like the Chicano mail art networks in the 1970s that created a "sense of community cultivated by queer social networking," Chicana artist Alma Lopez

engaged with email as a form of distributing and networking her queer interpretations of Mexican imagery, such as the Virgin of Guadalupe in the 1990s.[62] Using early versions of Photoshop, a raster graphics editor, Lopez created digital collages and would email them to friends.[63]

Her most renowned emailed digital collage, *Our Lady*, features the artist's reclamation of the colonial Mexican image of the Virgin of Guadalupe (**PL. 59**).[64] Historically, the "immaculately" rendered image of the Virgin is part of colonial Mexican mythology and is a recurring image throughout Latin America and in Chicanx visual culture. Lopez's image of the Virgin is unique in its ability to traverse temporalities and objectives; as Luz Calvo frames it, she can be "deployed by different groups for contradictory political ends."[65] Lopez invokes the Virgin as a vehicle for critiquing Catholic hegemony over her representation, and created her own Virgin: one that is not demure, and one that is, most importantly, queer. Her Virgin's contrapposto evokes a "relaxed assertiveness," and her bare-breasted cherubic angel stares "unabashedly."[66] In this digital bricolage, Lopez confronts and dismantles the restrictive heteronormativity that the church-sanctioned Virgin embodies.

Her digital collage integrates digitized postcards, photographs, and digital graphics, resulting in a multidimensional overlap. The result is "digital *rasquachismo*": by infusing popular images from working-class Chicana visual culture with "high

technology," Lopez digitally disassembles the Virgin icon to create her own queer icon.[67] The artist self-identifies her digital editing as a form of "queering" her Mexican cultural ephemera, such as *lotería* cards, and Virgin of Guadalupe and Coyolxauhqui images.[68] The act of queering or visualizing a new realm of queerness is "essentially about the rejection of the here and now and insistence on potentiality or concrete possibility for another world."[69]

When it was displayed in 2001 in the now infamous *Cyber Arte: Where Tradition Meets Technology* exhibition, curated by Tey Marianna Nunn, the sexual forthrightness of Lopez's *Our Lady* caused controversy, similar to the unsettled response provoked by the animated human look-alikes in the metaphorical "uncanny valley."[70] The 1990s introduced the era of "photoshopping" in which images are manipulated using Photoshop, often to create an impossible reality centered on female physical perfection. The public's negative reception of the ersatz *Our Lady* was in part a retaliatory response to the absence of photoshopping by Lopez.

Lopez's personal image sharing to her contacts is representative of an emerging network of shareable graphics, artistic images shared across digital platforms for further distribution. The Web 1.0 platform of the 1990s facilitated these beginnings of artistic sharing, but it is the next phase of the web that consolidates a Chicanx retaliatory network and voice.

WEB 2.0

The emergence of Web 2.0, or the interactive web-based experience, has fundamentally changed web users' ability to interact with one another within an "architecture of participation."[71] This interactivity defines the social network boom in the aughts with the emergence of Myspace (2003), Facebook (2004), YouTube (2005), Twitter (2006), and Tumblr (2007).[72] These new channels, along with the perfunctory use of image-editing software such as Adobe Photoshop and Illustrator, have resulted in unique generational modalities in digital artistic production.

Artists are now able to create a "born-digital" work, or images that are electronically developed and distributed.[73] Digital content's unfettered portability translates to endless shareability through online social networks, creating an alternative gallery space for critical reception. For Chicanx artists, this electronic pipeline allows them to promote socially conscious art that creates a shareable database for the political zeitgeist, speaks to immediate and contemporary moments, and acts as a form of advocacy and pedagogy.

Artist websites, such as Favianna Rodriguez's Favianna.com, serve as a multimedia resource platform for their shareable graphics (**FIG. 4**). Rodriguez's digital space features instructional videos, free art downloads, and educational materials on how to stencil your own protest banner,

FAVIANNA RODRIGUEZ

ART WORK SHOP MEDIA ⌄ EVENTS ABOUT ⌄ CONTACT

RESOURCES

For Educators, Social Justice Organizers,
& Art Fans

This section features a selection of articles, hands-on art activities, instructional videos, reports, and publications created by or in collaboration with Favianna Rodriguez. These materials may be reproduced or shared for educational or non-commercial purposes.

Please share your reactions and images with our social media team by tagging us on social media: @favianna on Facebook, @favianna1 on Instagram, and @favianna on Twitter. We love to hear feedback and new ideas for resources, especially for classrooms. Send us a message on our Contact page.

MAKING WAVES
A Guide to Cultural Strategy

HOW TO MAKE STENCIL POSTERS
A hands-on art activity

MAKE YOUR OWN "MIGRATION IS BEAUTIFUL" POSTER
A coloring activity

HOW TO MAKE YOUR OWN BUTTERFLY WINGS
A hands-on art activity

RACIAL JUSTICE ART & STORY SESSIONS
An art and story based activity guide for understanding Racial Justice

UNTIL WE ARE ALL FREE ART KIT
An art kit to create social justice banners, stencils and protest signs

FRUITS & VEGGIES COLORING ACTIVITY FOR KIDS
A collaboration with MomsRising.org

FAVIANNA RODRIGUEZ: SELECTED ART WORKS
A slideshow of Favianna's art for educators

FIG. 4

Screenshot of "Resources" page from Favianna Rodriguez's website. Websites such as this serve as multimedia resource platforms for an artist's shareable graphics.

among other activities, using her shared work.[74] Rodriguez self-identifies as an "artivist," a portmanteau of *artist* and *activist*, recalling the early Chicano art movement practice of interpreting one's own artwork as a vehicle for social change.[75] Today, with so many more channels as a mouthpiece for her advocacy, Rodriguez's transmedia pervasiveness proffers her users a foundational image gallery for them to create "their own movement media."[76]

Many of her shared online works, such as *Migration Is Beautiful* (PL. 95), have become iconic images around

contemporary immigration advocacy.[77] The dominant monarch butterfly, "a symbol of fluid and peaceful migration," reminds viewers of the monarch's migratory patterns across the Americas.[78] *Migration Is Beautiful*'s design is also a nod to the sunray patterns prominent in the work of Emory Douglas, a graphic artist for the Black Panther Party, and the thick strokes that characterize the "Xerox art" of activist artist Rini Templeton (FIGS. 5, 6).[79] Rodriguez's accompanying phrase "migration is beautiful" is part of what journalist Cristina Costantini refers to as a hopeful rebranding of the

immigration movement.[80] The message is positive, but most importantly, it is, as Rodriguez states, "demanding" and declarative.[81] This approach to social injustice iconography is just as impactful as images that incite action and revolution because it humanizes the marginalized without a need to see them suffer.

Fellow artivist Julio Salgado uses blogs, or weblogs, to make visible previously unseen immigrants, and challenges the "false image of enclosure" in which they supposedly exist.[82] As a mentee of Favianna Rodriguez and a queer, undocumented artist, Salgado is part of an artivist community that aims to rethink immigrant-movement

branding in the United States by redefining the intersectional communities that fundamentally comprise it.[83] Salgado's artistic efforts focus on the experience of the "undocuqueer," or immigrants that are both undocumented and queer.[84] In a post on his Tumblr site in 2012, Salgado sought out other undocuqueers, asking for a photo of themselves and a personal reflection on their intersectional identities as an undocumented queer person (**PLS. 96–99**).[85] Salgado then created brightly colored digital portraits with hand-drawn text responses to share across social media platforms. Emphatic responses marked the relief of exposure, as in the caption for *I Am UndocuQueer-Reyna W.* (**PL. 99**): "COMING OUT OF THE SHADOWY CLOSET: UNDOCUMENTED AND QUEER, JOIN ME!" The phrase "coming out of the closet" is a recurring metaphor that the LGBTQ+ community closely aligns with the personal process of coming to terms with and sharing of one's own sexual identity. In this context, the metaphor suggests the additional variable of repressive existence for the undocuqueer.[86] As an undocumented artist, Salgado initially feared that engaging with street art might mean incarceration and deportation, so he sought social media as an alternative gallery space.[87] These digital platforms provide undocuqueer online users with increased mobility, intimacy, and often anonymity, together with a community and sense of empowerment to move their declarations off-line, if they so choose.[88]

Afro-American solidarity
with the oppressed
People of the world

The organization of social movements and their interplay between on- and off-line activism is part of liberation movements such as Black Lives Matter (BLM). In 2013 a Florida jury acquitted George Zimmerman of murder after the fatal shooting of Trayvon Martin. The verdict sparked intense social media discussion, prompting Alicia Garza, Patrisse Kahn-Cullors, and Opal Tometi to create a platform for the Black Lives Matter movement emerging from online dialogues and the hashtag #blacklivesmatter.[89] This community coalesced into a decentralized, global network aimed at mobilizing efforts to "[end] state-sanctioned violence against black people."[90] Artists such as Oree Originol created artworks in solidarity with these efforts, focusing on singular portraits of individuals killed by police. Working with the victims' families, Originol produced his ongoing social justice project *Justice for Our Lives* (PL. 119).[91] The project consists of a series of black-and-white digital portraits with each victim's likeness and name available for download on Originol's website; the black-and-white austerity makes the images affordable for users to print out and disseminate in their communities.[92] Originol's vectored illustrations, often

based on personal photographs, highlight the positive visual memories that remain and capture the youth of many of the deceased, such as *Justice for Aiyana Jones* (FIG. 7). In 2010, seven-year-old Aiyana Stanley-Jones died after a SWAT team member shot her in the head during a raid of the family's Detroit home.[93] These portraits act as a pedagogical resource centered on a critical conversation around race, systemic oppression, and state-sanctioned violence. Originol wheat pastes his portraits throughout San Francisco's Mission District, creating a gridded wall of loss, monumentalizing the dead (FIG. 8).[94] The sheer number of faces and names of the deceased recalls Maya Lin's granite tribute to Vietnam veterans and her articulation of the power of a name on a memorial: "Literally as you read a name, and touch a name, the pain will come out."[95]

Fellow Bay Area artist Jesus Barraza's practice also historicizes the continued legacy of police brutality, with his work *I Am Alex Nieto and My Life Matters* (PL. 116). In 2014, San Francisco police killed Alex Nieto, a local resident in the Bernal Heights neighborhood.[96] Working with "guidance and feedback from local community organizers," Barraza created a limited-edition screenprint, digital prints, and a downloadable file featuring Nieto's portrait.[97] Across the Bay Area, mourners and protesters wielded Barraza's portrait at rallies and as part of the subsequent political actions contesting Nieto's wrongful death (FIG. 9).[98]

FIG. 8

Oree Originol with an installation of his portraits, victims of police violence, in San Francisco's Mission District, 2016. Photo by Jessica Jones.

FIG. 9

Marian Doub holds up Jesus Barraza's poster of slain resident Alex Nieto during a protest, San Francisco, December 6, 2014.

This artwork is part of the artist's formidable body of work produced at the Oakland-based studio Dignidad Rebelde, a graphic arts collaboration between Barraza and Melanie Cervantes. Dignidad Rebelde is an integral producer of social justice and visual advocacy that follows the "principles of Xicanisma and Zapatismo" to create artwork accessible to the "communities who inspire it."[99] Barraza's emphasis on portraiture reclaims negative media stories that often unsympathetically portray the victim as either a threat or promote a justification for their killing.[100] His artwork, as both public mourning and radical rejection of the state's "truth," creates a new visual legacy for the deceased that commemorates their likeness, reaffirms their humanity, and confronts the state with its victims.[101]

Both Originol's and Barraza's artistic practice is part of a meditative process of honoring the deceased while concomitantly expediting artistic production to facilitate their image's use in political actions. Artists like Lalo Alcaraz and his dedicatory image of gun-control activist Emma González occupy the same urgency. In 2018, student Emma González survived the shooting at Marjory Stoneman Douglas High School in Parkland, Florida; several days later, she gave an impassioned speech on live television, advocating for stronger gun control. Alcaraz digitally illustrated her portrait after watching her televised delivery (**PL. 114**).[102] He then posted it on his social media channels, asking people to distribute it across social media platforms or download a high-resolution file from his website for personal printing.[103] The image features a portrait of González along with "We Call B.S.," a reference to her speech, in which she called out government officials for the lack of gun reform.[104] In the lower register, #gun-controlNOW and #standwiththekids add to the social media–centered trending tags, like #NeverAgain used by Parkland survivors to lobby for solidarity and gun reform.[105]

Alcaraz's transmedia image sharing across multiple platforms is common practice among Web 2.0 artists, where the image exists in artist's websites, blogs, social media channels, and often in print form. The artist's social media post space is a critical intersection for direct engagement with social media followers, with the allotted caption space acting as a direct conversation with the audience. Digital scholar Angélica Becerra argues that this digital caption space acts as an artist's statement, wherein the artist provides commentary regarding the image's objective.[106] In this case, Alcaraz urges users to print his image for social protests or share the image in solidarity with Emma González (**FIG. 10**).[107]

This transmedia distribution and subsequent re-creation of the artwork by the user defines the portrait of González as an open-source artwork. Open source is primarily associated with software sources that owners make freely accessible to the general public for redistribution and modification.[108]

Artists are imitating the software's iterative capabilities by allowing their images to be shared and supplemented. The user's shareable image may vary in size, context, and caption. The new personal caption attached to a shareable image then becomes a reconfiguration of the artwork itself, a folksonomic effort at attaching metadata of the user's choosing for organizing and connecting.[109]

AUGMENTED REALITY (AR)

Graphic artists are increasingly incorporating augmented reality (AR) technologies in their work, creating new visual experiences that both challenge and integrate the very space they are enhancing. Scholar Ronald Azuma explains, "AR allows the user to see the real world with virtual objects superimposed or composited with the real world."[110] AR supplements reality rather than comprehensively replacing it, as with virtual reality (VR).[111] To see these multidimensional juxtapositions, viewers must engage with hardware such as a smartphone or a tablet equipped with a camera and augmented reality software.

In 2015, with the assistance of master printer Arturo Negrete, and David Figueroa of Augment El Paso in Texas, Zeke Peña developed the AR-enhanced screenprint *A Nomad in Love* (**PL. 108**).[112] The print is an example of Peña's evolving transmedia practice, part of a legacy of experimentation with AR technology among Chicanx graphic artists. After viewers download the free Augment El Paso app on their device and position their camera in front of the enhanced print, they experience the integrated overlaid animations (**FIG. 11**).[113] *A Nomad in Love* has several animated sequences, including a hummingbird that rapidly flutters, motion lines that emit from a spring-necked self-portrait, and a personified coyote with a visible heart that howls and says "Orale" (Right on!) against a rotating rabbit-shaped moon.

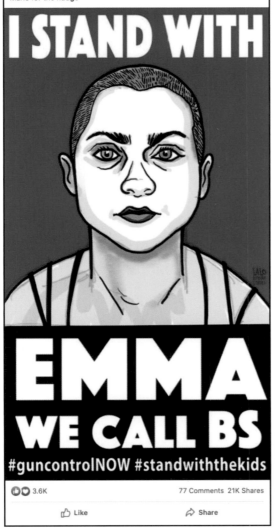

FIG. 10

Screenshot of Lalo Alcaraz's Facebook post, February 18, 2018, featuring an image he created in support of Emma González, a student who became a gun-control activist after surviving the shooting at Marjory Stoneman Douglas High School, Parkland, Florida.

Made during a depressing breakup, the print reflects Peña's disillusionment. While the rabbit is a common referent to the moon in indigenous Southwest mythology, the artist uses it to reference his ex-girlfriend and their inside joke that the animal often reminded him of her. A Maya teacher once told Peña that the hummingbird is responsible for the heartbeat, thus leading to its placement on the main figure's chest in the composition.[114] The personified coyote, based on the figure Huehuecoyotl found in ancient Mesoamerican codices, is a trickster.[115] Peña often uses the coyote as a zoomorphic rendition of himself, given their shared love of running around in the desert and playful personalities.[116] These Native symbols recall the natural environment and the necessary motion augmented reality provides to properly recognize the living landscape Peña venerates throughout his work.

Revealing the collaborative nature of his print, *A Nomad in Love* involved several phases of technical intervention and interpretation, from the drawings and separations created by Peña, to the screenprint Arturo Negrete printed at 75 Grados printmaking studio, to the AR enhancements that David Figueroa of Augment El Paso produced.[117] In the life of the print, Figueroa occupies a new, undefined role as the "master enhancer," one with few precedents in fine art printmaking.[118] Like the master printer, he collaborates with the artist to understand and articulate his objectives. And just as the traditional printmaker properly aligns registration marks and color in a cohesive overlay, Figueroa's three-dimensional animation choices must conform to the original work's spatial and now conceptual arrangements, resulting in an augmented yet integrated whole.

In a similar viewer-experience digital print, Xico González's *Salam* defines an emergent DIY artistic practice using free AR technologies as a form of social justice (**PL. 115**). Using Hewlett-Packard's mobile app HP Reveal (previously Aurasma and now defunct), González creates augmented reality–enhanced digital prints to promote historical portraiture and social advocacy, and construct transmedia oral histories.[119] Based in Sacramento, California, González is an educator, artist, poet, and political activist who has been mentored by canonical Chicano artists and cultural organizers, also based in Sacramento, such as Ricardo Favela (1944–2007) and José Montoya (1932–2013) of the Royal Chicano Air Force (RCAF).[120]

FIG. 11

Screenshot of user viewing *A Nomad in Love* in the Augment El Paso app. Desert Triangle Print Carpeta, "Zeke Pena's serigraph with Augmented Reality," February 1, 2016, YouTube video, 0:37.

FIG. 12

Screenshot of
Xico González's
augmented reality–
enhanced print
Salam or HP Reveal,
"elrevoltoso's Public
Auras," partially
based on the press
photo seen in fig. 13.

FIG. 13

Palestinian girl
brandishing a peace
sign, taken in the
West Bank/Gaza
Strip between
December 1987 and
September 1988.

Xico González's use of augmented reality began with a group of portraits titled the *Revoltosxs Series*, which he created in collaboration with the Sol Collective, a Sacramento arts and cultural center.[121] Using the HP Reveal app and printed banners, users can download the app, follow the artist's profile, and scan the banners to view a multimedia video narrative.[122] This image channel features interviews, archival photos, and historical film footage. Figures span the chronological and geographical and include Hunkpapa Lakota leader Tatanka Iyotake (Sitting Bull), transgender activist Marsha P. Johnson, and Filipino American labor activist Larry Itliong, among others.[123]

Hewlett-Packard markets the app as a new interactive engagement with the physical world: "With HP Reveal, augmented reality (AR) is everywhere, blending the physical and digital through dynamic experiences."[124] Users can up-load and share their own content

to "be revealed" after they create a trigger space in the physical world. The HP Reveal app then acts as a hub for users to populate and share their unique animations. When users follow González's HP Reveal profile they can access the animations meant to overlay and connect to a specifically enhanced print, such as *Salam*. Hovering over the *Salam* print, banner, or digital image with a phone or tablet triggers an overlaid video recording of the Mexican Pakistani Muslim activist Saeeda Islam in the image's lower left-hand corner (**FIG. 12**).[125] She looks directly at the camera and begins discussing how her multiple identities are under attack; the beauty of the Islamic faith; and her efforts to connect to those around her by emphasizing Islam as a religion of love.

The substrate image, or the image the animation overlays, features a recurring figure in González's work: a young Palestinian girl brandishing a peace sign (**FIG. 13**).[126] *Salam*'s lower register

FIG. 14

A scene from Nonny
de la Peña's *Out of
Exile: Daniel's Story*
(2017), a project that
uses interactive
virtual reality to
capture an LGBTQ+
youth's hostile
experiences and
foster empathy
in viewers.

FIG. 15

In Michael Menchaca's
Minority Report
(2019), gallery
visitors are invited
to wear a virtual
reality (VR) mask
and headset that
transports them
to an immersive
environment while
performing for
onlookers, creating
an interactive piece
that critiques Silicon
Valley's outsize
influence and
questions the
nature of viewers
and the viewed.

prominently features the phrase "We are a peaceful people." The Arabic word *salam*, meaning "peace," is a shortened form of the greeting *salaam alaikum* (peace be upon you).[127] González's *Salam* came about as a result of post–9/11 anti-Muslim violence across the United States in the 2000s.[128] The artist recalls working with Movimiento Estudiantil Chicano de Aztlán (MEChA), Palestinian, and Muslim groups, such as Students for Justice in Palestine, as an undergraduate at Sacramento State to organize against this growing hate.[129] The Palestinian child's promotion of peace challenges the negative connotations and vilification associated with the Muslim faith. Here the augmented reality dimension humanizes Muslims and the Islamic faith by staging a personal interaction.

There is a performance layer to the act of activating an enhanced print. The personalization of the augmented reality experience underscores the role of technology in perception. There is what one calls a "click."[130] Curator Britt Salvesen describes 3-D's click as the visual payoff to the visitor, where "all of a sudden, you are in another world and the other world is in you."[131] This personalization often begets varied responses from the user ranging from complete curiosity to impatience or immediate rejection. Art historian Jonathan Crary cites the physical relationship of the viewer to technology as a "subjective vision."[132] The phone or tablet acts as a lens-based facilitator, or as Anne Friedberg's screen analysis posited, as a "virtual window"

to a new, mobile vision.[133] Thus the three-dimensional graphic reflects the delicate give-and-take of interactivity: one must peer through and ultimately engage with it to experience it.

VIRTUAL REALITY (VR)

Virtual reality (VR) is an immersive, computer-generated environment that simulates either an actual or fantastical three-dimensional world. With a headset and adjoining software, users can transport themselves to created spaces for exploration. Technological advancements have increased VR's ability to provide users with what tech scholar Frank Biocca calls "social presence," when a participant "feels access to the intelligence, intentions, and sensory impressions of another [intelligence]."[134] Engagement with VR is dynamic because of its self-directed nature, placing the technology at the intersection of arts and activism. For journalist Nonny de la Peña, the "Godmother of VR," simulating the real world transforms VR into an "empathy machine."[135] The graphic quality of her created environments are part of what she refers to as "immersive storytelling."[136] VR is often associated with environments the user may not have access to whether it be the depths of an ocean, deep space, or some other inaccessible foreign place. De la Peña applies VR's observational tactics and interactivity to translate the experience of disenfranchised groups for users, to promote awareness and act as a simulated testimonial. Her 2017

VR project, *Out of Exile: Daniel's Story*, uses actual audio recorded by Daniel Ashley Pierce during a violent "religious intervention" in which he was subsequently kicked out of his home for being gay (**FIG. 14**).[137] The multisensory experience includes visuals and audio, and is meant to evoke Pierce's physical vulnerability.

In *Minority Report,* created in 2019, Michael Menchaca uses VR technology to critique the tech industry, largely represented by California's Silicon Valley (**FIG. 15**). Part of a body of work known as *The Codex Silex Vallis* (The Silicon Valley Codex), *Minority Report* questions the Valley's reach and influence on society, its ability to effect behavior modification in its users across an impressive and seemingly expanding array of devices and platforms. Menchaca is informed by scholar Shoshana Zuboff's descriptions of surveillance capitalism as a "new economic order that claims human experience as free raw material."[138] Menchaca uses the VR headset, and an attached graphic mask replete with tech semiotics, as a visual synecdoche of the tech experience, where users perform for onlookers.[139] The user's VR experience, then, is a meta-mixed reality project, with headset users viewing a 360-degree animated narrative, while passersby view someone immersed in a digital environment. The overwhelming discontent with Silicon Valley corporations and their negative effects on users has caused Menchaca to advocate for more ethical standards of business.[140]

CODA

While many of the technologies discussed here illustrate artistic partnerships in innovation and experimentation, the digital age itself—its uses and implications—is currently in a state of critical analysis. Edward Snowden's exposure of the U.S. National Security Agency's (NSA) mass surveillance programs in 2013 touched off a controversial debate on individual privacy that continues today.[141] The Facebook-Cambridge Analytica scandal in 2018 has likewise reshaped public opinion on privacy concerns and computational propaganda, or the "use informational technology for social control."[142] New studies on algorithmic oppression have revealed embedded biases in automated decision-making systems, despite users' subsequent hacktivist (a neologism of the words *hacking* and *activist*) counteractive resistance.[143] What does this technologically shifting moment mean for Chicanx graphics artists? Most likely, the institutional framework that supports their communication networks is another "machine" that must be actively critiqued and subverted in order to promote and protect the fight for social justice.

Since the 1980s, Chicanx artists have engaged with digital hardware, software, and networks to facilitate the time-honored practice of social protest. Despite the conduit, Chicanx artists share many of the same objectives of printmakers of the early Chicano movement: to disseminate their images and comment on contemporary issues, support social movements, and analyze and reform their cultural identities. A study of digital Chicanx art is not simply about the technological mechanisms that make this expanding field different, more efficient, or inherently better; rather, it is an epistemological exercise examining how artists continue to embrace and define new visual practices to reveal injustice, create a more inclusive history of digital art, and expand the definition of graphic arts.

NOTES

1 Barbara Carrasco, conversation with author, August 6, 2019.

2 Public Art Fund, "Barbara Carrasco: Messages to the Public: Pesticides!," accessed May 1, 2019, https://www.publicartfund.org/exhibitions/view/messages-to-the-public-carrasco/; Julie Ault, "A Chronology of Selected Alternative Structures, Spaces, Artists' Groups, and Organizations in New York City, 1965–85," in *Alternative Art, New York 1965–1985: A Cultural Politics Book for the Social Text Collective,* ed. Julie Ault (New York: Drawing Center, 2002), 51–53.

3 Anna Novakov, "The Artist as Social Commentator: A Critical Study of the Spectacolor Lightboard Series 'Messages to the Public'" (PhD diss., New York University, 1993), 2; "Guide to the Public Art Fund Archive 1966–2009," Fales Library & Special Collections, New York University, updated September 2017, http://dlib.nyu.edufindingaids/html/fales/paf/dscaspace_ref18.html.

4 Novakov, "Artist as Social Commentator," 4. Carrasco's July residency with the Public Art Fund coincided with César Chávez's effort in New York. Chávez held a press conference to promote his campaign against the use of agricultural pesticides as Mayor David Dinkins raised the UFW flag over City Hall. See Max Benavidez, "Cesar Chavez Nurtured Seeds of Art," *Los Angeles Times,* April 28, 1993, https://www.latimes.com/archives/la-xpm-1993-04-28-ca-28278-story.html.

5 Victor Alejandro Sorell, "Telling Images Bracket the 'Broken-Promise(d) Land': The Culture of Immigration and the Immigration of Culture across Borders," in *Culture across Borders: Mexican Immigration & Popular Culture,* ed. David R. Maciel and María Herrera-Sobek (Tucson: University of Arizona Press, 1998), 133.

6 Barbara Carrasco, "Barbara Carrasco: Artist, Muralist," in *The Complete Guide to Animation and Computer Graphics Schools,* ed. Ernest Pintoff (New York: Watson-Guptill, 1995), 299–300.

7 The Chicano movement is not over, and others prefer a post-identity theoretical framework. For more on post-identity politics, see Rose G. Salseda, "The New Wave of Identity Politics: Juan Capistran's *White Minority," American Art* 28, no. 1 (Spring 2014): 24–31, https://doi.org/10.1086/ 676626. For a discussion of Chicano art's afterlife, see Rita Gonzalez, "Post-Chicano," *Poliester*

(Mexico City) (Spring/Summer 1999): 40–47. For a breakdown of the significant industrial revolutions, See Klaus Schwab, *The Fourth Industrial Revolution* (New York: Crown Business, 2017), 6–7. For the present study, I focus on the digital revolution during the eras since personal computing. For more about the personal computer and its expansion, see Dennis E. Baron, *A Better Pencil: Readers, Writers, and the Digital Revolution* (New York: Oxford University Press, 2012), 96–112.

8 Oliver Grau, *Virtual Art: From Illusion to Immersion,* rev. ed. (Cambridge, MA: MIT Press, 2007), 255–56. Grau suggests using the term "thinktool," given the computer's options to modify, randomize, and rectify images during the artistic process. Fundamentally, anything digital reflects that which has been developed or can be reduced to binary codes consisting of zeros and ones. This encoding data is how computers and communication devices interpret, send, and store information. For more on the history and invention of binary code, see Lydia He Liu, *The Freudian Robot: Digital Media and the Future of the Unconscious* (Chicago: University of Chicago Press, 2010), 183.

9 My conceptual framework continues the effort of expanding the definition of Chicanx graphics. In the appendix of the canonical exhibition catalogue *¿Just Another Poster? Chicano Graphic Arts in California,* the last thoughts detail the emergence of new "computer aided-techniques," in reference to Alma Lopez's digital prints. See Chon A Noriega, ed., *¿Just Another Poster? Chicano Graphic Arts in California* (Santa Barbara, CA: University Art Museum, 2001), 216. I also look to Latin American curator and scholar Mari Carmen Ramírez's postmodern interpretation for the expansion of printmaking and her notion of "polygraphic strategies for the multiple image." See Mari Carmen Ramírez, "Stamping (Molding) Marks: The San Juan Triennial Tracking the New Century," in *Trienal Poli/Gráfica de San Juan. San Juan Poly/Graphic Triennial: Latin America and the Caribbean,* vol. 1, ed. Mari Carmen Ramírez et al. (San Juan: Artes Plasticas, Instituto de Cultura Puertorriqueña, 2004), 20.

10 Romo was referencing Bay Area Chicano artists' role in critiquing U.S. intervention in Latin America, specifically the Cuban Revolution and "international ideology." Terezita Romo, "¡Presente!

Chicano Posters and Latin American Politics," in *Latin American Posters: Public Aesthetics and Mass Politics,* ed. Russ Davidson (Santa Fe: Museum of New Mexico Press, 2006), 53.

11 Deborah Cullen states the print center has been the formal "contact zone" for artistic production and distribution, and now, new online communities and increased personal printing are a catalyst for broader "zones" due to the exigent necessities of radical intervention and exchange. Deborah Cullen, "Contact Zones: Places, Spaces, and Other Test Cases," *American Art* 26, no. 2 (Summer 2012): 14, https://doi.org/10.1086/667946. The digital mural represents an additional Chicanx engagement. Judy Baca and her nonprofit Social and Public Art Resource Center (SPARC) in Venice, California, are leading the field in digital murals as part of an ongoing educational, artistic, and preservation effort in collaboration with UCLA. See UCLA@SPARC Digital/Mural Lab, "About the Digital Mural Lab," accessed November 21, 2019, http://digitalmurallab.com/dml/.

12 Lev Manovich, *The Language of New Media* (Cambridge, MA: MIT Press, 2010), 46.

13 Cristina Constantini, "Hopeful, 'Unapologetic' Art Rebrands the Immigration Movement," ABC News, March 1, 2013, https://abcnews.go.com/ABC_Univision/art-rebrands-immigration-reform-movement/story?id=18610975.

14 Marshall McLuhan, *Understanding Media: The Extensions of Man* (New York: McGraw-Hill, 1964), 174.

15 For more on new media art, see Mark Tribe, Uta Grosenick, and Reena Jana, *New Media Art* (Cologne: Taschen, 2009), 6–25. For a general overview of digital art, see Christiane Paul, ed., *A Companion to Digital Art* (Chichester, UK: John Wiley & Sons, 2016), 7–25 ; and Michael Connor, "Introduction to Net Art Anthology," in *The Art Happens Here: Net Art Anthology,* ed. Michael Connor (New York: Rhizome, 2019), 5–12.

16 *Sangre Boliviana* was featured in the 1995 exhibition *Xicano Progeny: Investigative Agents, Executive Council, and Other Representatives from the Sovereign State of Aztlán,* curated by Armando Rascón for the Mexican Museum. According to Lucia Grossberger-Morales an art disk is an artwork on a disk: "The artwork is contained as bits of information on some sort of storage

device, such as a floppy disk, an optical disk, a compact disk-read only memory (CD-ROM), or even on an on-line system. An art disk is actually not that different from a videotape, where the artwork is also stored as magnetic media." Lucia Grossberger-Morales, "Sangre Boliviana," *Leonardo* 28, no. 4 (1995): 246.

17 Aria Dean, "From 'Tactical Poetics: FloodNet's Virtual Sit-Ins,'" in *The Art Happens Here: Net Art Anthology*, ed. Michael Connor (New York: Rhizome, 2019), 99–100; and Ricardo Dominguez, "Electronic Disturbance Theater: Timeline 1994–2002," *TDR: The Drama Review* 47, no. 2 (2003): 132–34.

18 *Cyber Arte* incorporated the work of New Mexican artist Marion C. Martinez, who uses deconstructed hardware, such as circuit boards, placing it at the intersection of digital art, Chicano-futurism, and the speculative arts. Chicanx speculative studies is an emerging field centered on the imagining and producing of a new world. For more on Chicanofuturism and the work of Marion C. Martinez, see Catherine S. Ramírez, "Deus ex Machina: Tradition, Technology, and the Chicanafuturist Art of Marion C. Martinez," *Aztlán: A Journal of Chicano Studies* 29, no. 2 (Spring 2002): 55–92.

19 Carrasco, "Barbara Carrasco: Artist, Muralist," 299–300.

20 In a June 22, 1989, letter to George Stonbely, owner of Spectacolor, Lyn Freeman, project director for Messages to the Public, pleads Carrasco's case: "It would seem that Barbara's message offers an excellent opportunity to get some publicity for a good cause, as well as Spectacolor. This is a topical issue, and Chavez's appearance in New York most certainly would be a newsworthy event." See Public Art Fund Archive, Series V, Subseries A, Box 27, Folder 2, "Carrasco, Barbara–'Pesticides!,'" Fales Library & Special Collections, Elmer Holmes Bobst Library, New York University. The Spectacolor owner asked the artist to change her original design to avoid showing children dying. About her required modification, Carrasco said, "It was funny that he was ok with seeing a dying farmworker but not a sick kid." Barbara Carrasco, conversation with author, August 6, 2019.

21 Claudia E. Zapata, "Branding 'Death' in a High-Tech Boycott: United Farm Workers and the Wrath of Grapes Campaign," *Journal of Latino-Latin American Studies (JOLLAS)* 10, no. 1 (2019): 48–69.

22 Zapata, "Branding 'Death,'" 52. See also Curtis Marez, *Farm Worker Futurism: Speculative Technologies of Resistance* (Minneapolis: University of Minnesota Press, 2016).

23 Carrasco, "Barbara Carrasco: Artist, Muralist," 299–300.

24 For more information on pixels, see Bruce Duyshart, *The Digital Document: A Reference for Architects, Engineers and Design Professionals* (London: Routledge, 2017), 51.

25 Novakov, "Artist as Social Commentator," 3.

26 Self Help Graphics & Art, "Professional Printmaking Program," accessed May 1, 2019, https://www.selfhelpgraphics.com /professional-printmaking-program. See also "Artist in Residence," Serie Project, accessed May 1, 2019, http:// serieproject.org/about/artist-in -residence-application/.

27 Benavidez, "Cesar Chavez Nurtured Seeds of Art."

28 Rena Bransten Gallery, "Rupert Garcia: The Magnolia Editions Projects 1991–2011," 2011, produced by Bay Package Productions in association with Rena Bransten Gallery, Vimeo video, 4:01, https://vimeo.com/21727915.

29 Magnolia Editions, "A Conversation with Rupert Garcia," *Magnolia Editions Newsletter*, no. 11 (Spring 2007): 7, http://www.magnoliaeditions.com /wp-content/uploads/2012/04 /MagnoliaNewsletter11.pdf.

30 Magnolia Editions, 7.

31 Magnolia Editions, 6.

32 Rupert García, email message to author, July 9, 2019.

33 "Frederick Douglass Papers at the Library of Congress," Library of Congress, accessed July 6, 2019, https://www.loc.gov/collections /frederick-douglass-papers/articles -and-essays/frederick-douglass -timeline/1860-to-1876/.

34 John Zarobell, "Rupert Garcia," Studio Sessions, Art Practical, January 30, 2018, https://www.artpractical.com/column /studio-sessions-rupert-garcia/.

35 Zarobell, "Rupert Garcia."

36 Magnolia Editions, "Inkjet Info," accessed July 6, 2019, http:// www.magnoliaeditions.com /inkjet-info/.

37 Magnolia Editions, "Inkjet Info."

38 2ndwnd, "Studio," accessed July 12, 2019, http://2ndwnd.com/?page_id =159.

39 Terezita Romo, quoted in Regina M. Marchi, *Day of the Dead in the USA: The Migration and Transformation of a Cultural Phenomenon* (New Brunswick, NJ: Rutgers University Press, 2009), 37.

40 Karen Mary Davalos, "Innovation through Tradition: The Aesthetics of Día de los Muertos," in *Día de los Muertos: A Cultural Legacy, Past, Present & Future*, ed. Mary Thomas (Los Angeles: Self Help Graphics & Art, 2017), 22. For more information on the history of Self Help Graphics & Art, see Colin Gunckel, ed., *Self Help Graphics & Art: Art in the Heart of East Los Angeles*, 2nd ed. (Los Angeles: UCLA Chicano Studies Research Center Press, 2014).

41 For an expansive look at Self Help Graphics & Art, see Thomas, *Día de los Muertos*. For more information about the Day of the Dead commemorative prints and celebrations, see Ana Velasco, "Self Help Graphics & Art's Día de los Muertos Legacy Told Through Prints," KCET.org, May 30, 2019, https://www.kcet.org/shows /artbound/self-help-graphics-arts -dia-de-los-muertos-legacy-told -through-prints. For a history of Self Help Graphics & Art Day of the Dead exhibitions, see Self Help Graphics & Art, "Past Exhibitions," accessed February 20, 2019, https://www.selfhelpgraphics.com /exhibitions.

42 Daniel González, "Self Help Graphics 40th Anniv. Day of the Dead Print," Cargo Collective, December 11, 2013, https:// cargocollective.com/printgonzalez /Self-Help-Graphics-40th-Anniv-Day -of-the-Dead-Print; Sonia Romero's 2015 Self Help Day of the Dead commemorative print was the first 3-D print. Romero also worked with 2ndwnd for her laser-cutting processes in preparing the print. See SHGTV, "Día de los Muertos: A Cultural Legacy, Past, Present & Future: Sonia Romero," YouTube video, 01:19, September 11, 2017, https://www .youtube.com/watch?v=40gmidl1YOk.

Rosalie López's 2017 Self Help Day of the Dead commemorative print, *Hands Remind Us,* includes hand-cut *papel picado* designs as well as additional light fixtures behind the print, creating a unique print lantern. See Rosalie Lopez, "Recent Artwork," accessed May 5, 2019, http://www.rosalielopez.com/recent-artwork.

43 María Herrera-Sobek, ed., *Celebrating Latino Folklore: An Encyclopedia of Cultural Traditions* (Santa Barbara, CA: ABC-CLIO, 2012), 406–7, 879–81.

44 Herrera-Sobek, *Celebrating Latino Folklore,* 406–7.

45 2ndwnd, "Studio."

46 SHGTV, "Biennial Printmaking Summit • New Technologies in Print Panel Moderated by Rosalie Lopez," YouTube video, 1:04:23, May 17, 2019, https://www.youtube.com/watch?v=ERmP_9zh3e0&t=3099s. Manny Torres used the following equipment: make: rabbit last usa; model: RL–80–129C; laser type: sealed CO2 laser tube; laser power: 80 watts. Manny Torres, email message to author, June 18, 2019. For a more extensive history of laser cutting, see Mario Bertolotti, *The History of the Laser* (Bristol, UK: Institute of Physics, 2005).

47 Daniel González, phone conversation with author, June 12 and 18, 2019.

48 Rose Salseda, "The Legacy of Self Help Graphics' Día de los Muertos," in Thomas, *Día de los Muertos,* 40.

49 Salseda, "Legacy of Self Help Graphics," 39–40. For the artist's personal reflection on this work and his experience with Self Help Graphics & Art, see Gonzalez, "Self Help Graphics 40th Anniv."

50 Robert Kahn and Vinton Cerf, "Al Gore and the Internet," accessed June 25, 2019, https://web.eecs.umich.edu/~fessler/misc/funny/gore,net.txt. For a comprehensive history of the internet, see Janet Abbate, *Inventing the internet* (Cambridge, MA: MIT Press, 2000).

51 Sion Retzkin, *Hands-On Dark Web Analysis: Learn What Goes on in the Dark Web, and How to Work with It* (Birmingham, UK: Packt, 2018), 8–9.

52 See Tim Berners-Lee and Mark Fischetti, *Weaving the Web: The Original Design and Ultimate Destiny of the World Wide Web by Its Inventor* (New York: HarperCollins, 2008).

53 James Governor, Dion Hinchcliffe, and Duane Nickull, *Web 2.0 Architectures* (Sebastopol, CA: O'Reilly Media, 2009), 29–62.

54 Jacalyn Lopez Garcia, "*Glass Houses*: A View of American Assimilation from a Mexican-American Perspective," *Leonardo* 33, no. 4 (2000): 263.

55 Kaytie Johnson, "Jacalyn López García," in *Contemporary Chicana and Chicano Art: Artists, Works, Culture, and Education,* ed. Gary D. Keller (Tempe, AZ: Bilingual Press/Editorial Bilingüe, 2002) 2 92–93; and Manovich, *Language of New Media,* 131.

56 Manovich, *Language of New Media,* 131.

57 Garcia, "*Glass Houses,*" 263–64.

58 The other spaces include: FAMILY ROOM: Culture; CLOSET: Secrets; BEDROOM 1: Fears; DRESSING ROOM: Self-Portraits; STUDIO: Mi Arte de Aztlan; and MESSAGE CENTER: Guestbook. See Jacalyn Lopez Garcia, "Glass Houses: Bienvenidos/Welcome," accessed June 25, 2019, http://artelunasol.com/glasshouses/glasshouses.1.html.

59 Jacalyn Lopez Garcia, "Glass Houses: Artist Statement," accessed June 25, 2019, http://artelunasol.com/glasshouses/.

60 Garcia, "*Glass Houses.*"

61 The term "killer app" refers to a game-changing innovation, the first being email. For more, see Larry Downes and Chunka Mui, *Unleashing the Killer App: Digital Strategies for Market Dominance* (Boston: Harvard Business School Press, 1998).

62 For more on these zine and mail art networks, see Richard T. Rodriguez, "*Homeboy Beautiful*; or Chicano Gay Male Sex Expression in the 1970s," in *Axis Mundo: Queer Networks in Chicano L.A.,* ed. C. Ondine Chavoya and David Evans Frantz (Los Angeles: ONE National Gay & Lesbian Archives at USC Libraries with DelMonico/Prestel, 2017), 112–23.

63 Alma López, "It's Not about the Santa Fe in My Fe, but the Santa Fe in My Santa," in *Our Lady of Controversy: Alma López's "Irreverent Apparition,"* ed. Alicia Gaspar de Alba and Alma López (Austin University of Texas Press, 2012), 264–65.

64 For more on the history and impact of the Virgin of Guadalupe, see D. A. Brading, *Mexican Phoenix: Our Lady of Guadalupe; Image and Tradition Across Five Centuries* (Cambridge: Cambridge University Press, 2002).

65 Luz Calvo, "Art Comes for the Archbishop: The Semiotics of Contemporary Chicana Feminism and the Work of Alma López," in Gaspar de Alba and López, *Our Lady of Controversy,* 96.

66 López, "It's Not about the Santa Fe," 264–65.

67 Calvo, "Art Comes for the Archbishop," 111–12.

68 Lotería is similar to bingo where multiple players try to cover images on their gridded player card, typically with a bean. The caller selects images from a deck of cards, revealing the image's titular nomenclature. The cards feature iconic, brightly colored fruits, objects, and characters such as El Músico (the musician), among others. On its December 9, 2019, homepage, Google featured an interactive doodle of the traditional game. See Google, "Celebrating Lotería!," accessed December 26, 2019, https://www.google.com/doodles/celebrating-loteria. For a review of Chicana theorists' reclamation of Coyolxauhqui, and a retake on the ancient myth, see Alicia Gaspar de Alba, *[Un]Framing the "Bad Woman": Sor Juana, Malinche, Coyolxauhqui, and Other Rebels with a Cause* (Austin: University of Texas Press, 2014), 190–93.

69 José Esteban Muñoz, *Cruising Utopia: The Then and There of Queer Futurity,* 10th anniv. ed. (New York: New York University Press, 2019), 1.

70 López, "It's Not about the Santa Fe," 266–68. For more about the "uncanny valley" concept, see Jeremy Hsu, "Why 'Uncanny Valley' Human Look-Alikes Put Us on Edge," April 3, 2012, *Scientific American,* https://www.scientificamerican.com/article/why-uncanny-valley-human-look-alikes-put-us-on-edge/.

71 Charalambos Tsekeris and Ioannis Katerelos, "Interdisciplinary Perspectives on Web 2.0, Complex Networks and Social Dynamics," in *The Social Dynamics of Web 2.0: Interdisciplinary Perspectives,* ed. Charalambos Tsekeris and Ioannis Katerelos (London: Routledge, 2015), 2; Dinu Gabriel Munteanu, "Improbable Curators: Analysing Nostalgia, Authorship and Audience on Tumblr Microblogs," in *Collaborative Production in the Creative Industries,* ed. James Graham and Alessandro Gandini (London: University of Westminster Press, 2017), 125.

72 Francisco J. Pérez-Latre, "The Paradoxes of Social Media: A Review of Theoretical Issues," in *The Social Media Industries*, ed. Alan B. Albarran (New York: Routledge, 2013), 46.

73 John F. Barber, "Digital Archiving and 'The New Screen,'" in *Transdisciplinary Digital Art: Sound, Vision and the New Screen*, ed. Randy Adams, Steve Gibson, and Stefan Müller Arisona (Berlin: Springer-Verlag, 2008), 110.

74 Favianna Rodriguez, "Resources," accessed July 12, 2019, https://favianna.com/media/resources.

75 Gabby De Cicco, "There Can Never Be Political Change without Cultural Change," Association for Women's Rights in Development (AWID), February 14, 2017, https://www.awid.org/news-and-analysis/there-can-never-be-political-change-without-cultural-change.

76 Sasha Costanza-Chock, *Out of the Shadows, Into the Streets! Transmedia Organizing and the Immigrant Rights Movement* (Cambridge, MA: MIT Press, 2014), 185.

77 Rodriguez's butterfly was part of an artistic effort for immigration reform on the now defunct website, migrationisbeautiful.com. As part of a collaboration among the Culture Group, Air Traffic Control, and Culture-Strike, artists Julio Salgado, Jason Carne, Ray Hernandez, and Favianna Rodriguez share their butterfly artwork and invite online visitors to spread their work: "Please share these butterflies and help spread 'Migration is Beautiful.'" Migration Is Beautiful, accessed October 12, 2019, http://web.archive.org/web/20130730123902 and http://migrationisbeautiful.com/.

78 John Lee, "What do butterflies have to do with open borders? Migration Is Beautiful," May 27, 2013, https://openborders.info/blog/what-do-butterflies-have-to-do-with-open-borders-migration-is-beautiful/. There are several colorways and versions of the butterfly design as part of the "Migration Is Beautiful" campaign in 2012. For more on the image's history, see Favianna Rodriguez, "Migration Is Beautiful," accessed November 5, 2019, https://www.favianna.com/artworks/migration-is-beautiful-2018.

79 Favianna Rodriguez, phone conversation with author, June 19, 2019; see Sam Durant, ed., *Black Panther: The Revolutionary Art of Emory Douglas* (New York: Rizzoli, 2014); and Rini Templeton Memorial Fund, "Welcome," accessed July 1, 2019, https://riniarts.com/. Templeton's work is available for download on her web library, which offers guidelines for use: "Activists serving causes that Rini would have supported are invited to use drawings freely in their leaflets." RiniArt, "How to Use," accessed December 1, 2019, https://riniart.com/how-to-use.html.

80 Constantini, "Hopeful, 'Unapologetic' Art."

81 Constantini, "Hopeful, 'Unapologetic' Art."

82 The term "weblog" originated in 1997, and the abbreviated form "blog" emerged in 1999. See Richard Davis, *Typing Politics: The Role of Blogs in American Politics* (Oxford: Oxford University Press, 2009), 3; and Stefano Harney and Fred Moten, *The Undercommons: Fugitive Planning & Black Study* (Wivenhoe, UK: Minor Compositions, 2013), 18.

83 Salgado is a prominent activist for the rights of undocumented immigrants. In 2012 he was featured on the cover of *Time* magazine's "We Are Americans" issue. He later applied for Deferred Action for Childhood Arrivals (DACA). See Maya Rhodan and Emma Talkoff, "We Are Americans, Revisted," accessed June 30, 2019, https://time.com/daca-dream-act-jose-antonio-vargas-time-cover-revisited/. Kimberlé Crenshaw developed her concept of "intersectionality" to articulate the intersecting identities of women of color and the need to address these contemporaneous experiences to define social context. Kimberlé Crenshaw, "Demarginalizing the Intersection of Race and Sex: A Black Feminist Critique of Antidiscrimination Doctrine, Feminist Theory, and Antiracist Politics," *University of Chicago Legal Forum*, Iss. 1, Article 8 (1989): 139–68; and Kimberlé Crenshaw "Mapping the Margins: Intersectionality, Identity Politics, and Violence against Women of Color," *Stanford Law Review* 43, no. 6 (July 1991): 1241–99.

84 Hinda Seif, "'Layers of Humanity': Interview with Undocuqueer Artivist Julio Salgado," *Latino Studies* 12 (2014): 300–309, https://doi.org/10.1057/lst.201.

85 Salgado's Tumblr post read: "'I am UndocuQueer!' is an art project in conjunction with the Undocumented Queer Youth Collective and the Queer Undocumented Immigrant Project (QUIP) that aims to give us undocumented queers more of a presence in the discussion of migrant rights. If you want your own 'I am UndocuQueer!' image, message me a photograph from the waist up of yourself and a quote telling us what it means to be both undocumented and queer to you to juliosalgado83@yahoo.com. These images also serve as a great way to fundraise for your organization. I can e-mail you higher resolution versions so you can print them and sell them. Hit me up if you're interested for this option as well." Julio Salgado, January 13, 2012, https://juliosalgadoart.com/post/15803758188/i-am-undocuqueer-is-an-art-project-in.

86 For a more detailed reading about the concept of the closet, see Eve Kosofsky Sedgwick, *Epistemology of the Closet* (Berkeley: University of California Press, 2008).

87 Julio Salgado, conversation with author, February 7, 2019.

88 These declarations represent the emergence of what I call an "undocuqueer register," or a subsection of linguistic analysis that studies the situational context of language. The undocuqueer may linguistically perform differently depending on the context, public or private. See Douglas Biber and Susan Conrad, *Register, Genre, and Style* (Cambridge: Cambridge University Press, 2019).

89 Garrett Chase, "The Early History of the Black Lives Matter Movement, and the Implications Thereof," *Nevada Law Journal* 18, Iss. 3, Article 11 (2018): 1091–112, https://scholars.law.unlv.edu/nlj/vol18/iss3/11; Black Lives Matter, "HERSTORY," accessed June 1, 2019, https://blacklivesmatter.com/about/herstory/.

90 Dipka Bhambhani, "The Communications Goals and Strategies of Black Lives Matter," *PR Week*, February 10, 2016, https://www.prweek.com/article/1383011/communications-goals-strategies-black-lives-matter.

91 Oree Originol, conversation with author, May 22, 2019.

92 Oree Originol, "Justice for Our Lives," accessed June 10, 2019, https://www.oreeoriginol.com/justiceforourlives.html.

93 Rose Hackman, "'She Was Only a Baby': Last Charge Dropped in Police Raid That Killed Sleeping Detroit Child," *Guardian* (U.S. edition), January 31, 2015, https://www.theguardian.comus-news /2015/jan/31/detroit-aiyana-stanley -jones-pol ce-officer-cleared. A&E was filming the SWAT team for a reality television show during the raid; on his blog, Originol discussed his dissent for the case and the influence of the cameras during the raid: "A young black girl's life was deemed disposable for the sake of entertainment and still none of these chilc killers are held accountable."See Oree Originol, "Just ce for Aiyana Jones," Tumblr, January 18, 2016, https://oreeoriginol .tumblr.com/post/137597081273 /offcer- joseph-weekley-shot-and -killed-7-year-old.

94 Originol, "Justice for Aiyana Jones."

95 James Reston Jr., *A Rift in the Earth: Art, Memory, and the Fight for a Vietnam War Memorial* (New York: Arcade, 2017), 62.

96 William West, "SF Police Kill Alex Nieto," San Francisco Bay Area Independent Media Center, March 31, 2014, https:// www.indybay.org/newsitems/2014 /03/31/18753360.php.

97 Jesus Barraza, conversation with author, July 8, 2019; and Dignidad Rebelde, "I am Alex Nieto and My Life Matters," April 2, 2014, https:// dign dadrebelde.com/?p=2319. The image is also available for download on JustSeeds.org. See Jesus Barraza, "I am Alex Nieto and My Life Matters," accessed June 3, 2019, https:// justseeds.org/graphic/i-am-alex -nieto-and-my-life-matters/. Just- Seeds is a network of twenty-nine artists promoting social, environmental, and political change in art and resis- tance projects around the world. Originally founded in 1998 by Josh MacPhee, JustSeeds has an online store and wholesale distribution center.

98 Henry K. Lee and Kale Williams, "4 San Francisco Cops Cleared in Alex Nieto Killing," *SFGATE*, February 13, 2015, https://www.sfgate.com/bayarea /article/4-San-Francisco-cops-cleared -in-Alex-Nieto-killing-6079794.php #photo-7238295

99 Dignidad Rebelde, "About Us," accessed June 6, 2019, https:// dignidadrebelde.com/?page_id=8.

100 Lisa Wade, "Racial Bias and How the Media Perpetuates It with Coverage of Violent Crime," *Pacific Standard*, April 17, 2015, https://psmag.com /social-justice/racial-bias-and-how -the-media-perpetuates-it-with -coverage-of-violent-crime.

101 Jesus Barraza, "Signs of Solidarity: The Work of Dignidad Rebelde," *ASAP/ Journal* 3, no. 2 (May 2018): 214.

102 Araceli Cruz, "Lalo Alcaraz Has Painted Emma Gonzalez, the Face of the Gun Control Debate, and Here's How People Are Reacting," wearemitu .com, February 21, 2018, https:// wearemitu.com/things-that-matter /emma-gonzalez-portrait/. Alcaraz is a prolific graphic artist. My favorite response to the breadth of his work was HuffPost contributing writer Daniel Olivas's opening sentence, "Lalo Alcaraz is one busy Chicano." See Daniel A. Olivas,"No Walls Here: Lalo Alcaraz Discusses the New Fox Animated Series, Bordertown," Huff Post, updated December 6, 2017, https://www.huffpost.com/entry /no-walls-here-lalo-alcara_b_8882532.

103 Lalo Alcaraz (@LaloAlcaraz), "Please share my 'I stand with Emma' Gonzalez poster if you can. #standwiththekids #WeCallBS #GunControlNOW I want to thank Bequi Marie for the nudge," Twitter, February 18, 2018; Lalo Alcaraz, "Please share my 'I stand with Emma' Gonzalez poster if you can. #standwiththekids #WeCallBS #GunControlNOW I want to thank Bequi Marie for the nudge—with Laurie Leas," Facebook, February 18, 2018; Lalo Alcaraz (@laloalcaraz1), "Please share my 'I stand with Emma' Gonzalez poster if you can. #standwiththekids #WeCallBS #GunControlNOW I want to thank Bequi Marie for the nudge," Instagram, February 18, 2018, https://www.instagram.com/p /BfWyO4fnmbc/; and Lalo Alcaraz, "I stand with Emma! #GunControl- Now #WeCallBS #StandWiththeKids (video, toon, poster, free print-quality PDF download)," Pocho.com, February 18, 2018, http://www .pocho com/i-stand-with-emma -guncontrolnow-wcallbs -standwiththekids/.

104 Emily Witt, "How the Survivors of Parkland Began the Never Again Movement," *New Yorker*, February 19, 2018, https://www.newyorker.com /news/news-desk/how-the-survivors -of-parkland-began-the-never-again -movement.

105 Witt, "How the Survivors of Parkland."

106 Angélica Becerra, phone conversation with author, October 2, 2019.

107 Lalo Alcaraz, "Please share my 'I stand with Emma' Gonzalez poster..." Face- book, February 18, 2018, https://www .facebook.com/photo.php?fbid =10155292610998715.

108 Klint Finley, "The Wired Guide to Open Source Software," *Wired*, April 24, 2019, https://www.wired.com/story/wired -guide-open-source-software/.

109 For more on the future of metadata practice and its nuanced implementa- tion, see Jeffrey Pomerantz, *Metadata* (Cambridge, MA: MIT Press, 2015), 187–207.

110 Helen Papagiannis, *Augmented Human: How Technology Is Shaping the New Reality* (Bejing: O'Reilly, 2017), 167.

111 Papagiannis, *Augmented Human*, 135.

112 *A Nomad in Love* is part of the Desert Triangle Print Carpeta, a Southwestern print portfolio commissioned by artist Karl Whitaker. For more on this project's regional and international efforts, see Karl Whitaker, "Premise," accessed February 1, 2019, http:// deserttriangle.blogspot.com/2015 /07/premise.html.

113 Michael Figureroa, "Augment El Paso," Apple App Store (2013–19), https:// apps.apple.com/us/app/augment -el-paso/id704045404.

114 Zeke Peña, phone conversation with author, February 16, 2019.

115 Elizabeth Hill Boone, *Cycles of Time and Meaning in the Mexican Books of Fate* (Austin: University of Texas Press, 2007), 104–5.

116 Peña, phone conversation with author.

117 Peña, phone conversation with author.

118 I suggested this term to Figueroa to recognize his special role in the print's production. David Figueroa, phone conversation with author, January 24, 2019.

119 Aurasma, "HP Reveal," Apple App Store (2011–17), Vers. 6.c.1, https:// apps.apple.com/us/app/hp-reveal /id432526396.

120 Xico González, phone conversation with author, November 29, 2018.

121 Sol Collective, "Revoltosxs Arte," *Global Local AR Magazine*, no. 1 (2019), 12–15, https://issuu.com/solcollective /docs/globallocalissue1.

122 Sol Collective includes viewing instructions and pullout posters of González's artwork in their *AR Magazine*. See Sol Collective, "Revoltosxs Arte," 3, 12–15.

123 Xico González, "Arte Revoltoso: Selected Work by Xico Gonzalez," self-published presentation, 2018.

124 Hewlett-Packard, "HP Reveal," accessed May 6, 2019, https://www8.hp.com/us/en/printers/reveal.html.

125 HP Reveal, "elrevoltoso's Public Auras, *Salam*," accessed May 6, 2019.

126 See *The Intifada: A Message from Three Generations of Palestinians* (Knight Financial Services, 1988).

127 Malise Ruthven, with Azim Nanji, *Historical Atlas of Islam* (Cambridge, MA: Harvard University Press, 2004), 7.

128 Eric Lichtblau, "Hate Crimes against American Muslims Most Since Post-9/11 Era," *New York Times*, September 17, 2016, https://www.nytimes.com/2016/09/18/us/politics/hate-crimes-american-muslims-rise.html.

129 Xico González, phone conversation with author, June 18, 2019; Lichtblau, "Hate Crimes." González used this Palestinian girl's photo several times: as part of his efforts to denounce the Gaza War in 2014, during the Women's March on Sacramento, California, in 2018 to protest U.S. president Donald Trump, and as part of an image protesting Trump's proposed border wall and the Muslim ban, which he issued in 2017; Xico González, email message to author, June 18, 2019. For more on the Muslim ban, see American Civil Liberties Union of Washington (ACLU), "Timeline of the Muslim Ban," accessed July 1, 2019, https://www.aclu-wa.org/pages/timeline-muslim-ban.

130 Britt Salvesen, "Surface and Depth," in *3D: Double Vision*, ed. Britt Salvesen (Los Angeles: Los Angeles County Museum of Art, 2018), 12.

131 Salvesen, 5.

132 Jonathan Crary, *Techniques of the Observer: On Vision and Modernity in the Nineteenth Century* (Cambridge, MA: MIT Press, 2012), 14. Crary uses the example of the stereoscope, noting that viewers can choose to interact with the "apparatus."

133 Anne Friedberg, *The Virtual Window: From Alberti to Microsoft* (Cambridge, MA: MIT Press, 2006), 87.

134 Frank Biocca, "The Cyborg's Dilemma: Progressive Embodiment in Virtual Environments," *Journal of Computer–Mediated Communication* 3, no. 2 (September 1997): n.p., doi:10.1111/j.1083-6101.1997. tb00070.x. Catherine S. Oh, Jeremy N. Bailenson, and Gregory F. Welch, "A Systematic Review of Social Presence: Definition, Antecedents, and Implications," *Frontiers in Robotics and AI* 5, art. 114 (October 2018): 1–35. For a timeline of the stereo antecedents to VR, see Zachary Rottman, "3D Timeline," in Salvesen, *3D: Double Vision*, 158–85.

135 Ryan Bradley, "How Nonny de la Pena, the 'Godmother of VR,' Is Changing the Mediascape," November 3, 2018, https://www.wsj.com/articles/how-nonny-de-la-pena-the-godmother-of-vr-is-changing-the-mediascape-1541253890?ns=prod/accounts-wsj.

136 Sarah McDonagh, "SXSW: Virtual Reality Pioneer Nonny de la Peña on Immersive Storytelling," March 15, 2018, https://www.storybench.org/sxsw-virtual-reality-pioneer-nonny-de-la-pena-immersive-storytelling/; and Nonny de la Peña, "The Future of News? Virtual Reality," TEDWomen 2015, https://www.ted.com/talks/nonny_de_la_pena_the_future_of_news_virtual_reality?language=en.

137 This project began after Sara Ramirez, board member of True Colors Fund, an organization fighting homelessness among LGBTQ+ communities, relayed Pierce's story to her. For more about the development of the project, see Sara Rafsky, "Interview with Nonny de la Peña," accessed December 28, 2019, https://docubase.mit.edu/lab/interviews/interview-with-nonny-de-la-pena/; and Emblematic Group, "Out of Exile," accessed December 28, 2019, https://emblematicgroup.com/experiences/out-of-exile/.

138 Shoshana Zuboff, *The Age of Surveillance Capitalism: The Fight for a Human Future at the New Frontier of Power* (New York: PublicAffairs, 2019), 1–2.

139 For more on this project, see Claudia E. Zapata, "Digital Harbinger: Michael Menchaca's The Codex Silex Vallis (The Silicon Valley Codex)," *Michael Menchaca: The Codex Silex Vallis (Sept. 21–Dec. 22, 2019)*, Lawndale Art Center, October 1, 2019, n.p., https://issuu.com/lawndaleartcenter/docs/michael_menchaca_brochure.

140 Michael Menchaca, "Statement on Social Media," accessed August 20, 2019, https://michaelmenchaca.com/artwork/4596979-Social-Media-Statement.html. John Jota Leaños, founding member of Los Cybrids, a Bay Area collective, has also critiqued the negative effects of the tech industry; see Guisela Latorre, *Walls of Empowerment: Chicana/o Indigenist Murals of California* (Austin: University of Texas Press, 2008), 237–39; and Gary D. Keller, "John Jota Leaños," in Keller, *Contemporary Chicana and Chicano Art*, 2:48–49.

141 Glenn Greenwald and Ewen MacAskill, "Boundless Informant: The NSA's Secret Tool to Track Global Surveillance Data," *Guardian* (U.S. edition), June 11, 2013, https://www.theguardian.com/world/2013/jun/08/nsa-boundless-informant-global-datamining; and Glenn Greenwald, Ewen MacAskill, and Laura Poitras, "Edward Snowden: The Whistleblower Behind the NSA Surveillance Revelations," *Guardian* (U.S. edition), June 11, 2013, https://www.theguardian.com/world/2013/jun/09/edward-snowden-nsa-whistleblower-surveillance.

142 Emiliano Treré, *Hybrid Media Activism: Ecologies, Imaginaries, Algorithms* (London: Routledge, 2019), 169. See Carole Cadwalladr and Emma Graham-Harrison, "How Cambridge Analytica Turned Facebook 'Likes' into a Lucrative Political Tool," *Guardian* (U.S. edition), March 17, 2018, https://www.theguardian.com/technology/2018/mar/17/facebook-cambridge-analytica-kogan-data-algorithm; and Matthew Rosenberg, Nicholas Confessore, and Carole Cadwalladr, "How Trump Consultants Exploited the Facebook Data of Millions," *New York Times*, March 17, 2018, https://www.nytimes.com/2018/03/17/us/politics/cambridge-analytica-trump-campaign.html?module=inline.

143 For more on algorithms and social movements, see Treré, *Hybrid Media Activism*, 169–70.

¡PRINTING THE REVOLUTION!

PLATES

PLATE 1

Carlos A. Cortéz

Draftees of the World, Unite!

ca. 1965

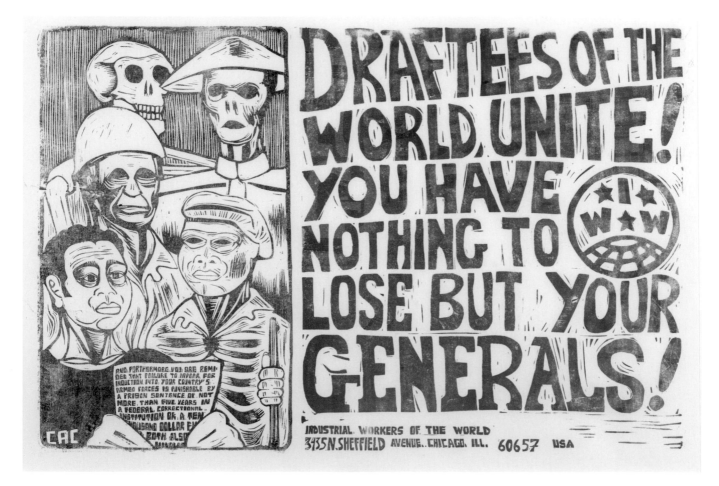

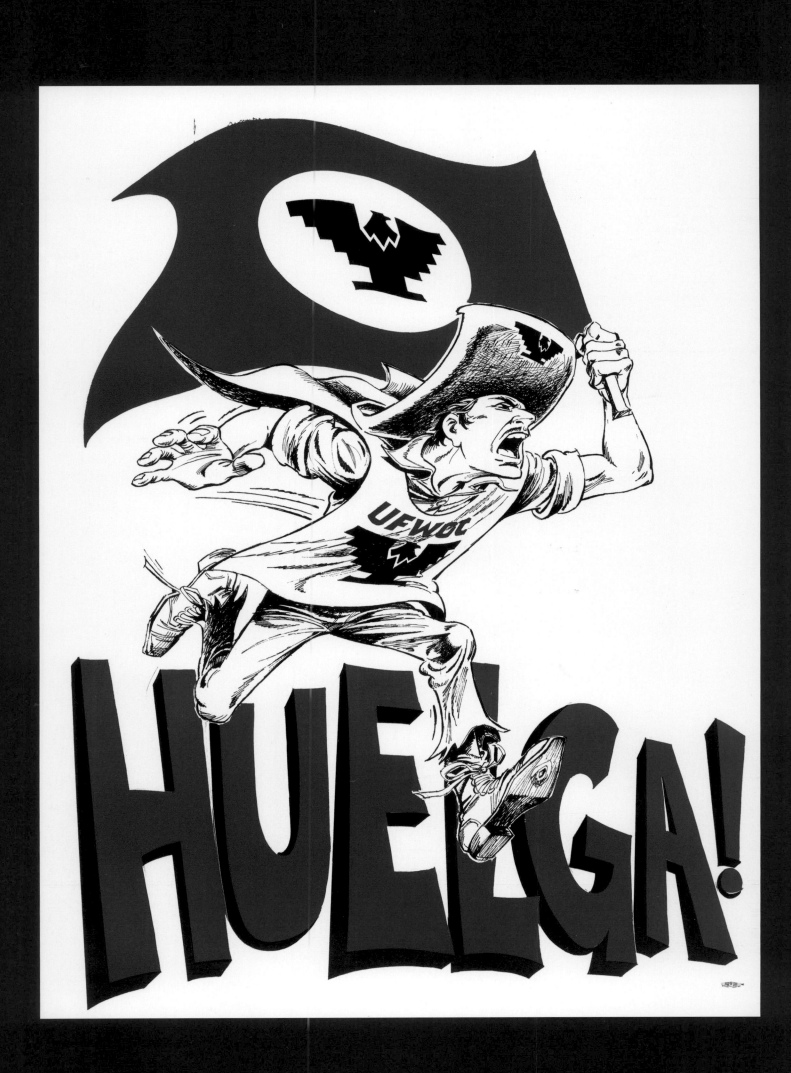

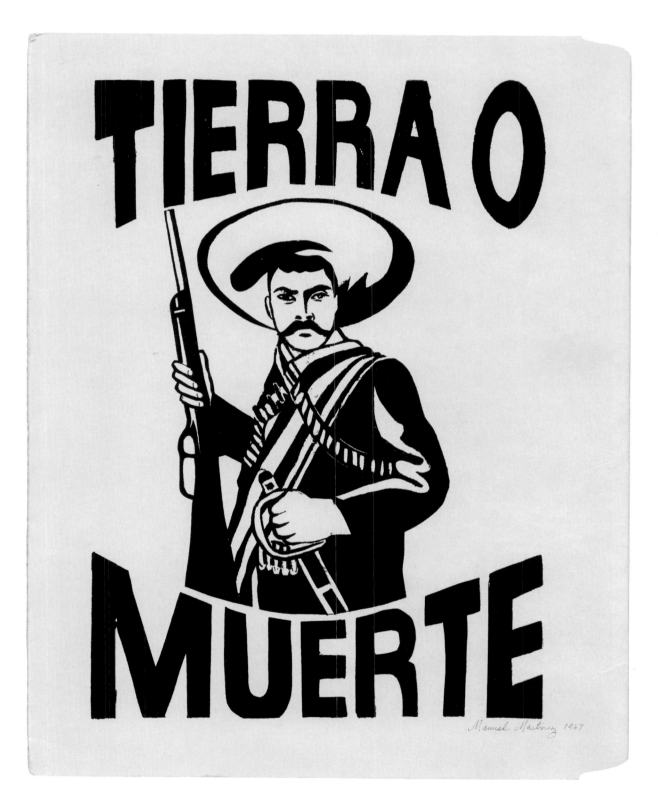

PLATE 8

Rupert García

¡LIBERTAD PARA
LOS PRISONEROS
POLÍTICAS!

1971

¡LIBERTAD PARA LOS PRISONEROS POLITICAS!

PLATE 9

Malaquias Montoya

*Julio 26—Cuba Vietnam
y Nosotros Venceremos*

1972

PLATE 10

Malaquias Montoya

Yo Soy Chicano

1972, reprinted in collaboration with
Dignidad Rebelde in 2013

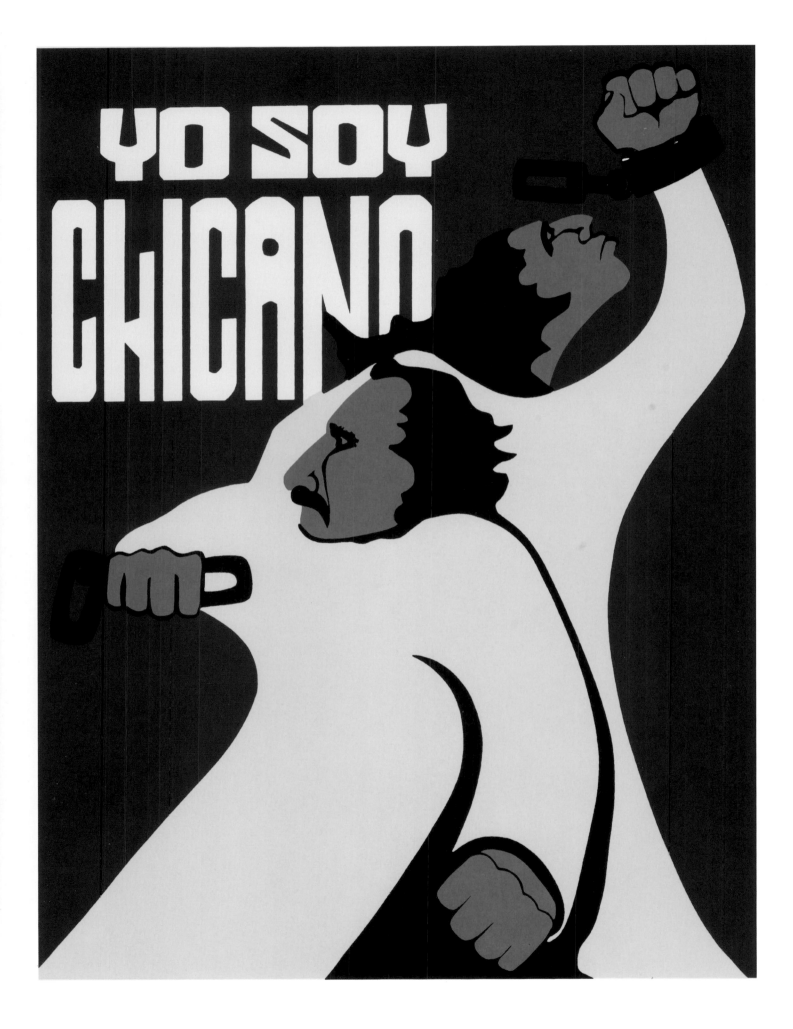

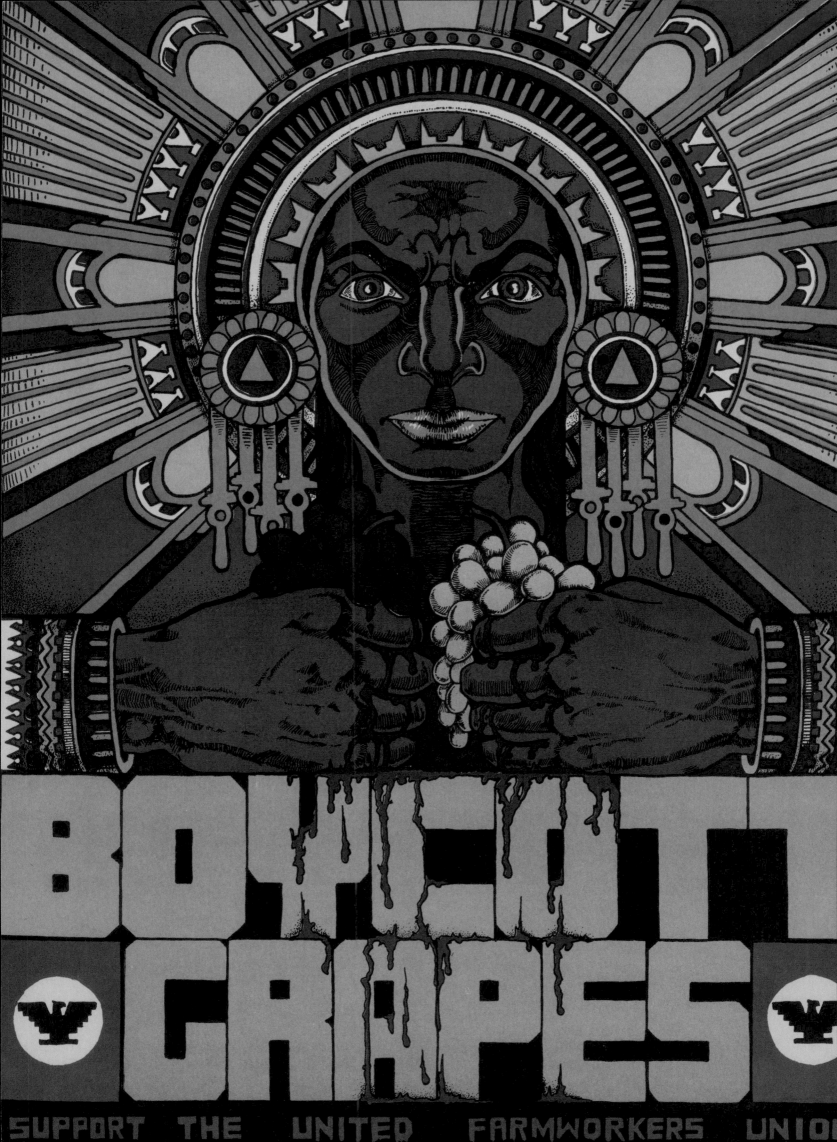

PLATE 11

Xavier Viramontes

*Boycott Grapes,
Support the United
Farm Workers Union*

1973

▶ PLATE 12

Rupert García

¡Cesen Deportación!

1973, reprinted in
collaboration with
Dignidad Rebelde
in 2011

DEPORTACIÓN!

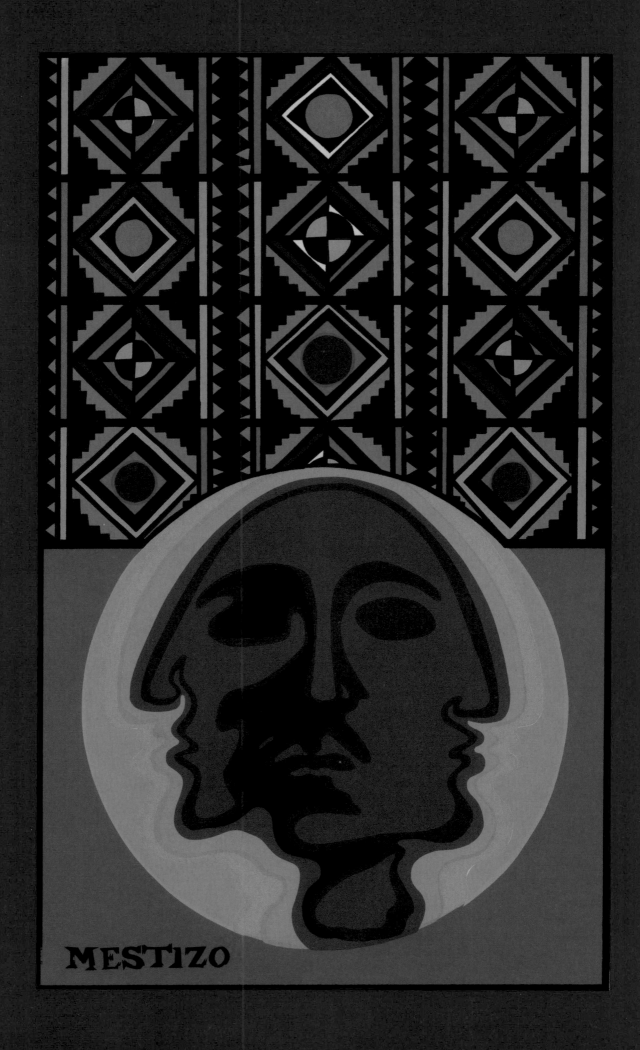

MESTIZO

PLATE 13

Amado M. Peña Jr.

Mestizo

1974

PLATE 14

Carmen Lomas Garza

La Curandera

ca. 1974

PLATE 13

Amado M. Peña Jr.

Mestizo

1974

PLATE 14

Carmen Lomas Garza

La Curandera

ca. 1974

PLATE 15

Amado M. Peña Jr.

*Aquellos que
han muerto*

1975

PLATE 16

Linda Zamora Lucero

*Lolita Lebrón, ¡Viva
Puerto Rico Libre!*

1975

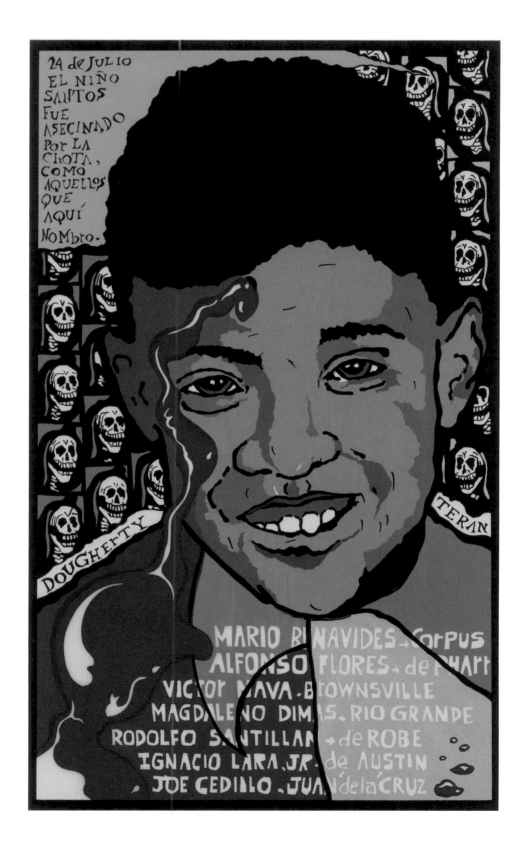

LOLITA LEBRÓN

"TODOS SOMOS PEQUEÑOS, SOLO LA PATRÍA
ES GRANDE Y ESTÁ ENCARCELADA"

¡VIVA PUERTO RICO LIBRE!

PLATE 17

Juan Fuentes

Untitled (April),
from *Galería de la Raza's
1975 Calendario*

1975

PLATE 18

Francisco X Camplis

Untitled (February),
from *Galería de la Raza's
1975 Calendario*

1975

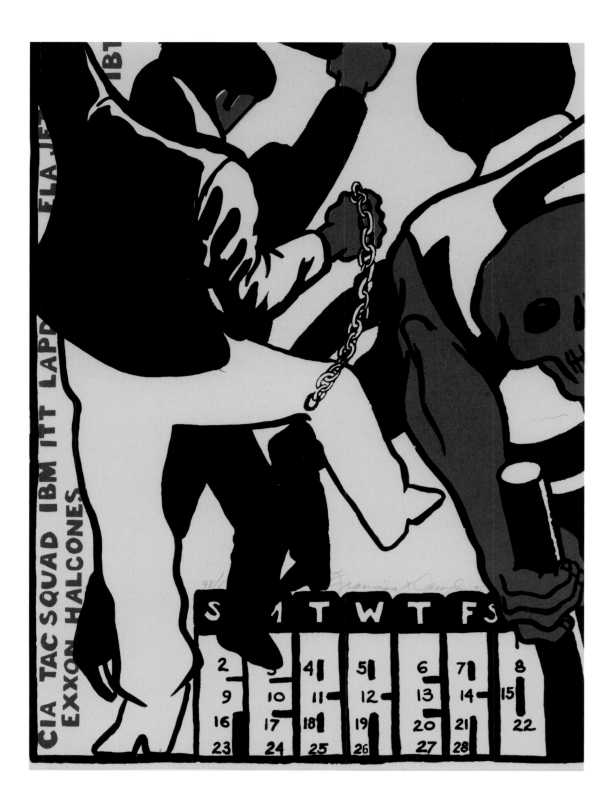

PLATE 19

Rupert García

Frida Kahlo (September),
from *Galería de la Raza's*
1975 Calendario

1975

PLATE 20

**Luis C. González and
Héctor D. González**

*Hasta La Victoria
Siempre*

1975

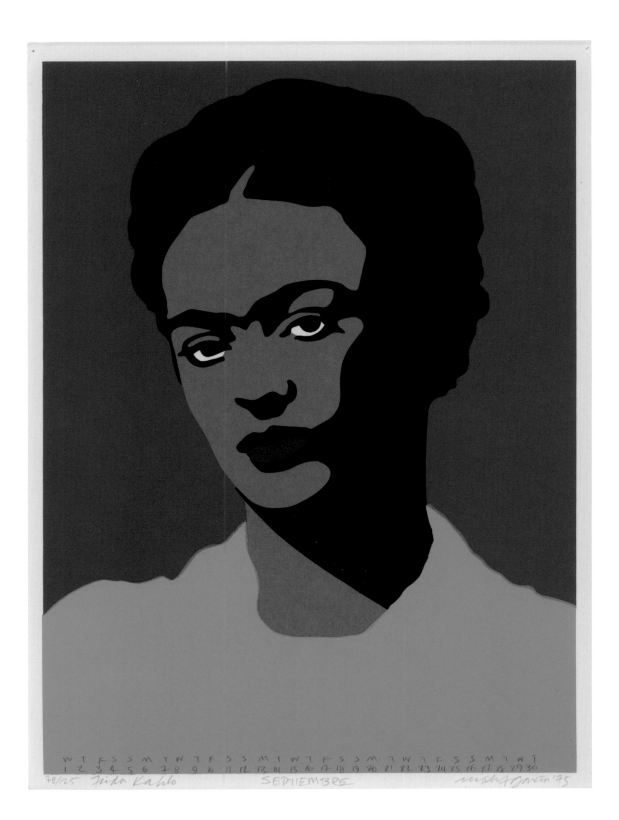

PLATE 21

Ester Hernandez

*La Virgen de Guadalupe
Defendiendo los Derechos
de los Xicanos*

1975

PLATE 22

Rodolfo O. Cuellar

*Humor in Xhicano
Arte 200 Years of
Oppression 1776–1976*

1976

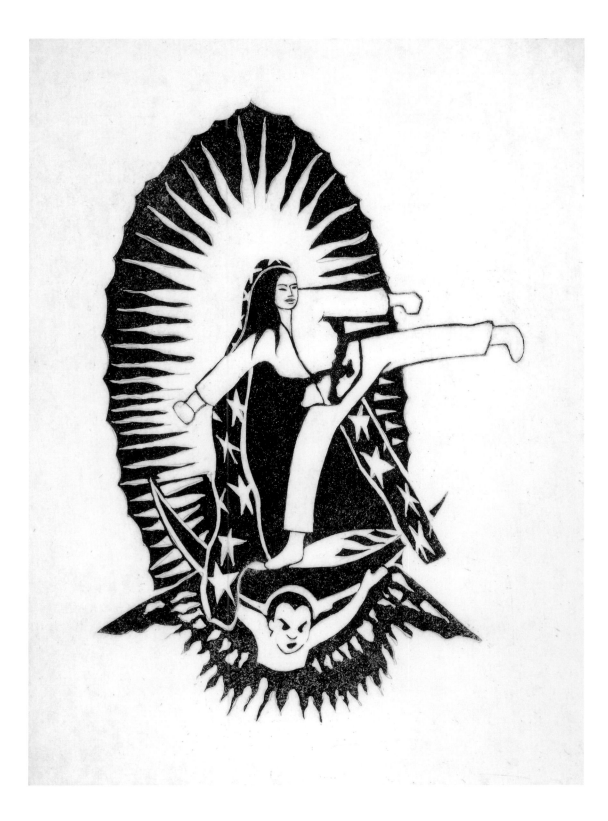

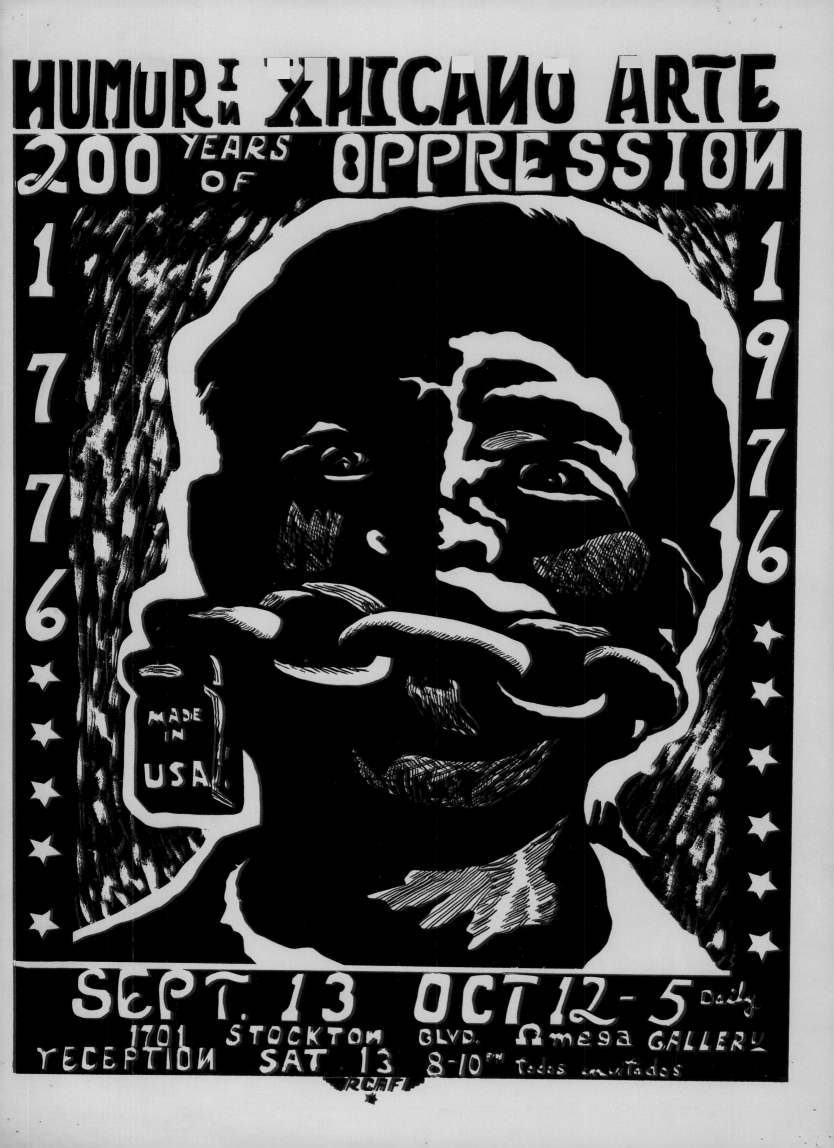

PLATE 23

Ricardo Favela

*Centennial Means 500
Years of Genocide!*

1976

PLATE 24

Oscar Melara

José Martí

1976

PLATE 25

**Max E. Garcia and
Luis C. González**

*The Last Papa with the
Big Potatoe (October),* from
Calendario de Comida 1976

1975

PLATE 26

Malaquias Montoya

George Jackson Lives

1976

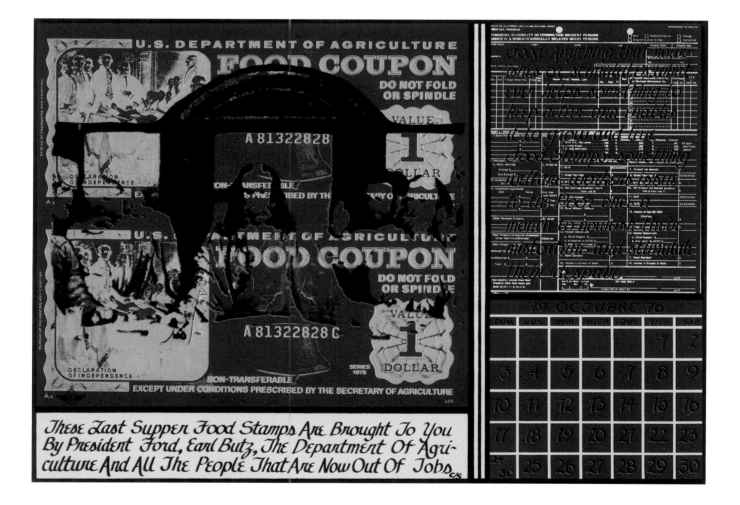

GEORGE JACKSON LIVES

THOSE WHO BROUGHT YOU THE MURDER OF GEORGE JACKSON...

THE STATE OF CALIFORNIA PRESENTS THE TRIAL OF THE

SAN QUENTIN SIX

FEATURING: —RACISM— —FACISM— —INJUSTICE—

PLATE 29

Rupert García

*Chicano Research
as a Catalyst for
Social Change*

1977

PLATE 30

Mario Torero

*You Are Not
a Minority!!*

1977

PLATE 31

Juan Fuentes

*South African
Women's Day*

1978

PLATE 32

**Rodolfo O. Cuellar,
Luis C. González, and
José Montoya**

*José Montoya's Pachuco Art,
A Historical Update*

1978

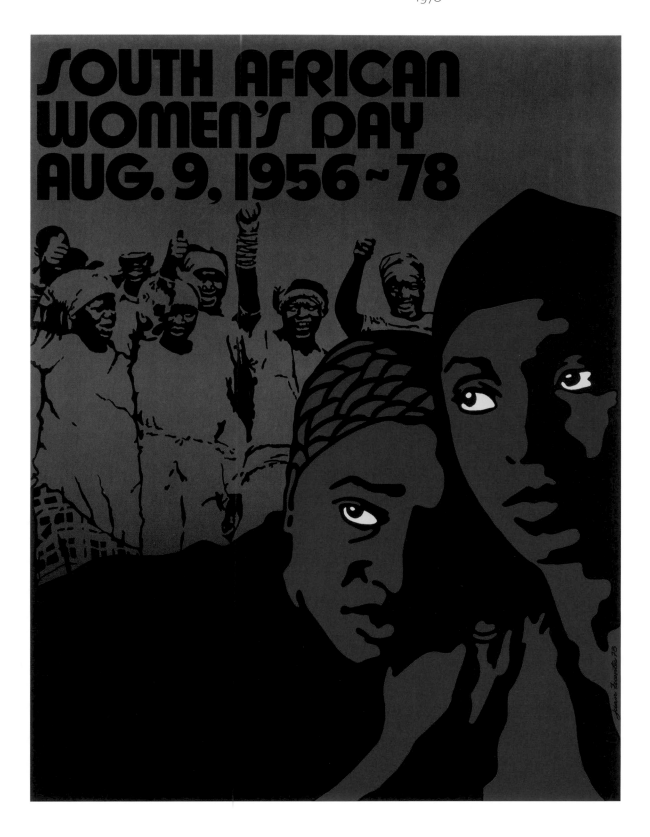

PLATE 33

Luis C. González

Fiesta del Maiz

1979

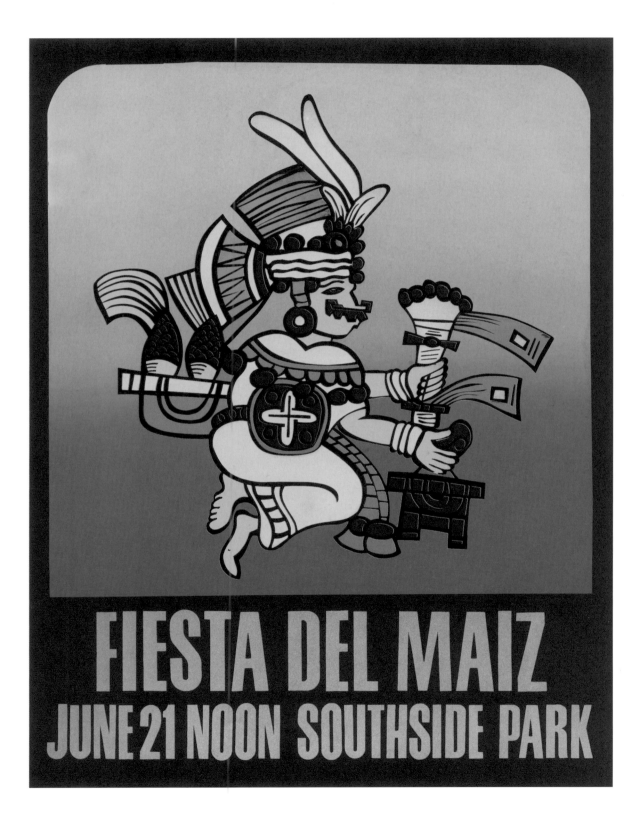

PLATE 34

Carlos A. Cortéz

Joe Hill

1979

PLATE 35

Luis C. González

*Tenth Annual Día de los
Muertos Celebration*

1980

PLATE 36

Malaquias Montoya

Undocumented

1980, signed 1981

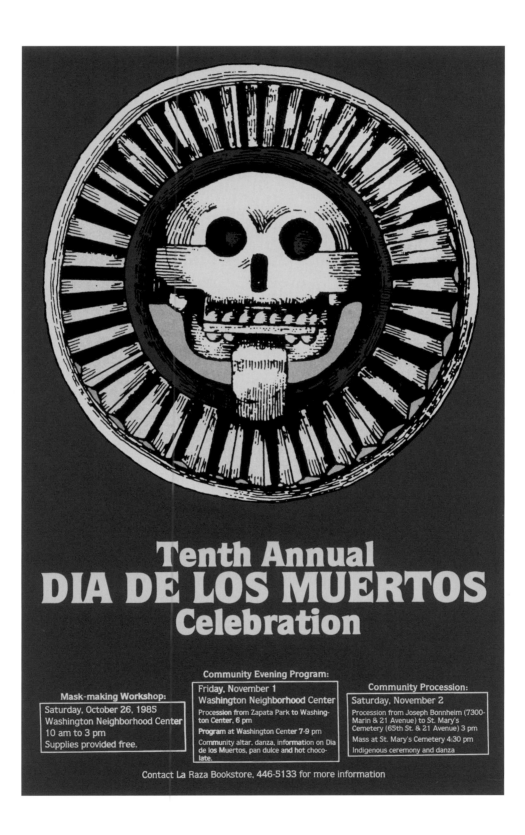

**Tenth Annual
DIA DE LOS MUERTOS
Celebration**

Community Evening Program:

Mask-making Workshop:

Saturday, October 26, 1985
Washington Neighborhood Center
10 am to 3 pm
Supplies provided free.

**Friday, November 1
Washington Neighborhood Center**
Procession from Zapata Park to Washington Center, 6 pm
Program at Washington Center **7-9 pm**
Community altar, danza, information on Dia de los Muertos, pan dulce and hot chocolate.

Community Procession:

Saturday, November 2
Procession from Joseph Bonnheim (7300-Marin & 21 Avenue) to St. Mary's Cemetery (65th St. & 21 Avenue) 3 pm
Mass at St. Mary's Cemetery 4:30 pm
Indigenous ceremony and danza

Contact La Raza Bookstore, 446-5133 for more information

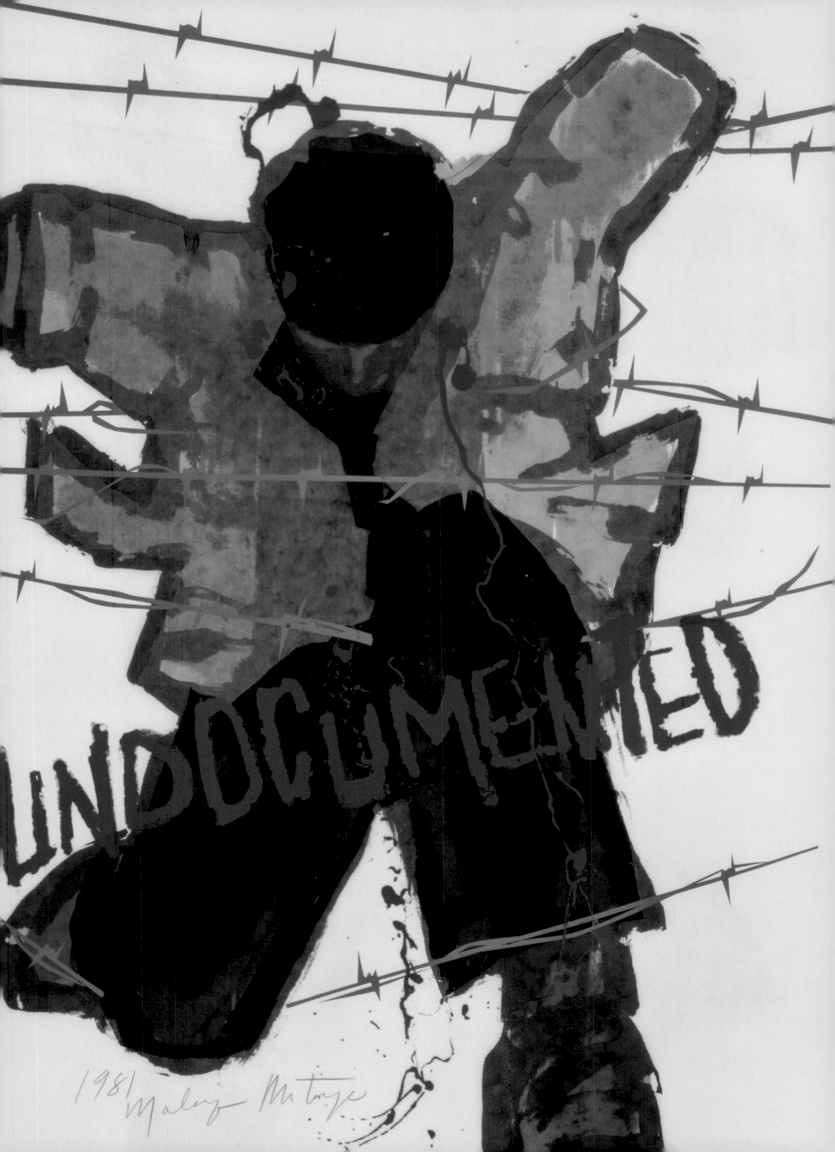

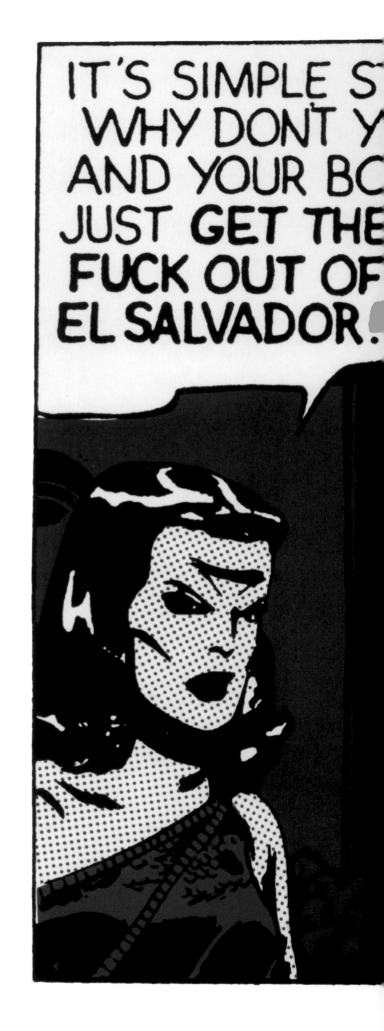

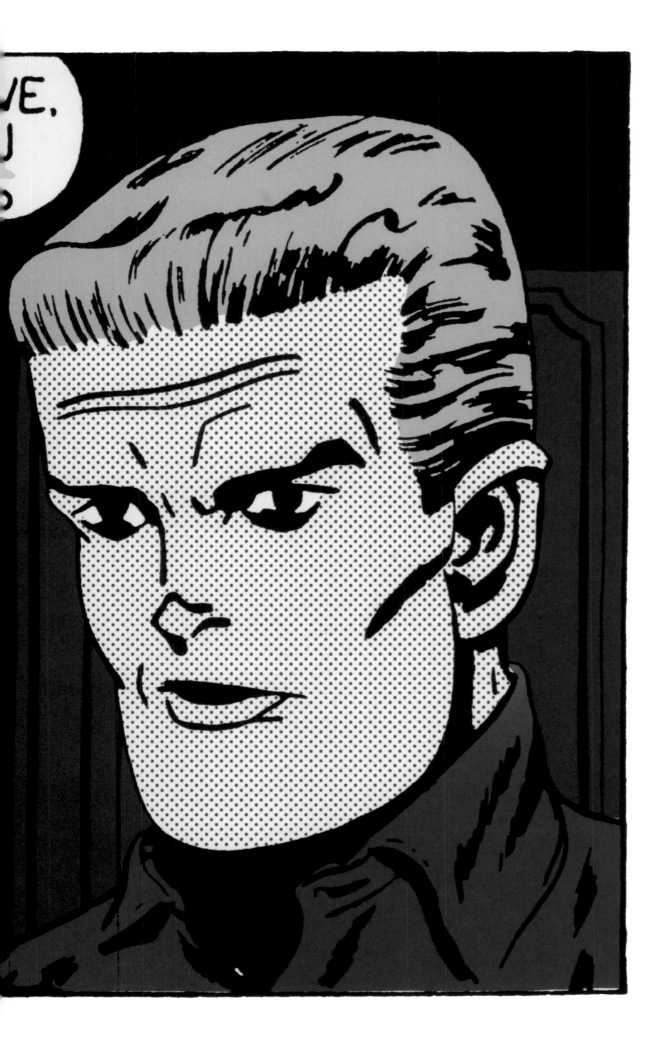

PLATE 38

Carlos A. Cortéz

*José Guadalupe
Posada*

1981, signed 1983

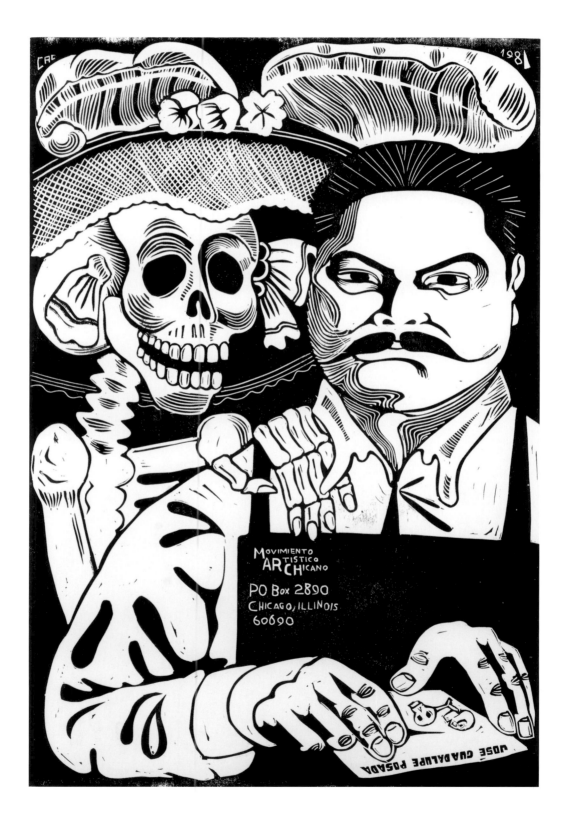

PLATE 39

Yolanda López

*Who's the Illegal Alien,
Pilgrim?*

1981

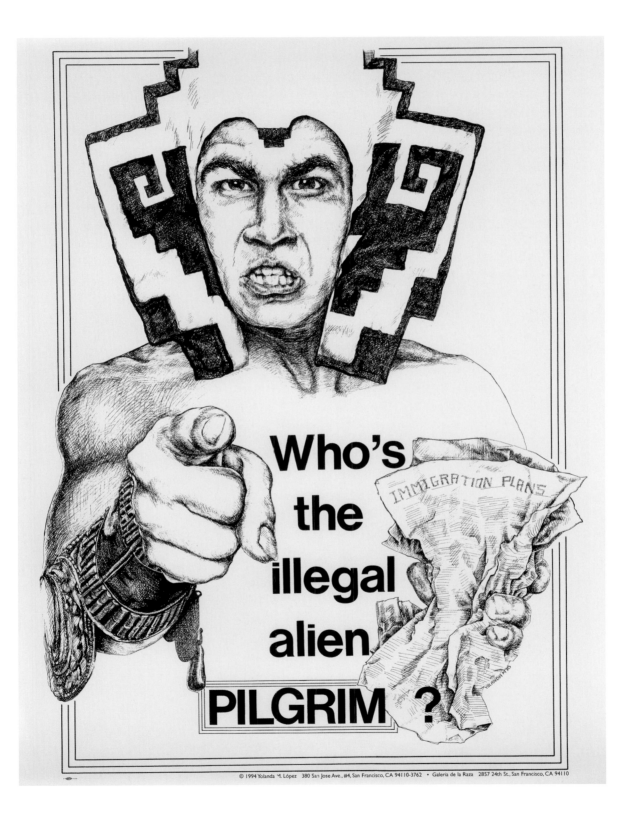

PLATE 40

Ester Hernandez

Sun Mad

1982

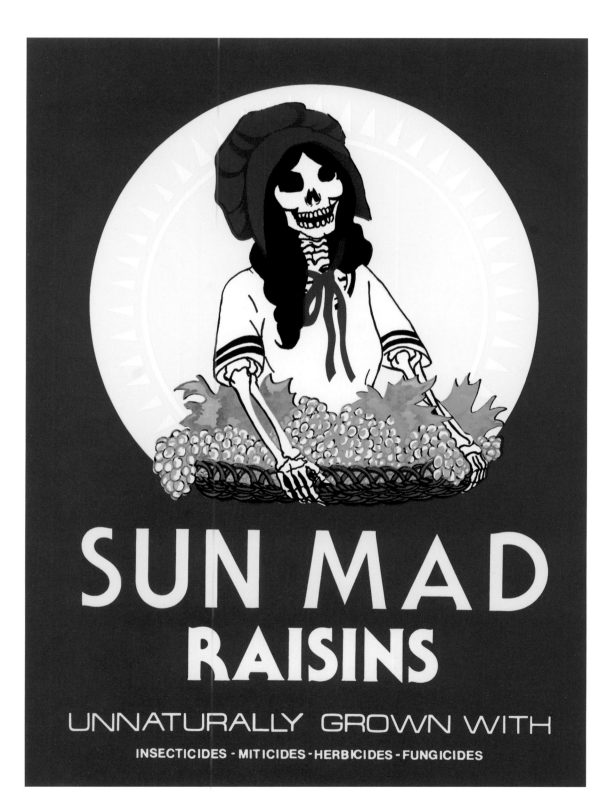

PLATE 41

Ester Hernandez

Sun Raid

2008

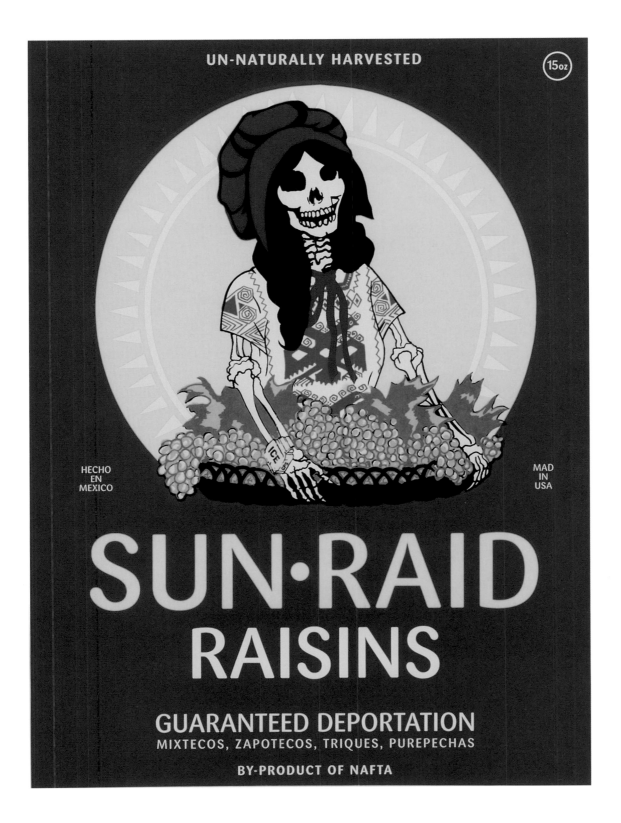

PLATE 42

Richard Duardo

Aztlan

1982

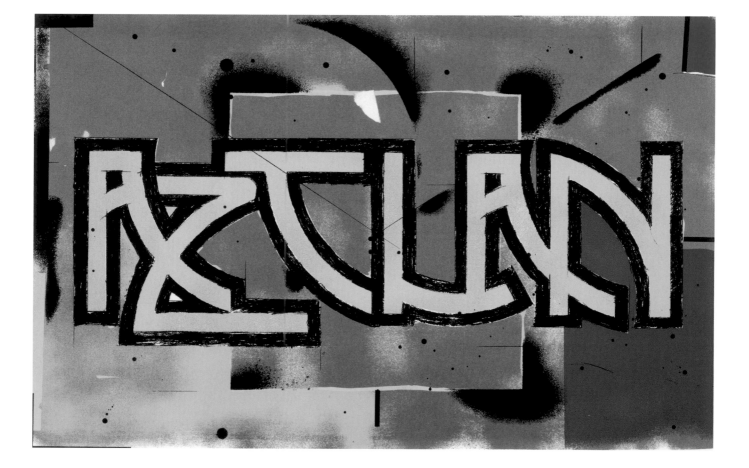

PLATE 43

Nancy Hom

*No More Hiroshima/
Nagasakis: Medical Aid
for the Hibakushas*

1982

PLATE 44

Juan Fuentes

January/February, from
*La Raza Graphic Center's
1983 Political Art Calendar*

1982

PLATE 45

Jos Sances

March/April, from *La Raza*
Graphic Center's 1983
Political Art Calendar

1982

PLATE 46

Herbert Sigüenza

July/August, from *La Raza
Graphic Center's 1983
Political Art Calendar*

1982

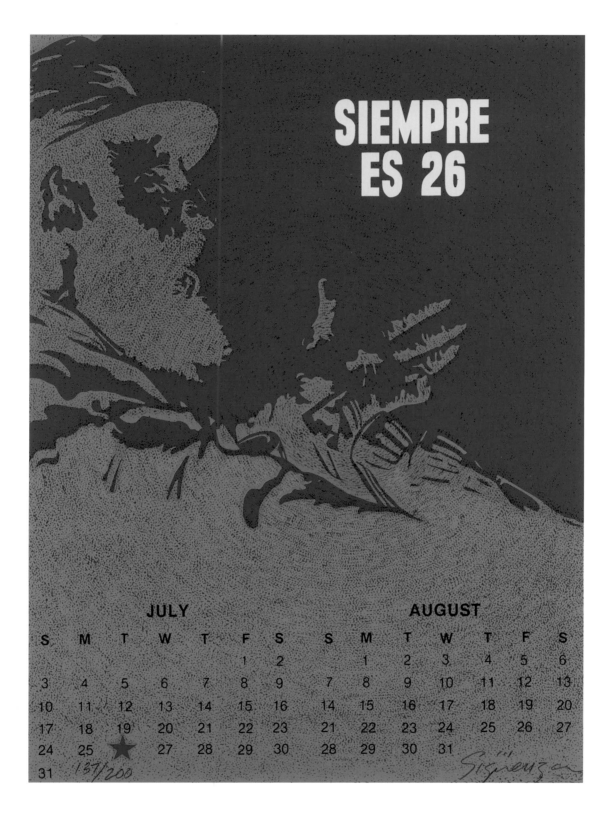

PLATE 47

René Castro

September/October, from *La Raza Graphic Center's 1983 Political Art Calendar*

1982

PLATE 48

Luis C. González

*Miguel Hidalgo
y Costílla*

1976

PLATE 49

René Castro

Víctor Jara

1986

Welcome to A

Tou
Plan

This art project funded by
the National Endowment for the Art
the City of San Diego, COMBO,
and Art Matters, Inc.
©1988 GBU

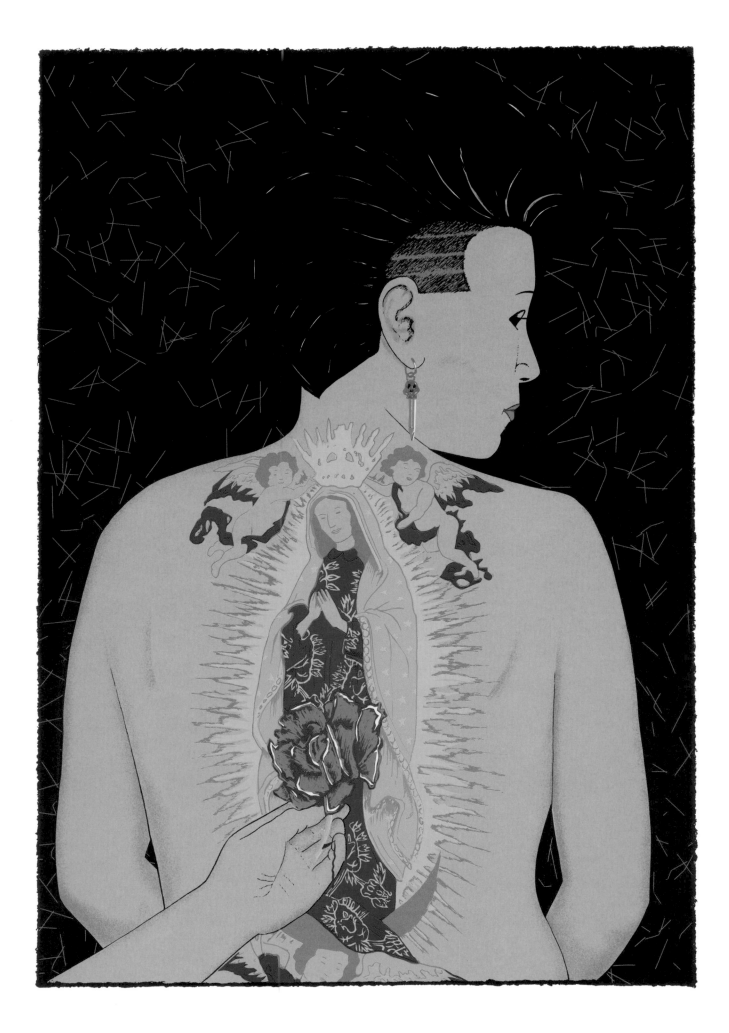

PLATE 54

Ester Hernandez

La Ofrenda, from the
National Chicano
Screenprint Taller,
1988–1989

1988

PLATE 55

Barbara Carrasco

Messages to the Public:
Pesticides!

July 1989, on Spectacolor
board, Times Square,
New York City

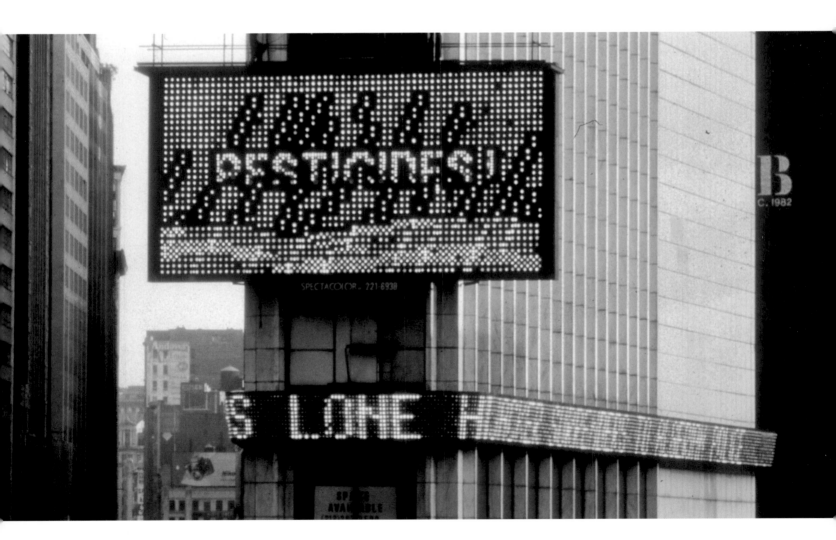

PLATE 56

René Castro

I Am Ashamed MLK

1992

PLATE 57

Rodolfo O. Cuellar

Selena, A Fallen Angel

1995

PLATE 58

Yreina D. Cervántez

*Mujer de Mucha Enagua,
PA'TI XICANA*

1999

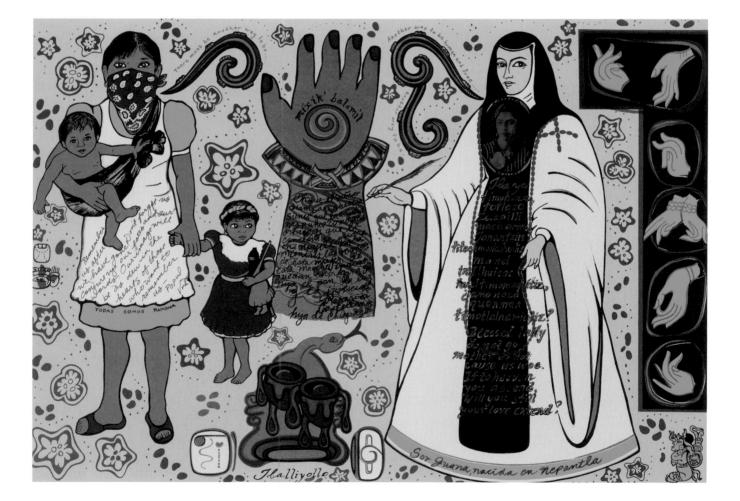

PLATE 59

Alma Lopez

Our Lady

1999

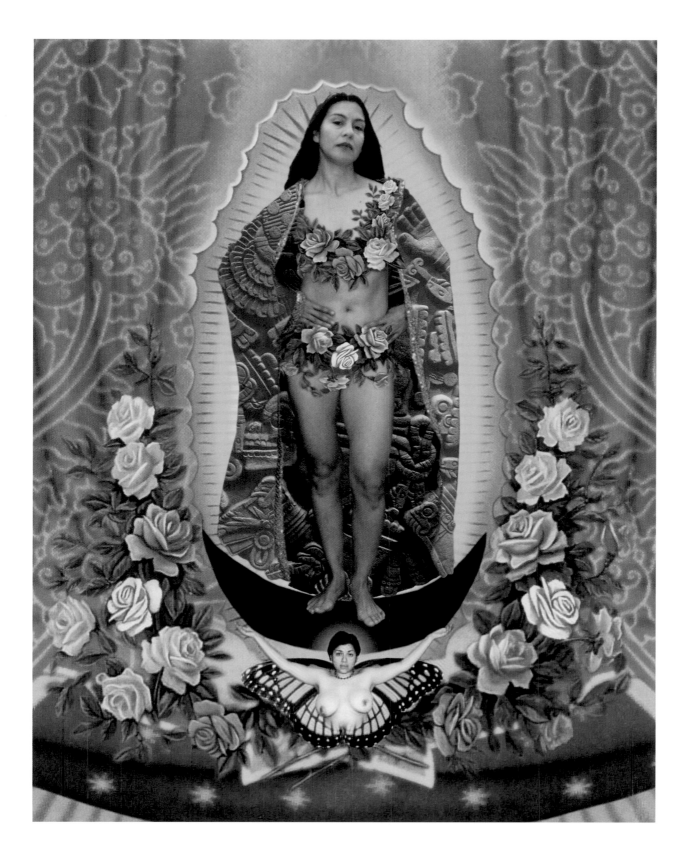

PLATE 60

Barbara Carrasco

Dolores

1999

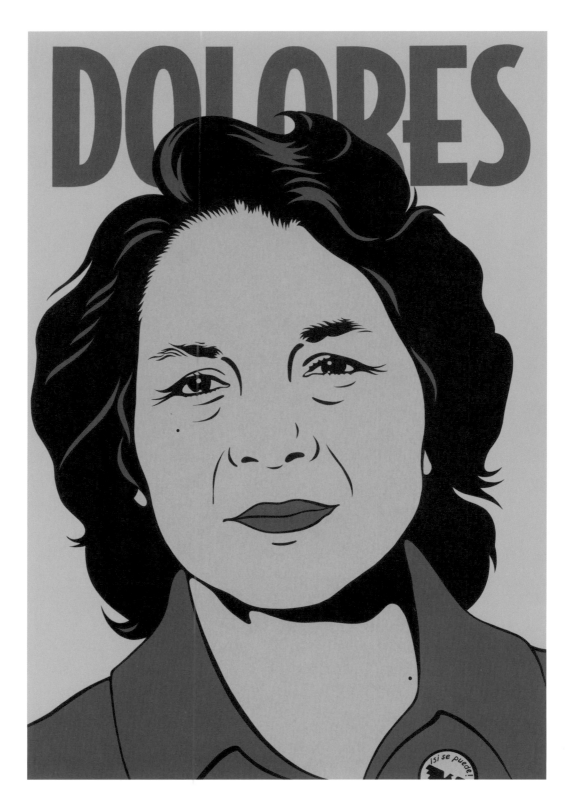

PLATE 61

Sam Coronado

Guerillera II

2001

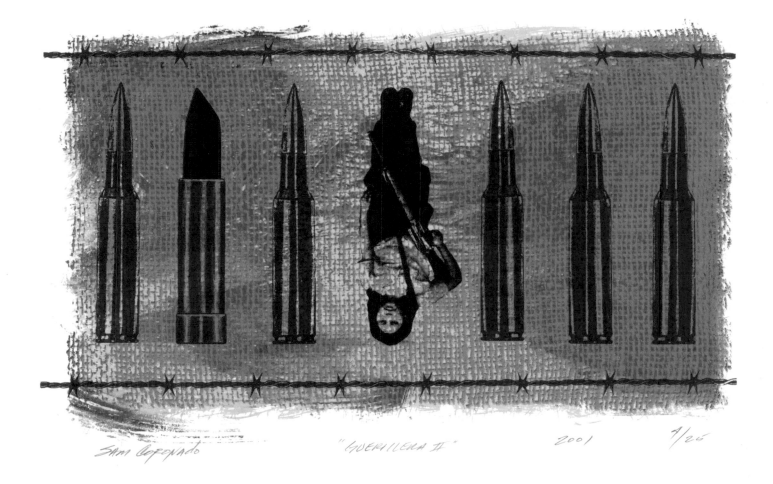

PLATE 62

Alejandro Diaz

I ♥ Cuba

2003

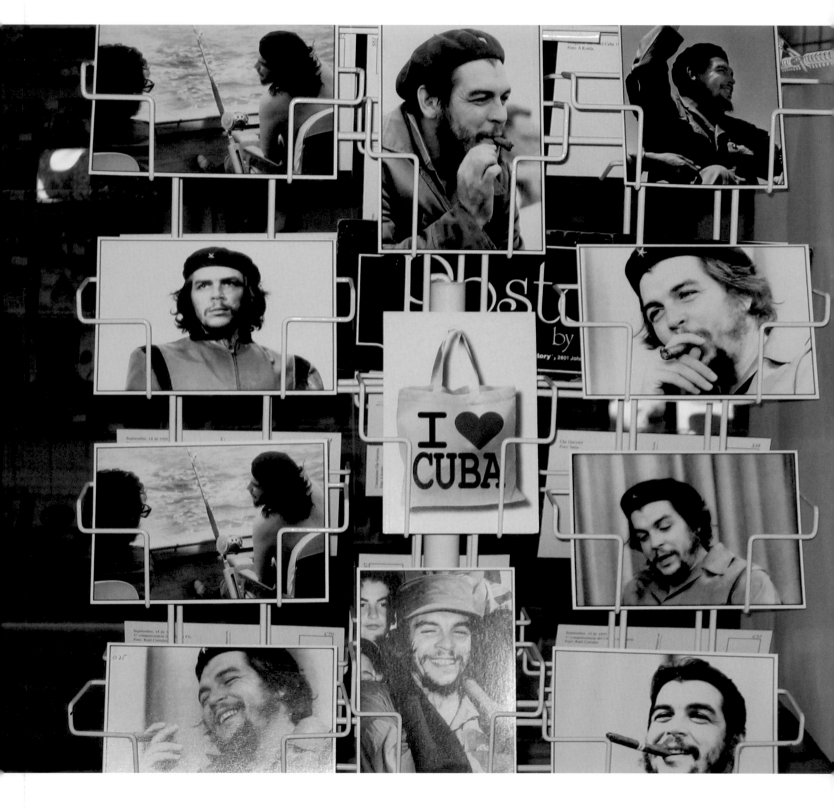

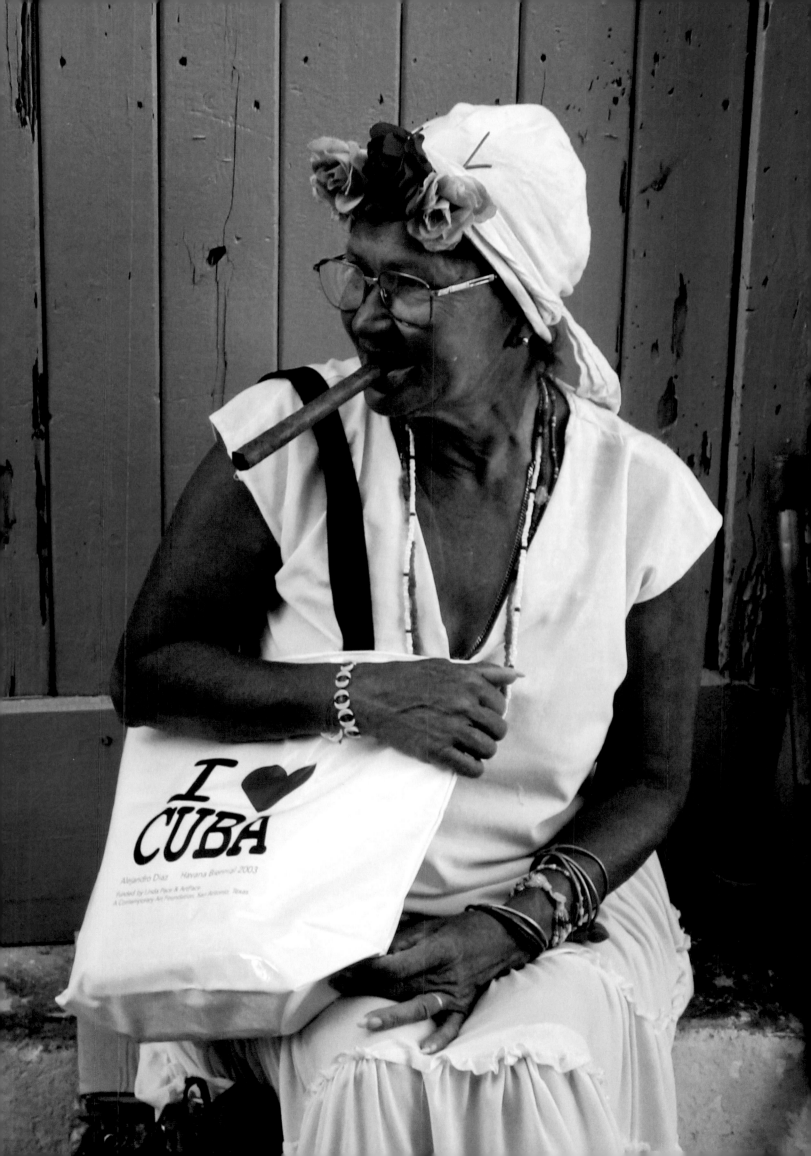

女見受言
殷郊見毋己死又
見姜環跪在一旁。
便將西宮門上一
口寶劍取在手中。
叫道好逆賊你欺
心行刺敢陷害國
毋便把姜環一劍
砍為兩段血濺滿
地又大叫曰我先
旦己。以報毋仇。
公就跑往
乱雷見太
公前來只當
公了黃妃
就殺了姜環。
公大驚曰
兔家不語事體。
叫殷洪快起回來。
說我有話說

黃貴妃

殷洪

PLATE 64

**Jesus Barraza,
Dignidad Rebelde**

Edward Said

2005

PLATE 65

Sam Coronado

Quince II

2011

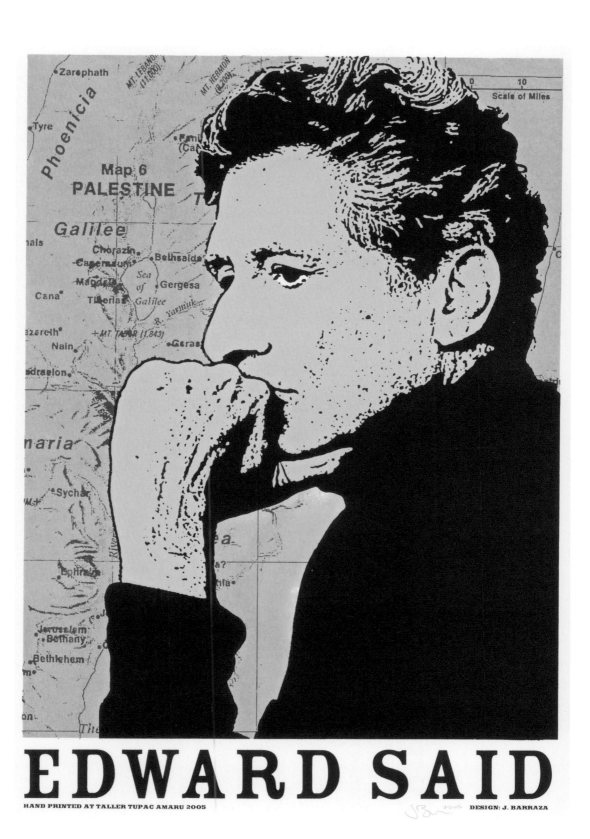

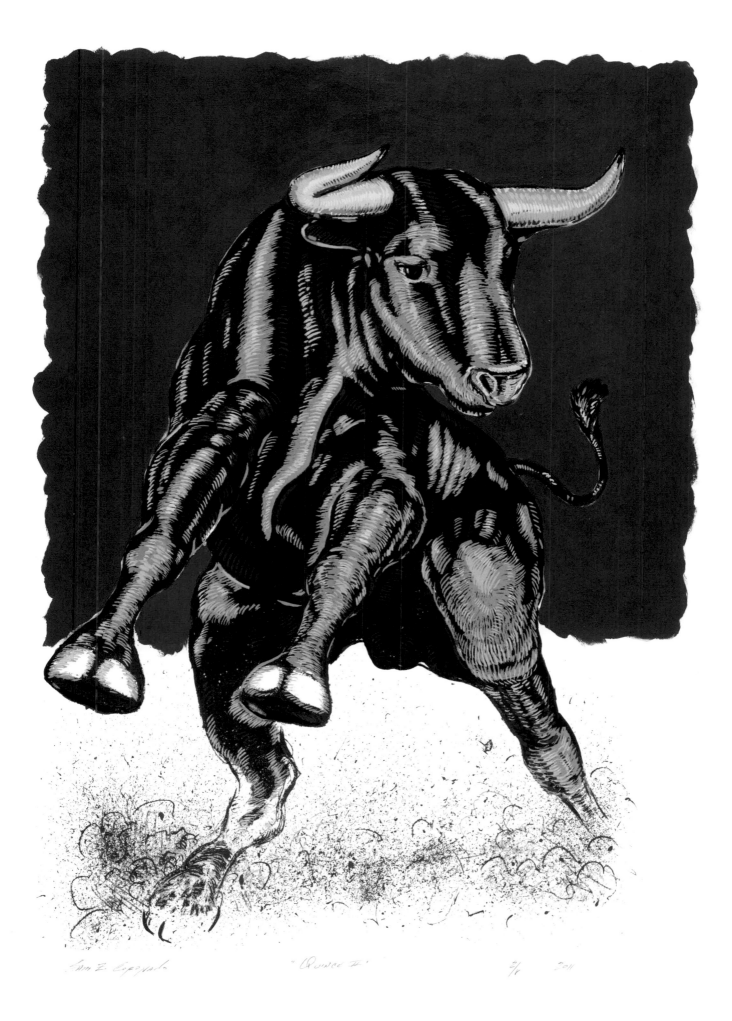

Sam E. Coronado, "Quince II," 2/6, 2011

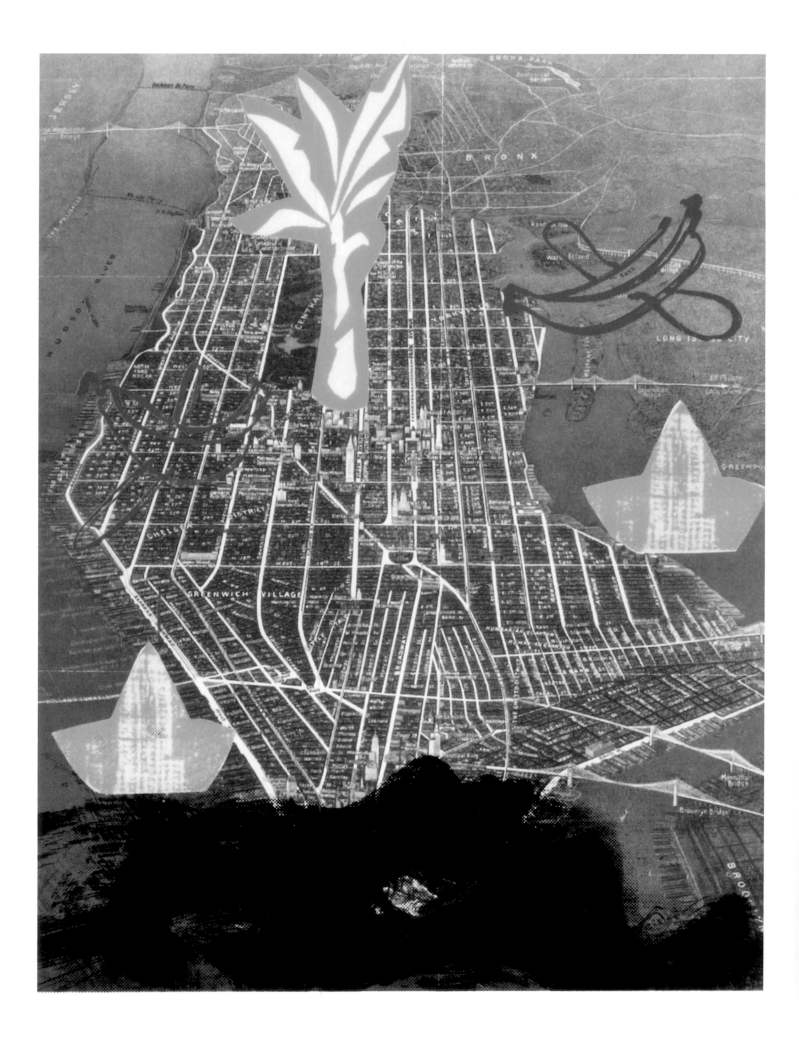

PLATE 66

**Dominican York
Proyecto GRAFICA
Scherezade García**

*Day Dreaming/
Soñando despierta*,
from the portfolio
Manifestaciones

2010

PLATE 67

**Dominican York
Proyecto GRAFICA
René de los Santos**

*Cigüita Cibaeña
en Nueva York*,
from the portfolio
Manifestaciones

2010

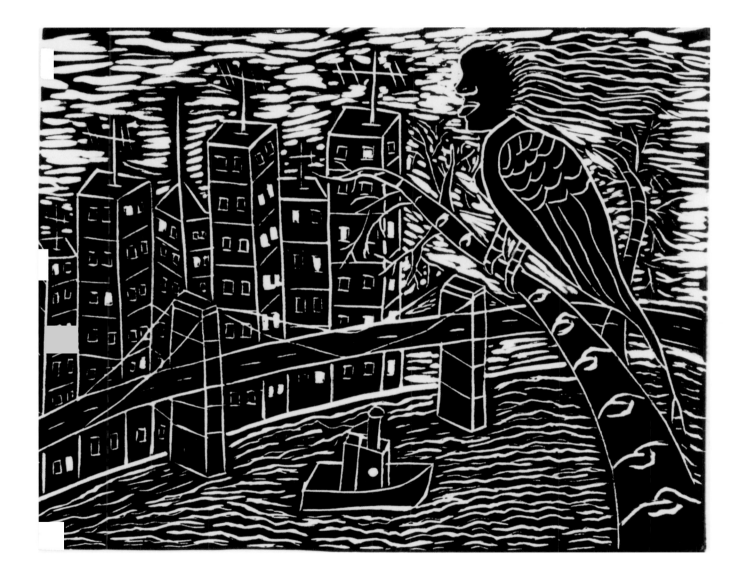

PLATE 68

**Dominican York
Proyecto GRAFICA
Yunior Chiqui Mendoza**

Bananhattan,
from the portfolio
Manifestaciones

2010

PLATE 69

**Dominican York
Proyecto GRAFICA
Carlos Almonte**

Vale John,
from the portfolio
Manifestaciones

2010

PLATE 70

**Dominican York
Proyecto GRAFICA
Alex Guerrero**

Vista Psicotrópica,
from the portfolio
Manifestaciones

2010

PLATE 71

**Dominican York
Proyecto GRAFICA
Luanda Lozano**

Sálvame Santo,
from the portfolio
Manifestaciones

2010

**Dominican York
Proyecto GRAFICA**

PLATE 72

**Dominican York
Proyecto GRAFICA
Miguel Luciano**

Detrás de la oreja,
from the portfolio
Manifestaciones

2010

PLATE 73

**Dominican York
Proyecto GRAFICA
Moses Ros-Suárez**

El Reggaeton del Bachatero,
from the portfolio
Manifestaciones

2010

PLATE 74

**Dominican York
Proyecto GRAFICA
Rider Ureña**

My girl on the floor,
from the portfolio
Manifestaciones

2010

PLATE 75

**Dominican York
Proyecto GRAFICA
Pepe Coronado**

Intrépido,
from the portfolio
Manifestaciones

2010

PLATE 76

**Dominican York
Proyecto GRAFICA
iliana emilia garcía**

Dreambox,
from the portfolio
Manifestaciones

2010

PLATE 77

**Dominican York
Proyecto GRAFICA
Reynaldo García Pantaleón**

Amarrao,
from the portfolio
Manifestaciones

2010

**Dominican York
Proyecto GRAFICA**

PLATE 78

Rupert García

Obama from Douglass

2010

PLATE 79

Sonia Romero

Bee Pile

2010

PLATE 80

Michael Menchaca

El Paso Superior

2010

PLATE 82

Michael Menchaca

Mucho Gato Amor

2010

PLATE 83

Michael Menchaca

*Cuando El Rio Suena
Gatos Lleva*

2011

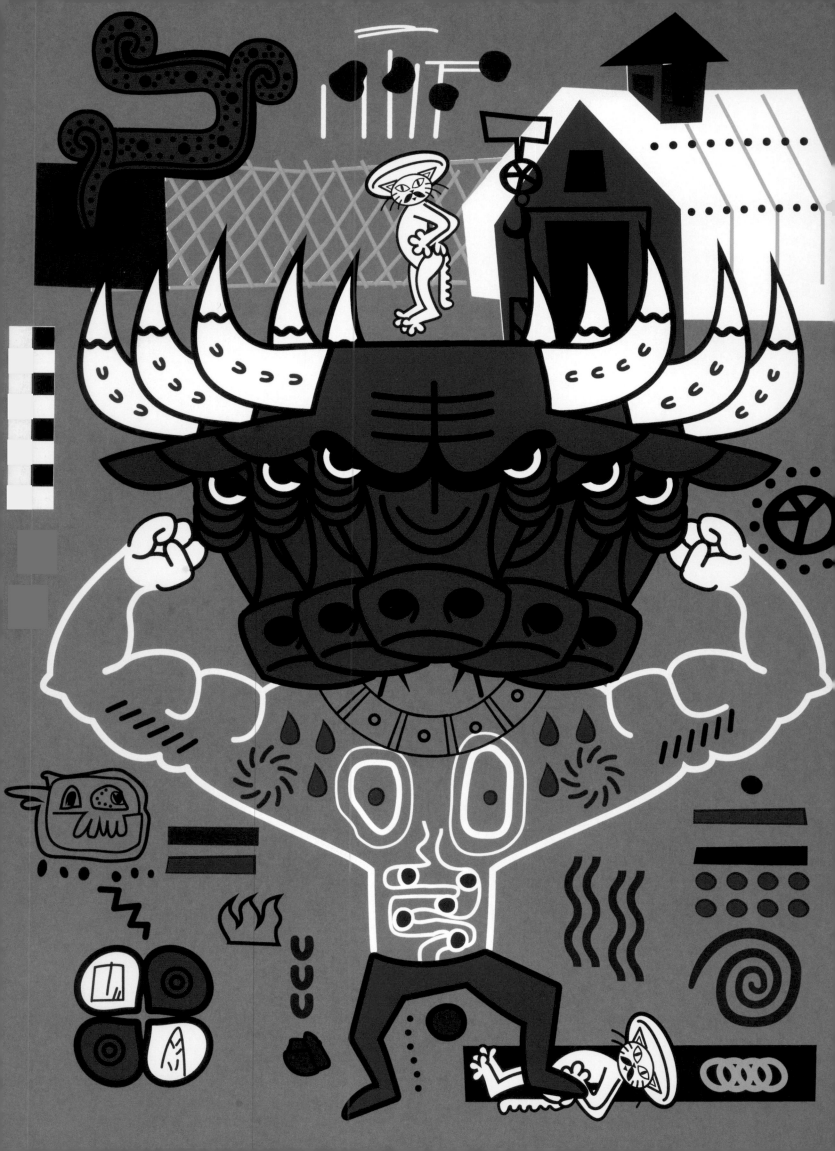

PLATE 84

Michael Menchaca

*Toro Lo Que Quieras
Es Tuyo*

2013

PLATE 88

Michael Menchaca

*Castigo Con Sus
Amigos Encima
Del Tren*

2010

PLATE 84

Michael Menchaca

*Toro Lo Que Quieras
Es Tuyo*

PLATE 86

Michael Menchaca

*Three figures
confronting an
Eagle deity*

2013

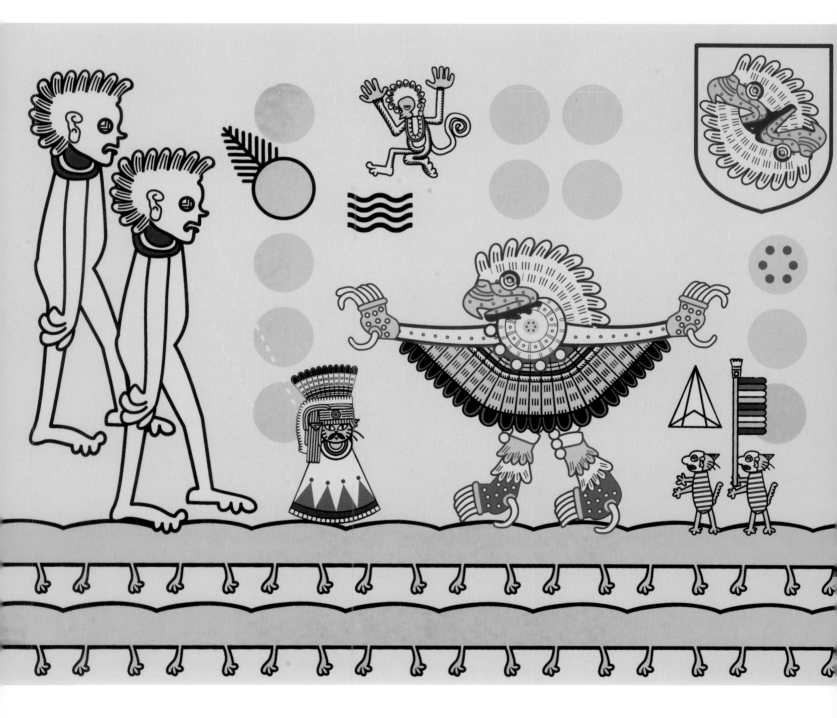

PLATE 87

Michael Menchaca

*An arrangement of
logograms, presumably
a sacrificial ornamentation*

2013

PLATE 88

Michael Menchaca

*Index of figural archetypes
and recurring pattern
ornamentation*

2013

PLATE 89

Michael Menchaca

*Index of figural archetypes
and recurring pattern
ornamentation*

2014

PLATE 90

Michael Menchaca

*Index of figural archetypes
and recurring pattern
ornamentation*

2014

PLATE 91

Michael Menchaca

*Index of figural archetypes
and recurring pattern
ornamentation*

2014

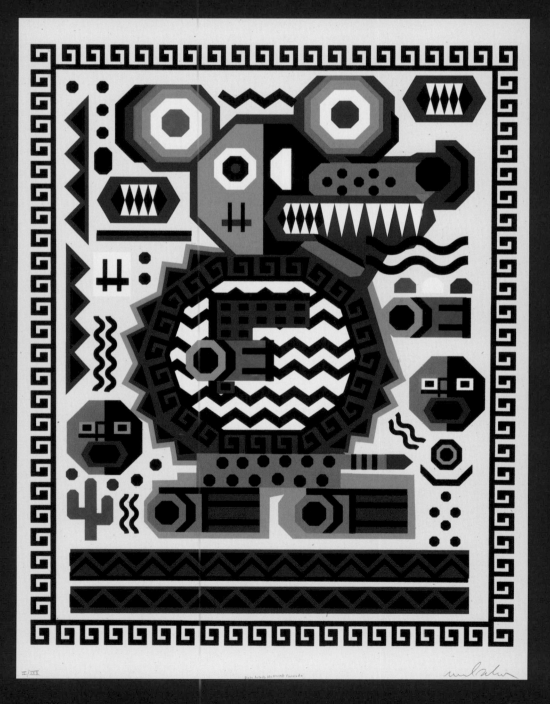

1,000,000 DEPORTATIONS

OBAMA: STOP THE DEPORTATIONS

YA BASTA! NO MORE! END S-COMM

Enviá la palabra **COMUNIDAD** al **30644**
para firmar una petición en contra de S-Comm

Text **COMMUNITY** to **30644**
to sign a National Petition against S-Comm

presente.org

PLATE 94

Favianna Rodriguez

Mi Cuerpo. Yo Decido.

2012

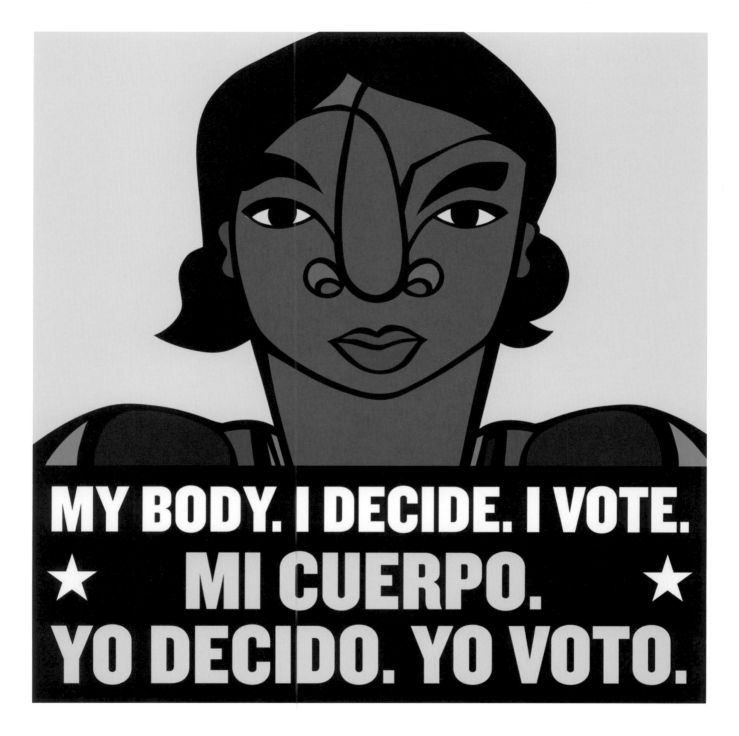

PLATE 95

Favianna Rodriguez

Migration Is Beautiful

2018

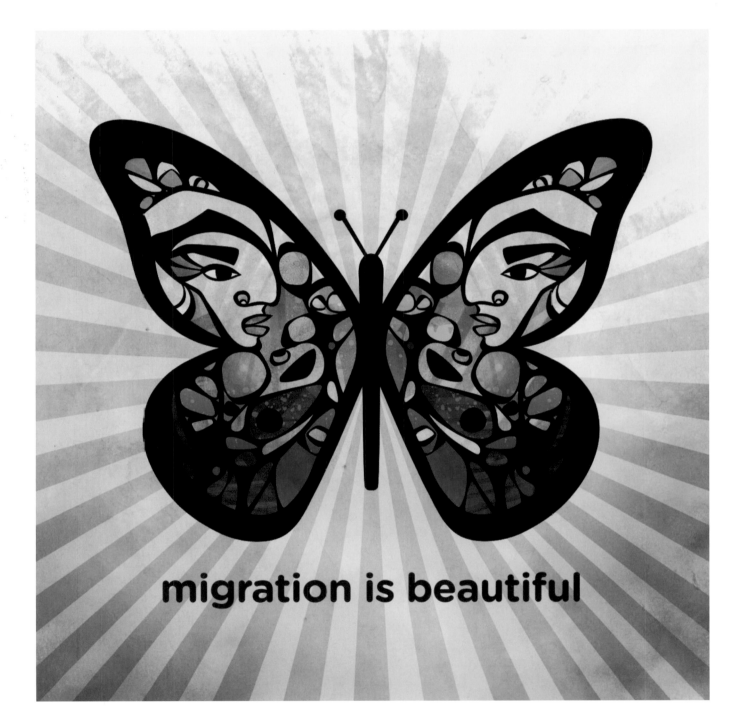

PLATE 96

Julio Salgado

*I Am UndocuQueer–
Nicolas*

2012

PLATE 97

Julio Salgado

*I Am UndocuQueer–
Jorge M.*

2012

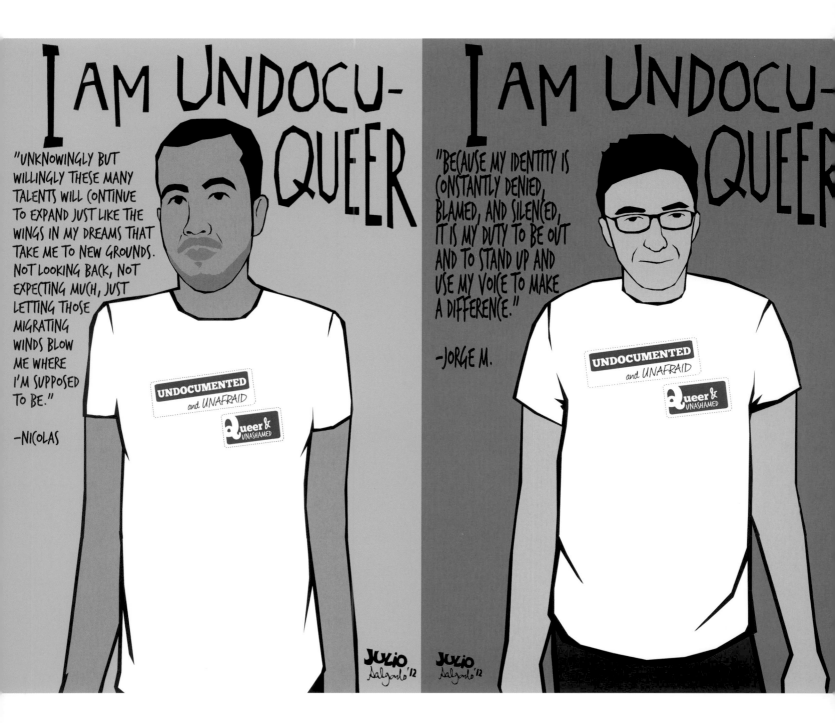

PLATE 98

Julio Salgado

*I Am UndocuQueer–
Ireri*

2012

PLATE 99

Julio Salgado

*I Am UndocuQueer–
Reyna W.*

2012

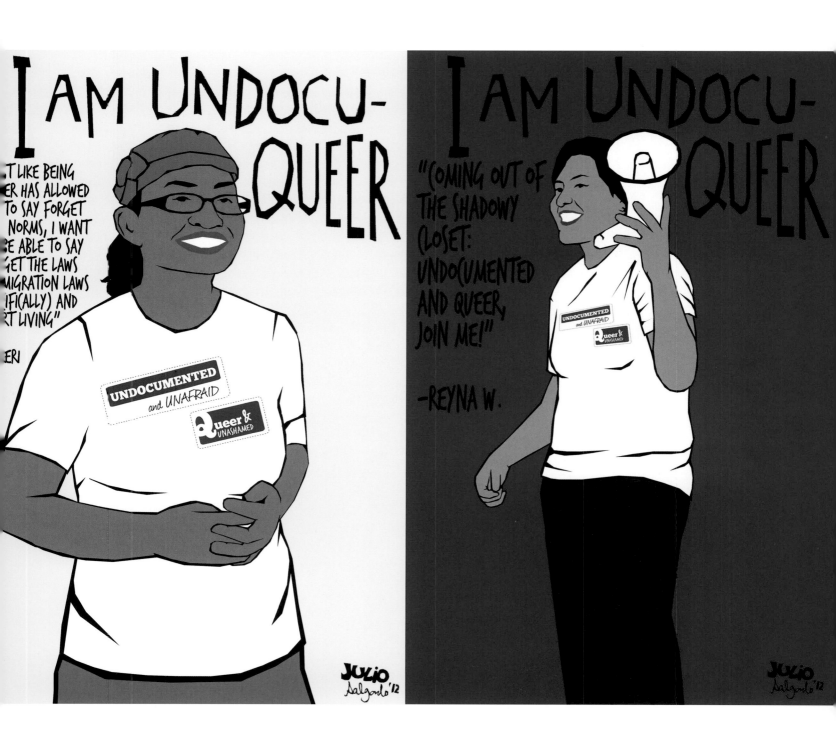

PLATE 100

Daniel González

*Arte es Vida:
40th Anniversary
Día de Los Muertos
Celebration*

2013

PLATE 101

**Jesus Barraza,
Dignidad Rebelde**

Steve Biko

2001/2013

The most potent weapon in the hands of the oppressor is the minds of the oppressed.

-Steve Biko

PLATE 103

Julio Salgado

Quiero Mis Queerce

2014

PLATE 104

Ramiro Gomez

All About Family

2014

WE ARE HUMAN

NOT ONE MORE
DEPORTATION

PLATE 108

Zeke Peña

A Nomad in Love

2015

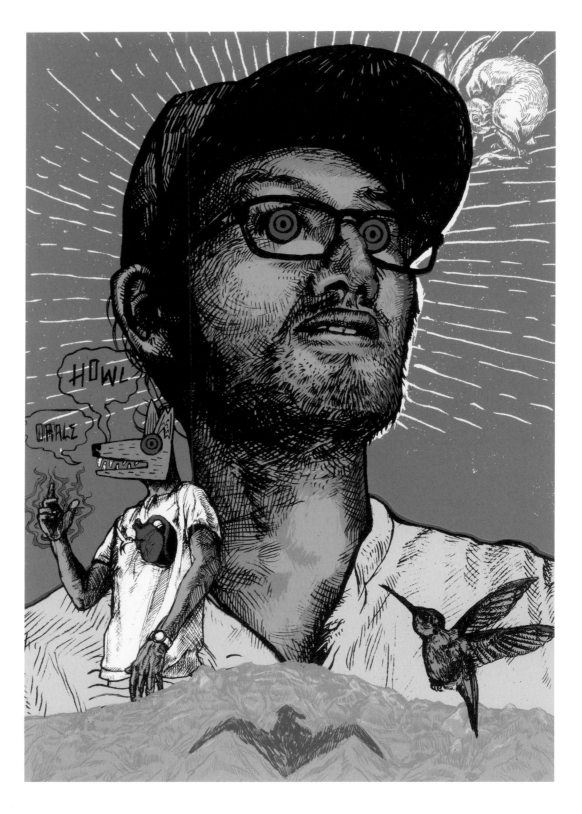

PLATE 109

Shizu Saldamando

Alice Bag

2016

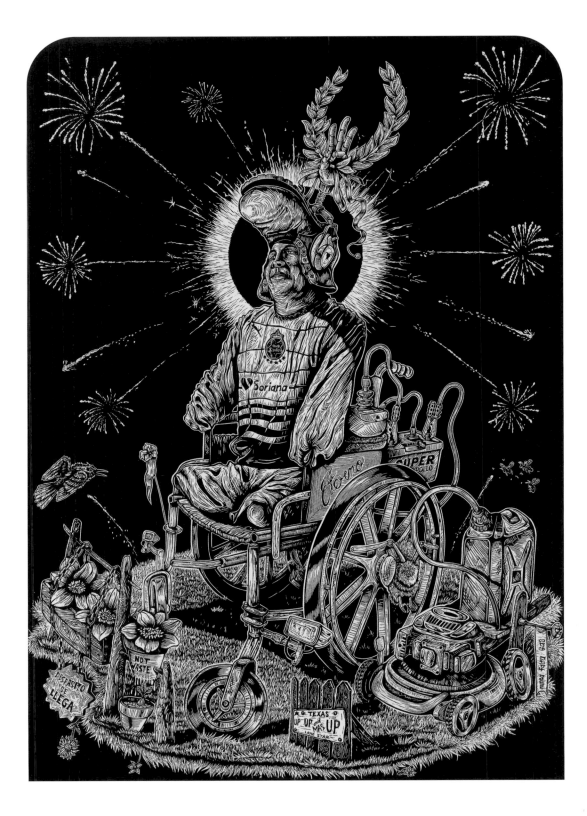

PLATE 114

Lalo Alcaraz

I Stand with Emma

2018

PLATE 115

Xico González

Salam

2019

I AM ALEX NIETO
AND MY LIFE MATTERS

PLATE 116

**Jesus Barraza,
Dignidad Rebelde**

*I Am Alex Nieto and
My Life Matters*

2014

PLATE 117

**Melanie Cervantes,
Dignidad Rebelde**

*Between the Leopard
and the Jaguar*

2019

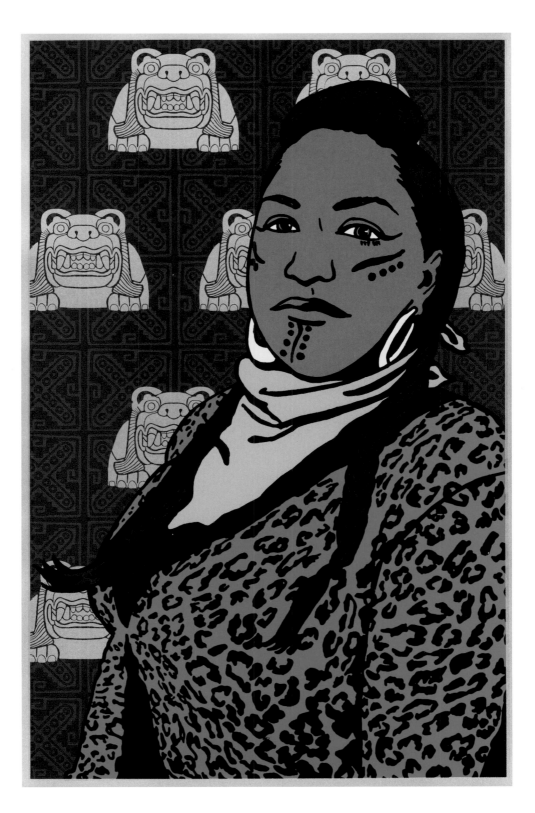

**Jesus Barraza,
Dignidad Rebelde**

**Melanie Cervantes,
Dignidad Rebelde**

STAND WITH LA TEACHERS

TEACHERS FIGHT FOR STUDENT RIGHT

COMMUNITY SCHOOLS BUILD DEMOCRACY

UTLA
UNITED TEACHERS LOS ANGELES

99/300

JUSTICE FOR KAYLA MOORE

JUSTICE FOR F EDDIE GRAY

JUSTICE FOR JC IATHAN FERRELL

JUSTICE FOR JOHN CRAWFORD III

JUSTICE FOR RAMARLEY GRAHAM

JUSTICE FOR ATATIANA JEFFERSON

JUSTICE FOR ALEX NIETO

JUSTICE FOR SANDRA BLAND

JUSTICE FOR ALTON STERLING

JUSTICE FOR
MI E []R WN

JUSTICE FOR
B[]THAM JE[]

JUSTICE F[]
[]HINE[] J[]Y

JUSTICE FOR
**CARLOS GREGORIO
HERNÁNDEZ VÁSQUEZ**

JUSTICE FOR
ERIC GARNER

JUSTICE F[]
IDRISS STELLEY

JUSTICE FOR
**CL[]DIA PATRICIA
G[]MEZ GONZÁLEZ**

JUSTICE FOR
**FELIPE
GÓMEZ ALONZO**

JUSTICE F[]
JEMEL ROBERSON

PLATE 118

**Ernesto Yerena Montejano
and Roxana Dueñas**

Stand with LA Teachers!

2019

▶

PLATE 119

Oree Originol

Justice for Our Lives

2014–present

PLATE 118

**Ernesto Yerena Montejano
and Roxana Dueñas**

Stand with LA Teachers!

2019

PLATE 119

Oree Originol

Justice for Our Lives

2014–present

JUSTICE FOR BREONNA TAYLOR

All works are in the permanent collection of the Smithsonian American Art Museum. Dimensions are given in inches; height precedes width and depth.

LALO ALCARAZ
b. San Diego, CA 1964

I Stand with Emma
2018
digital image
Gift of the artist, 2020.41
[PL. 114]

JESUS BARRAZA,
Dignidad Rebelde
b. El Paso, TX 1976

Edward Said
2005
screenprint on paper
image: 15 ½ × 14 ½ in.;
sheet: 24 ⅞ × 19 in.
Museum purchase through the Samuel and Blanche Koffler Acquisition Fund, 2020.39.8
[PL. 64]

Steve Biko
2001/2013
screenprint on paper
image: 21 ½ × 16 in.;
sheet: 26 × 20 in.
Museum purchase through the Samuel and Blanche Koffler Acquisition Fund, 2020.39.3
[PL. 101]

I Am Alex Nieto and My Life Matters
2014
screenprint on paper
image: 21 ½ × 16 in.;
sheet: 26 × 20 in.
Museum purchase through the Samuel and Blanche Koffler Acquisition Fund, 2020.39.4
[PL. 116]

JESUS BARRAZA,
Dignidad Rebelde
b. El Paso, TX 1976

and NANCYPILI HERNANDEZ
b. San Francisco, CA 1980

Indian Land
2010
screenprint on paper
sheet and image: 40 × 28 in.
Museum purchase through the Samuel and Blanche Koffler Acquisition Fund, 2020.39.7
[PL. 110]

FRANCISCO X CAMPLIS
b. San Francisco, CA 1934

Untitled (February), from *Galería de la Raza's 1975 Calendario*
1975
screenprint on paper
image: 22 ½ × 17 ⅛ in.;
sheet: 23 × 17 ½ in.
Gift of the Margaret Terrazas Santos Collection, 2019.52.12
[PL. 18]

BARBARA CARRASCO
b. El Paso, TX 1955

Messages to the Public: *Pesticides!*
Presented by Public Art Fund,
July 1, 1989–July 31, 1989,
on Times Square Spectacolor board,
New York City
analog video transferred to digital video, 0:48 mins.
Gift of the artist, 2020.31
[PL. 55]

Dolores
1999
screenprint on paper
image: 26 × 18 in.;
sheet: 30 ½ × 22 in.
Museum purchase through the Frank K. Ribelin Endowment, 2020.22.7
[PL. 60]

LEONARD CASTELLANOS
b. Los Angeles, CA 1943

RIFA, from *Méchicano 1977 Calendario*
1976
screenprint on paperboard
sheet and image: 28 × 22 in.
Museum purchase through the Luisita L. and Franz H. Denghausen Endowment, 2012.53.1
[PL. 27]

RENÉ CASTRO
b. Viña del Mar, Chile 1943

September/October, from *La Raza Graphic Center's 1983 Political Art Calendar,*
1982
screenprint on paper
sheet and image: 22 ⅞ × 17 ½ in.
Museum purchase through the Luisita L. and Franz H. Denghausen Endowment, 2020.45.18
[PL. 47]

Víctor Jara
1986
screenprint on paper
image: 24 ⅛ × 16 ½ in.;
sheet: 30 × 22 ⅛ in.
Gift of Gilberto Cárdenas and Dolores García, 2019.51.35
[PL. 49]

I Am Ashamed MLK
1992
screenprint on paper
image: 25 ⅞ × 18 ¼ in.;
sheet: 30 ⅛ × 23 ¼ in.
Museum purchase through the Luisita L. and Franz H. Denghausen Endowment, 2020.45.2
[PL. 56]

MELANIE CERVANTES,
Dignidad Rebelde

b. Harbor City, CA 1977

Between the Leopard
and the Jaguar
2019
screenprint on paper
image: 37 × 24 in.;
sheet: 44 × 30 in.
Museum purchase through
the Samuel and Blanche Koffler
Acquisition Fund, 2020.39.5
[PL. 117]

YREINA D. CERVÁNTEZ

b. Garden City, KS 1952

Mujer de Mucha Enagua,
PA'TI XICANA
1999
screenprint on paper
image: 17 ⅞ × 26 in.;
sheet: 21 ⅞ × 29 ⅝ in.
Museum purchase through the
Samuel and Blanche Koffler
Acquisition Fund, 2020.40.1
[PL. 58]

ENRIQUE CHAGOYA

b. Mexico City, Mexico 1953

The Ghost of Liberty
2004
color lithograph with chine collé on
amate paper
sheet and image: 11 ½ × 85 in.
Gift of Susanne Joyner, 2012.51.3
[PL. 63]

SAM CORONADO

b. Ennis, TX 1946;
d. Fort Wayne, IN 2013

Guerillera II
2001
screenprint on paper
image: 12 × 16 in.;
sheet: 15 × 19 ½ in.
Museum purchase through the
Frank K. Ribelin Endowment,
2020.24.2
[PL. 61]

Quince II
2011
screenprint on paper
sheet and image: 44 × 32 ½ in.
Museum purchase through the
Frank K. Ribelin Endowment,
2020.24.5
[PL. 65]

CARLOS A. CORTÉZ

b. Milwaukee, WI 1923;

d. Chicago, IL 2005

Draftees of the World, Unite!
ca. 1965
linocut on paper
image: 19 ⅞ × 29 ⅞ in.;
sheet: 23 ⅛ × 35 in.
Gift of Tomás Ybarra-Frausto,
1995.50.7
[PL. 1]

Joe Hill
1979
linocut on paper
image: 30 × 20 ⅛ in.;
sheet: 35 × 23 ¼ in.
Gift of Tomás Ybarra-Frausto,
1995.50.8
[PL. 34]

José Guadalupe Posada
1981, signed 1983
linocut on paper mounted
on paperboard
image: 29 × 19 ⅞ in.;
sheet: 36 × 24 ⅛ in.
Gift of Tomás Ybarra-Frausto,
1995.50.9
[PL. 38]

RODOLFO O. CUELLAR

b. Auburn, CA 1950

Humor in Xhicano Arte 200 Years
of Oppression 1776–1976
1976
screenprint on paper
image: 21 ½ × 16 ⅝ in.;
sheet: 25 × 19 in.
Museum purchase through the
Julia D. Strong Endowment,
2020.36.7
[PL. 22]

Selena, A Fallen Angel
1995
screenprint on paper
image: 33 ⅜ × 21 ½ in.;
sheet: 35 × 23 in.
Museum purchase through the
Julia D. Strong Endowment,
2020.36.1
[PL. 57]

RODOLFO O. CUELLAR

b. Auburn, CA 1950

LUIS C. GONZÁLEZ

b. Mexico City, Mexico 1953

and JOSÉ MONTOYA

b. Escobosa, NM 1932;
d. Sacramento, CA 2013

José Montoya's Pachuco Art,
A Historical Update
1978
linocut on paper
image: 28 × 10 in.;
sheet: 31 × 13 ⅛ in.
Museum purchase through the
Julia D. Strong Endowment,
2020.36.3
[PL. 32]

ALEJANDRO DIAZ

b. San Antonio, TX 1963

I ♥ Cuba
2003
screenprint and offset printing
on souvenir items
dimensions variable
Museum purchase through the
Patricia Tobacco Forrester
Endowment, 2020.44.1.1–.40A–B
[PL. 62]

Dominican York
Proyecto GRAFICA

CARLOS ALMONTE

b. Santo Domingo,
Dominican Republic 1960

Vale John, from the portfolio
Manifestaciones
2010
screenprint on paper
image: 10 × 7 in.;
irregular sheet: 15 × 11 ¼ in.
Museum purchase made possible
by the R. P. Whitty Company and
the Cooperating Committee on
Architecture, 2013.28.3.1
[PL. 69]

YUNIOR CHIQUI MENDOZA

b. Santiago,
Dominican Republic 1964

Bananhattan, from the portfolio
Manifestaciones
2010
inkjet and screenprint on paper
image: 9 ½ × 7 in.;
irregular sheet: 15 × 11 ¼ in.
Museum purchase made possible
by the R. P. Whitty Company and
the Cooperating Committee on
Architecture, 2013.28.3.10
[PL. 68]

PEPE CORONADO

b. Santo Domingo,
Dominican Republic 1965

Intrépido, from the portfolio
Manifestaciones
2010
screenprint on paper
image: 7 × 9 in.;
sheet: 11 ¼ × 15 in.
Museum purchase made possible
by the R. P. Whitty Company and
the Cooperating Committee on
Architecture, 2013.28.3.2
[PL. 75]

iliana emilia garcía

b. Santo Domingo,
Dominican Republic 1970

Dreambox, from the portfolio
Manifestaciones
2010
screenprint on reflective Mylar
and chine collé on paper
image: 9 × 7 in.;
sheet: 15 × 11 ¼ in.
Museum purchase made possible
by the R. P. Whitty Company and
the Cooperating Committee on
Architecture, 2013.28.3.4
[PL. 76]

SCHEREZADE GARCÍA

b. Santo Domingo,
Dominican Republic 1966

Day Dreaming/Soñando despierta,
from the portfolio *Manifestaciones*
2010
inkjet and screenprint on paper
image: 9 × 7 in.;
sheet: 15 × 11 ¼ in.
Museum purchase made possible
by the R. P. Whitty Company and
the Cooperating Committee on
Architecture, 2013.28.3.6
[PL. 66]

REYNALDO GARCÍA PANTALEÓN

b. Santo Francisco,
Dominican Republic 1967

Amarrao, from the portfolio
Manifestaciones
2010
polymer plate etching on paper
image: 9 ¼ × 7 ¼ in.;
sheet: 15 × 11 ¼ in.
Museum purchase made possible
by the R. P. Whitty Company and
the Cooperating Committee on
Architecture, 2013.28.3.5
[PL. 77]

ALEX GUERRERO

b. Bani, Dominican Republic 1960

Vista Psicotrópica, from the
portfolio *Manifestaciones*
2010
screenprint on paper
image: 7 ¼ × 9 ¼ in.;
irregular sheet: 11 ¼ × 15 in.
Museum purchase made possible
by the R. P. Whitty Company and
the Cooperating Committee on
Architecture, 2013.28.3.7
[PL. 70]

LUANDA LOZANO

b. Humpata, Angola 1973

Sálvame Santo, from the
portfolio *Manifestaciones*
2010
etching and chine collé on paper
image: 8 ⅞ × 6 ⅞ in.;
sheet: 15 × 11 ¼ in.
Museum purchase made possible
by the R. P. Whitty Company and
the Cooperating Committee on
Architecture, 2013.28.3.8
[PL. 71]

MIGUEL LUCIANO

b. Santo Domingo,
Dominican Republic 1966

Detrás de la oreja, from the
portfolio *Manifestaciones*
2010
screenprint and rubber stamp
on paper
image: 7 ¼ × 9 ¼ in.;
irregular sheet: 11 ¼ × 15 in.
Museum purchase made possible
by the R. P. Whitty Company and
the Cooperating Committee on
Architecture, 2013.28.3.9
[PL. 72]

MOSES ROS-SUÁREZ

b. New York City 1958

El Reggaeton del Bachatero, from
the portfolio *Manifestaciones*
2010
etching, aquatint, and chine collé
on paper
image: 7 × 9 ³⁄₈ in.;
irregular sheet: 11 ¼ × 15 in.
Museum purchase made possible
by the R. P. Whitty Company and
the Cooperating Committee on
Architecture, 2013.28.3.11
[PL. 73]

RENÉ DE LOS SANTOS

b. Santiago,
Dominican Republic 1953

Cigüita Cibaeña en Nueva York,
from the portfolio *Manifestaciones*
2010
linocut and screenprint on paper
image: 7 × 9 in.;
sheet: 11 ¼ × 15 in.
Museum purchase made possible
by the R. P. Whitty Company and
the Cooperating Committee on
Architecture, 2013.28.3.3
[PL. 67]

RIDER UREÑA

b. Santiago,
Dominican Republic 1972

My girl on the floor, from the
portfolio *Manifestaciones*
2010
silk acuatint and inkjet print
on paper
image: 7 × 9 in.;
sheet: 11 ¼ × 15 in.
Museum purchase made possible
by the R. P. Whitty Company and
the Cooperating Committee on
Architecture, 2013.28.3.12
[PL. 74]

RICHARD DUARDO

b. Los Angeles, CA 1952
d. Los Angeles, CA 2014

Aztlan
1982
screenprint on paper
sheet and image: 25 ¼ × 38 ⅛ in.
Museum purchase through the
Samuel and Blanche Koffler
Acquisition Fund, 2020.23
[PL. 42]

RICARDO FAVELA

b. Kingsburg, CA 1944;
d. Visalia, CA 2007

*Centennial Means 500 Years
of Genocide!*
1976
screenprint on paper
image: 23 ¼ × 16 ⅞ in.;
sheet: 24 ⅞ × 19 in.
Museum purchase through the
Frank K. Ribelin Endowment,
2020.6.1
[PL. 23]

SANDRA C. FERNÁNDEZ

b. New York City 1964

*Mourning and Dreaming
High: con mucha fé*
2014–2018
lithography, thread drawings,
milagros, collage, pages of
an 18th-century book
overall: 86 ½ × 95 in.
Museum purchase through the
Frank K. Ribelin Endowment,
2019.34.1A-S
[PL. 102; FIG. 23, P. 54]

JUAN FUENTES

b. Artesia, NM 1950

Untitled (April), from *Galería
de la Raza's 1975 Calendario*
1975
screenprint on paper
image: 22 ⅝ × 17 in.;
sheet: 23 × 17 ½ in.
Gift of the Margaret Terrazas
Santos Collection, 2019.52.14
[PL. 17]

South African Women's Day
1978
offset lithograph on paper
sheet and image: 21 ⅝ × 16 ⅝ in.
Gift of Gilberto Cárdenas and
Dolores García, 2019.51.5
[PL. 31]

January/February, from
*La Raza Graphic Center's 1983
Political Art Calendar*
1982
screenprint on paper
image: 22 × 16 ½ in.;
sheet: 23 × 17 ½ in.
Museum purchase through
the Luisita L. and Franz H.
Denghausen Endowment,
2020.45.14
[PL. 44]

Many Mandelas
1986
screenprint on paper
image: 28 ⅝ × 20 in.;
sheet: 30 ⅛ × 22 ¼ in.
Gift of Tomás Ybarra-Frausto,
1995.50.20
[PL. 51]

ERIC J. GARCÍA

b. Albuquerque, NM 1977

*Chicano Codices #1: Simplified
Histories: The U.S. Invasion of
Mexico 1846–1848*
2015
offset lithograph on paper
open: 6 × 23 in.
Museum purchase through the
Lichtenberg Family Foundation,
2020.21.1R-V
[PL. 107]

MAX E. GARCIA
b. Uruapan, Mexico 1941;
d. Sacramento, CA 2020
and LUIS C. GONZÁLEZ
b. Mexico City, Mexico 1953

*The Last Papa with the Big Potatoe
(October),* from *Calendario de
Comida 1976*
1975
screenprint on paper
image: 15 ⅛ × 21 ¾ in.;
sheet: 17 ½ × 23 in.
Gift of the Margaret Terrazas
Santos Collection, 2019.52.46
[PL. 25]

RUPERT GARCÍA
b. French Camp, CA 1941

Right On!
1968
screenprint on paper
image: 20 × 12 ⅛ in.;
sheet: 23 ½ × 14 ⅜ in.
Museum purchase through the
Luisita L. and Franz H. Denghausen
Endowment, 2020.42.3
[PL. 4]

DDT
1969
screenprint on paper
image: 23 ½ × 17 ¼ in.;
sheet: 26 ⅛ × 20 in.
Museum purchase through the
Luisita L. and Franz H. Denghausen
Endowment, 2020.42.2
[PL. 5]

*¡LIBERTAD PARA LOS PRISONEROS
POLITICAS!*
1971
screenprint on paper
sheet and image: 24 ⅜ × 18 ¾ in.
Gift of the Margaret Terrazas
Santos Collection, 2019.52.2
[PL. 8]

¡Cesen Deportación!
1973, reprinted in collaboration
with Dignidad Rebelde in 2011
screenprint on paper
image: 20 ½ × 28 in.;
sheet: 25 × 32 in.
Museum purchase through the
Samuel and Blanche Koffler
Acquisition Fund, 2020.39.9
[PL. 12]

Frida Kahlo (September), from
Galería de la Raza's 1975 Calendario
1975
screenprint on paper
image: 22 × 16 ½ in.;
sheet: 23 × 17 ½ in.
Gift of the Margaret Terrazas
Santos Collection, 2019.52.19
[PL. 19]

*Chicano Research as a
Catalyst for Social Change*
1977
offset lithograph on paper
image: 19 ⅛ × 14 ¼ in.;
sheet: 20 × 15 ¹⁄₁₆ in.
Gift from the Trustees of the
Corcoran Gallery of Art
(Gift of Mr. and Mrs. Gerald D. Kohs),
2020.20.89
[PL. 29]

Obama from Douglass
2010
pigment inkjet on paper
image: 31 × 90 in.;
sheet: 37 ¾ × 95 ¼ in.
Museum purchase through the
Luisita L. and Franz H. Denghausen
Endowment, 2020.42.5
[PL. 78]

RAMIRO GOMEZ
b. San Bernardino, CA 1986

All About Family
2014
acrylic on pigment inkjet on paper
image: 46 × 34 in.;
sheet: 53 ½ × 41 ½ in.
Museum purchase through the
Lichtenberg Family Foundation,
2020.7
[PL. 104]

DANIEL GONZÁLEZ
b. Los Angeles, CA 1980

*Arte es Vida: 40th Anniversary
Día de Los Muertos Celebration*
2013
laser-cut screenprint on paper
sheet and image: 35 × 25 in.
Museum purchase through the
Frank K. Ribelin Endowment,
2020.22.5
[PL. 100]

LUIS C. GONZÁLEZ
b. Mexico City, Mexico 1953

Fiesta del Maiz
1979
screenprint on paper
sheet and image: 28 × 22 in.
Museum purchase through the
Patricia Tobacco Forrester
Endowment, 2020.47.2
[PL. 33]

*Tenth Annual Día de los
Muertos Celebration*
1980
screenprint on paper
36 × 24 in.
Gift of Tomás Ybarra-Frausto,
1995.50.52
[PL. 35]

Miguel Hidalgo y Costílla
1976
screenprint on paper
image: 21 ¼ × 16 ⅛ in.;
sheet: 22 ¾ × 17 ½ in.
Gift of Gilberto Cárdenas and
Dolores García, 2019.51.51
[PL. 48]

LUIS C. GONZÁLEZ
b. Mexico City, Mexico 1953
and HÉCTOR D. GONZÁLEZ
b. Chapala, Mexico 1945

Hasta La Victoria Siempre
1975
screenprint on paper
image: 22 ⅛ × 14 ¼ in.;
sheet: 25 ⅛ × 19 in.
Gift of Tomás Ybarra-Frausto,
1995.50.23
[PL. 20]

XICO GONZÁLEZ

b. Los Angeles, CA 1975

Salam
2019
augmented reality digital print on paper
image: 20 × 14 in.;
sheet: 23 ¾ × 17 in.
Museum purchase through the
Lichtenberg Family Foundation,
2020.19.4
[PL. 115]

ESTER HERNANDEZ

b. Dinuba, CA 1944

*La Virgen de Guadalupe Defendiendo
los Derechos de los Xicanos*
1975
etching and aquatint on paper
plate: 11 ½ × 8 ⅝ in.;
sheet: 15 × 11 in.
Museum purchase through the
Frank K. Ribelin Endowment,
2013.56
[PL. 21]

Sun Mad
1982
screenprint on paper
image: 20 × 15 in.;
sheet: 22 × 17 in.
Gift of Tomás Ybarra-Frausto,
1995.50.32
[PL. 40]

La Ofrenda, from the National
Chicano Screenprint Taller,
1988–1989
1988
screenprint on paper
sheet: 37 ¾ × 25 in.
Gift of the Wight Art Gallery,
University of California, Los Angeles,
1991.65.3
[PL. 54]

Sun Raid
2008
screenprint on paper
image: 19 ¾ × 15 in.;
sheet: 29 × 22 ½ in.
Gift of the artist, 2020.12.2
[PL. 41]

NANCY HOM

b. Toisan, China 1949

*No More Hiroshima/Nagasakis:
Medical Aid for the Hibakushas*
1982
screenprint on paper
image: 10 × 9 in.;
sheet: 17 × 14 ¼ in.
Gift of Gilberto Cárdenas and
Dolores García, 2019.51.53
[PL. 43]

CARLOS FRANCISCO JACKSON

b. Los Angeles, CA 1978

Breaking the Fast, 1968
2012
screenprint on paper
image: 25 ¾ × 40 in.;
sheet: 29 ⅞ × 44 in.
Gift of Drs. Harriett and
Ricardo Romo, 2019.50.2
[PL. 105]

LUIS JIMÉNEZ

b. El Paso, TX 1940;
d. Hondo, NM 2006

Howl
1977
lithograph on paper
image: 36 ⅛ × 26 ⅛ in.
Gift of the artist, 1978.91
[PL. 28]

CARMEN LOMAS GARZA

b. Kingsville, TX 1948

La Curandera
ca. 1974
hand-colored etching and
aquatint on paper
image: 13 ⅞ × 17 ¾ in.;
sheet: 16 ½ × 20 ⅜ in.
Gift of Tomás Ybarra-Frausto,
1995.50.60
[PL. 14]

ALMA LOPEZ

b. Los Mochis, Mexico 1966

Our Lady
1999
inkjet print on canvas
image: 17 ⅜ × 13 ⅞ in.;
sheet: 22 ¼ × 17 ¾ in.
Museum purchase, 2020.48.1
[PL. 59]

YOLANDA LÓPEZ

b. San Diego, CA 1942

Free Los Siete
1969
offset lithograph on paper
sheet and image: 22 ¼ × 14 ¼ in.
Gift of Gilberto Cárdenas and
Dolores García, 2019.51.69
[PL. 6]

Who's the Illegal Alien, Pilgrim?
1981
offset lithograph on paper
22 ½ × 17 ¾ in.
Museum purchase through the
Samuel and Blanche Koffler
Acquisition Fund, 2020.43.1
[PL. 39]

LINDA ZAMORA LUCERO

b. San Francisco, CA

*Lolita Lebrón, ¡Viva Puerto Rico
Libre!*
1975
screenprint on paper
image: 26 ½ × 18 ⅞ in.;
sheet: 28 ⅝ × 22 ⅝ in.
Gift of Tomás Ybarra-Frausto,
1995.50.34
[PL. 16]

GILBERT "MAGU" LUJÁN

b. Stockton, CA 1940;
d. Arcadia, CA 2011

Cruising Turtle Island
1986
screenprint on paper
image: 24 ¼ × 36 ½ in.;
sheet: 25 × 38 ¼ in.
Museum purchase through the
Frank K. Ribelin Endowment,
2020.22.1
[PL. 50]

POLI MARICHAL

b. Ponce, Puerto Rico 1955

Santuario
2018
linocut on paper
sheet and image: 17 ¾ × 11 ¼ in.
Museum purchase through the
Frank K. Ribelin Endowment,
2020.32.5
[PL. 112]

EMANUEL MARTINEZ

b. Denver, CO 1947

Tierra o Muerte
1967
screenprint on manila folder
sheet and image: 11 ¾ × 9 ½ in.
Gift of the artist, 1996.8
[PL. 3; fig. 4, p. 77]

OSCAR MELARA

b. San Francisco, CA 1949

José Martí
1976
screenprint on paper
sheet and image: 23 × 17 ½ in.
Gift of Lincoln Cushing/Docs
Populi, 2019.54.5
[PL. 24]

MICHAEL MENCHACA

b. San Antonio, TX 1985

*Castigo Con Sus Amigos
Encima Del Tren*
2010
screenprint on paper
sheet and image: 26 × 40 in.
Gift of Drs. Harriett and
Ricardo Romo, 2019.50.31
[PL. 85]

El Coyote
2010
screenprint on paper
sheet and image: 40 × 26 in.
Gift of Drs. Harriett and
Ricardo Romo, 2019.50.29
[PL. 81]

El Paso Superior
2010
screenprint on paper
sheet and image: 26 × 40 in.
Gift of Gilberto Cárdenas and
Dolores García, 2019.51.26
[PL. 80]

Mucho Gato Amor
2010
screenprint on paper
sheet and image: 26 × 40 in.
Gift of Gilberto Cárdenas and
Dolores García, 2019.51.27
[PL. 82]

Cuando El Rio Suena Gatos Lleva
2011
screenprint on paper
sheet and image: 26 × 40 in.
Gift of Drs. Harriett and
Ricardo Romo, 2019.50.33
[PL. 83]

*Rata Avisada No Muerde Carnada
(The Informed Rat Doesn't Bite Bait)*
2012
screenprint on paper
sheet and image: 25 × 19 in.
Gift of Drs. Harriett and
Ricardo Romo, 2019.50.21
[PL. 92]

*An arrangement of logograms,
presumably a sacrificial
ornamentation*
2013
screenprint on paper
sheet and image: 19 × 25 in.
Gift of Drs. Harriett and
Ricardo Romo, 2019.50.20
[PL. 87]

*Index of figural archetypes and
recurring pattern ornamentation*
2013
pigment inkjet on paper
sheet and image: 22 ¼ × 30 ¼ in.
Gift of Drs. Harriett and
Ricardo Romo, 2019.50.24
[PL. 88]

*Three figures confronting
an Eagle deity*
2013
screenprint on paper
sheet and image: 19 × 25 in.
Gift of Drs. Harriett and
Ricardo Romo, 2019.50.22
[PL. 86]

Toro Lo Que Quieras Es Tuyo
2013
screenprint on paper
25 × 18 in.
Gift of Drs. Harriett and
Ricardo Romo, 2019.50.16
[PL. 84]

*Index of figural archetypes and
recurring pattern ornamentation*
2014
pigment inkjet on paper
sheet and image: 22 ¼ × 30 ¼ in.
Gift of Drs. Harriett and
Ricardo Romo, 2019.50.25
[PL. 89]

*Index of figural archetypes and
recurring pattern ornamentation*
2014
pigment inkjet on paper
sheet and image: 22 ¼ × 30 ⅛ in.
Gift of Drs. Harriett and
Ricardo Romo, 2019.50.26
[PL. 90]

*Index of figural archetypes and
recurring pattern ornamentation*
2014
pigment inkjet on paper
sheet and image: 22 ¼ × 30 in.
Gift of Drs. Harriett and
Ricardo Romo, 2019.50.27
[PL. 91]

MALAQUIAS MONTOYA

b. Albuquerque, NM 1938

*Julio 26—Cuba Vietnam y Nosotros
Venceremos*
1972
offset lithograph on paper
sheet and image: 22 ⅛ × 16 ⅞ in.
Gift of the Margaret Terrazas
Santos Collection, 2019.52.3
[PL. 9]

Yo Soy Chicano
1972, reprinted in collaboration
with Dignidad Rebelde in 2013
screenprint on paper
image: 20 ½ × 16 in.;
sheet: 26 ⅛ × 20 in.
Gift of Gilberto Cárdenas and
Dolores García, 2019.51.1
[PL. 10; fig. 1, p. 24]

George Jackson Lives
1976
offset lithograph on paper
sheet and image: 23 ½ × 18 in.
Museum purchase through the
Frank K. Ribelin Endowment,
2015.29.1
[PL. 26]

Undocumented
1980, signed 1981
screenprint on paper
sheet and image: 30 × 23 ⅛ in.
Museum purchase through the
Frank K. Ribelin Endowment,
2015.29.2
[PL. 36]

JUAN DE DIOS MORA
b. Yahualica, Mexico 1984

*El Animo es Primero
(Encouragement Is First)*
2018
linocut on paper
image: 24 ⅝ × 17 ¾ in.;
sheet: 29 ⅞ × 22 ⅜ in.
Museum purchase through the
Frank K. Ribelin Endowment,
2019.35.4
[PL. 111]

OREE ORIGINOL
b. Glendale, CA 1984

Justice for Our Lives
2014–present
installation
dimensions variable
Museum purchase through the
Patricia Tobacco Forrester
Endowment, 2020.51A–MM
[PL. 119]

AMADO M. PEÑA JR.
b. Laredo, TX 1943

Mestizo
1974
screenprint on paper
image: 15 ¼ × 9 ½ in.;
sheet: 18 × 12 in.
Gift of Amado M. Peña Sr., and
Maria Peña, 1996.47.5
[PL. 13]

Aquellos que han muerto
1975
screenprint on paper
image: 15 ¼ × 9 ½ in.;
sheet: 18 × 12 in.
Gift of Amado M. Peña Sr.,
and Maria Peña, 1996.47.6
[PL. 15]

ZEKE PEÑA
b. Las Cruces, NM 1983

A Nomad in Love
2015
augmented reality screenprint
on paper
image: 27 ⅝ × 19 ⅝ in.;
sheet: 29 ⅞ × 22 ⅛ in.
Gift of the artist, 2020.11
[PL. 108]

FAVIANNA RODRIGUEZ
b. Oakland, CA 1978

Mi Cuerpo. Yo Decido.
2012
digital image
Museum purchase through the
Julia D. Strong Endowment,
2020.38.2
[PL. 94]

Climate Woke
2018
digital image
Museum purchase through the
Julia D. Strong Endowment,
2020.38.1
[PL. 113]

Migration Is Beautiful
2018
digital image
Museum purchase through the
Julia D. Strong Endowment,
2020.38.3
[PL. 95]

FAVIANNA RODRIGUEZ
b. Oakland, CA 1978
and CÉSAR MAXIT
b. Comodoro Rivadavia,
Argentina 1976

*1 Million Deportations ain't
Enough for Pres. Obama!
Sign the Petition & Spread Art*
2011
digital image
Museum purchase through the
Julia D. Strong Endowment,
2020.38.4
[PL. 93]

SONIA ROMERO
b. Los Angeles, CA 1980

Bee Pile
2010
block printing on hand-sewn felt
overall: 15 × 7 in.
Museum purchase through the
Lichtenberg Family Foundation,
2020.18
[PL. 79]

SHIZU SALDAMANDO
b. San Francisco, CA 1978

Alice Bag
2016
screenprint on cotton paño
overall: 15 ½ × 16 in., irregular
Museum purchase through the
Frank K. Ribelin Endowment,
2020.22.8
[PL. 109]

JULIO SALGADO
b. Ensenada, Mexico 1983

I Am UndocuQueer—Ireri
2012
digital image
Museum purchase in part through
the Lichtenberg Family Foundation,
2020.37.3
[PL. 98]

I Am UndocuQueer—Jorge M.
2012
digital image
Museum purchase in part through
the Lichtenberg Family Foundation,
2020.37.2
[PL. 97]

I Am UndocuQueer—Nicolas
2012
digital image
Museum purchase in part through
the Lichtenberg Family Foundation,
2020.37.1
[PL. 96]

I Am UndocuQueer—Reyna W.
2012
digital image
Museum purchase in part through
the Lichtenberg Family Foundation,
2020.37.4
[PL. 99]

Quiero Mis Queerce
2014
screenprint on paper
image: 38 ¾ × 24 ½ in.;
sheet: 44 × 30 ¼ in.
Museum purchase through the
Lichtenberg Family Foundation,
2020.37.6
[PL. 103]

JOS SANCES
b. Boston, MA 1952

March/April, from *La Raza Graphic Center's 1983 Political Art Calendar*
1982
screenprint on paper
sheet and image: 23 × 17 ½ in.
Museum purchase through the
Luisita L. and Franz H. Denghausen
Endowment, 2020.45.15
[PL. 45]

HERBERT SIGÜENZA
b. San Francisco, CA 1959

July/August, from *La Raza Graphic Center's 1983 Political Art Calendar*
1982
screenprint on paper
image: 22 ¼ × 16 ⅞ in.;
sheet: 23 ⅛ × 17 ½ in.
Museum purchase through the
Luisita L. and Franz H. Denghausen
Endowment, 2020.45.17
[PL. 46]

HERBERT SIGÜENZA
b. San Francisco, CA 1959

and UNIDENTIFIED ARTIST

It's Simple Steve
ca. 1980
screenprint on paper
image: 14 ⅞ × 16 ⅜ in.;
sheet: 15 ⅞ × 17 × ⅛ in.
Museum purchase through the
Luisita L. and Franz H. Denghausen
Endowment, 2020.45.8
[PL. 37]

ELIZABETH SISCO
b. Cheverly, MD 1954
LOUIS HOCK
b. Los Angeles, CA 1948
and DAVID AVALOS
b. San Diego, CA 1947

Welcome to America's Finest Tourist Plantation
1988
screenprint on vinyl mounted
on foam board
21 × 72 in.
Gift of Mr. Alfred S. Pagano and
Susan A. Tyler, 2015.37
[PL. 53]

MARIO TORERO
b. Lima, Peru 1947

You Are Not a Minority!!
1977
offset lithograph on paper
sheet and image: 22 × 17 in.
Gift of the artist, 2020.9
[PL. 30]

UNIDENTIFIED ARTIST

Untitled (Side with the Farmworker)
ca. 1973
screenprint on computer tractor
paper
sheet and image: 22 × 14 ⅛ in.
Gift of the Margaret Terrazas
Santos Collection, 2019.52.4
[PL. 7]

PATSSI VALDEZ
b. Los Angeles, CA 1951

LA/TJ
1987
screenprint on paper
sheet and image: 26 ¼ × 20 in.
Gift of Gilberto Cárdenas and
Dolores García, 2019.51.23
[PL. 52]

XAVIER VIRAMONTES
b. Richmond, CA 1947

Boycott Grapes, Support the United Farm Workers Union
1973
offset lithograph on paper
image: 21 ¾ × 16 in.;
irregular sheet: 23 ⅝ × 17 ½ in.
Gift of Tomás Ybarra-Frausto,
1995.50.58
[PL. 11; fig. 7, p. 33]

ERNESTO YERENA MONTEJANO
b. El Centro, CA 1987
and ROXANA DUEÑAS
b. Los Angeles, CA 1984

Stand with LA Teachers!
2019
screenprint on paper
sheet and image: 24 × 18 in.
Museum purchase through
the Patricia Tobacco Forrester
Endowment, 2020.50.1
[PL. 118; fig. 21, p. 50]

ERNESTO YERENA MONTEJANO
b. El Centro, CA 1987
and SHEPARD FAIREY
b. Charleston, SC 1970

Not One More Deportation
2015
screenprint on paper
sheet and image: 24 × 18 in.
Museum purchase through the
Patricia Tobacco Forrester
Endowment, 2020.50.2
[PL. 106]

ANDREW ZERMEÑO
b. Salinas, CA 1935

Huelga!
1966
offset lithograph on paper
sheet and image: 24 × 18 ½ in.
Gift of the Margaret Terrazas
Santos Collection, 2019.52.1
[PL. 2]

BIBLIOGRAPHY

Abbate, Janet. *Inventing the Internet.* Cambridge, MA: MIT Press, 2000.

Acuña, Rodolfo. *Occupied America: The Chicano's Struggle Toward Liberation.* San Francisco: Canfield Press, 1972.

Alarcón, Norma. "Traddutora, Traditora: A Paradigmatic Figure of Chicana Feminism." In *Scattered Hegemonies: Postmodernity and Transnational Feminist Practices*, edited by Inderpal Grewal and Caren Kaplan, 110–33. Minneapolis: University of Minnesota Press, 1994.

Alberro, Alexander. "Reconsidering Conceptual Art, 1966–1977." In *Conceptual Art: A Critical Anthology*, edited by Alexander Alberro and Blake Stimson, xvi–xxxvii. Cambridge, MA: MIT Press, 1999.

Albright, Thomas. "Oakland Museum: A Wide Range of Latin Art." *San Francisco Chronicle*, September 12, 1970.

Alexander, Darsie, et al. *Martha Rosler: Irrespective.* New York: Jewish Museum in association with Yale University Press, 2018.

Almaraz, Carlos. "The Artist as a Revolutionary." *Chismearte* (Los Angeles) 1, no. 1 (Fall 1976): 47–55.

Alvarado, Leticia. "Malflora Aberrant Femininities." In Chavoya and Frantz, *Axis Mundo*, 94–109.

American Civil Liberties Union of Washington (ACLU). "Timeline of the Muslim Ban." Accessed July 1, 2019. https://www.aclu-wa.org /pages/timeline-muslim-ban.

Apple Store. "HP Reveal (formerly Aurasma)." App Store Preview. Accessed May 1, 2019. https:// apps.apple.com/us/app /hp-reveal/id432526396.

Arizona State University. "Movimiento Artístico del Río Salado (MARS) Records 1974–1992." ASU Library, Chicano Research Collection. Accessed January 14, 2020. http://www.azarchivesonline.org /xtf/view?docId=ead/asu/mars .xml&doc.view=print;chunk.id=0.

Augment El Paso. "About." Accessed January 1, 2019. http:// augmentelpaso.com/about.html.

Ault, Julie. "A Chronology of Selected Alternative Structures, Spaces, Artists' Groups, and Organizations in New York City, 1965–85." In *Alternative Art, New York 1965–1985: A Cultural Politics Book for the Social Text Collective,* edited by Julie Ault, 17–76. New York: Drawing Center, 2002.

Austin Chronicle. "Man on a Mission: Professor, Collector, Leader Gil Cárdenas." August 18, 1995. https://www.austinchronicle.com /arts/1995-08-18/533955/.

Barber, John F. "Digital Archiving and 'The New Screen.'" In *Transdisciplinary Digital Art: Sound, Vision and the New Screen*, edited by Randy Adams, Steve Gibson, and Stefan Müller Arisona, 110–19. Berlin: Springer-Verlag, 2008.

Barnet-Sanchez, Holly. "Where Are the Chicana Printmakers?" In Noriega, *¿Just Another Poster?,* 117–49.

Barnitz, Jacqueline. *Twentieth-Century Art of Latin America.* Austin: University of Texas Press, 2001.

Baron, Dennis E. *A Better Pencil: Readers, Writers, and the Digital Revolution.* New York: Oxford University Press, 2012.

Barraza, Jesus. "Signs of Solidarity: The Work of Dignidad Rebelde." *ASAP/Journal* 3, no. 2 (May 2018): 208–16.

Bazzano-Nelson, Florencia. "Xavier Viramontes." In Ramos, *Our America*, 338–41.

Bebout, Lee. *Mythohistorical Interventions: The Chicano Movement and Its Legacies.* Minneapolis: University of Minnesota Press, 2011.

Benavidez, Max. "Cesar Chavez Nurtured Seeds of Art." *Los Angeles Times.* April 28, 1993. https://www.latimes.com /archives/la-xpm-1993-04-28 -ca-28278-story.html.

———. *Gronk.* Los Angeles: UCLA Chicano Studies Research Center Press, 2007.

Benichou, Lauren. "A Brief History of Día de los Muertos in Oakland, California, 1970–2000." *Clio's Scroll: The Berkeley Undergraduate History Journal* 13, no. 1 (Fall 2011): 1–38.

Bennett, Scott H. "Workers/ Draftees of the World Unite! Carlos A. Cortéz Redcloud Koyokuikatl: Soapbox Rebel, WWII CO & IWW Artist/Bard." In *Carlos Cortéz Koyokuikatl: Soapbox Artist and Poet*, edited by Victor Alejandro Sorell, 12–56. Chicago: Mexican Fine Arts Center Museum, 2002.

Berelowitz, Jo-Anne. "Conflict over 'Border Art.'" *Third Text* 11, no. 40 (1997): 69–83.

Berners-Lee, Tim, and Mark Fischetti. *Weaving the Web: The Original Design and Ultimate Destiny of the World Wide Web by Its Inventor.* New York: HarperCollins, 2008.

Bhambhani, Dipka. "The Communications Goals and Strategies of Black Lives Matter." *PR Week.* February 10, 2016. https:// www.prweek.com/article/1383011 /communications-goals-strategies -black-lives-matter.

Biber, Douglas, and Susan Conrad. *Register, Genre, and Style.* Cambridge: Cambridge University Press, 2019.

Biko, Steven. "White Racism and Black Consciousness." In *The South Africa Reader: History, Culture, Politics*, edited by Clifton Crais and Thomas V. McClendon, 361–66. Durham, NC: Duke University Press, 2013.

Biocca, Frank. "The Cyborg's Dilemma: Progressive Embodiment in Virtual Environments." *Journal of Computer-Mediated Communication* 3, no. 2 (September 1997): n.p. https:// doi:10.1111/j.1083-6101.1997 .tb00070.x.

Bishop, Claire, ed. *Participation.* Cambridge, MA: MIT Press, 2006.

Black Lives Matter. "HERSTORY." Accessed June 1, 2019. https:// blacklivesmatter.com/about /herstory/.

Boone, Elizabeth Hill. *Cycles of Time and Meaning in the Mexican Books of Fate.* Austin: University of Texas Press, 2007.

———. *Stories in Red and Black: Pictorial Histories of the Aztecs and Mixtecs.* Austin: University of Texas Press, 2000.

Bowden, Charles. *Murder City: Ciudad Juárez and the Global Economy's New Killing Fields.* New York: Nation Books, 2011.

Brading, D. A. *Mexican Phoenix: Our Lady of Guadalupe; Image and Tradition Across Five Centuries.* Cambridge: Cambridge University Press, 2002.

Bradley, Ryan. "How Nonny de la Peña, the 'Godmother of VR,' Is Changing the Mediascape." *Wall Street Journal.* November 3, 2018. https://www.wsj.com/ articles/how-nonny-de-la-pena -the-godmother-of-vr-is-changing -the-mediascape-1541253890?ns =prod/accounts-wsj.

Breuer, Karin. *An American Focus: The Anderson Graphics Arts Collection.* San Francisco: Fine Arts Museums of San Francisco, 2000.

———. *Thirty-Five Years at Crown Point Press: Making Prints, Doing Art.* San Francisco: Fine Arts Museums of San Francisco, 1997.

Broyles-González, Yolanda. "El Teatro Campesino and the Mexican Popular Performance Tradition." In *Radical Street Performance: An International Anthology*, edited by Jan Cohen-Cruz, 245–54. London: Routledge, 1998.

Buchloh, Benjamin H. D. "Conceptual Art 1962–1969: From the Aesthetic of Administration to the Critique of Institutions." *October* 55 (Winter 1990): 105–43.

Buhle, Paul, and Nicole Schulman, eds. *Wobblies! A Graphic History of the Industrial Workers of the World.* London: Verso, 2005.

Bush, George H. W. "Address Before a Joint Session of the Congress on the Persian Gulf Crisis and the Federal Budget Deficit." George H. W. Bush Presidential Library and Museum, College Station, TX. September 11, 1990. https:// bush41library.tamu.edu/archives /public-papers/2217.

Caban, Pedro. "Cointelpro" (2005). *Latin American, Caribbean, and U.S. Latino Studies Faculty Scholarship* 18. http://scholarsarchive .library.albany.edu/lacs_fac _scholar/18.

Cadwalladr, Carole, and Emma Graham-Harrison. "How Cambridge Analytica Turned Facebook 'Likes' into a Lucrative Political Tool." *Guardian* (U.S. edition). March 17, 2018. https://www .theguardian.com/technology /2018/mar/17/facebook -cambridge-analytica-kogan -data-algorithm.

Calvo, Luz. "Art Comes for the Archbishop: The Semiotics of Contemporary Chicana Feminism and the Work of Alma López." In Gaspar de Alba and López, *Our Lady of Controversy*, 96–120.

Camnitzer, Luis. *Conceptualism in Latin American Art: Didactics of Liberation*. Austin: University of Texas Press, 2007.

Camnitzer, Luis, Jane Farver, and Rachel Weiss, eds. *Global Conceptualism: Points of Origin, 1950s–1980s*. New York: Queens Museum of Art, 1999.

Caragol, Taína. "When War Hits Home." *Face to Face* (blog). National Portrait Gallery, Smithsonian Institution. https://npg.si.edu/blog /when-war-hits-home.

Carlsson, Chris, and Lisa Ruth Elliott, eds. *Ten Years That Shook the City: San Francisco 1968–1978*. San Francisco: City Lights Foundation Books, 2011.

Carrasco, Barbara. Interview by Karen Mary Davalos, August 30, September 11 and 21, and October 10, 2007, Los Angeles, California. CSRC Oral History Series, no. 3. Los Angeles: UCLA Chicano Studies Research Center Press, 2013.

Carroll, Amy Sara. *REMEX: Toward an Art History of the NAFTA Era*. Austin: University of Texas Press, 2017.

Castellanos, Leonard. "Chicano Centros, Murals and Art." *Arts in Society* (Madison, WI) 12, no. 1 (1974): 38–43.

Castillo, Andrea. "Must Reads: This Boyle Heights Teacher Is the Face of the L.A. Teachers' Strike." *Los Angeles Times*. January 17, 2019. https://www.latimes.com/local /lanow/la-me-edu-teachers-strike -poster-20190117-story.html.

Castro, René. "Mission Gráfica: Un Taller Humilde en el Barrio de la Mission." In *Corazon del Barrio: 25 Years of Art and Culture in the Mission*, n.p. San Francisco: Mission Cultural Center, February 2003.

Center for the Study of Political Graphics (CSPG). "Decade of Dissent: Andy Zermeño." February 12, 2012. YouTube video, 10:10. http://www.youtube .com/watch?v= ht7HG68Vwdk.

Chabram-Dernersesian, Angie. "I Throw Punches for My Race, But I Don't Want to Be a Man: Writing Us—Chica-Nos (Girl, Us)/ Chicanas—into the Movement Script." In *Cultural Studies*, edited by Lawrence Grossberg, Cary Nelson, and Paula A. Treichler, 81–95. New York: Routledge, 1992.

Chase, Garrett. "The Early History of the Black Lives Matter Movement, and the Implications Thereof." *Nevada Law Journal* 18, Iss. 3, Article 11 (2018): 1091–1112. https://scholars.law.unlv.edu/nlj /vol18/iss3/11.

Chavoya, C. Ondine. "Collaborative Public Art and Multimedia Installation: David Avalos, Louis Hock, and Elizabeth Sisco's *Welcome to America's Finest Tourist Plantation* (1988)." In *The Ethnic Eye: Latino Media Arts*, edited by Chon A. Noriega and Ana M. López, 208–27. Minneapolis: University of Minnesota Press, 1996.

Chavoya, C. Ondine, and David Evans Frantz, eds. *Axis Mundo: Queer Networks in Chicano L.A.* Los Angeles: ONE National Gay & Lesbian Archives at the USC Libraries with DelMonico/ Prestel, 2017.

Chavoya, C. Ondine, and Rita Gonzalez. "Asco and the Politics of Revulsion." In Chavoya and Gonzalez, *Asco: Elite of the Obscure,* 37–106.

———, eds. *Asco: Elite of the Obscure: A Retrospective, 1972–1987*. Ostfildern: Hatje Cantz, 2011.

Constantini, Cristina. "Hopeful, 'Unapologetic' Art Rebrands the Immigration Movement." ABC News. March 1, 2013. https:// abcnews.go.com/ABC_Univision /art-rebrands-immigration -reform-movement/story?id =18610975.

Coppel, Stephen. *The American Dream: Pop to the Present*. New York: Thames & Hudson, 2017.

Cordova, Cary. *The Heart of the Mission: Latino Art and Politics in San Francisco*. Philadelphia: University of Pennsylvania Press, 2017.

Cordova, Ruben C. *Con Safo: The Chicano Art Group and the Politics of South Texas*. Los Angeles: UCLA Chicano Studies Research Center Press, 2009.

Cornejo, Kency. "US Central Americans in Art and Visual Culture." *Oxford Research Encyclopedia of Literature*. February 2019. http://cx .doi.org/10.1093 acrfore /9780190201098.013.434.

Cortez, Constance. *Carmen Lomas Garza*. Los Angeles: UCLA Chicano Studies Research Center Press, 2010.

Costanza-Chock, Sasha. *Out of the Shadows, Into the Streets! Transmedia Organizing and the Immigrant Rights Movement.* Cambridge, MA: MIT Press, 2014.

Craft and Folk Art Museum (Los Angeles). "Folk Art Everywhere." Accessed May 4, 2019. http://m.cafam.org /folkarteverywhere.html.

Crary, Jonathan. *Techniques of the Observer: On Vision and Modernity in the Nineteenth Century.* Cambridge, MA: MIT Press, 2012.

Crenshaw, Kimberlé. "Demarginalizing the Intersection of Race and Sex: A Black Feminist Critique of Antidiscrimination Doctrine, Feminist Theory, and Antiracist Politics." *University of Chicago Legal Forum*, Iss. 1, Article 8 (1989): 139–68.

———. "Mapping the Margins: Intersectionality, Identity Politics, and Violence against Women of Color." *Stanford Law Review* 43, no. 6 (July 1991): 1241–99.

Cruz, Araceli. "Lalo Alcaraz Has Painted Emma Gonzalez, the Face of the Gun Control Debate, and Here's How People Are Reacting." Things That Matter, Mitú. February 21, 2018. https://wearemitu.com /things-that-matter/emma -gonzalez-portrait/.

Cullen, Deborah. "Contact Zones: Places, Spaces, and Other Test Cases." *American Art* 26, no. 2 (Summer 2012): 14–20. https:// doi.org/10.1086/667946.

———. "Robert Blackburn (1920– 2003): A Printmaker's Printmaker." *American Art* 17, no. 3 (Autumn 2003): 92–94.

Cushing, Lincoln. *All of Us or None: Social Justice Posters of the San Francisco Bay Area.* Berkeley, CA: Heyday, 2012.

———. "Artist's Statements: Malaquias Montoya." *One Struggle, Two Communities: Late Twentieth-Century Political Posters of Havana, Cuba, and the San Francisco Bay Area.* Docs Populi. September 28, 2003. http://www .docspopuli.org/articles/Cuba /BACshow.html.

Cushing, Lincoln, and Timothy W. Drescher. *Agitate! Educate! Organize! American Labor Posters.* Ithaca, NY: Cornell University Press, 2009.

Darder, Antonia. "Chapter 2: The Politics of Biculturalism: Culture and Difference in the Formation of 'Warriors of Gringostroika' and 'The New Meztizas.'" *Counterpoints* 418 (2011): 41–60.

Davalos, Karen Mary. *Chicana/o Remix: Art and Errata Since the Sixties.* New York: New York University Press, 2017.

———. "Innovation through Tradition: The Aesthetics of Día de los Muertos." In Thomas, *Día de los Muertos*, 21–29.

———. "The Landscapes of Gilbert 'Magu' Luján." In *Aztlán to Magulandia: The Journey of Chicano Artist Gilbert "Magu" Luján*, edited by Constance Cortéz and Hal Glicksman, 37–56. Munich: DelMonico Books, 2017.

———. *Yolanda M. López*. Los Angeles: UCLA Chicano Studies Research Center Press, 2008.

Davis, Richard. *Typing Politics: The Role of Blogs in American Politics*. Oxford: Oxford University Press, 2009.

Dean, Aria. "From 'Tactical Poetics: FloodNet's Virtual Sit-Ins.'" In *The Art Happens Here: Net Art Anthology*, edited by Michael Connor, 99–100. New York: Rhizome, 2019.

De Cicco, Gabby, "There Can Never Be Political Change without Cultural Change." Association for Women's Rights in Development (AWID). February 14, 2017. https:// www.awid.org/news-and-analysis /there-can-never-be-political -change-without-cultural-change.

De la Garza, Rudolph O., Z. Anthony Kruszewski, and Tomás A. Arciniega. *Chicanos and Native Americans: The Territorial Minorities.* Englewood Cliffs, NJ: Prentice-Hall, 1973.

De la Peña, Nonny. "The Future of News? Virtual Reality." TEDWomen 2015. https://www .ted.com/talks/nonny_de_la _pena_the_future_of_news _virtual_reality?language=en.

DeRose, Elizabeth C. "León Ferrari's *Heliografias*." *Art in Print* 5, no. 3 (September–October 2015): 27–31.

Design Museum. "Q&A with Shepard Fairey." Accessed July 8, 2019. https://designmuseum.org /exhibitions/hope-to-nope-graphics -and-politics-2008-18/qa-with -shepard-fairey.

Deutsche, Rosalyn. "Unrest." In Alexander, *Martha Rosler*, 21–25.

Devon, Marjorie, Bill Lagattuta, and Rodney Hamon. *Tamarind Techniques for Fine Art Lithography.* New York Abrams, 2009.

Dewalt, Teddy, ed. *Emanuel Martinez: A Retrospective.* Denver, CO: Museo de Las Américas, 1995.

Diaz, Ella Maria. *Flying Under the Radar with the Royal Chicano Air Force: Mapping a Chicano/a Art History.* Austin: University of Texas Press, 2017.

Dignidad Rebelde. "About Us." Accessed June 6, 2019. https://dignidadrebelde.com/?page_id=8.

———. "I Am Alex Nieto and My Life Matters." April 2, 2014. https://dignidadrebelde.com/?p=2319.

Dominguez, Ricardo. "Electronic Disturbance Theater: Timeline 1994–2002." *TDR: The Drama Review* 47, no. 2 (2003): 132–34.

Douglas, Emory. "Art for the People." *Black Panther* 1, no. 1 (Spring 1991): n.p.

Downes, Larry, and Chunka Mui. *Unleashing the Killer App: Digital Strategies for Market Dominance.* Boston: Harvard Business School Press, 1998.

Duardo, Richard. Interview by Karen Mary Davalos, November 5, 8, and 12, 2007, Los Angeles, California. CSRC Oral History Series, no. 9. Los Angeles: UCLA Chicano Studies Research Center Press, 2013.

Durland, Steven, and Linda Burnham. "Gronk." *High Performance* 9, no. 3 (1986): 57.

Duyshart, Bruce. *The Digital Document: A Reference for Architects, Engineers and Design Professionals.* London: Routledge, 2017.

Eisenhammer, Stephen. "Bare Life in Ciudad Juárez: Violence in a Space of Exclusion." *Latin American Perspectives* 41, no. 2 (March 2014): 99–109.

Ellingwood, Ken. "Zapata Photo Shrouded in Mystery." *Los Angeles Times.* December 6, 2009. https://www.latimes.com/archives/la-xpm-2009-dec-06-la-fg-mexico-zapata6-2009dec06-story.html.

Emblematic Group. "Out of Exile." Accessed December 28, 2019. https://emblematicgroup.com/experiences/out-of-exile/.

Favela, Ramón. *The Art of Rupert Garcia.* San Francisco: Chronicle Books and Mexican Museum, 1986.

Ferreira, Jason. "'Our Frontiers Are in the Realm of Ideas: Identity,' Solidarity, and the Meaning of Raza Radicalism in Late 20th Century America." Paper presented at the Annual Meeting of the Organization of American Historians & National Council on Public History, Washington, DC, April 20, 2006.

Figureroa, Michael. "Augment El Paso." Apple App Store (2013–19). https://apps.apple.com/us/app/augment-el-paso/id704045404.

Finch, Wilbur A., Jr. "The Immigration Reform and Control Act of 1986: A Preliminary Assessment." *Social Service Review* 64, no. 2 (June 1990): 244–60.

Finkelpearl, Tom. *What We Made: Conversations on Art and Social Cooperation.* Durham, NC: Duke University Press, 2013.

Finley, Klint. "The Wired Guide to Open Source Software." *Wired.* April 24, 2019. https://www.wired.com/story/wired-guide-open-source-software/.

Flores, Tatiana. "Latino Art and the Immigrant Artist: The Case of Sandra C. Fernández." *Diálogo* 18, no. 2 (Fall 2015): 167–72.

Friedberg, Anne. *The Virtual Window: From Alberti to Microsoft.* Cambridge, MA: MIT Press, 2006.

Gabara, Esther, "Contesting Freedom." In Gabara, *Pop América*, 10–19.

———, ed. *Pop América, 1965–1975.* Durham, NC: Nasher Museum of Art at Duke University, 2018.

Gaiter, Colette. "What Revolution Looks Like: The Work of Black Panther Artist Emory Douglas." In *Black Panther: The Revolutionary Art of Emory Douglas*, edited by Sam Durant, 98–101. New York: Rizzoli, 2007.

Garcia, Jacalyn Lopez. "*Glass Houses*: A View of American Assimilation from a Mexican-American Perspective." *Leonardo* 33, no. 4 (August 2000): 263–64.

García, Mario T. *Border Correspondent: Selected Writings, 1955–1970, Rubén Salazar.* Berkeley: University of California Press, 1995.

García, Ramón. "Against Rasquache: Chicano Identity and the Politics of Popular Culture in Los Angeles." *Critica: A Journal of Critical Essays* (San Diego) (Spring 1998): 1–26.

García, Rupert. "Chicano/Latino Wall Art: The Mural and the Poster." In *The Hispanic American Aesthetic: Origins, Manifestations, and Significance*, edited by Jacinto Quirarte, 27–30. San Antonio: Research Center for the Arts and Humanities, University of Texas at San Antonio, 1983.

——. "Media Supplement, 1969–1970." Unpublished master's thesis, Department of Art, San Francisco State College, 1970.

García, Rupert, and Guillermo Gómez-Peña. "Turning It Around: A Conversation between Rupert Garcia and Guillermo Gómez-Peña." In *Aspects of Resistance: Rupert Garcia*, 13–35. New York: Alternative Museum, 1993.

Gaspar de Alba, Alicia. *Chicano Art Inside/Outside the Master's House: Cultural Politics and the CARA Exhibition.* Austin: University of Texas Press, 1998.

——. *[Un]Framing the "Bad Woman": Sor Juana, Malinche, Coyolxauhqui, and Other Rebels with a Cause.* Austin: University of Texas Press, 2014.

Gaspar de Alba, Alicia, and Alma López, eds. *Our Lady of Controversy: Alma López's "Irreverent Apparition."* Austin: University of Texas Press, 2011.

Gilbert, Coral, and Ricardo Frazer. "Interview with Carlos Cortez." *Cultural Crossroads* 6, no. 1 (November 1995): 1–3.

Goldman, Shifra M. "Luis Jiménez: Recycling the Ordinary into the Extraordinary." In Jiménez, *Man on Fire*, 7–20.

——. "A Public Voice: Fifteen Years of Chicano Posters." *Art Journal* 44, no. 1 (Spring 1984): 50–57.

Goldman, Shifra M., and Tomás Ybarra-Frausto. *Arte Chicano: A Comprehensive Annotated Bibliography of Chicano Art, 1965–1981.* Berkeley: Chicano Studies Library Publications Unit, University of California, 1985.

——. "Outline of a Theoretical Model for the Study of Chicano Art." In Goldman and Ybarra-Frausto, *Arte Chicano*, 7–55.

——. "The Political and Social Contexts of Chicano Art." In Griswold del Castillo, McKenna, and Yarbro-Bejarano, *Chicano Art: Resistance and Affirmation*, 83–95.

Gómez-Barris, Macarena. "Mestiza Cultural Memory: The Self-Ecologies of Laura Aguilar." In *Laura Aguilar: Show and Tell*, edited by Rebecca Epstein and Sybil Venegas, 79–85. Los Angeles: UCLA Chicano Studies Research Center Press, 2017.

Gonzales, Rodolfo "Corky." "Colorado Springs Bicentennial Speech of July 4, 1976." In *Message to Aztlán: Selected Writings of Rodolfo "Corky" Gonzales*, compiled by Antonio Esquibel, 82–89. Houston, TX: Arte Público Press, 2001.

Gonzales, Rodolfo, and Alberto Urista. "El Plan Espiritual de Aztlán." *El Grito del Norte* 2, no. 9 (July 6, 1969): 5.

González, Daniel. "Self Help Graphics 40th Anniv. Day of the Dead Print." Cargo Collective. December 11, 2013. https://cargocollective.com/printgonzalez/Self-Help-Graphics-40th-Anniv-Day-of-the-Dead-Print.

González, Gilbert G. "A Critique of the Internal Colony Model." *Latin American Perspectives* 1, no. 1 (Spring 1974): 154–61.

González, Jennifer A. *Subject to Display: Reframing Race in Contemporary Installation Art* Cambridge, MA: MIT Press, 2008.

González, Rita, Howard N. Fox, and Chon A. Noriega. *Phantom Sightings: Art After the Chicano Movement.* Los Angeles: Los Angeles County Museum of Art and University of California Press, 2008.

González, Xico. "Arte Revoltoso: Selected Work by Xico Gonzalez." Self-published presentation, 2018.

Governor, James, Dion Hinchcliffe, and Duane Nickull. *Web 2.0 Architectures.* Sebastopol, CA: O'Reilly Media, 2009.

Grau, Oliver. *Virtual Art: From Illusion to Immersion.* Rev. ed. Cambridge, MA: MIT Press, 2007.

Greeley, Robin Adèle. "Richard Duardo's 'Aztlan' Poster: Interrogating Cultural Hegemony in Graphic Design." *Design Issues* 14, no. 1 (Spring 1998): 21–34.

Greenwald, Glenn, and Ewen MacAskill. "Boundless Informant: The NSA's Secret Tool to Track Global Surveillance Data." *Guardian* (U.S. edition). June 11, 2013. https://www.theguardian.com/world/2013/jun/08/nsa-boundless-informant-global-datamining.

Greenwald, Glenn, Ewen MacAskill, and Laura Poitras. "Edward Snowden: The Whistleblower Behind the NSA Surveillance Revelations." *Guardian* (U.S. edition). June 11, 2013. https://www.theguardian.com/world/2013/jun/09/edward-snowden-nsa-whistleblower-surveillance.

Griswold del Castillo, Richard, Teresa McKenna, and Yvonne Yarbro-Bejarano, eds. *Chicano Art: Resistance and Affirmation, 1965–1985*. Los Angeles: Wight Art Gallery, University of California, 1991.

Grossberger-Morales, Lucia. "Sangre Boliviana." *Leonardo* 28, no. 4 (1995): 246–47.

Gruzinski, Serge. *Images at War: Mexico from Columbus to Blade Runner (1492–2019)*. Translated by Heather MacLean. Durham, NC: Duke University Press, 2001.

Gunckel, Colin. "Art and Community in East L.A: Self Help Graphics & Art from the Archive Room." In Gunckel, *Self Help Graphics and Art*, 38–48.

———. "The Chicano/a Photographic: Art as Social Practice in the Chicano Movement." *American Quarterly* 67, no. 2 (June 2015): 377–412.

———, ed. *Self Help Graphics and Art: Art in the Heart of East Los Angeles*. 2nd ed. Los Angeles: UCLA Chicano Studies Research Center Press, 2014.

Gutiérrez, Ramón A. "Community, Patriarchy and Individualism: The Politics of Chicano History and the Dream of Equality." *American Quarterly* 45, no. 1 (March 1993): 44–72.

———. "Internal Colonialism: An American Theory of Race." *Du Bois Review: Social Science Research on Race* 1, no. 2 (2004): 281–95.

Guzmán, Kristen. "Art in the Heart of East Los Angeles." In Gunckel, *Self Help Graphics and Art*, 1–30.

Hackman, Rose. "'She Was Only a Baby': Last Charge Dropped in Police Raid That Killed Sleeping Detroit Child." *Guardian* (U.S. edition). January 31, 2015. https://www.theguardian.com/us-news/2015/jan/31/detroit-aiyana-stanley-jones-police-officer-cleared.

Harding, James M., and Cindy Rosenthal, eds. *Restaging the Sixties: Radical Theaters and Their Legacies*. Ann Arbor: University of Michigan Press, 2006.

Harney, Stefano, and Fred Moten. *The Undercommons: Fugitive Planning & Black Study*. Wivenhoe, UK: Minor Compositions, 2013.

Hazelwood, Art. "Mission Gráfica: Reflecting a Community in Print." Unpublished manuscript, 2017.

Helguera, Pablo. *Education for Socially Engaged Art: A Materials and Techniques Handbook*. New York: Jorge Pinto Books, 2011.

Herrera-Sobek, María, ed. *Celebrating Latino Folklore: An Encyclopedia of Cultural Traditions*. Santa Barbara, CA: ABC-CLIO, 2012.

Hewlett-Packard. "elrevoltoso's Public Auras, *Salam*." HP Reveal. Accessed May 6, 2019.

———. "HP Reveal." Accessed May 6, 2019. https://www8.hp.com/us/en/printers/reveal.html.

Heyman, Therese Thau. *Posters American Style*. Washington, DC: National Museum of American Art, Smithsonian Institution, and Harry N. Abrams, 1998.

Hickey, Donald R. "A Note on the Origins of 'Uncle Sam,' 1810–1820." *New England Quarterly* 88, no. 4 (December 2015): 681–92.

Hill, Sarah. "The War for Drugs: How Juárez Became the World's Deadliest City." *Boston Review*. July/August 2010. http://bostonreview.net/archives/BR35.4/hill.php.

Hsu, Jeremy. "Why 'Uncanny Valley' Human Look-Alikes Put Us on Edge." *Scientific American*. April 3, 2012. https://www.scientificamerican.com/article/why-uncanny-valley-human-look-alikes-put-us-on-edge/.

Huacuja Pearson, Judith. *Chicana Critical Pedagogies: Chicana Art as Critique and Intervention*, Smithsonian Institution, Washington, DC. Accessed May 28, 2019. (site discontinued) http://latino.si.edu/researchandmuseums/presentations/huacaya.html.

iamOTHER. "Voice of Art: Migration Is Beautiful, Pt. 1." January 14, 2013. YouTube video, 12:00. https://www.youtube.com/watch?v=LWE2T8Bx5d8.

The Intifada: A Message from Three Generations of Palestinians. Knight Financial Services, 1988.

Jackson, Carlos Francisco. "A Victory: Harriett and Ricardo Romo's Collection of Contemporary Art." *Estampas de la Raza: Contemporary Prints from the Romo Collection*. San Antonio, TX: McNay Art Museum, 2012.

Jiménez, Luis. *Man on Fire: Luis Jiménez*. Albuquerque, NM: Albuquerque Museum, 1994.

Johnson, Kaytie. "Jacalyn López García." In *Contemporary Chicana and Chicano Art: Artists, Works, Culture, and Education,* edited by Gary D. Keller, 2:92–93. Tempe, AZ: Bilingual Press/Editorial Bilingüe, 2002.

Karp, Ivan, Christine Mullen Kreamer, and Steven D. Lavine, eds. *Museums and Communities: The Politics of Public Culture.* Washington, DC: Smithsonian Institution Press, 1992.

Kelley, Robin D. G. *Yo' Mama's Disfunktional! Fighting the Culture Wars in Urban America.* Boston: Beacon Press, 1997.

Kelly, Michael. "The Political Autonomy of Contemporary Art: The Case of the 1993 Whitney Biennial." In *Politics and Aesthetics in the Arts*, edited by Salim Kemal and Ivan Gaskell, 221–63. Cambridge: Cambridge University Press, 2000.

Kun, Josh. "The Personal Equator: Patssi Valdez at the Border." In Chavoya and Gonzalez, *Asco: Elite of the Obscure*, 359–60.

———. "Vex Populi." *Los Angeles Magazine*, March 2003, 62–70.

Lacy, Suzanne, ed. *Mapping the Terrain: New Genre Public Art.* Seattle: Bay Press, 1995.

"La Historia de Mechicano." *La Gente de Aztlán* (University of California, Los Angeles) 8, no. 1 (November 2, 1977): 14.

Langa, Helen. *Radical Art: Printmaking and the Left in 1930s New York*. Berkeley: University of California Press, 2004.

Latner, Teishan A. "'Agrarians or Anarchists?' The Venceremos Brigades to Cuba, State Surveillance, and the FBI as Biographer and Archivist." *Journal of Transnational American Studies* 9, no. 1 (2018): 119–40.

Latorre, Guisela. "Icons of Love and Devotion: Alma López's Art." *Feminist Studies* 34, nos. 1/2 (2008): 131–50.

———. *Walls of Empowerment: Chicana/o Indigenist Murals of California*. Austin: University of Texas Press, 2008.

Lee, Henry K., and Kale Williams. "4 San Francisco Cops Cleared in Alex Nieto Killing." SFG*ATE*. February 13, 2015. https://www .sfgate.com/bayarea/article /4-San-Francisco-cops-cleared -in-Alex-Nieto-killing-6079794 .php#photo-7238295.

Lehmbeck, Leah, ed. *Proof: The Rise of Printmaking in Southern California*. Los Angeles: Getty Publications in association with the Norton Simon Museum, 2011.

Library of Congress. "Frederick Douglass Papers at the Library of Congress." Accessed July 6, 2019. https://www.loc.gov/collections /frederick-douglass-papers /articles-and-essays/frederick -douglass-timeline/1860-to-1876/.

Lichtblau, Eric. "Hate Crimes against American Muslims Most Since Post-9/11 Era." *New York Times*. September 17, 2016. https://www.nytimes.com/2016 /09/18/us/politics/hate-crimes -american-muslims-rise.html.

Lippard, Lucy R. "Dancing with History: Culture, Class, and Communication." In Jiménez, *Man on Fire*, 21–38.

———. "Rupert García: Face to Face." In *Rupert García: Prints and Posters, 1967–1990*, 28–31. San Francisco: Fine Arts Museums of San Francisco, 1990.

———, ed. *Six Years: The Dematerialization of the Art Object from 1966 to 1972*. New York: Praeger, 1973.

Lipsitz, George. "Not Just Another Social Movement: Poster Art and the Movimiento Chicano." In Noriega, *¿Just Another Poster?*, 71–89.

Liu, Lydia He. *The Freudian Robot: Digital Media and the Future of the Unconscious*. Chicago: University of Chicago Press, 2010.

López, Alma. "It's Not about the Santa Fe in My Fe, but the Santa Fe in My Santa." In Gaspar de Alba and López, *Our Lady of Controversy*, 249–92.

———. "LUPE & SIRENA." Accessed July 1, 2019. https://almalopez .myportfolio.com/lupe-sirena.

Lopez, Lalo. "Power Prints." *Hispanic* 8, no. 9 (October 1995): 68–72.

López, Miguel A., and Josephine Watson. "How Do We Know What Latin American Conceptualism Looks Like?" *Afterall: A Journal of Art, Context and Enquiry*, no. 23 (2010): 5–21.

Lucero, Linda. "Lolita Lebrón: Viva Puerto Rico Libre!" In *FEMINAE: Typographic Voices of Women, by Women*, edited by Gloria Kondrup, 22–25. Pasadena, CA: Hoffmitz Milken Center for Typography, 2018.

Macchiavello, Carla. "Appropriating the Improper: The Problem of Influence in Latin American Art." *ARTMargins* 3, no. 2 (2014): 31–59.

MacPhee, Josh, ed. *Paper Politics: Socially Engaged Printmaking Today*. Oakland, CA: PM Press, 2009.

Magnolia Editions. "A Conversation with Rupert Garcia." *Magnolia Editions Newsletter*, no. 11 (Spring 2007): 5–12. http://www.magnoliaeditions .com/wp-content/uploads/2012 /04MagnoliaNewsletter11.pdf.

———. "Inkjet Info." Accessed July 6, 2019. http://www .magnoliaeditions.com/inkjet-info/.

Malagamba Ansótegui, Amelia, ed. *Caras Vemos, Corazones No Sabemos: Faces Seen, Hearts Unknown, The Human Landscape of Mexican Migration*. Notre Dame, IN: Snite Museum of Art, University of Notre Dame, 2006.

Manovich, Lev. *The Language of New Media*. Cambridge, MA: MIT Press, 2010.

Marchi, Regina M. *Day of the Dead in the USA: The Migration and Transformation of a Cultural Phenomenon*. New Brunswick, NJ: Rutgers University Press, 2009.

Marez, Curtis. *Farm Worker Futurism: Speculative Technologies of Resistance*. Minneapolis: University of Minnesota Press, 2016.

Maroja, Camila. "Pop Goes Conceptual: Visual Language in América." In Gabara, *Pop América*, 42–51.

MARS Artspace. Accessed June 30, 2019. http://www .mars-artspace.org/info/history .jsp?chapter=8 (site discontinued).

McDonagh, Sarah. "SXSW: Virtual Reality Pioneer Nonny de la Peña on Immersive Storytelling." March 15, 2018. https://www .storybench.org/sxsw-virtual -reality-pioneer-nonny-de-la-pena -immersive-storytelling/.

McLuhan, Marshall. *Understanding Media: The Extensions of Man*. New York: McGraw-Hill, 1964.

Menchaca, Michael. "Statement on Social Media." Accessed August 20, 2019. https://michaelmenchaca.com /artwork/4596979-Social-Media -Statement.html.

Mendoza Avilés, Mayra. "El Zapata de Brehme: El análisis de un caso." *Alquimia* 36 (2009): 83–84.

Mesa-Bains, Amalia. "Domesticana: The Sensibility of Chicana Rasquache." *Aztlán: A Journal of Chicano Studies* (Los Angeles) 24, no. 2 (Fall 1999): 157–67.

Mirandé, Alfredo. *The Chicano Experience: An Alternative Perspective*. Notre Dame, IN: University of Notre Dame Press, 1985.

Mitchell, Raye Bemis. "MARCH to an Aesthetic of Revolution." *New Art Examiner* 4, no. 5 (February 1977): 11.

Molina, Natalia. *How Race Is Made in America: Immigration, Citizenship, and the Historical Power of Racial Scripts*. Berkeley: University of California Press, 2014.

Montoya, José. "Rupert Garcia and the SF Museum of Modern Art." *RAYAS*, no. 2 (March/April 1978): 5, 11.

Montoya, José, and Juan M. Carrillo. "Posada: The Man and His Art. A Comparative Analysis of José Guadalupe Posada and the Current Chicano Art Movement as They Apply Toward Social and Cultural Change. A Visual Resource Unit for Chicano Education." Unpublished master's thesis, California State University, Sacramento, 1975.

Montoya, Malaquias, and Lezlie Salkowitz-Montoya. "A Critical Perspective on the State of Chicano Art." *Metamórfosis* (Seattle) 3, no. 1 (1980): 3–7.

Moreno, Dorinda. "Ester, Lupe y La Chicana en el Arte." Special edition, *La Razon Mestiza II* (Summer 1976): n.p.

Morris, Catherine, and Vincent Bonin, eds. *Materializing "Six Years": Lucy R. Lippard and the Emergence of Conceptual Art*. Cambridge, MA: MIT Press, 2012.

Muñoz, José Esteban. *Cruising Utopia: The Then and There of Queer Futurity*. 10th anniv. ed. New York: New York University Press, 2019.

Munteanu, Dinu Gabriel. "Improbable Curators: Analysing Nostalgia, Authorship and Audience on Tumblr Microblogs." In *Collaborative Production in the Creative Industries*, edited by James Graham and Alessandro Gandini, 125–56. London: University of Westminster Press, 2017.

New York University. "Guide to the Public Art Fund Archive 1966–2009." Fales Library & Special Collections. Updated September 2017. http://dlib.nyu .edu/findingaids/html/fales/paf /dscaspace_ref18.html.

Nieto, Margarita. "Across the Street: Self-Help Graphics and Chicano Art in Los Angeles." In *Across the Street: Self-Help Graphics and Chicano Art in Los Angeles*, 21–37. Laguna Beach, CA: Laguna Art Museum, 1995.

Noriega, Chon A. "Decolonizing American Art: Chicanx Art and Wars of Influence." Paper presented at the Latino Art Now! Conference, Houston, TX, April 6, 2019.

———, ed. *¿Just Another Poster? Chicano Graphic Arts in California*. Santa Barbara, CA: University Art Museum, 2001.

———. "On Museum Row: Aesthetics and the Politics of Exhibition." *Daedalus* 128, no. 3 (1999): 57–81.

———. "Postermodernism; or Why This Is Just Another Poster." In Noriega, *¿Just Another Poster?*, 19–23.

———. "'Your Art Disgusts Me': Early Asco, 1971–75." *Afterall: A Journal of Art, Context and Enquiry*, no. 19 (2008): 109–21.

Noriega, Chon A., and Pilar Tompkins Rivas. "Chicano Art in the City of Dreams: A History in Nine Movements." In Noriega, Romo, and Tompkins Rivas, *L.A. Xicano*, 71–102.

Noriega, Chon A., Terezita Romo, and Pilar Tompkins Rivas, eds. *L.A. Xicano*. Los Angeles: UCLA Chicano Studies Research Center Press, 2011.

Novakov, Anna. "The Artist as Social Commentator: A Critical Study of the Spectacolor Lightboard Series 'Messages to the Public.'" PhD diss., New York University, 1993.

Nunn, Tey Marianna. "It's Not about the Art in the Folk, It's about the Folks in the Art: A Curator's Tale." In Gaspar de Alba and López, *Our Lady of Controversy*, 17–42.

Oh, Catherine S., Jeremy N. Bailenson, and Gregory F. Welch. "A Systematic Review of Social Presence: Definition, Antecedents, and Implications." *Frontiers in Robotics and AI* 5, art. 114 (October 2018): 1–35. https://doi.org/10.3389/frobt.2018.00114.

Originol, Oree. "Justice for Our Lives." Accessed June 10, 2019. https://www.oreeoriginol.com/justiceforourlives.html.

Papagiannis, Helen. *Augmented Human: How Technology Is Shaping the New Reality*. Bejing: O'Reilly, 2017. Kindle.

———. "The Critical Role of Artists in Advancing Augmented Reality." 2016. OpenMind, BBVA. https://www.bbvaopenmind.com/en/articles/the-critical-role-of-artists-in-advancing-augmented-reality/.

Paquette, Catha. "(Re)Visions: Sacred Mothers and Virgins." In *Mex/L.A.: "Mexican" Modernism(s) in Los Angeles, 1930–1985*, edited by Museum of Latin American Art, Long Beach, CA, 48–57. Ostfildern: Hatje Cantz, 2011.

Patiño, Jimmy. *Raza Sí, Migra No: Chicano Movement Struggles for Immigrant Rights in San Diego*. Chapel Hill: University of North Carolina Press, 2017.

Paul, Christiane, ed. *A Companion to Digital Art*. Chichester, UK: John Wiley & Sons, 2016.

Pérez, Emma. *The Decolonial Imaginary: Writing Chicanas into History*. Bloomington: Indiana University Press, 1999.

Pérez-Barreiro, Gabriel, Ursula Davila-Villa, and Gina McDaniel Tarver, eds. *The New York Graphic Workshop, 1964–1970*. Austin: Blanton Museum of Art, University of Texas at Austin, 2009.

Pérez-Latre, Francisco J. "The Paradoxes of Social Media: A Review of Theoretical Issues." In *The Social Media Industries*, edited by Alan B. Albarran, 46–59. New York: Routledge, 2013.

Pérez-Torres, Rafael. "Remapping Chicano Expressive Culture." In Noriega, *¿Just Another Poster?*, 151–69.

Peterson, Jeanette Favrot. *Visualizing Guadalupe: From Black Madonna to Queen of the Americas*. Austin: University of Texas Press, 2014.

Pintoff, Ernest, ed. *The Complete Guide to Animation and Computer Graphics Schools*. New York: Watson-Guptill, 1995.

Pomerantz, Jeffrey. *Metadata*. Cambridge, MA: MIT Press, 2015.

Prado Saldivar, Reina Alejandra. "Más Production of Art for the Masses: Serigraphs of Self-Help Graphic Arts, Inc." In *Latinos in Museums: A Heritage Reclaimed*, edited by Antonio Jose Ríos-Bustamante and Christine Marin, 119–30. Malabar, FL: Krieger, 1998.

———. "Mechicano Art Center: Defining Chicano Art for Los Angelenos." Unpublished manuscript, 2011.

———. "On Both Sides of the Los Angeles River: Mechicano Art Center." In Noriega, Romo, and Tompkins Rivas, *L.A. Xicano*, 41–51.

———. "Self-Help Graphics: A Case Study of a Working Space for Arts and Community." *Aztlán: A Journal of Chicano Studies* 25, no. 1 (Spring 2000): 167–81.

Pratt, Mary Louise. "'Yo Soy la Malinche': Chicana Writers and the Poetics of Ethnonationalism." *Callallo* 16, no. 4 (1993): 859–73.

Public Art Fund. "Barbara Carrasco: Messages to the Public: Pesticides!" Accessed May 1, 2019. https://www.publicartfund.org/exhibitions/view/messages-to-the-public-carrasco/.

Quirarte, Jacinto. *Mexican American Artists.* Austin: University of Texas Press, 1973.

———. "Sources of Chicano Art: Our Lady of Guadalupe." *Explorations in Ethnic Studies* 15, no. 1 (January 1992): 13–26.

Ramírez, Catherine S. "Deus ex Machina: Tradition, Technology, and the Chicanafuturist Art of Marion C. Martinez." *Aztlán: A Journal of Chicano Studies* 29, no. 2 (Spring 2002): 55–92.

Ramírez, Mari Carmen. "Blueprint Circuits: Conceptual Art and Politics in Latin America." In Alberro and Stimson, *Conceptual Art,* 550–62.

———. "Stamping (Molding) Marks: The San Juan Triennial Tracking the New Century." In *Trans/Migrations: Graphics as Contemporary Art,* edited by Mari Carmen Ramírez et al., 14–21. Vol. 1 of *Trienal Poli/Gráfica de San Juan. San Juan Poly/Graphic Triennial: Latin America and the Caribbean.* San Juan: Artes Plasticas, Instituto de Cultura Puertorriqueña, 2004.

———. "Tactics for Thriving on Adversity: Conceptualism in Latin America, 1960–1980." In Camnitzer, Farver, and Weiss, *Global Conceptualism,* 53–71.

Ramírez, Yasmin, Henry C. Estrada, and Gilberto Cárdenas. *Pressing the Point: Parallel Expressions in the Graphic Arts of the Chicano and Puerto Rican Movements.* New York: Museo del Barrio, 1999.

Ramos, E. Carmen. "Manifestaciones: Expresiones de Dominicanidad en Nueva York." *Manifestaciones: Dominican York Proyecto GRAFICA.* New York: CUNY Dominican Studies Institute Gallery, 2010.

———. *Our America: The Latino Presence in American Art.* Washington, DC: Smithsonian American Art Museum in association with D Giles, 2014.

Regents of the University of California. *Special Report Relating to Boalt Hall, Wurster Hall, Eshleman Hall,* issued to the Regents of the University of California, September 11, 1970. San Francisco: Haskins and Sells, 1970.

Reinoza, Tatiana. "Collecting in the Borderlands: Ricardo and Harriett Romo's Collection of Chicano Art." Master's thesis, University of Texas at Austin, 2009.

———. "The Island Within the Island: Remapping Dominican York." *Archives of American Art Journal* 57, no. 2 (Fall 2018): 4–27.

———. "'No Es un Crimen': Posters, Political Prisoners, and the Mission Counterpublics." *Aztlán: A Journal of Chicano Studies* 42, no.1 (Spring 2017): 239–56.

———. "Printed Proof: The Cultural Politics of Ricardo and Harriett Romo's Print Collection." In *A Library for the Americas: The Nettie Lee Benson Latin American Collection,* edited by Julianne Gilland and José Montelongo, 145–155. Austin: University of Texas Press, 2018.

Rena Bransten Gallery. "Rupert Garcia: The Magnolia Editions Projects 1991–2011." Produced by Bay Package Productions in association with Rena Bransten Gallery, 2011. Vimeo video, 4:01 https://vimeo.com/21727915.

Reston, James, Jr. *A Rift in the Earth: Art, Memory, and the Fight for a Vietnam War Memorial.* New York: Arcade, 2017.

Retzkin, Sion. *Hands-On Dark Web Analysis: Learn What Goes on in the Dark Web, and How to Work with It.* Birmingham, UK: Packt, 2018.

Rini Templeton Memorial Fund. "Welcome." Accessed July 1, 2019. https://riniart.com/.

Riojas, Mirasol. *The Accidental Arts Supporter: An Assessment of the Comprehensive Employment and Training Act (CETA).* Report no. 8. Los Angeles: UCLA Chicano Studies Research Center Press, May 2006.

Rodriguez, Favianna. "Resources." Accessed July 12, 2019. https://favianna.com/media/resources.

Rodríguez, Richard T. "Homeboy Beautiful; or Chicano Gay Male Sex Expression in the 1970s." In Chavoya and Frantz, *Axis Mundo,* 112–23.

Romo, Terezita. "The Chicanization of Mexican Calendar Art." Smithsonian Latino Center. Accessed June 30, 2019. http://latino.si.edu /researchandmuseums/abstracts /romo_abstract.htm.

———. *Chicanos en Mictlán: Día de los Muertos in California*. San Francisco: Mexican Museum, 2000.

———. "Conceptually Divine: Patssi Valdez's Vírgen de Guadalupe Walking the Mural." In Chavoya and Gonzalez, *Asco: Elite of the Obscure*, 276–83.

———. *Malaquias Montoya*. Los Angeles: UCLA Chicano Studies Research Center Press, 2011.

———. "Mexican Heritage, American Art: Six Angeleno Artists." In Noriega, Romo, and Tompkins Rivas, *L.A. Xicano*, 3–28.

———. "¡Presente! Chicano Posters and Latin American Politics." In *Latin American Posters: Public Aesthetics and Mass Politics*, edited by Russ Davidson, 51–64. Santa Fe: Museum of New Mexico Press, 2006.

Rosenberg, Matthew, Nicholas Confessore, and Carole Cadwalladr. "How Trump Consultants Exploited the Facebook Data of Millions." *New York Times*. March 17, 2018. https://www.nytimes.com/2018 /03/17/us/politics/cambridge -analytica-trump-campaign.html ?module=inline.

Rossman, Michael. *Speak, You Have the Tools: Social Serigraphy in the Bay Area: 1966–1986*. Santa Clara, CA: de Saisset Museum, Santa Clara University, 1987.

Ruthven, Malise, with Azim Nanji. *Historical Atlas of Islam*. Cambridge, MA: Harvard University Press, 2004.

Salazar, Rubén. "Who Is a Chicano? And What Is It the Chicanos Want?" *Los Angeles Times*, February 6, 1970.

Salgado, Julio. "I Am Undocuqueer." January 13, 2012. https:// juliosalgadoart.com/post /15803758188/i-am-undocuqueer -is-an-art-project-in.

Salseda, Rose. "The Legacy of Self Help Graphics' Día de los Muertos." In Thomas, *Día de los Muertos*, 37–41.

Salvesen, Britt. "Surface and Depth." In *3D: Double Vision*, edited by Britt Salvesen, 9–12. Los Angeles: Los Angeles County Museum of Art, 2018.

Saylor, Miranda. "'A Cry for Freedom.'" In *Found in Translation: Design in California and Mexico, 1915–1985*, edited by Wendy Kaplan, 328–29. Los Angeles: Los Angeles County Museum of Art, 2017.

Schwab, Klaus. *The Fourth Industrial Revolution*. New York: Crown Business, 2017.

Scott-Heron, Gil. "The Revolution Will Not Be Televised" (1970). In *The Norton Anthology of African American Literature*, edited by Henry Louis Gates Jr. and Nellie Y. McKay, 61–62. New York: W. W. Norton, 1996.

2ndwnd. "Studio." Accessed July 12, 2019. http://2ndwnd.com /?page_id=159.

Sedgwick, Eve Kosofsky. *Epistemology of the Closet*. Berkeley: University of California Press, 2008.

Seif, Hinda. "'Layers of Humanity': Interview with Undocuqueer Artivist Julio Salgado." *Latino Studies* 12 (2014): 300–309. https://doi.org/10.1057/lst.201.

Self Help Graphics & Art. "About Us." Accessed July 9, 2019. https://www.selfhelpgraphics.com /about-us.

———. "Past Exhibitions." Accessed February 20, 2019. https://www .selfhelpgraphics.com/exhibitions.

———. "Self Help Graphics & Art Acquires Current Headquarters, Reaches New Milestone after 45 Years in Operation." *Stay Connected* (blog). April 25, 2018. https:// www.selfhelpgraphics.com /blog/2018/4/25/self-help -graphics-art-acquires-current -headquarters-reaches-new -milestone-after-45-years-in -operation.

———. "Self Help Graphics Día de los Muertos 10th Anniversary by Gronk 1982." June 30, 2017. https://www.selfhelpgraphics.com /pst-featured-works-1/2017 /6/30/dia-de-los-muertos-10th -anniversary-by-gronk-1982.

Selz, Peter. *Art of Engagement: Visual Politics in California and Beyond*. Berkeley: University of California Press, 2006.

Serie Project. "Mission Statement." Accessed July 1, 2019. http:// serieproject.org/about/mission -statement/.

Sheren, Ila N. *Portable Borders: Performance Art and Politics on the US Frontera since 1984*. Austin: University of Texas Press, 2015.

SHGTV. "Biennial Printmaking Summit: New Technologies in Print Panel Moderated by Rosalie Lopez." Self Help Graphics & Art TV. May 17, 2019. YouTube video, 1:04:23. https://www.youtube.com /watch?v=ERmP_9zh3eo.

———. "Día de los Muertos: A Cultural Legacy, Past, Present & Future: Gronk." Self Help Graphics & Art TV. September 7, 2017. YouTube video, 1:39. https://www.youtube.com/watch?v=zbPT04N7JGw&feature=youtu.be.

———. "Día de los Muertos: A Cultural Legacy, Past, Present & Future: Sonia Romero." Self Help Graphics & Art TV. September 11, 2017. YouTube video, 01:19. https://www.youtube.com/watch?v=4ogmidl1YOk.

Shirk, Adrian. "The Real Marlboro Man." *Atlantic*. February 17, 2015. https://www.theatlantic.com/business/archive/2015/02/the-real-marlboro-man/385447/.

Simonds, Cylena. "Public Audit: An Interview with Elizabeth Sisco, Louis Hock, and David Avalos." *Afterimage* 22, no. 1 (Summer 1994): 8–11.

Smith, Cherise. *Enacting Others: Politics of Identity in Eleanor Antin, Nikki S. Lee, Adrian Piper, and Anna Deavere Smith*. Durham, NC: Duke University Press, 2011.

Smithsonian American Art Museum. "Our America—Amado M. Peña, "Mestizo."" December 30, 2013. Audio podcast, 2:37. https://americanart.si.edu/videos/our-america-audio-podcast-amado-m-pena-jr-mestizo-154048.

Sol Collective. "Revoltosxs Arte." *Global Local AR Magazine*, no. 1 (2019): 12–15. https://issuu.com/solcollective/docs/globallocalissue1.

Sorell, Victor Alejandro. "The Persuasion of Art—The Art of Persuasion: Emanuel Martinez Creates a Pulpit for El Movimiento." In Dewart, *Emanuel Martinez: A Retrospective*, 26–28.

———. "Telling Images Bracket the 'Broken-Promise(d) Land': The Culture of Immigration and the Immigration of Culture across Borders." In *Culture across Borders: Mexican Immigration & Popular Culture*, edited by David R. Maciel and María Herrera-Sobek, 99–148. Tucson: University of Arizona Press, 1998.

Spector, Nancy. *Richard Prince*. New York: Guggenheim Museum, 2007.

Tarver, Gina McDaniel. *The New Iconoclasts: From Art of a New Reality to Conceptual Art in Colombia, 1961–1975*. Bogotá: Universidad de los Andes, 2016.

"The Third World Liberation Front Strike circa 1969." *Third World Forum* 24, no. 2 (February 2003): 6–7.

Thomas, Mary, ed. *Día de los Muertos: A Cultural Legacy, Past, Present, & Future*. Los Angeles: Self Help Graphics & Art, 2017.

Tompkins Rivas, Pilar, ed. *Regeneración: Three Generations of Revolutionary Ideology*. Monterey Park, CA: Vincent Price Art Museum at East Los Angeles College, 2018.

Treré, Emiliano. *Hybrid Media Activism: Ecologies, Imaginaries, Algorithms*. London: Routledge, 2019.

Tsekeris, Charalambos, and Ioannis Katerelos. "Interdisciplinary Perspectives on Web 2.0: Complex Networks and Social Dynamics." In *The Social Dynamics of Web 2.0: Interdisciplinary Perspectives*, edited by Charalambos Tsekeris and Ioannis Katerelos, 1–14. London: Routledge, 2015.

UC San Diego Library. "Farmworker Movement Documentation Project." Accessed July 12, 2019. https://libraries.ucsd.edu/farmworkermovement/gallery/index.php?cat=66).

United Farm Workers of America. *Food and Justice: Magazine of the United Farm Workers of America, AFL-CIO* 3, no. 2 (February/March 1986). Farmworker Movement Documentation Project, UC San Diego Library. https://libraries.ucsd.edu/farmworkermovement/ufwarchives/foodjustice/08_FebMar86_001.pdf.

Valdez, Luis. "Notes on Chicano Theater." In Valdez and Steiner, *Aztlan: An Anthology of Mexican American Literature*, 354–59.

Valdez, Luis, and Stan Steiner, eds. *Aztlan: An Anthology of Mexican American Literature*. New York: Knopf, 1972.

Velasco, Ana. "Self Help Graphics & Art's Día de los Muertos Legacy Told Through Prints." Artbound, KCET. May 30, 2019. https://www.kcet.org/shows/artbound/self-help-graphics-arts-dia-de-los-muertos-legacy-told-through-prints.

Wade, Lisa. "Racial Bias and How the Media Perpetuates It with Coverage of Violent Crime." *Pacific Standard*. April 17, 2015. https://psmag.com/social-justice/racial-bias-and-how-the-media-perpetuates-it-with-coverage-of-violent-crime.

"Walkout in Albuquerque: The Chicano Movement Becomes Nationwide." In Valdez and Steiner, *Aztlan: An Anthology of Mexican American Literature*, 211–14.

Warth, Gary. "Chicano Park Named National Historic Landmark." *San Diego Union-Tribune*. January 11, 2017. https://www.sandiegouniontribune.com/news/politics/sd-me-chicano-historic-20170111-story.html.

Watt, Peter, and Roberto Zepeda. *Drug War Mexico: Politics, Neoliberalism, and Violence in the New Narcoeconomy*. New York: Zed Books, 2012.

Weber, John Pitman. "Carlos Cortez." In *Culture, Politics and Art: Expressions in the Dance of Life*, 5–8. Evanston, IL: Northwestern University, 1995.

Wells, Carol A. "La Lucha Sigue: From East Los Angeles to the Middle East." In Noriega, *¿Just Another Poster?*, 171–201.

Weschler, Lawrence. *Domestic Scenes: The Art of Ramiro Gomez*. New York: Abrams, 2016.

West, William. "SF Police Kill Alex Nieto." San Francisco Bay Area Independent Media Center. March 31, 2014. https://www.indybay.org/newsitems/2014/03/31/18753360.php.

White, Michael J., Frank D. Bean, and Thomas J. Espenshade. "The U.S. 1986 Immigration Reform and Control Act and Undocumented Migration to the United States." *Population Research and Policy Review* 9, no. 2 (May 1990): 93–116.

Witt, Emily. "How the Survivors of Parkland Began the Never Again Movement." *New Yorker*. February 19, 2018. https://www.newyorker.com/news/news-desk/how-the-survivors-of-parkland-began-the-never-again-movement.

Womack, John, Jr. *Zapata and the Mexican Revolution*. New York: Knopf, 1969.

Wye, Deborah. *Committed to Print: Social and Political Themes in Recent American Printed Art*. New York: Museum of Modern Art, 1988.

Yarbro-Bejarano, Yvonne. "Ester Hernández and Yolanda López." *CrossRoads* (Oakland, CA), no. 31 (May 1993): 15, 17.

Ybarra, Lea, and Nina Genera. *La Batalla Está Aquí: Chicanos and the War*. El Cerrito, CA: Chicano Draft Help, 1972.

Ybarra-Frausto, Tomás. "*Califas*: California Chicano Art and Its Social Background." Unpublished manuscript, 20–21. Prepared for Califas Seminar at Mary Porter Sesnon Gallery, University of California, Santa Cruz, April 16–18, 1982.

———. "*Califas*: Socio-Aesthetic Chronology of Chicano Art." Unpublished manuscript, 11, ca. 1983.

———. "The Chicano Movement and the Emergence of a Chicano Poetic Consciousness." *New Scholar* 6 (1977): 81–109.

———. "Rasquachismo: A Chicano Sensibility." In *Chicano Aesthetics: Rasquachismo*, 5–8. Phoenix, AZ: MARS, Movimiento Artístico del Río Salado, 1989.

———. "Rasquachismo: A Chicano Sensibility." In Griswold del Castillo, McKenna, and Yarbro-Bejarano, *Chicano Art: Resistance and Affirmation*, 155–62.

Zapata, Claudia E. "Branding 'Death' in a High-Tech Boycott: United Farm Workers and the Wrath of Grapes Campaign." *Journal of Latino-Latin American Studies (JOLLAS)* 10, no. 1 (2019): 48–69.

———. "Digital Harbinger: Michael Menchaca's The Codex Silex Vallis (The Silicon Valley Codex)." *Michael Menchaca: The Codex Silex Vallis (Sept. 21–Dec. 22, 2019)*, Lawndale Art Center, n.p. October 1, 2019. https://issuu.com/lawndaleartcenter/docs/michael_menchaca_brochure.

Zarobell, John. "Rupert Garcia." Studio Sessions, Art Practical. January 30, 2018. https://www.artpractical.com/column/studio-sessions-rupert-garcia/.

Zavala, Adriana. "Ester Hernández." In *Art_Latin_America: Against the Survey*, edited by James Oles, 161–63. Austin: University of Texas Press, 2019.

Zuboff, Shoshana. *The Age of Surveillance Capitalism: The Fight for a Human Future at the New Frontier of Power*. New York: PublicAffairs, 2019.

E. Carmen Ramos is acting chief curator and curator of Latinx art at the Smithsonian American Art Museum. She received a bachelor's degree from New York University and her PhD from the University of Chicago. Ramos has curated numerous exhibitions, including *Down These Mean Streets: Community and Place in Urban Photography* (2017), and is the author, most recently, of *Tamayo: The New York Years* (2017) and *Our America: The Latino Presence in American Art* (2014). She is currently writing a monograph about Freddy Rodríguez as part of the *A Ver: Revisioning Art History* book series.

Tatiana Reinoza is an art historian and independent curator who specializes in contemporary Latinx art. She earned her PhD in art history from the University of Texas at Austin in 2016 and teaches at the University of Notre Dame. She has written articles for the *Archives of American Art Journal* and *Aztlán*, among others, and has edited anthologies such as *A Library for the Americas: The Nettie Lee Benson Latin American Collection* (2018). Reinoza is currently writing a history of Latinx printmaking and editing a commemorative anthology on the Chicanx workshop Self Help Graphics.

Terezita Romo is an art historian, curator, and a lecturer and affiliate faculty member at the University of California, Davis. She has curated numerous exhibitions of Chicano and Native American artists, and has published extensively on Chicana/o art. She was project coordinator for the Latino artist monograph series *A Ver: Revisioning Art History* at UCLA's Chicano Studies Research Center, and is the author of the artist monograph *Malaquias Montoya* (2011) and coeditor of *Chicano and Chicana Art: A Critical Anthology* (2019).

Claudia E. Zapata is curatorial assistant of Latinx art at the Smithsonian American Art Museum, and is a doctoral candidate at Southern Methodist University. She received her BA and MA in art history from the University of Texas at Austin, specializing in Classic Maya art. Her research interests include curatorial methodologies of identity-based exhibitions, Chicanx and Latinx art, digital humanities, people of color zines, and designer toys. Zapata has curated exhibitions at Mexic-Arte Museum in Austin and other Texas institutions, and has published articles in *Panhandle-Plains Historical Review*, *JOLLAS*, *Aztlán*, *Hemisphere*, and *El Mundo Zurdo 7*.

Page numbers in *italics* indicate illustrations. Titles of authored works will be found under the author's name.

IMAGE CREDITS

Unless otherwise specified, all photographs were provided by the owners/collections of the works of art noted in the captions and are reproduced with permission. Every effort has been made to obtain permissions for all copyright-protected images.

Printing and Collecting the Revolution

fig. 2 From Karen Mary Davalos, *Yolanda M. López* (Los Angeles: UCLA Chicano Studies Research Center Press, 2008), 30; **fig. 4** © 2020 Estate of Corita Kent/ Immaculate Heart Community/ Licensed by Artists Rights Society (ARS), New York; **figs. 5, 8, 27** Photo by Mildred Baldwin; **fig. 9** © Shepard Fairey/ObeyGiant.com; **figs. 10–12, 24, 25, 28** Photo by Mindy Barrett; **fig. 14** © The Trustees of the British Museum. All rights reserved. **fig. 15** © 1978, Yolanda López; photo by Mindy Barrett; **fig. 16** Courtesy of the Library of Congress, Prints and Photographs Division, LC-DIG-ppmsca-28668; **fig. 17** © 2020 Artists Rights Society (ARS), New York/SOMAAP, Mexico City; **fig. 18** © Estate of Roy Lichtenstein; **fig. 20** © San Antonio Express-News/ZUMA Press; **fig. 21** © Joe Brusky; **fig. 23** Doug Adams Gallery, Center for the Arts & Religion, Graduate Theological Union; **figs. 24, 25** © 2004, Xico González; photo by Mindy Barrett; **fig. 26** Photo by Jim Hess.

Aesthetics of the Message

fig. 1 Photo by George Rodriguez; **fig. 2** Courtesy of the photographer; **fig. 3** Courtesy of the Library of Congress, Prints and Photographs Division, LC-DIG-ppmsc-03521; **fig. 4** Courtesy of the Palace of the Governors Photo Archives (NMHM/DCA), Santa Fe New Mexican collection, HP.2014.14.476; **fig. 5** © Rupert García, Courtesy of Rena Bransten Gallery, San Francisco; **fig. 6** © 1973, Malaquias Montoya; photo by Mindy Barrett; **fig. 8** NMMA staff; **fig. 9** © 1975 Ricardo Favela; photo by Mildred Baldwin; **figs. 10, 17, 18** Photo by Mindy Barrett; **fig. 12** Photo by Mildred Baldwin; **fig. 14** © 1976, Judithe Hernández; photo by Mildred Baldwin; **fig. 16** From Chon A. Noriega, ed., *¿Just Another Poster? Chicano Graphic Arts in California* (Santa Barbara, CA: University Art Museum, 2001), 59; **fig. 19** © 2020 Estate of Luis A. Jimenez Jr./ Artists Rights Society (ARS), New York.

War at Home

fig. 2 © Martha Rosler; **fig. 3** Digital Image © 2020 Museum Associates/LACMA. Licensed by Art Resource, NY; **fig. 4** © Antonio Caro, Courtesy Casas Riegner, Bogotá; **fig. 5** © Antonio Caro, Courtesy Casas Riegner, Bogotá; photo by Charles Mayer; **fig. 6** © Hans Haacke/Artists Rights Society (ARS), New York/VG Bild-Kunst, Bonn; **fig. 7** © 1976, Harry Gamboa Jr.; photo by Mildred Baldwin; **fig. 8** © Adrian Piper Research Archive (APRA) Foundation, Berlin. Photo credit: Andrej Glusgold; **fig. 9** © Guerrilla Girls, Courtesy www.guerrillagirls.com; **fig. 11** Photo courtesy Doug Ashford; **fig. 12** Courtesy the Oldenburg van Bruggen Studio, Copyright 1984; **fig. 13** © Yoko Ono 1969/2020; **fig. 15** Courtesy of the artist; **fig. 17** © Teresa Margolles. Courtesy of Gabinete TM and James Cohan, New York; **fig. 18** © 2020 Robert Rauschenberg Foundation/ Licensed by VAGA at Artists Rights Society (ARS), NY; photo: Ben Blackwell.

Chicanx Graphics in the Digital Age

fig. 1 Photo courtesy of Barbara Carrasco; **fig. 2** Photo courtesy of Magnolia Editions; **fig. 3** Courtesy Jacalyn Lopez Garcia, transmedia visual storyteller; **fig. 4** Copyright 2020 Favianna. com; **fig. 5** Copyright © 2016 Rini Templeton Memorial Fund; **fig. 6** © 2020 Emory Douglas/ Artists Rights Society (ARS), New York; **fig. 7** © 7/28/2020, Oree Originol; **fig. 8** Photo by Jessica Jones; **fig. 9** Jessica Christian/San Francisco Chronicle/Polaris; **fig. 10** Courtesy of the artist; **fig. 11** © Federico Villalba, Videographer; **fig. 13** Photo by ALFRED/SIPA/ Sipa USA; **fig. 15** Photo taken by Suzy Gonzalez, Sept. 20 , 2019; Courtesy of the artist.

Plates

pl. 1 © 1965, Carlos A. Cortéz Estate; photo by Mildred Baldwin; **pl. 2** © 1966, Andrew Zermeño; photo by Mildred Baldwin; **pl. 3** © 1967, Emanuel Martinez; photo by Mindy Barrett; **pl. 4** © 1968, Rupert García; photo by Mindy Barrett; **pl. 5** © 1969, Rupert García; photo by Mindy Barrett; **pl. 6** © 1969, Yolanda López; photo by Mindy Barrett; **pls. 7, 28, 37, 38** Photo by Mildred Baldwin; **pl. 8** © 1971, Rupert García; photo by Mildred Baldwin; **pls. 9, 10** © 1972, Malaquias Montoya; photo by Mildred Baldwin; **pl. 11** © 1973, Xavier Viramontes; photo by Mildred Baldwin; **pl. 12** © 1973, Rupert García; photo by Mildred Baldwin; **pl. 13** © 1974, Amado M. Peña Jr.; photo by Mildred Baldwin; **pl. 14** © 1974, Carmen Lomas Garza; **pl. 15** © 1975, Amado M. Peña Jr.; photo by Gene Young; **pl. 16** © 1975, Linda Zamora Lucero; photo by Mildred Baldwin; **pl. 17** © Juan R. Fuentes; photo by Mildred Baldwin; **pl. 18** © 1974, Francisco X Camplis; photo by Mildred Baldwin; **pl. 19** © 1975, Rupert García; photo by Mildred Baldwin; **pl. 20** © 1975, Luis C. González; photo by Mildred Baldwin; **pl. 21** © 1975, Ester Hernandez; photo by Mindy Barrett; **pl. 22** © 2020, Rodolfo O. Cuellar; photo by Mindy Barrett; **pl. 23** © 1976, Estate of Ricardo Favela; photo by Mildred Baldwin; **pl. 24** © 1976, Oscar A. Melara; photo by Mildred Baldwin; **pl. 25** © 1975, Luis C. González and Max Garcia; photo by Mildred Baldwin; **pl. 26** © 1976, Malaquias Montoya; photo by Mindy Barrett; **pl. 27** © 1976, Leonard Castellanos; photo by Mildred Baldwin; **pl. 28** © 2020 Estate of Luis A. Jimenez Jr./Artists Rights Society (ARS), New York; photo by Mildred Baldwin; **pl. 29** © 1977, Rupert García; photo by Gene Young; **pl. 30** © 1977, Mario Torero; photo by Mildred Baldwin; **pl. 31** © Juan R. Fuentes; photo by Mindy Barrett; **pl. 32** © 2020, Rodolfo O. Cuellar, Luis C. González, and José Montoya; photo by Mindy Barrett; **pl. 33** © 1979, Luis C. González; photo by Mildred Baldwin; **pl. 35** © 1975, Luis C. González; photo by Mildred Baldwin; **pl. 34** © 1979, Carlos A. Cortéz Estate; photo by Mildred Baldwin; **pl. 36** © 1981, Malaquias Montoya; photo by Mindy Barrett; **pl. 39** © 1978, Yolanda López; photo by Mindy Barrett; **pl. 40** © 1982, Ester Hernandez; photo by Mildred Baldwin; **pl. 41** © 2008, Ester Hernandez; photo by Mildred Baldwin; **pl. 42** © 1982, Estate of Saul Richard Duardo; photo by Mildred Baldwin; **pl. 43** ©1982, Nancy Hom; photo by Mildred Baldwin; **pl. 44** © 1983, Juan Fuentes; photo by Mindy Barrett; **pls. 45–47, 49, 56** Photo by Mindy Barrett; **pl. 48** © 1976, Luis C. González; photo by Mildred Baldwin; **pl 50.** © 2020 Estate of Gilbert "Magu" Luján / Artists Rights Society (ARS), New York; photo by Mildred Baldwin; **pl. 51** © Juan R. Fuentes; photo by Mildred Baldwin; **pl. 52** © 1987, Patssi Valdez; photo by Mildred Baldwin; **pl. 53** © 1988, Elizabeth Sisco & Louis Hock & David Avalos; photo by Mindy Barrett; **pl. 54** © 1988, Self-Help Graphics & Art, Inc.; photo by Mildred Baldwin; **pl. 55** Artwork © 1989, Barbara Carrasco; video © 1989, GVI; **pl. 57** © 2020, Rodolfo O. Cuellar; photo by Mildred Baldwin; **pl. 58** © 1999, Yreina D. Cervántez; photo by Mindy Barrett; **pl. 59** © 1999, Alma Lopez; photo by Mindy Barrett; **pl. 60** © 1999, Barbara Carrasco; photo by Mildred Baldwin; **pls. 61, 65** © 01-01-14, Jill Ramirez; photo by Mildred Baldwin; **pl. 62** © 2003, Alejandro Diaz; **pl. 63** © 2004, Enrique Chagoya; photo by Mindy Barrett; **pls. 64, 116** © 2019, Jesus Barraza; photo by Mildred Baldwin; **pls. 66–77** © 2010, Dominican York Proyecto GRAFICA; photo by Mindy Barrett; **pl. 78** © 2010, Rupert García, Courtesy of Rena Bransten Gallery, San Francisco; **pl. 79** © 3/3/2020, Sonia Romero; photo by Mindy Barrett; **pls. 80–92** © MMXX, Michael Menchaca; photo by Mildred Baldwin; **pls. 93–95, 113** © 2020, Favianna Rodriguez; **pls. 96–99** © 2020, Julio Salgado; **pl. 100** © 2013, Daniel González; photo by Mindy Barrett; **pl. 101** © 2019, Jesus Barraza; photo by Mildred Baldwin; **pl. 102** © 2014, Sandra C. Fernández; photo by Mindy Barrett; **pl. 103** © 2020, Julio Salgado; photo by Mildred Baldwin; **pl. 104** © 1/4/2020, Ramiro Gomez; photo by Mildred Baldwin; **pl. 105** © 2012, Carlos Francisco Jackson; photo by Mildred Baldwin; **pl. 106** © 2015, Ernesto Yerena; photo by Mindy Barrett; **pl. 107** © 2020, Eric J. García; photo by Mindy Barrett; **pl. 108** © 2014 Zeke Peña; photo by Mildred Baldwin; **pl. 109** © 2016, Shizu Saldamando; photo by Mindy Barrett; **pl. 110** © 2019, Jesus Barraza; © 2010, Nancy Hernandez; photo by Mildred Baldwin; **pl. 111** © 8/7/19, Juan de Dios Mora; photo by Mindy Barrett; **pl. 112** © 2020, Poli Marichal; photo by Mindy Barrett; **pl. 114** © Lalo Alcaraz; **pl. 115** © 2019, Xico González; photo by Mindy Barrett; **pl. 116** © 2019, Jesus Barraza; photo by Mildred Baldwin; **pl. 117** © 2019, Melanie Cervantes; photo by Mildred Baldwin; **pl. 118** © 2019, Ernesto Yerena; photo by Mindy Barrett; **pl. 119** © 7/28/2020, Oree Originol.